ATHLETE

ATH

Sports Illustrated

LETE

BY WALTER IOOSS

INTRODUCTION BY MICHAEL JORDAN

BOOK DESIGN BY GIOVANNI CARRIERI RUSSO

I was 24 years old and *tired of photographers* when I met Walter for the first time. Or, to put the date of the meeting into context the way Walter does, I still had hair. It was *another dunk session,* this one in suburban Chicago. I had only one ground rule: *Make it quick.* The fact that it had to be great was a given. "I'll give you five," I told Walter. "That's all you get." He wasn't fazed. Now, I know confidence. And the fact that he felt that confident made me comfortable. "No problem, Michael." I found out very quickly that *I wasn't the only professional in the room.* We had the same focus on excellence, and Walter, with his *surfer — boy tan,* never flinched. He may have stood his ground and negotiated for what he needed to deliver the shot, but it never really mattered. From what I can tell, *Walter has never taken a bad shot of anybody or anything.* Years later, working together on *Rare Air,* we had become so comfortable around one another that I barely had to look up. You don't have to *perform for Walter.* He is an artist looking for a shot, usually *one that only he can see.* And that's the thing about genius. It's often only obvious after the fact. In Walter's case the whole world has been able to see it in books and magazines. This book is no different.

– MICHAEL JORDAN

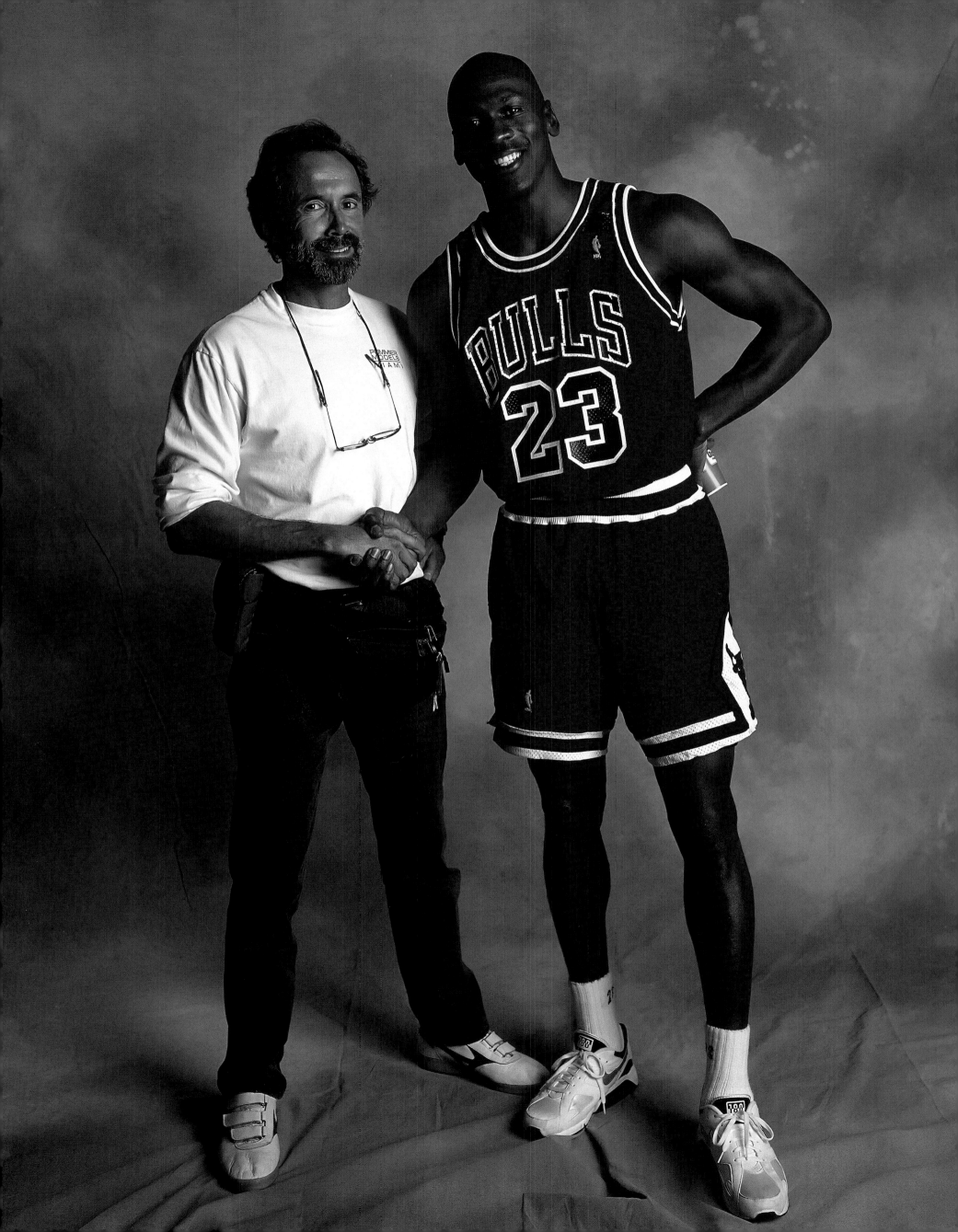

Walter Iooss shot his first frame at a professional football game at *Yankee Stadium in 1959 with his father's hobbyist camera.* Developing that first roll, seeing the image appear in a makeshift home darkroom unlocked his future. Iooss was *16 years old.* He has been putting photographs together in his mind ever since. As the years passed and sports (and life) became more complicated, *Iooss refined his technique but not his style, which has remained fundamentally improvisational.* (It will surprise no one familiar with his work to learn that his father, Walter C. Iooss Sr., was a jazz bassist who performed with Benny Goodman, Dizzy Gillespie, Billie Holiday and other musicians.) The action and purity of sport have been Iooss's concentration. To paraphrase Henri Cartier-Bresson, to make a brilliant image is to *capture, in a fraction of a second, the significance of an event.* This is what Iooss does at his best. He gets the picture. The meaning in the image is not always obvious, but something always lingers. Iooss is master of *the picture you can't forget* — but without cliché. You return to his images only to find something *previously unnoticed,* if not in the frame then certainly in your reaction to it. This is both *complicated and wonderful:* it is at this moment that the photograph becomes *more real than reality.* This is especially true of Iooss's portraits, in which his instinct is so finely tuned that he does not so much capture emotion as paint it on the faces of his subjects with light and timing. The images literally explode with character: *the intensity of Ray Lewis, the grace of Pelé.* This is Iooss's personal catalog. He insists that he is not an artist, and that is for him to say. *What I will say is that the work is transcendent.*

–TERRY MCDONELL

Editor, Sports Illustrated Group

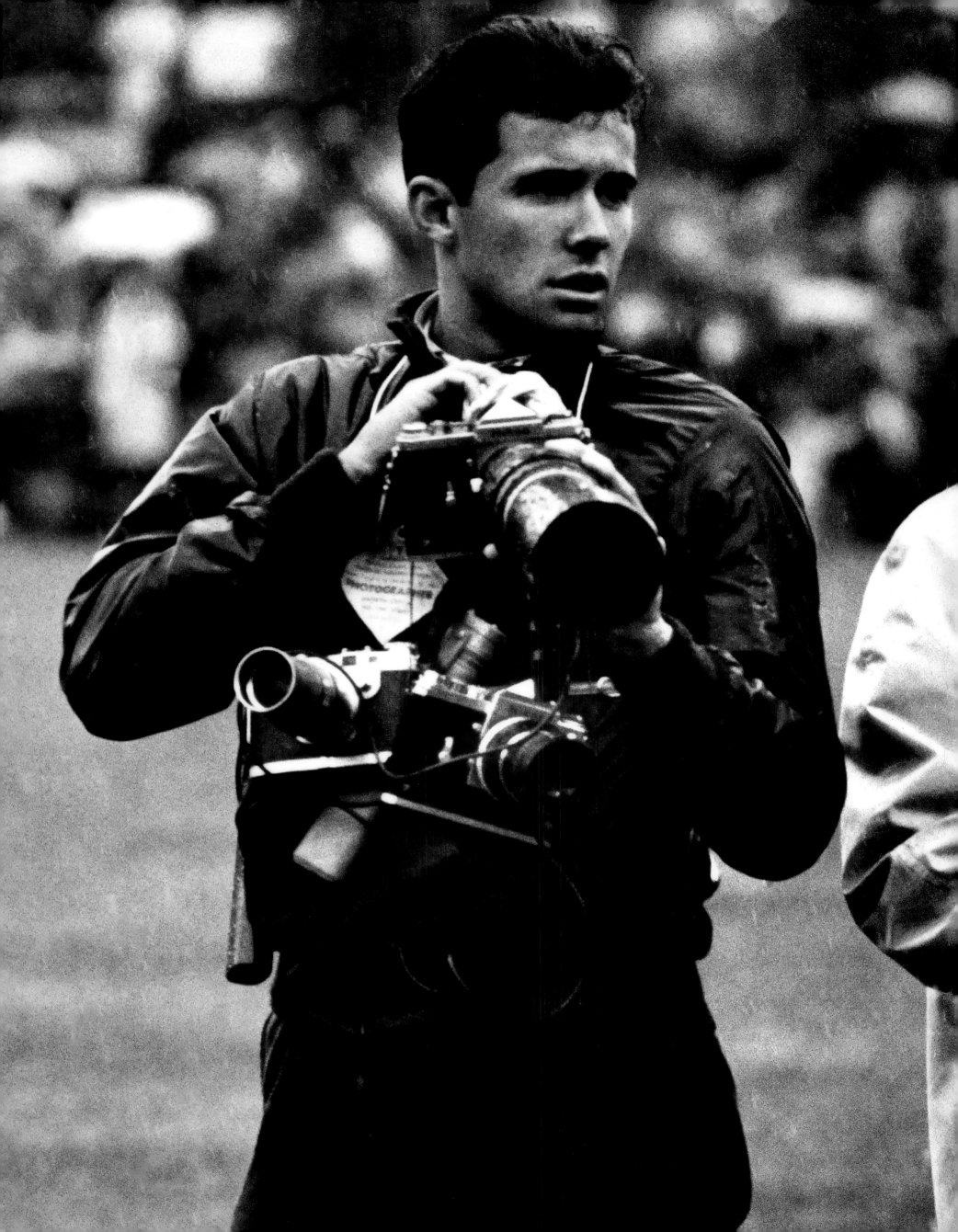

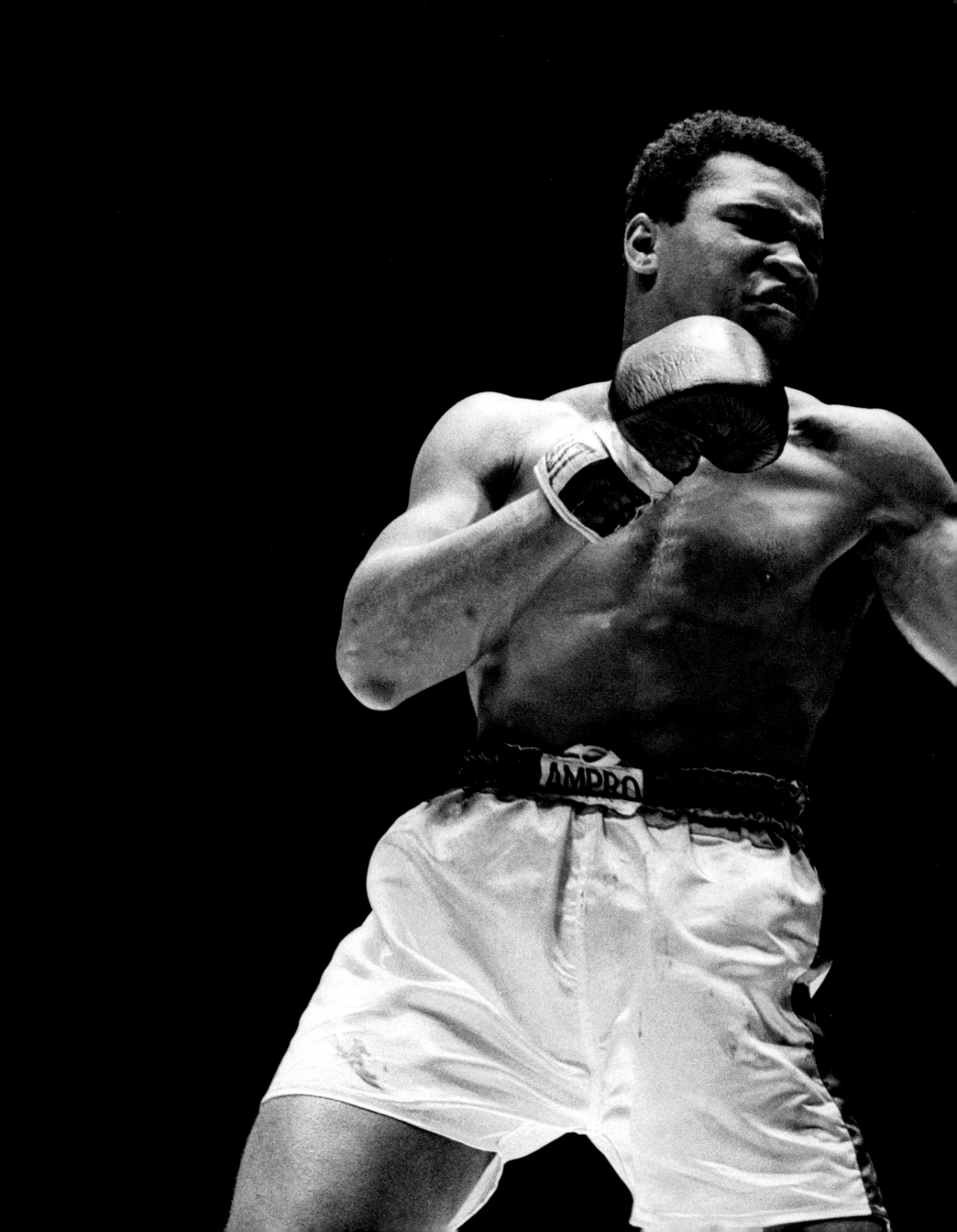

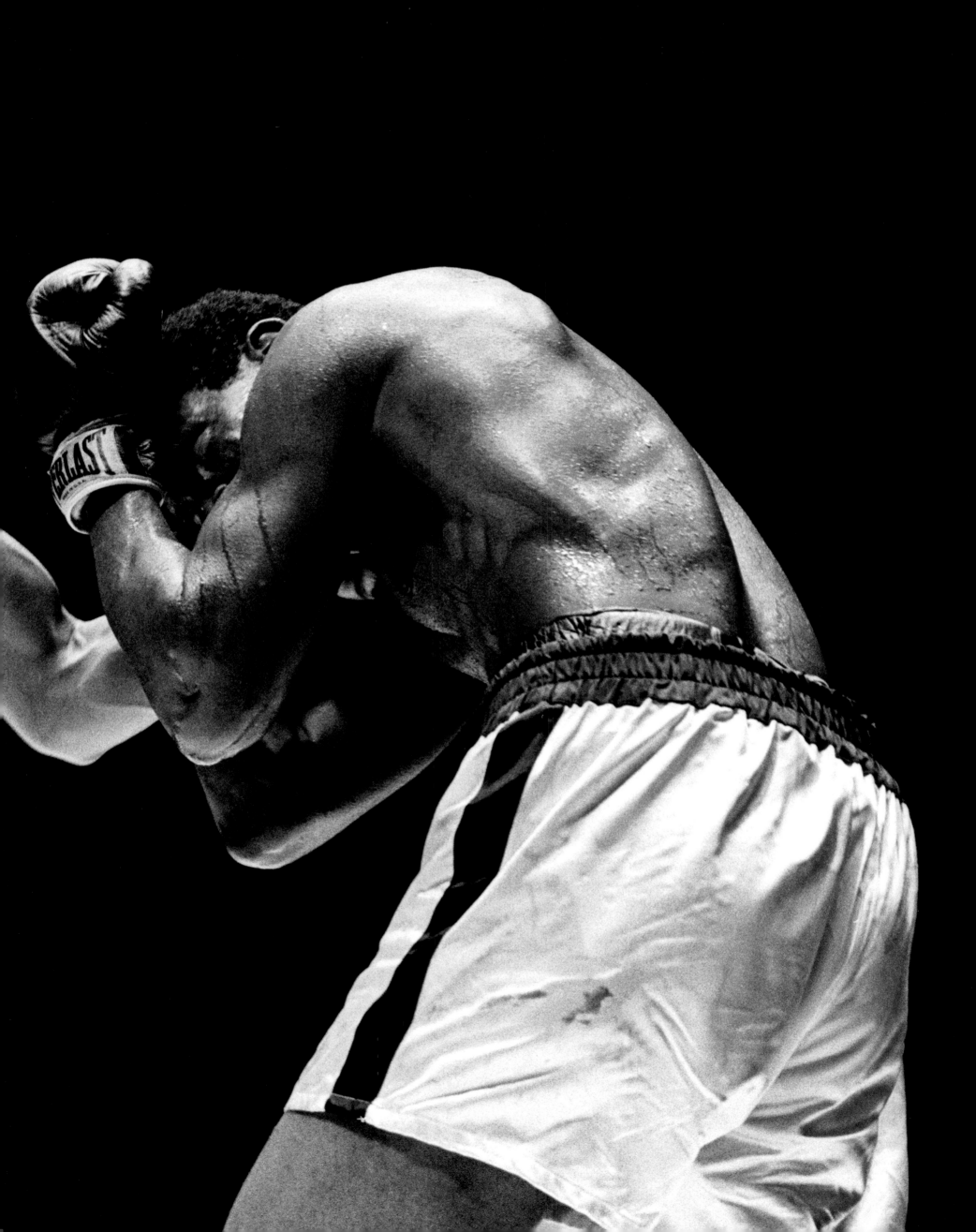

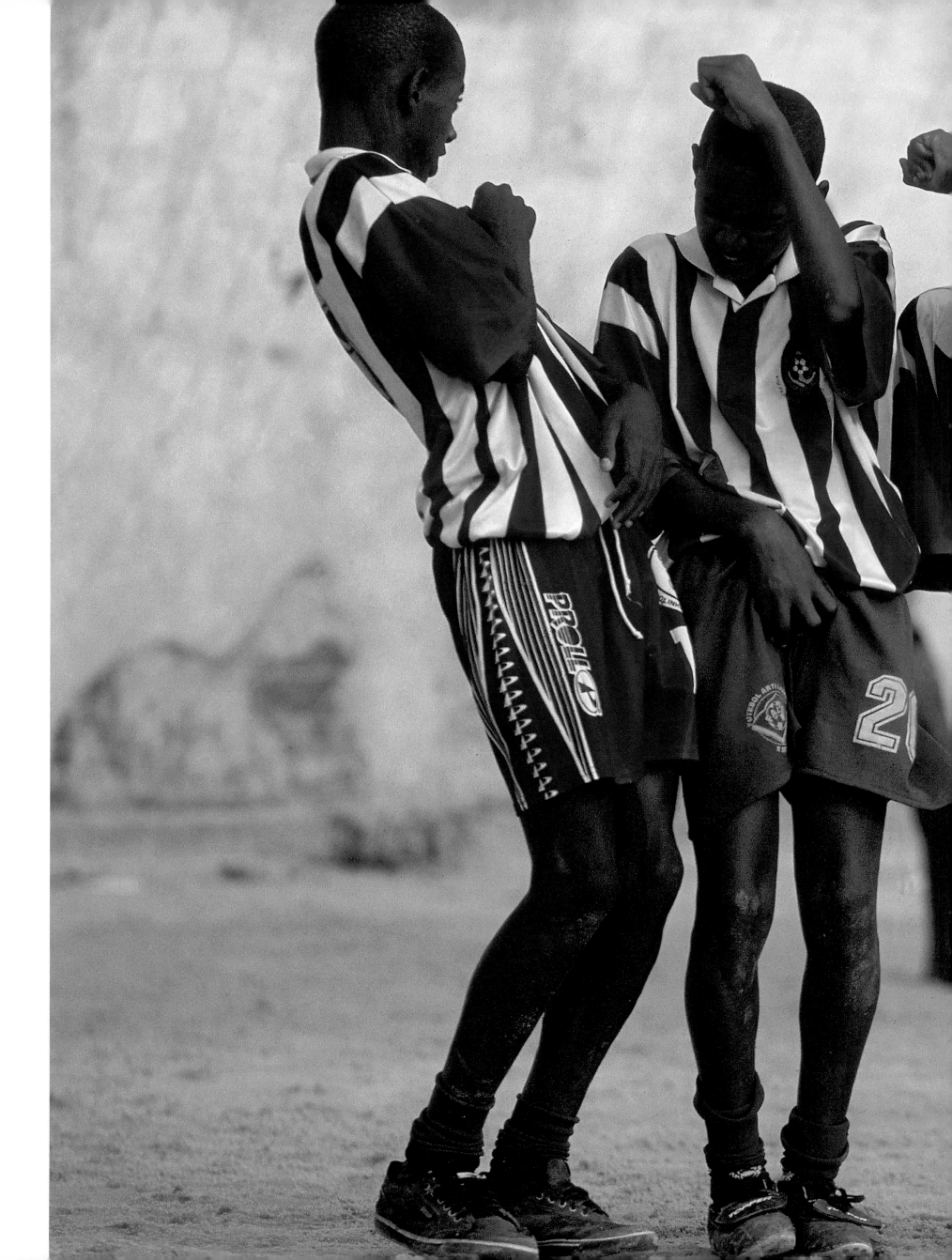

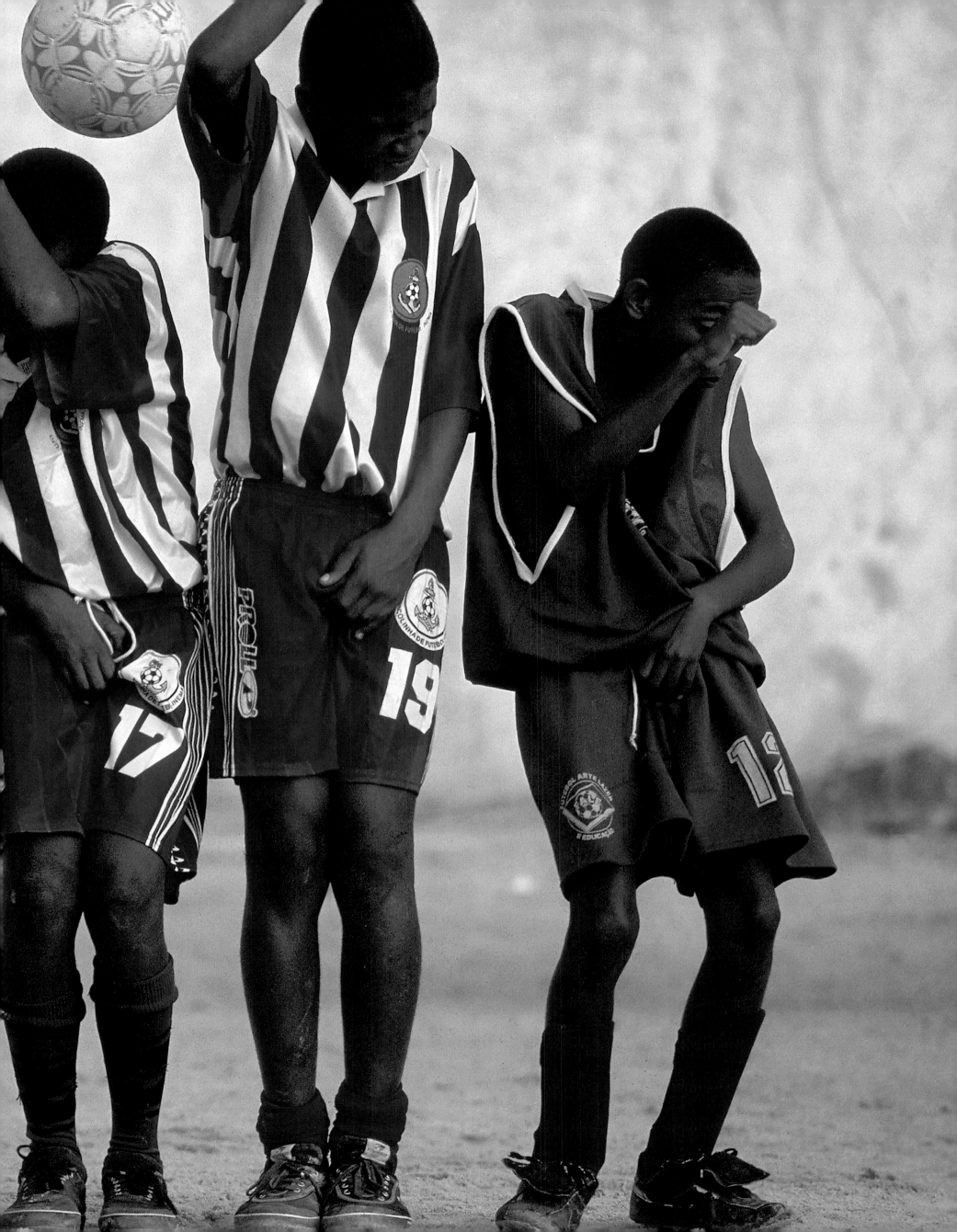

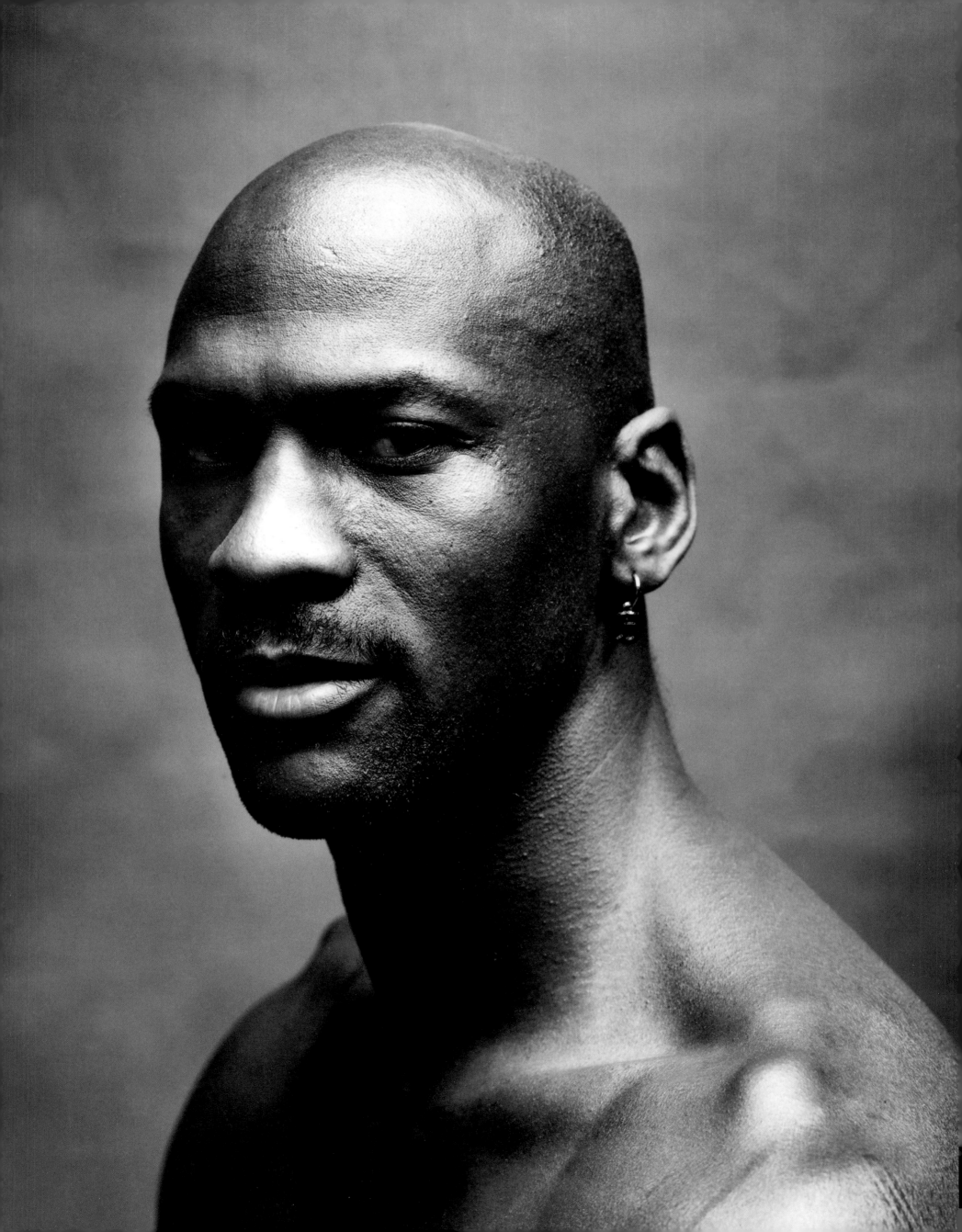

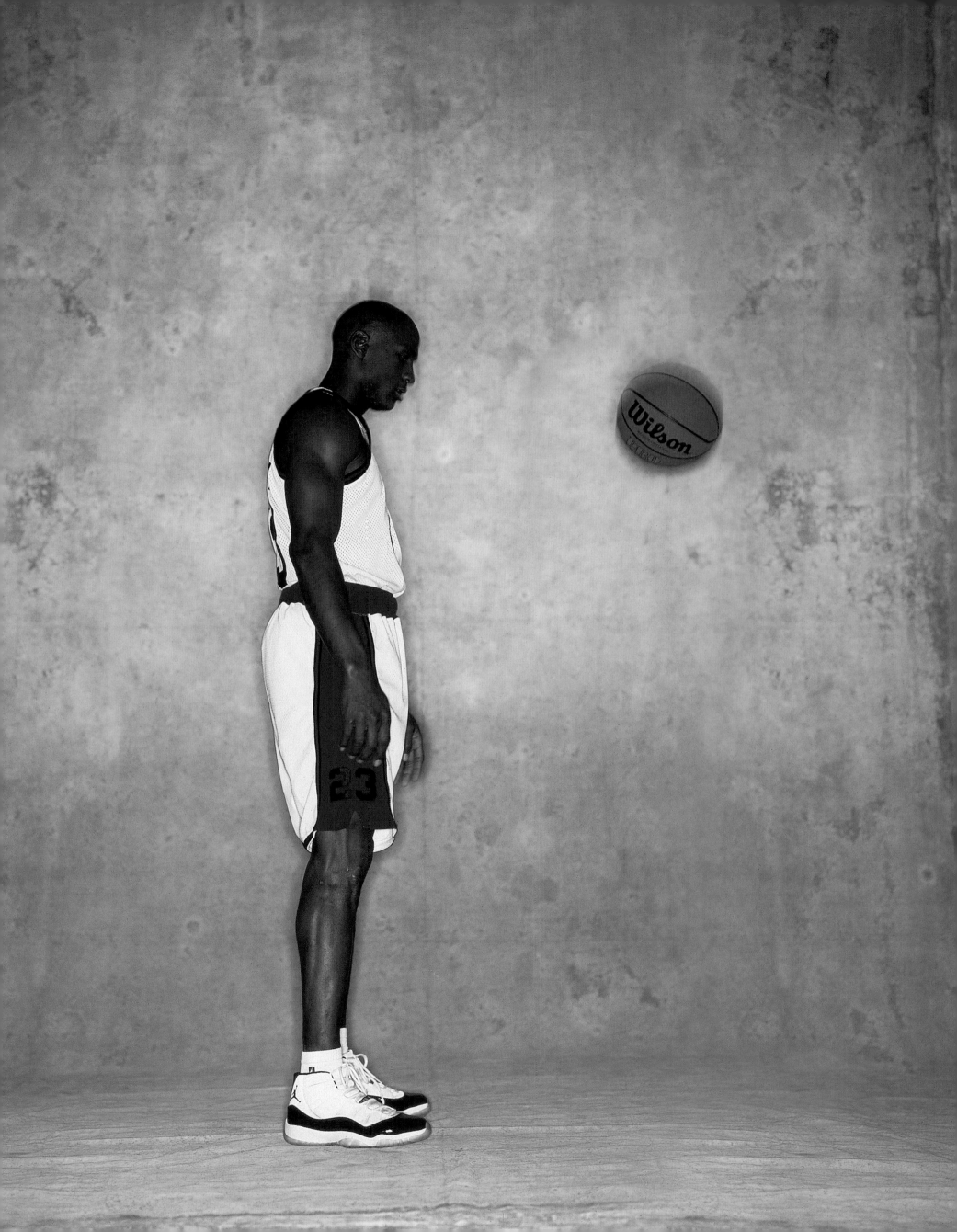

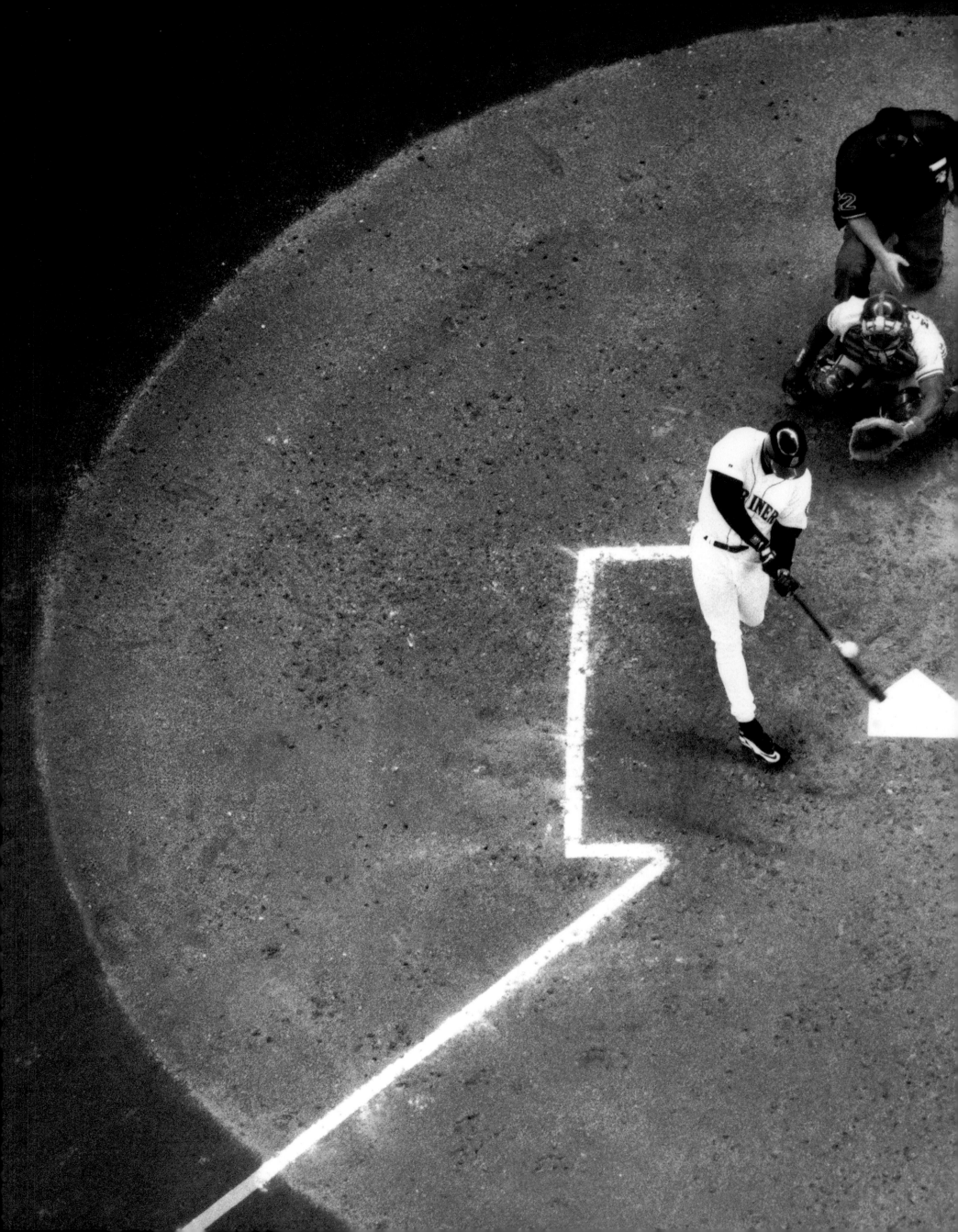

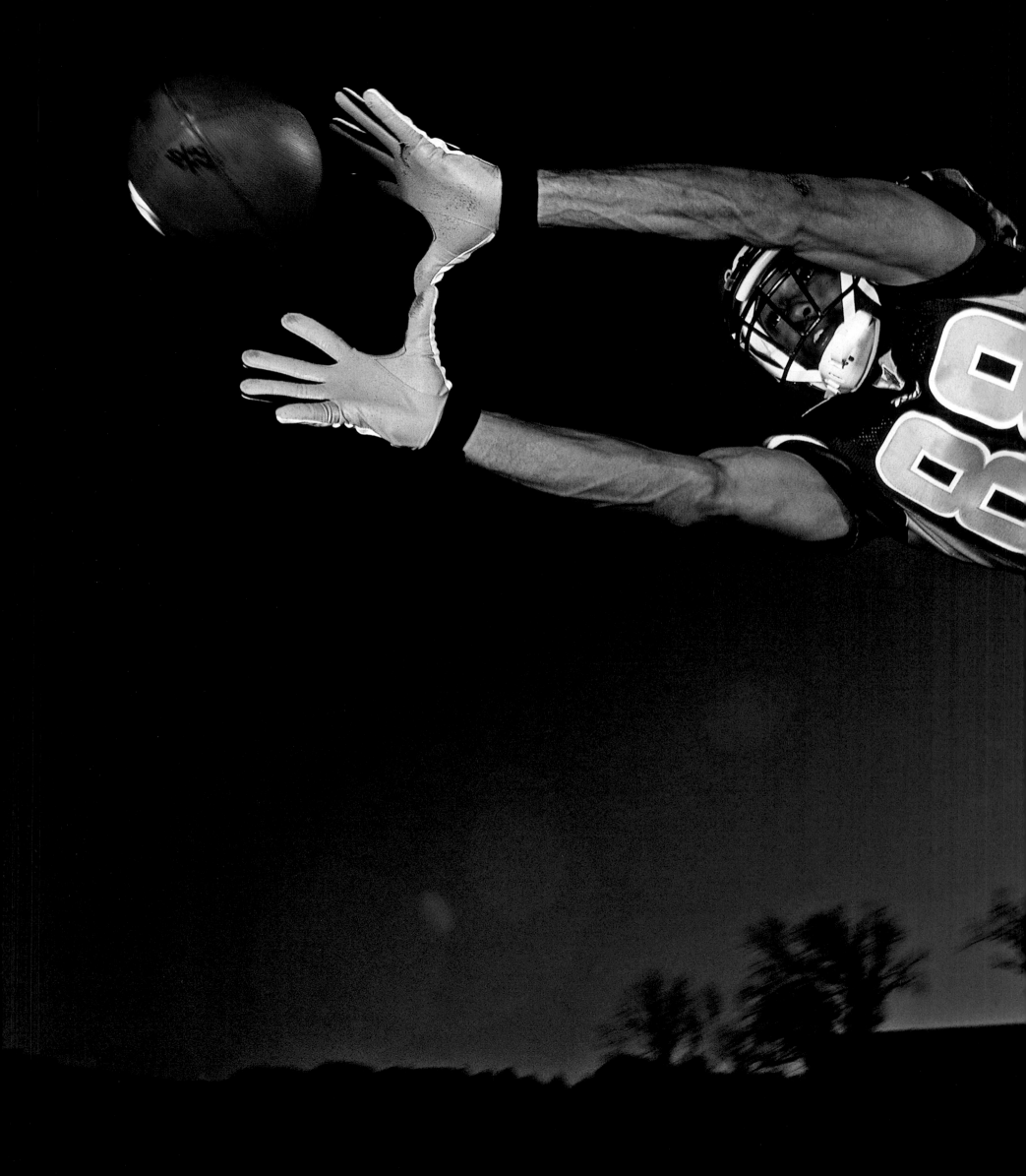

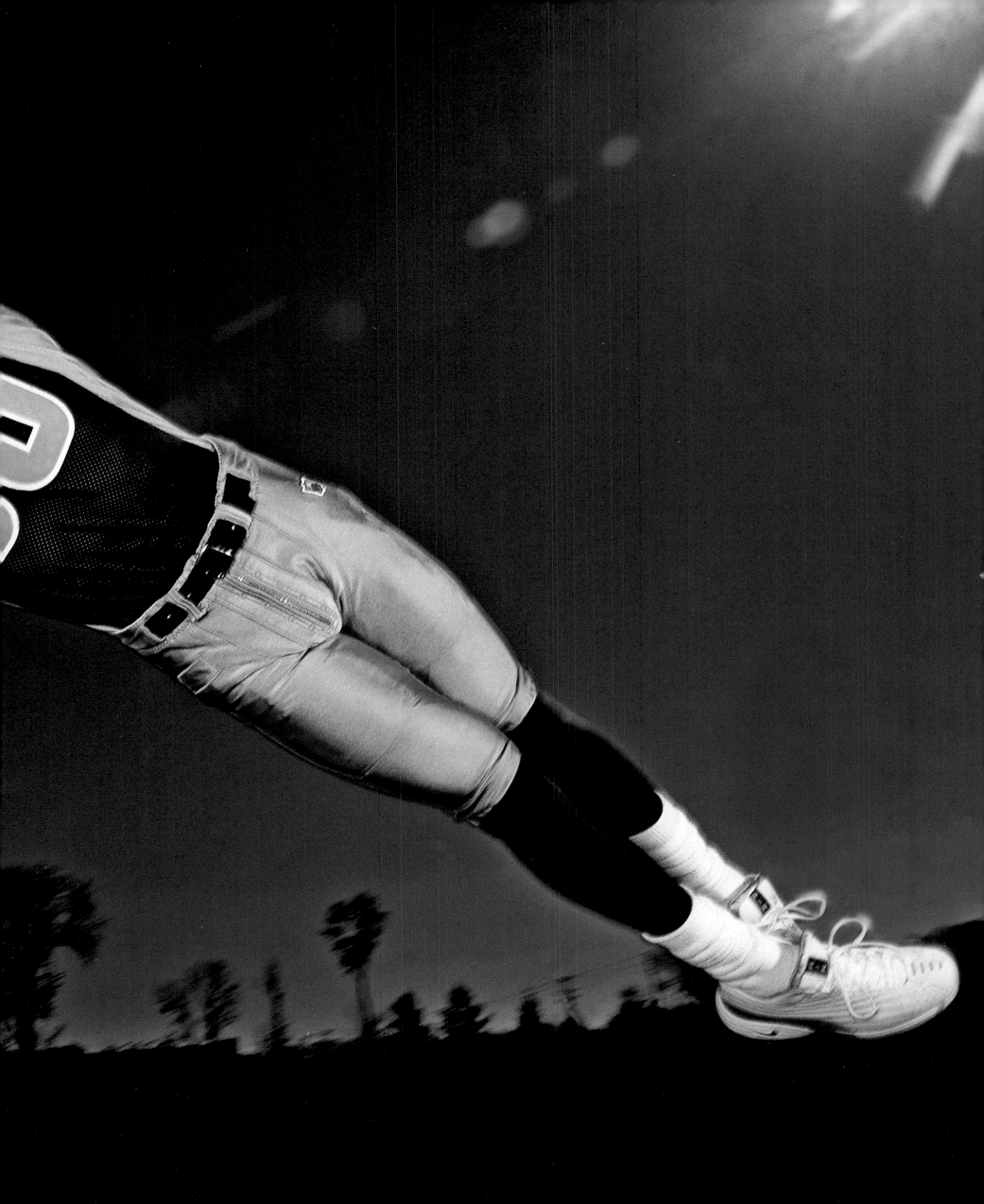

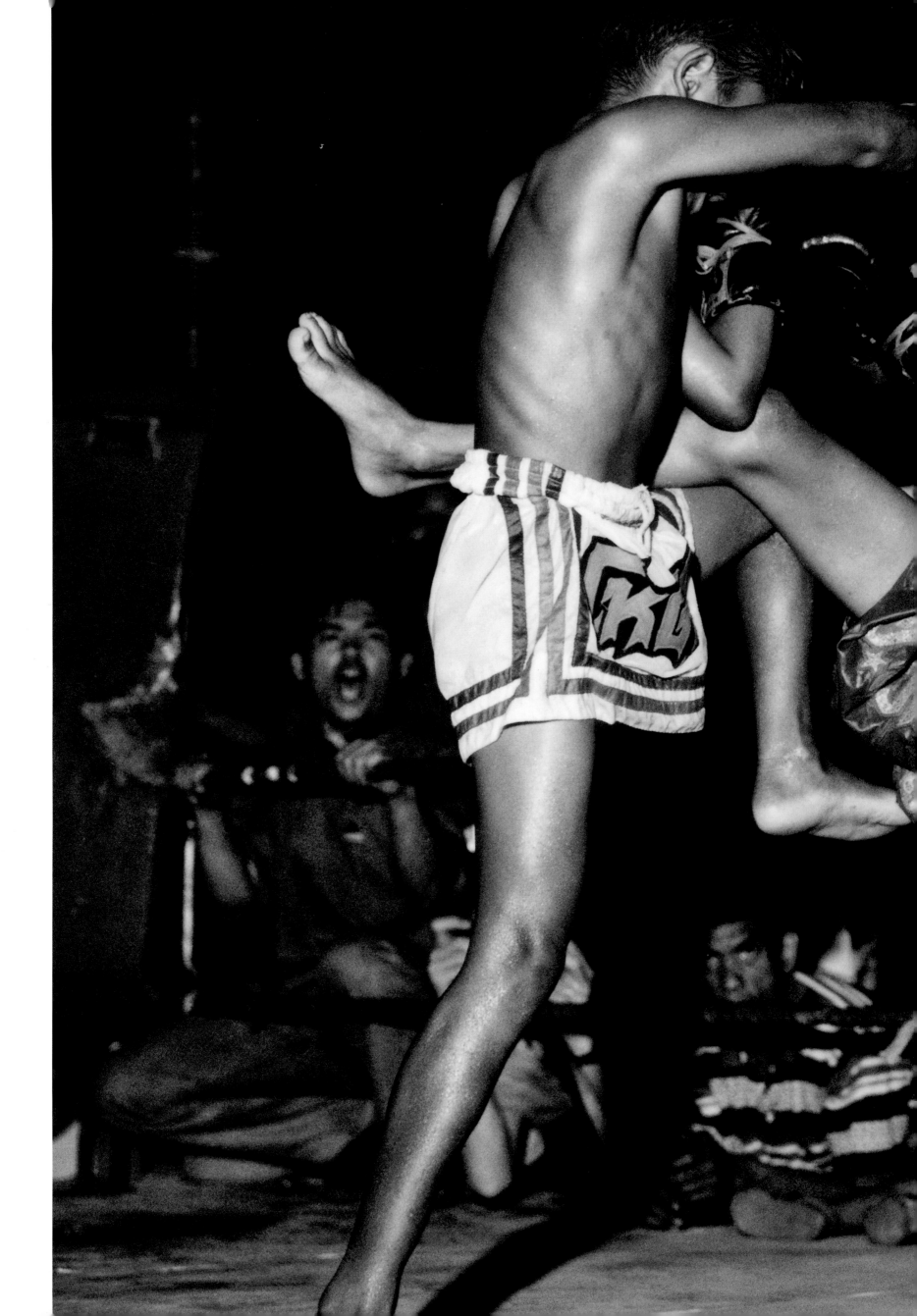

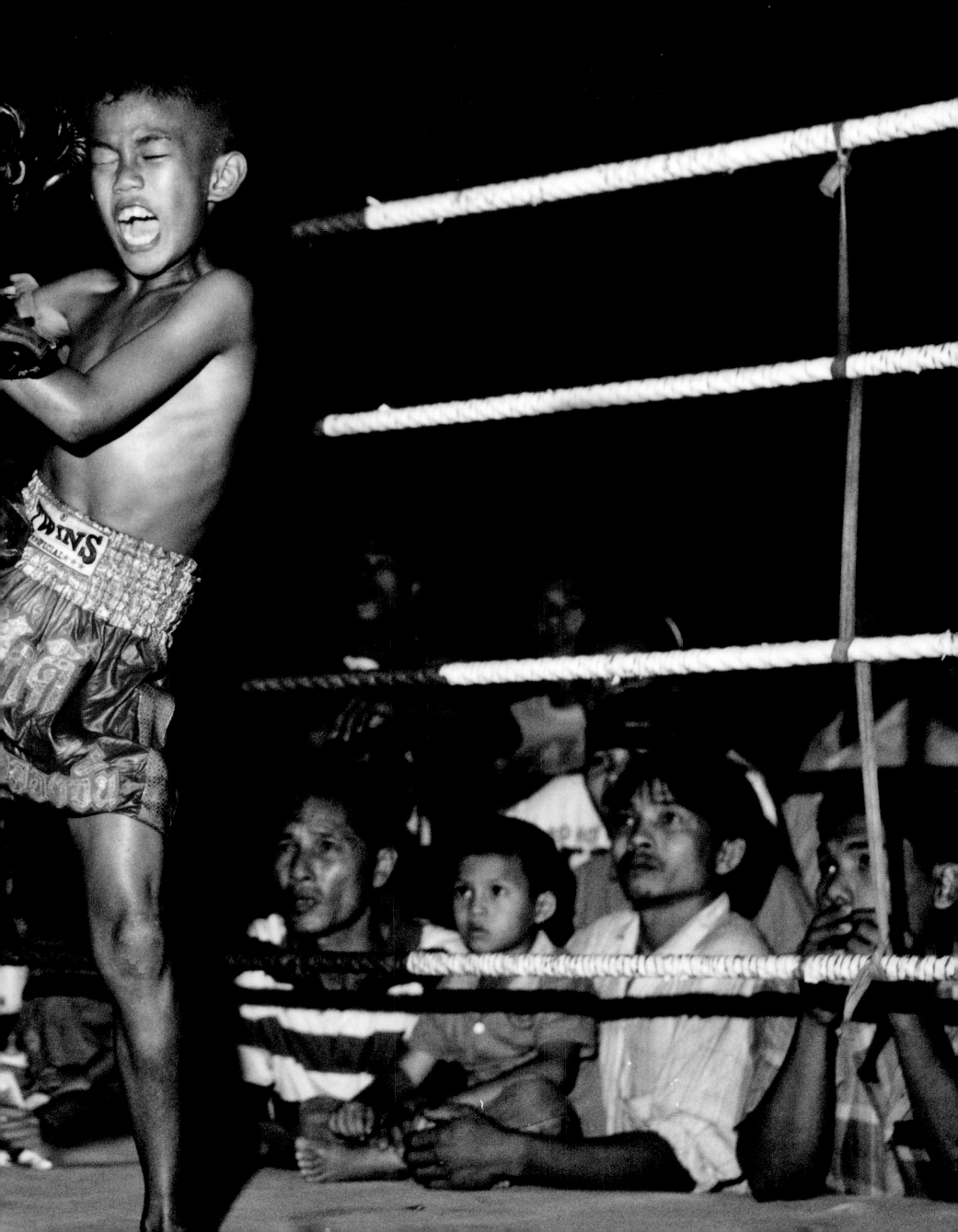

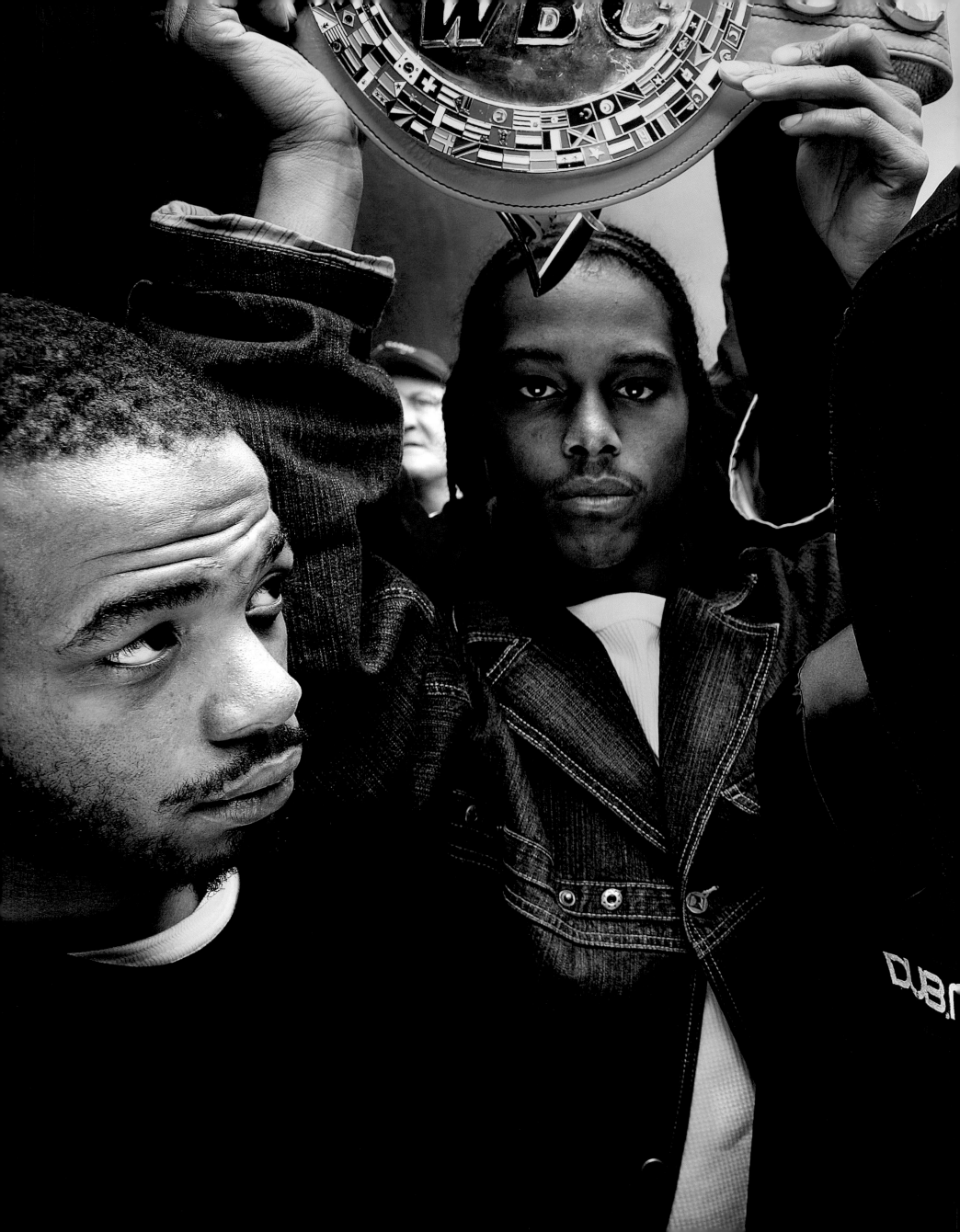

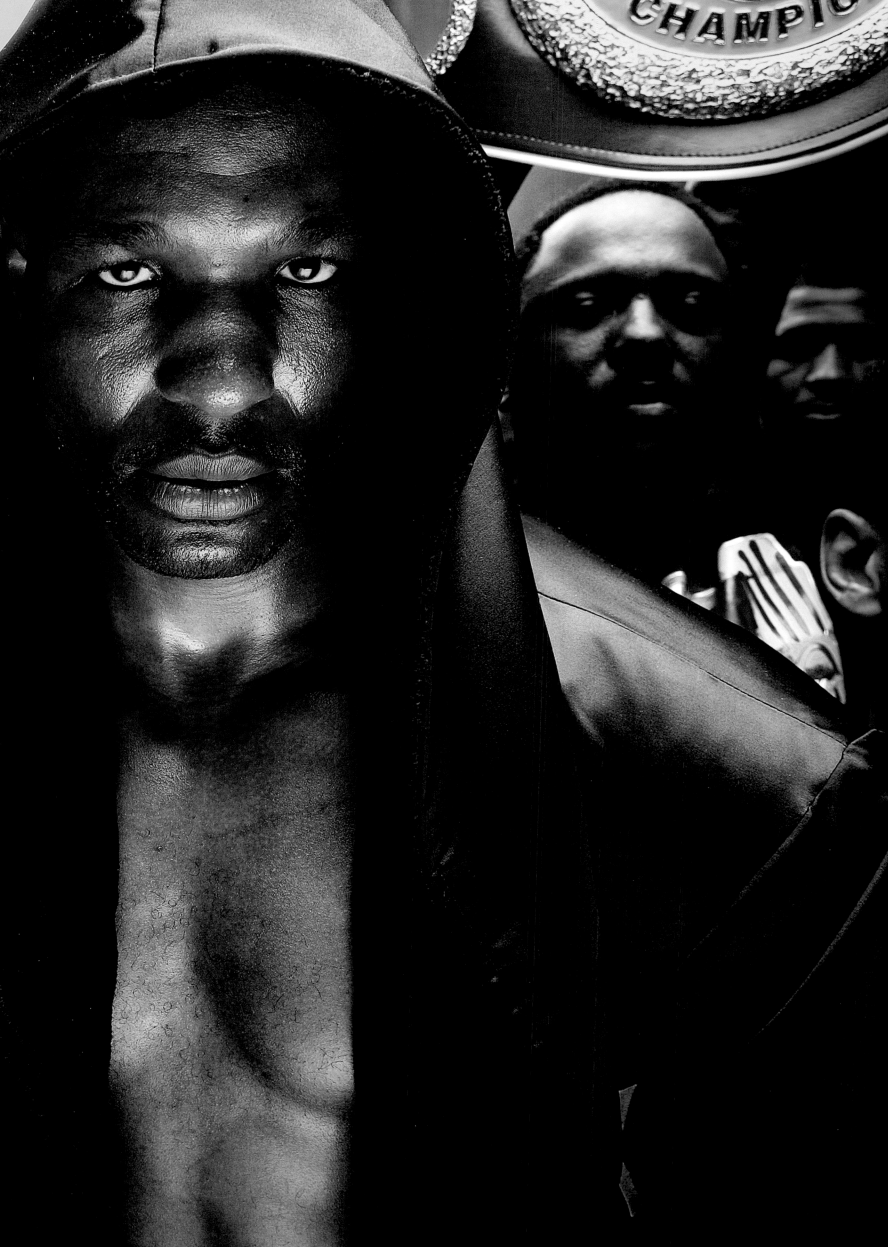

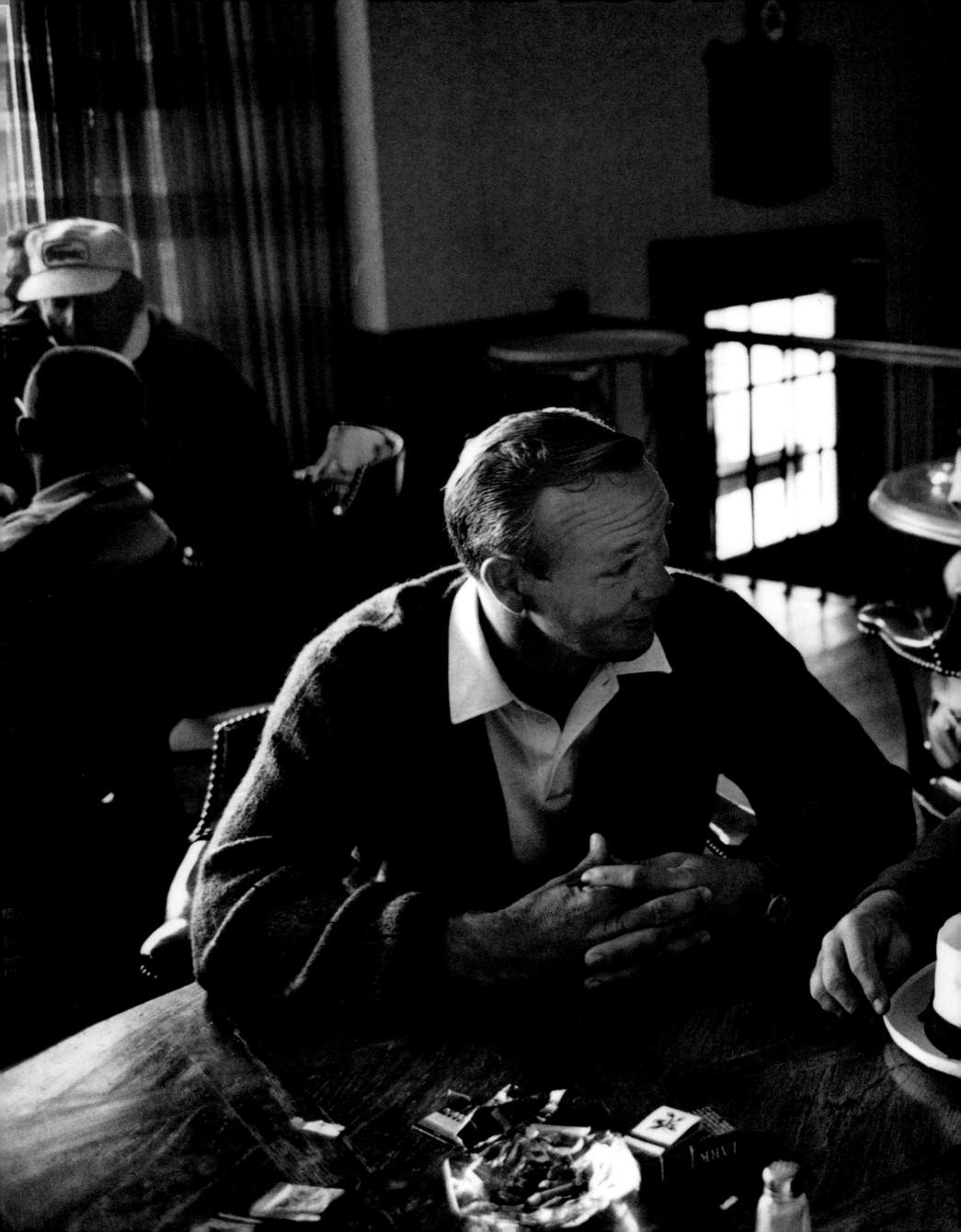

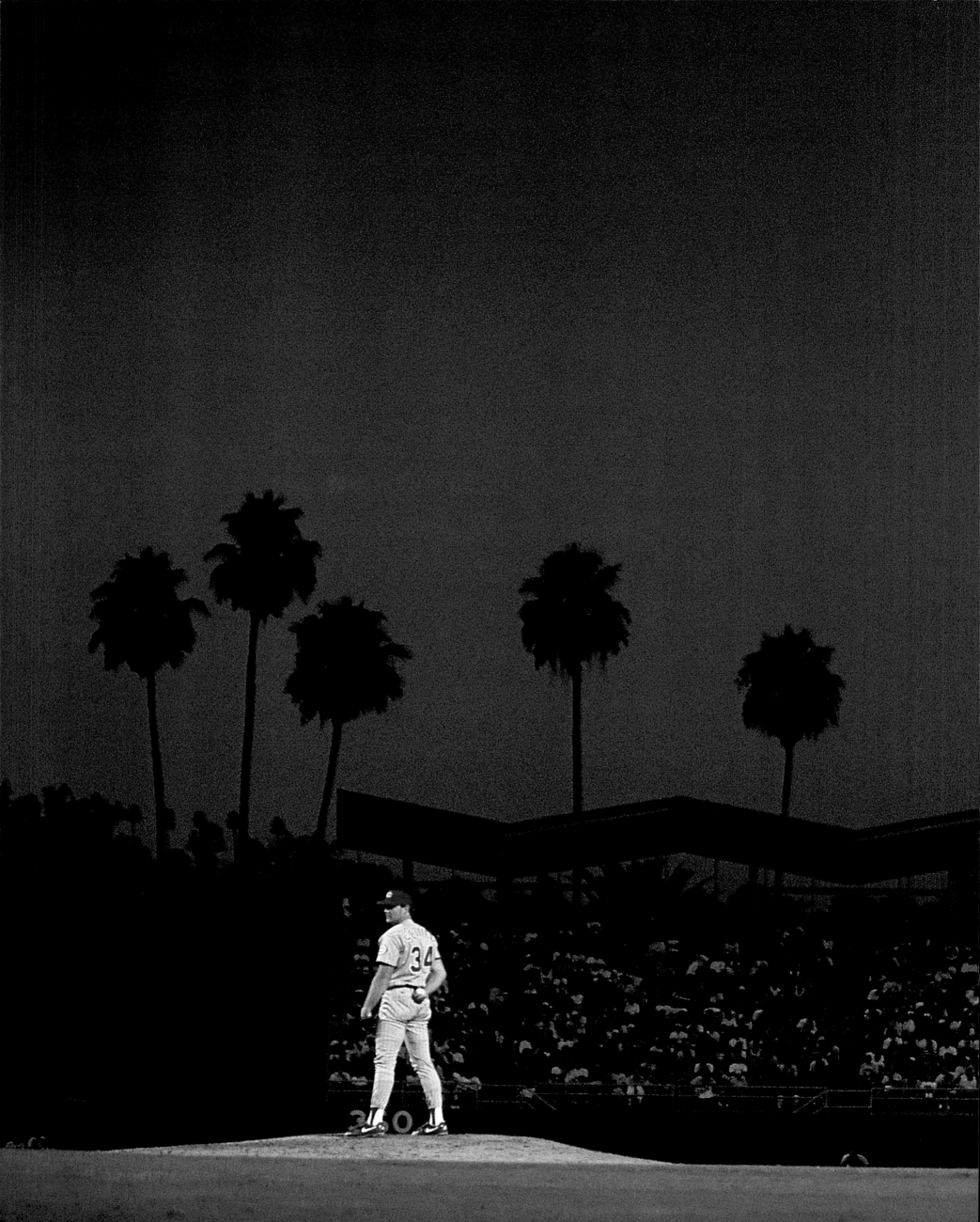

Coca-Cola

Mike Piazza

1 FOR 1

.312

MITSUBISHI

370 3

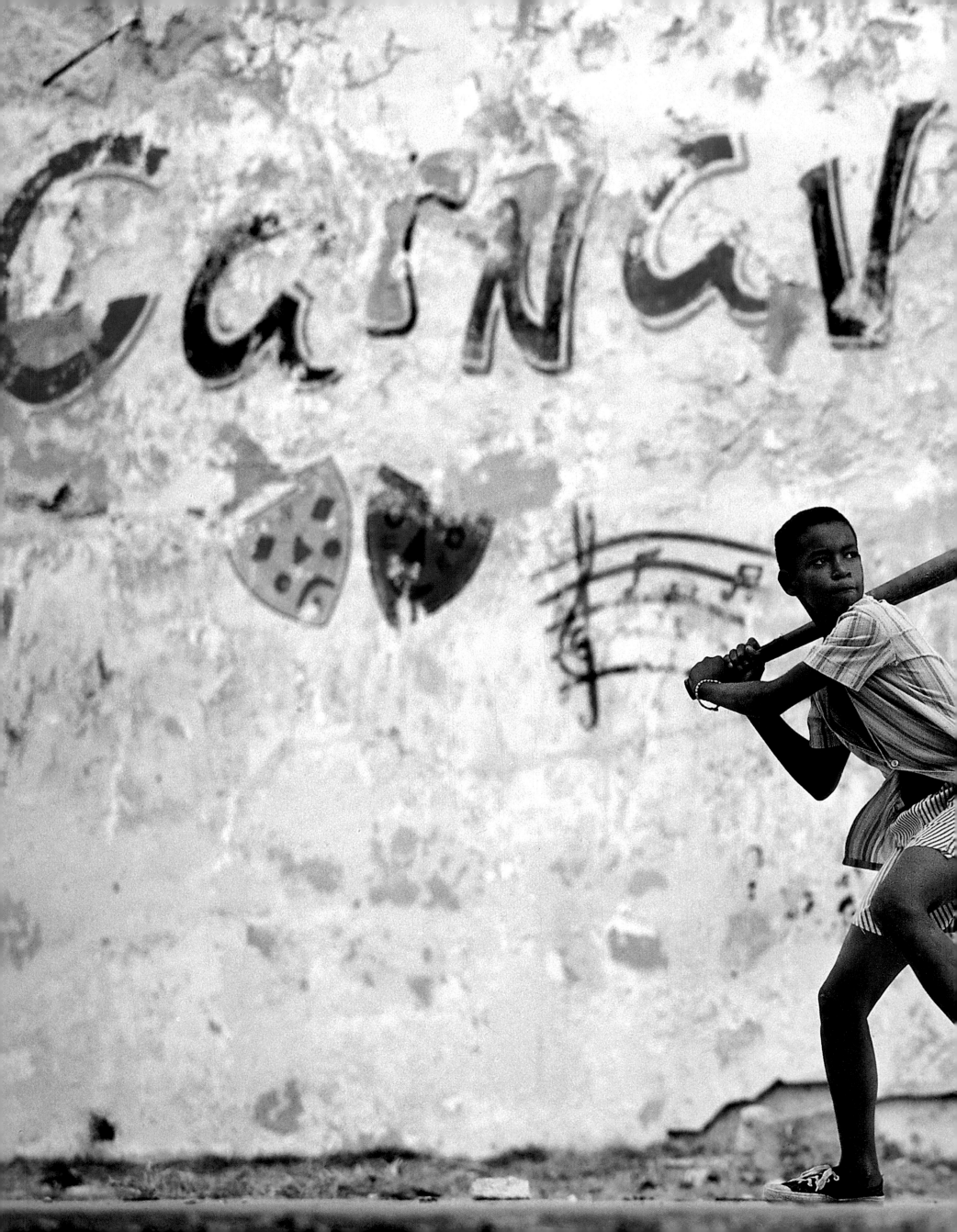

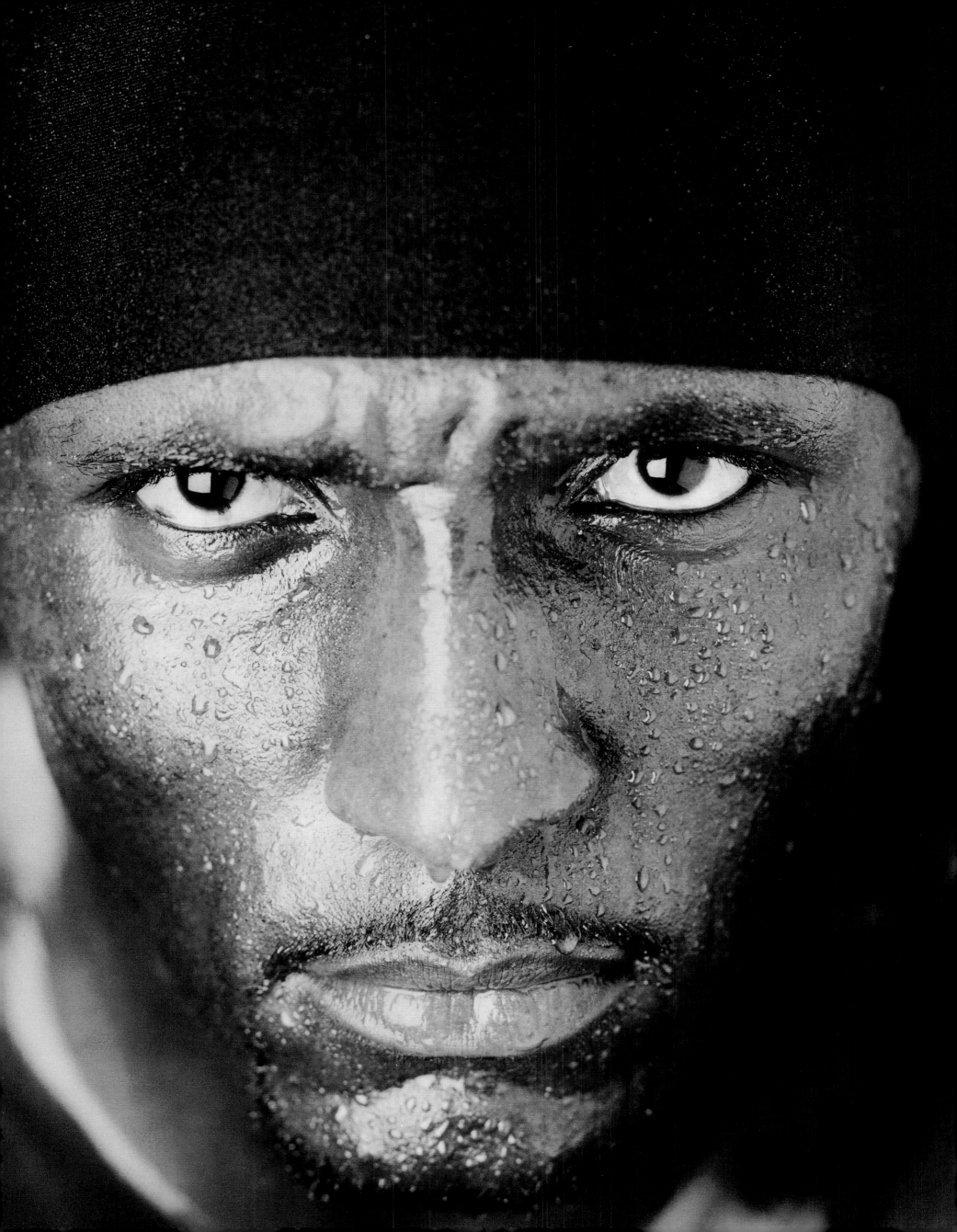

I had the idea to paint this *parking lot blue*. I also trucked in an NBA-regulation basket that I could move to *create a shadow* where I wanted one. I stood in a cherry picker, some 20 or 30 feet above the ground, and looked straight down, *waiting for the right light* with a camera that took

14 frames a second Michael had young legs back then and *could fly.* Not only do you see his beautiful form from above, but you also see the same image from the side, in his shadow. Of all the pictures I've taken of him, *it's my favorite.* It was just so unusual; *no one had quite gone there before.*

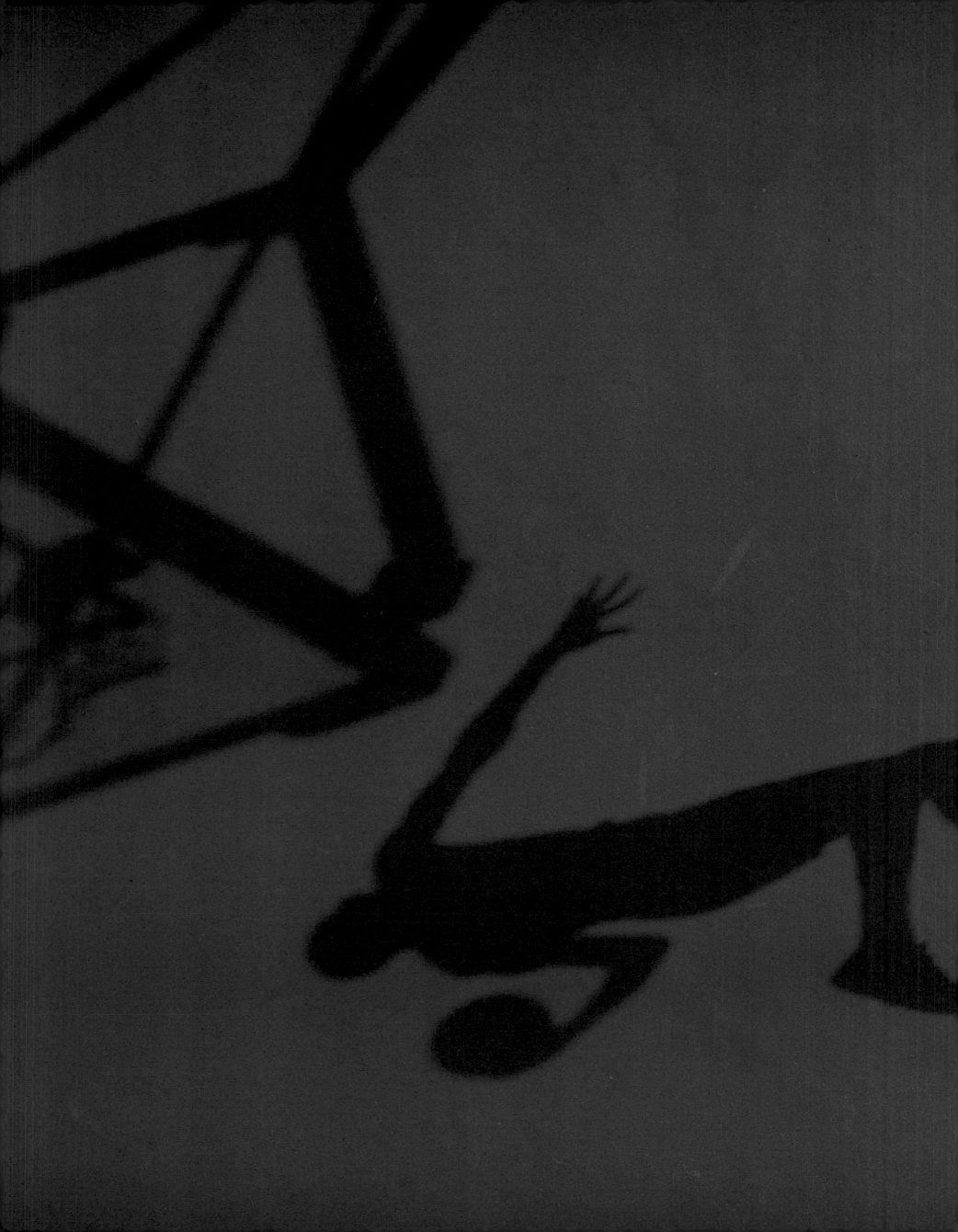

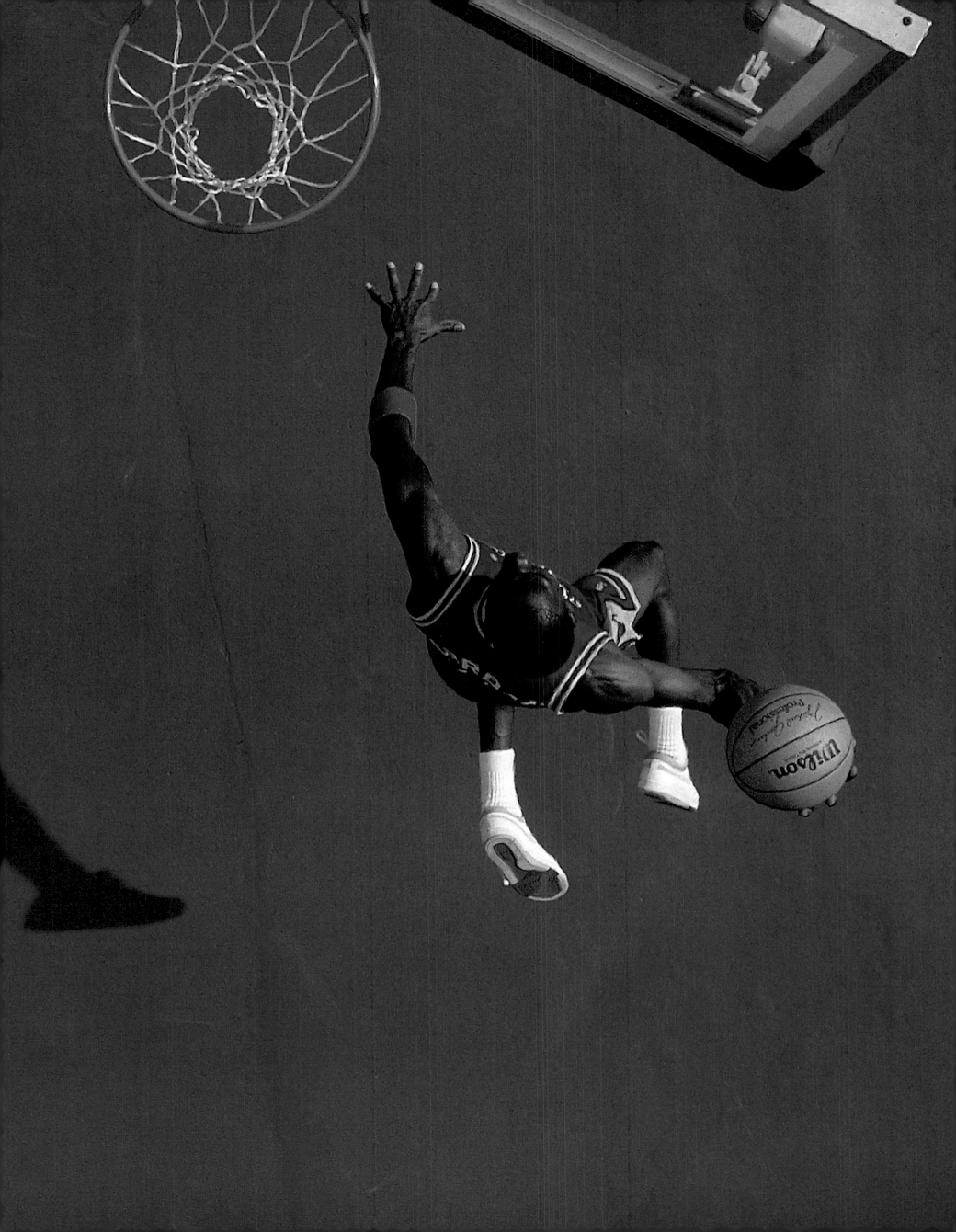

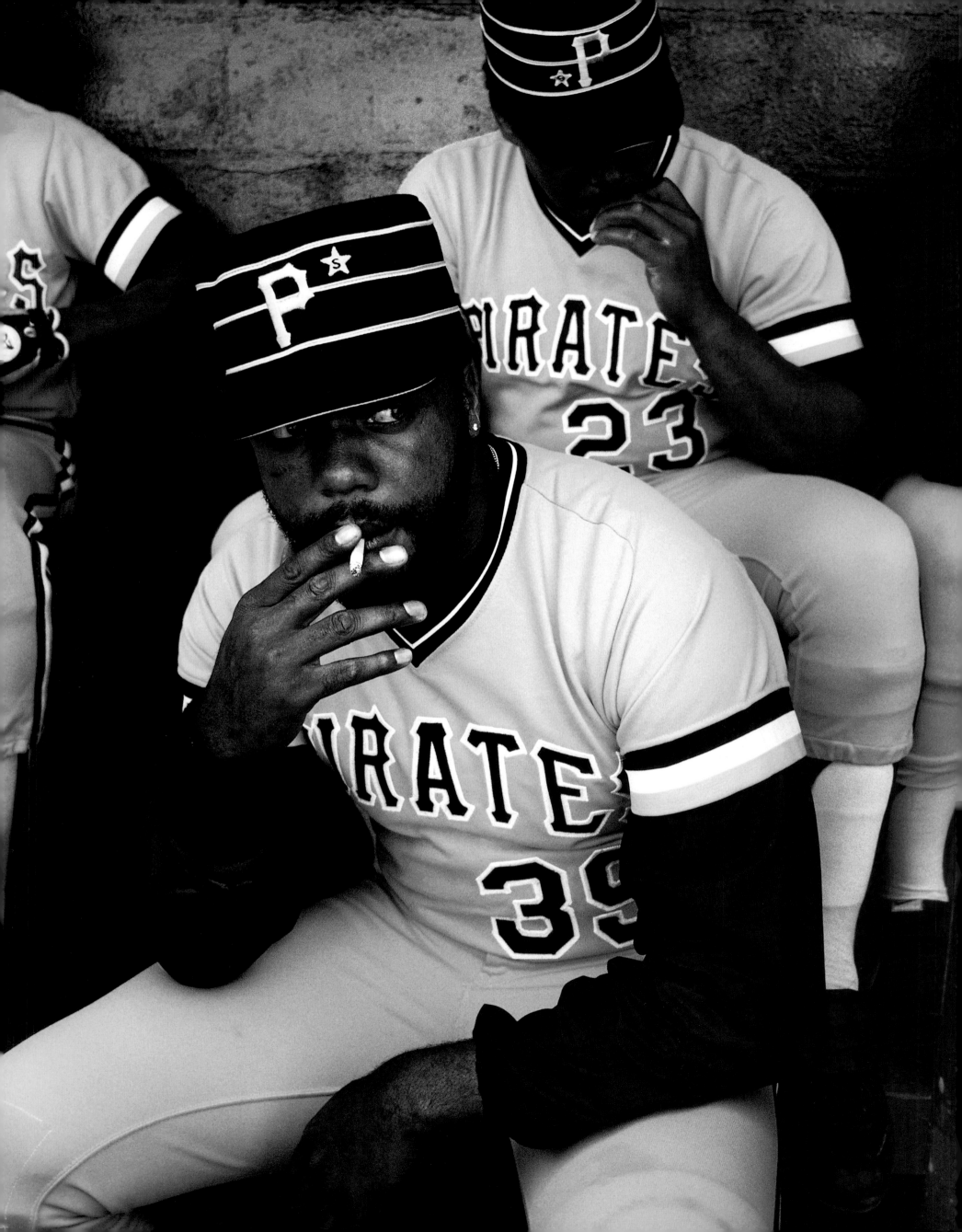

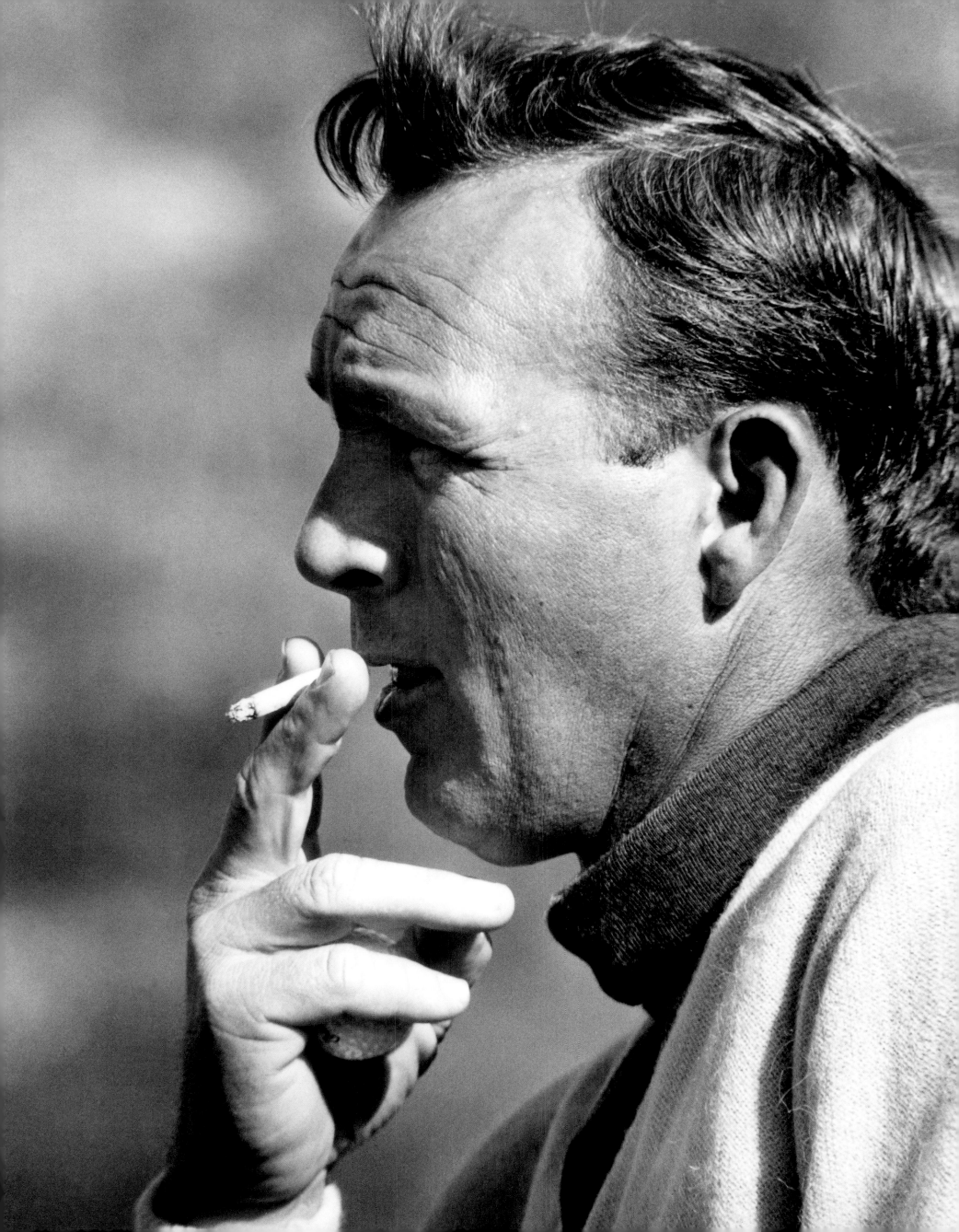

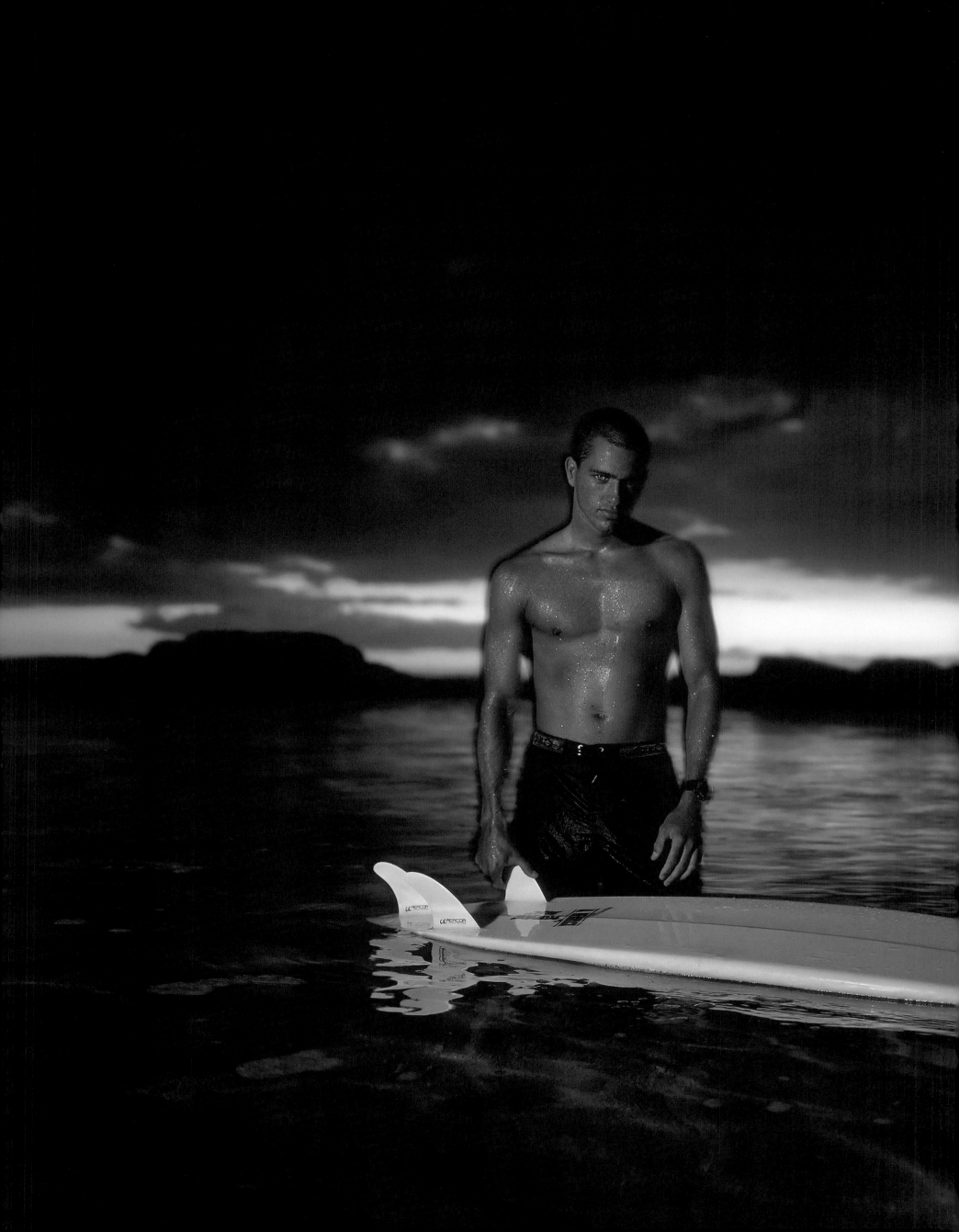

I brought together the two most *dominant surfers and watermen* of the last decade for a shoot on the *west side of Oahu.* I picked up Laird from the airport and Kelly drove in from the North Shore, where he'd surfed Pipeline earlier that

day. I asked him about it as we stood around talking before the shoot. He said he had gotten some *really good rides at Backdoors,* to which Laird replied, *"It's only Pipeline."* Anyone who surfed knew the young man had just been put in his place.

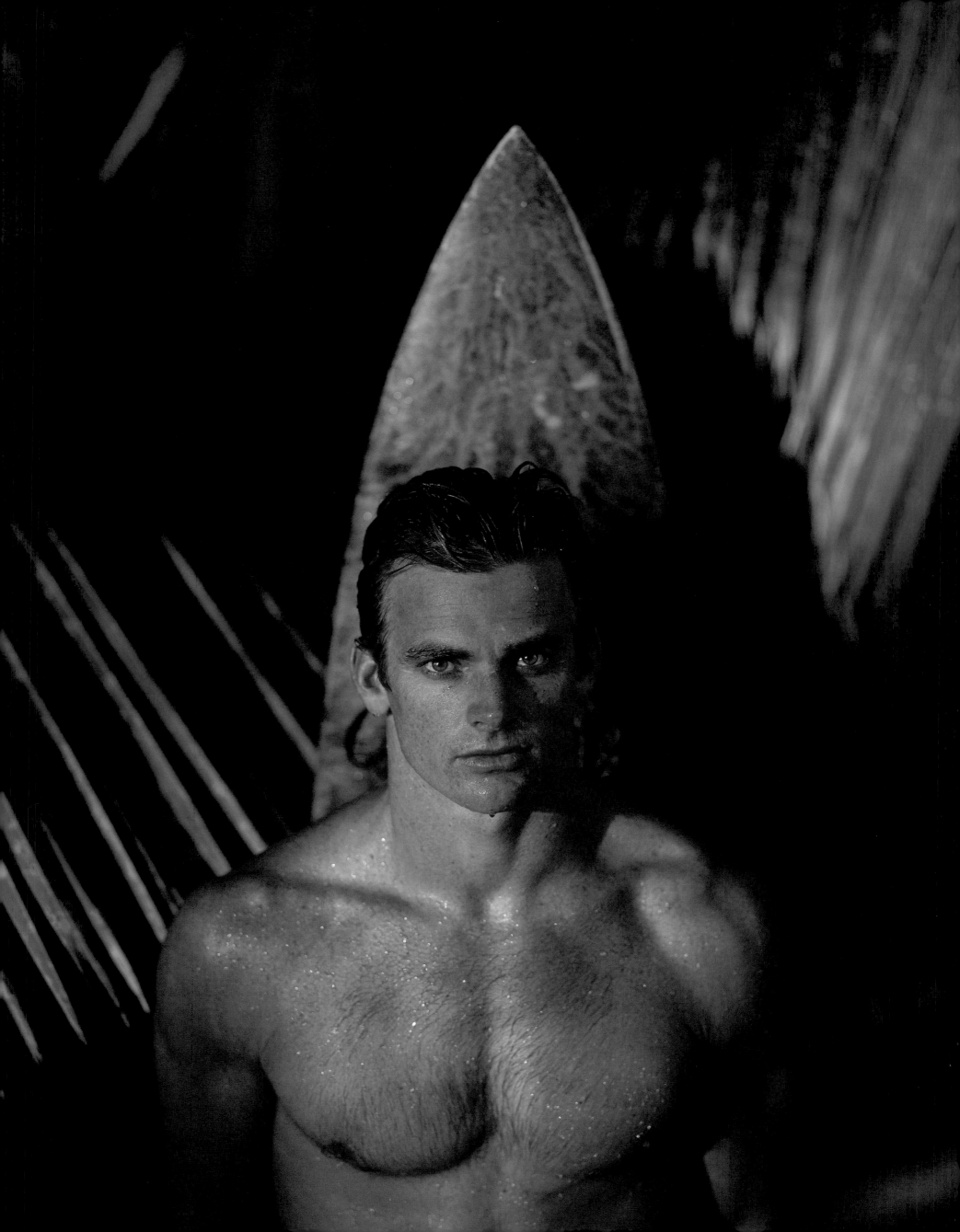

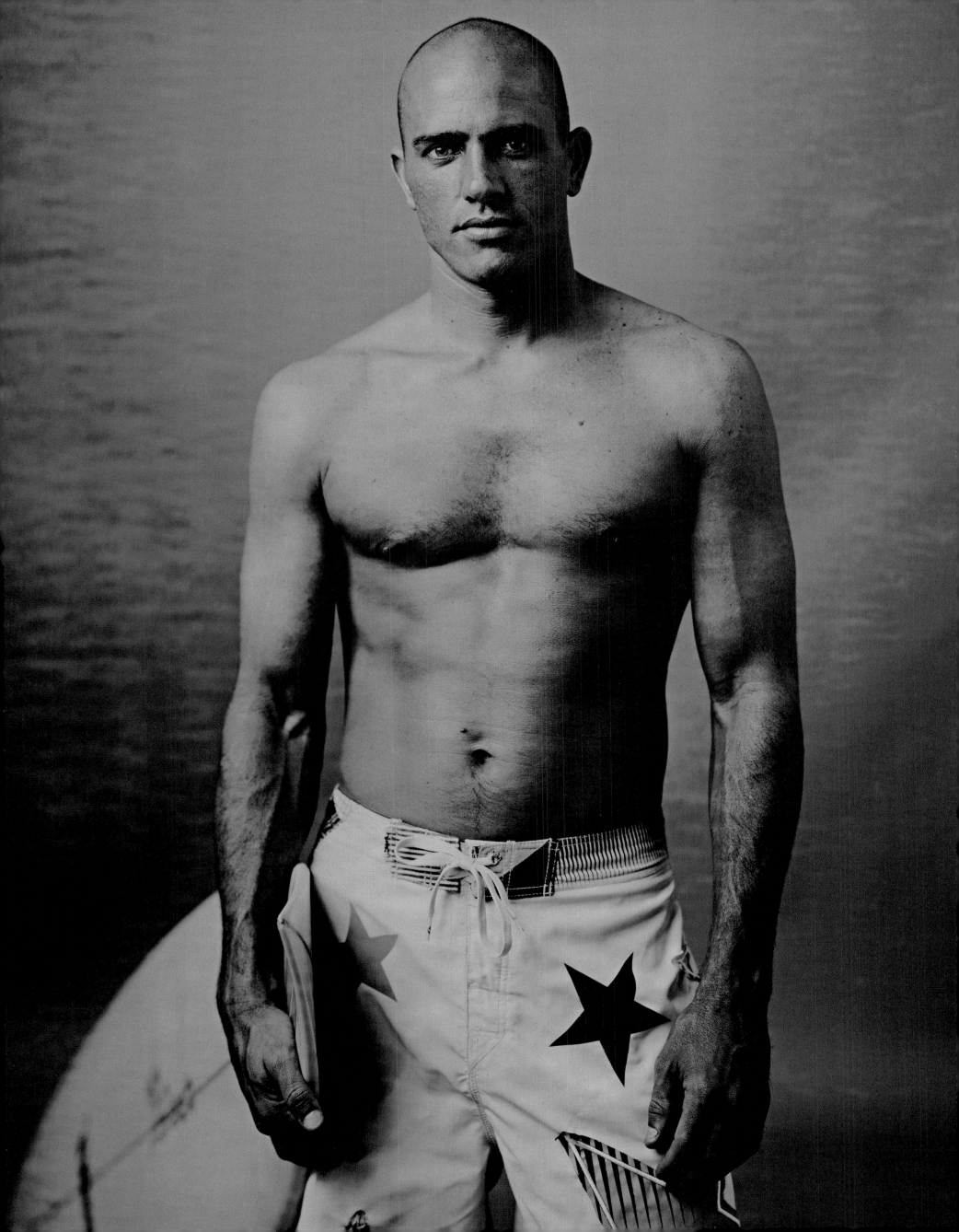

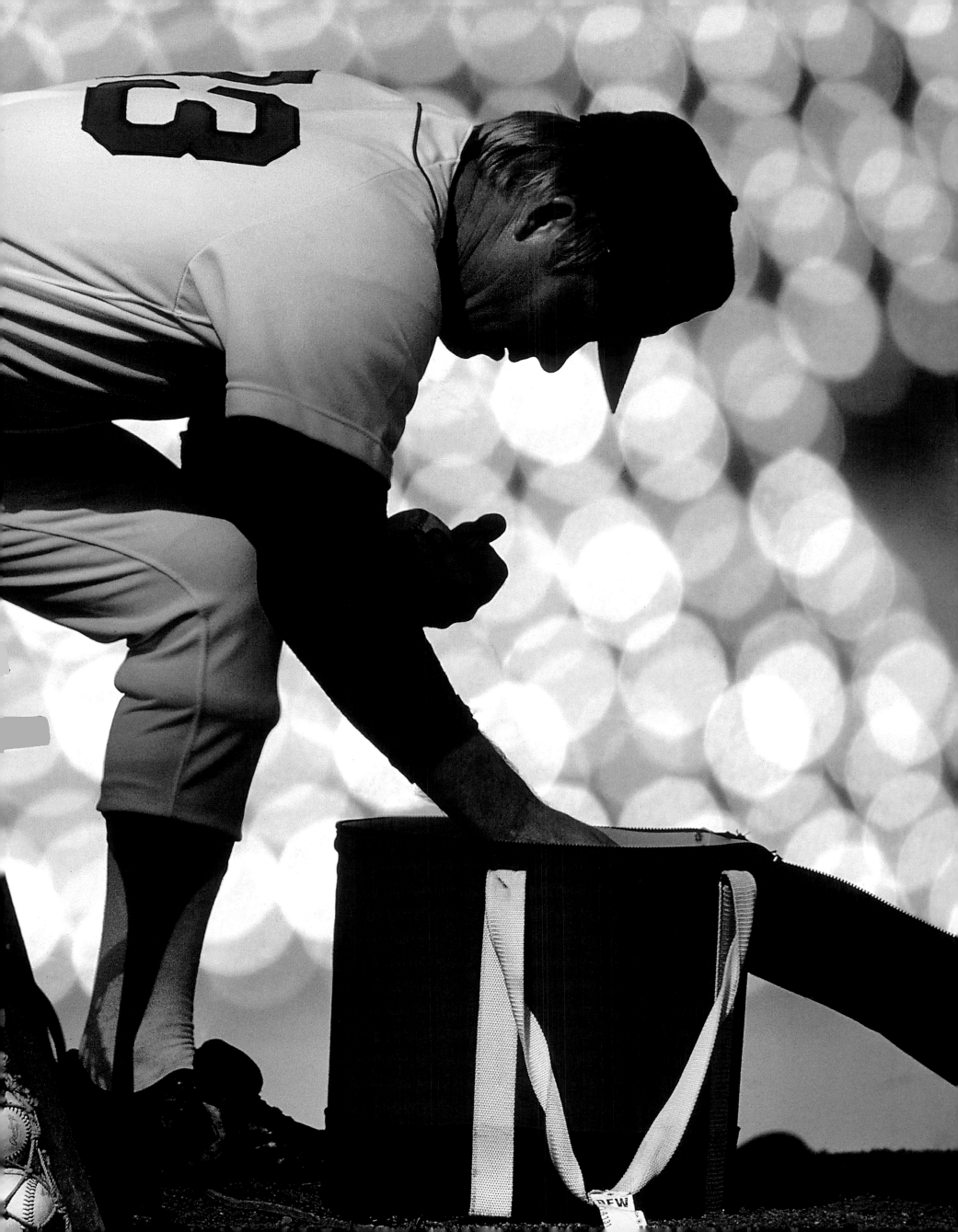

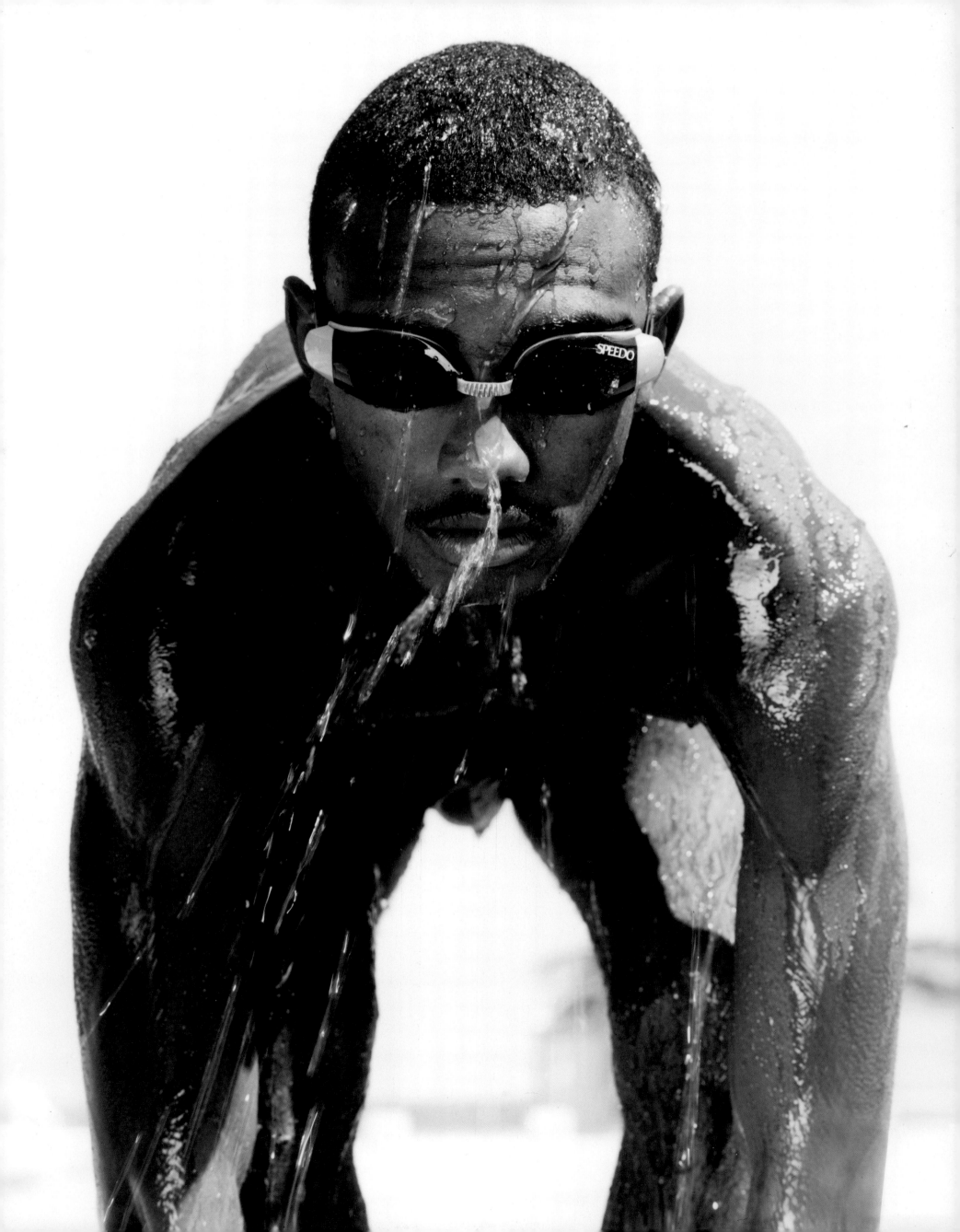

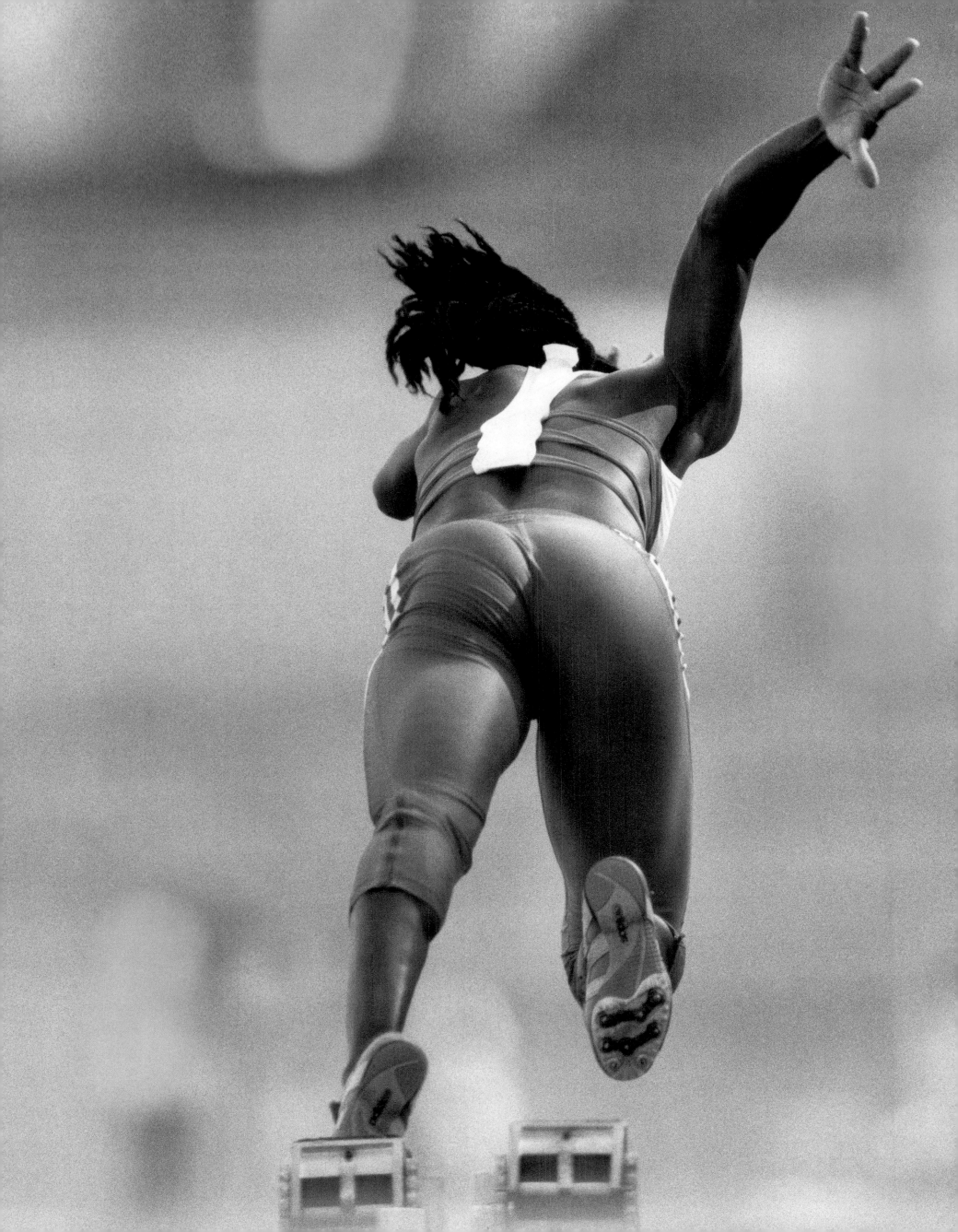

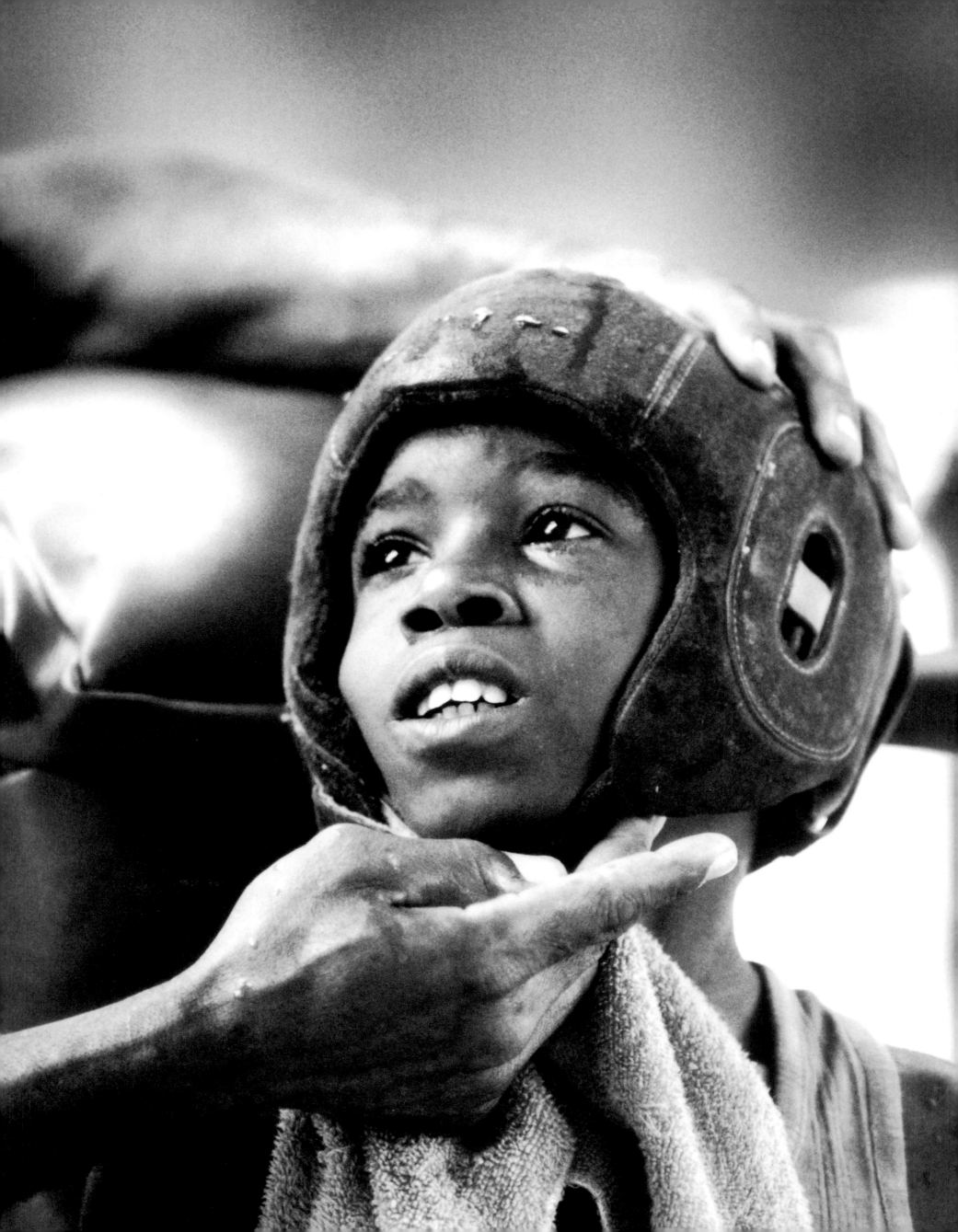

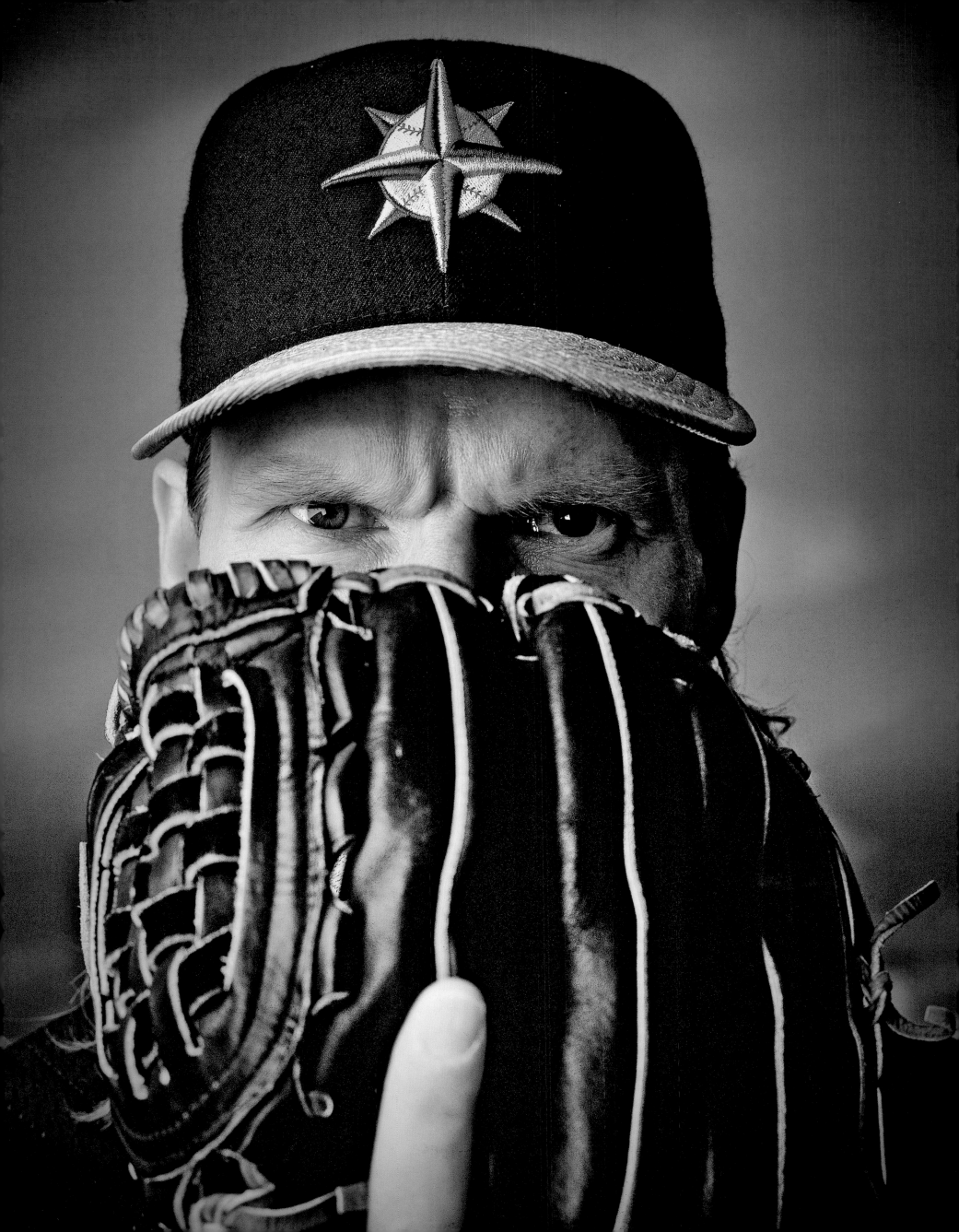

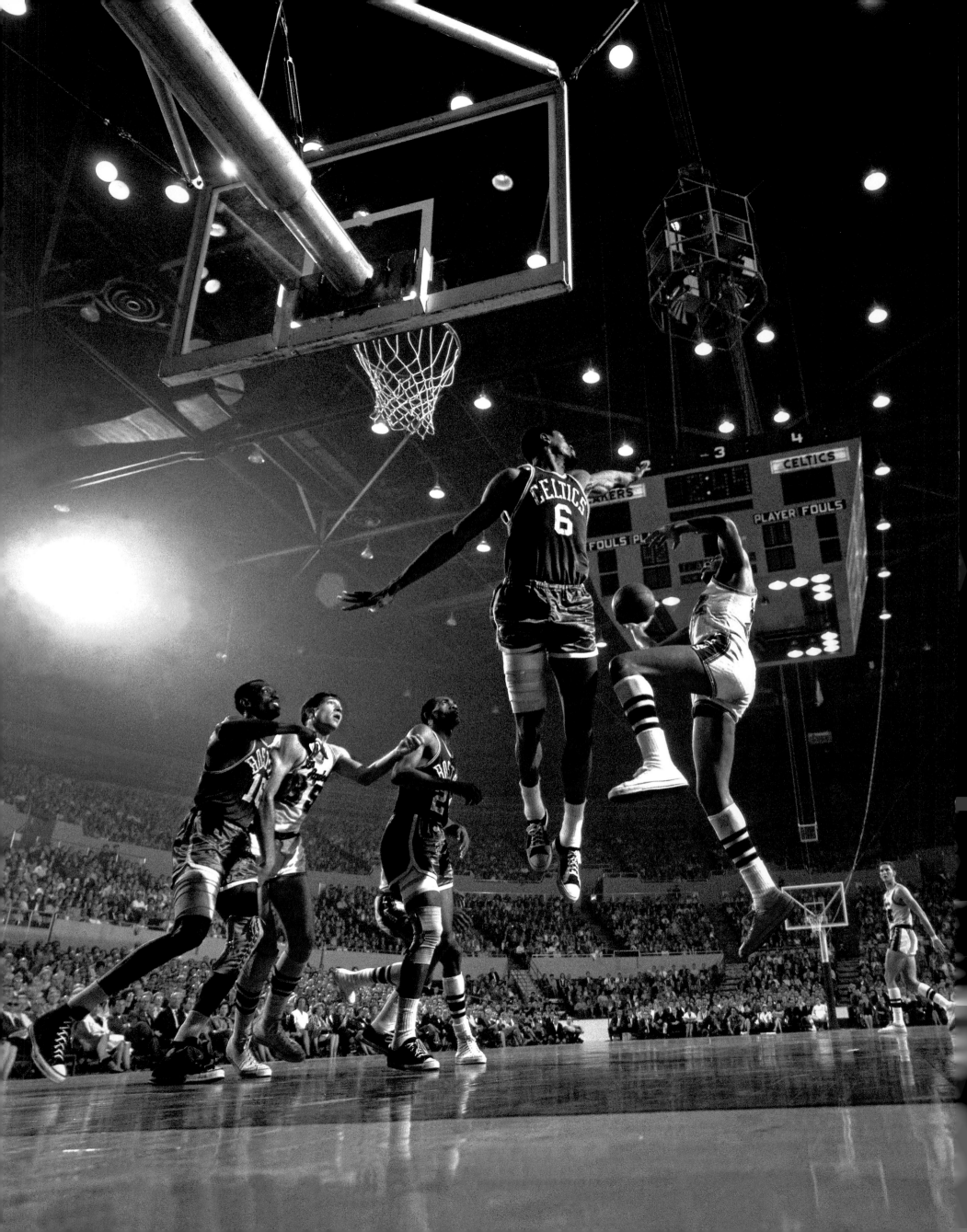

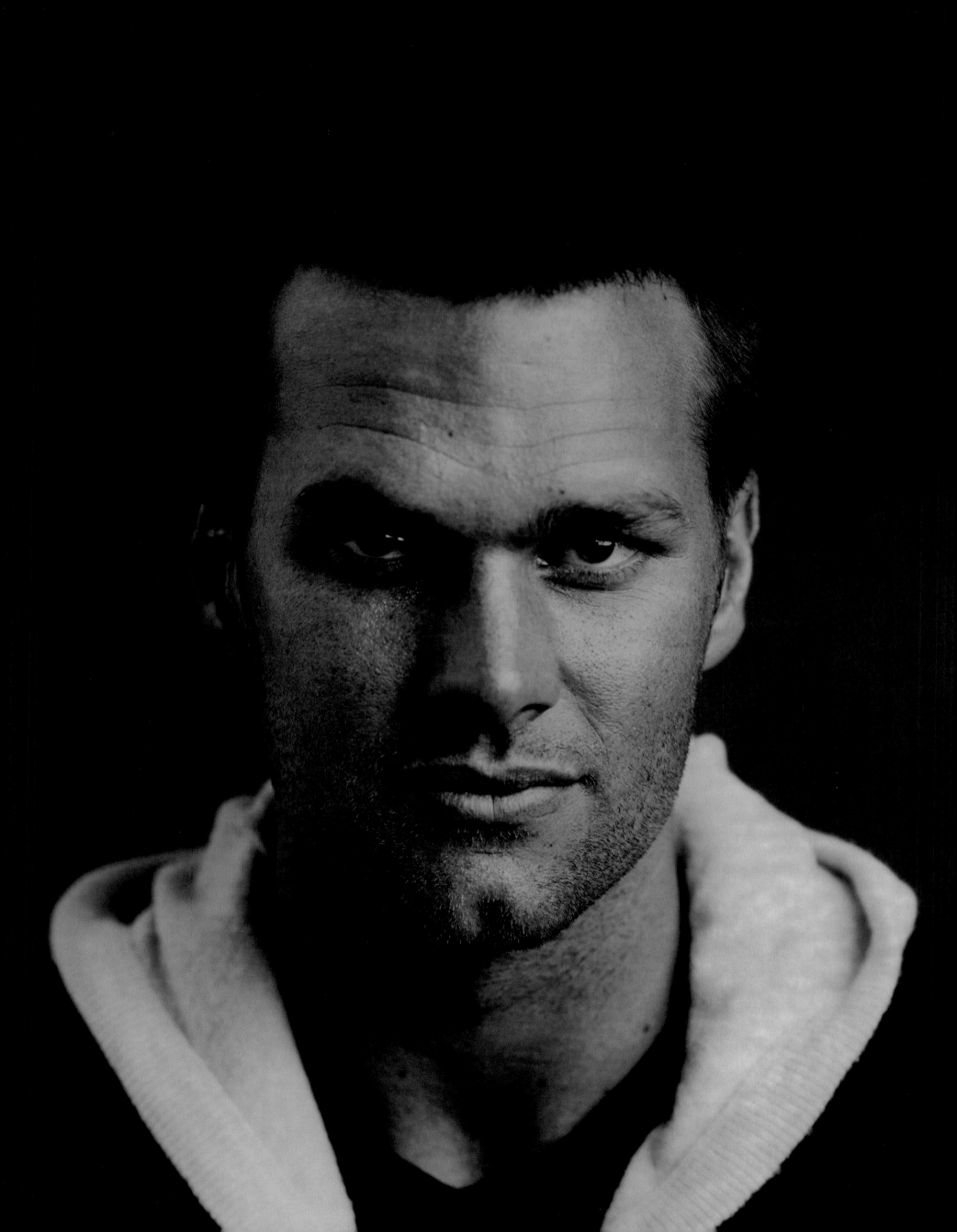

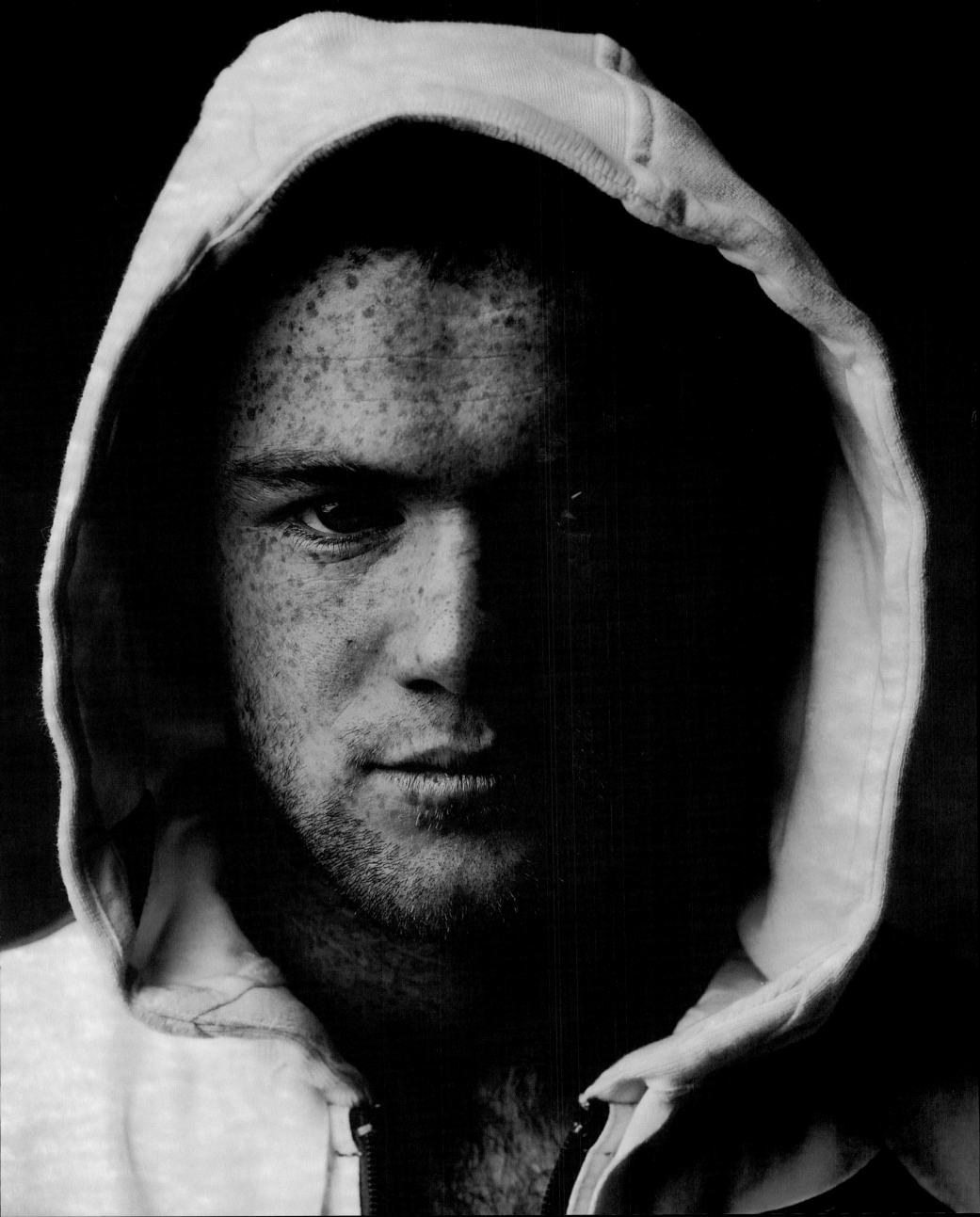

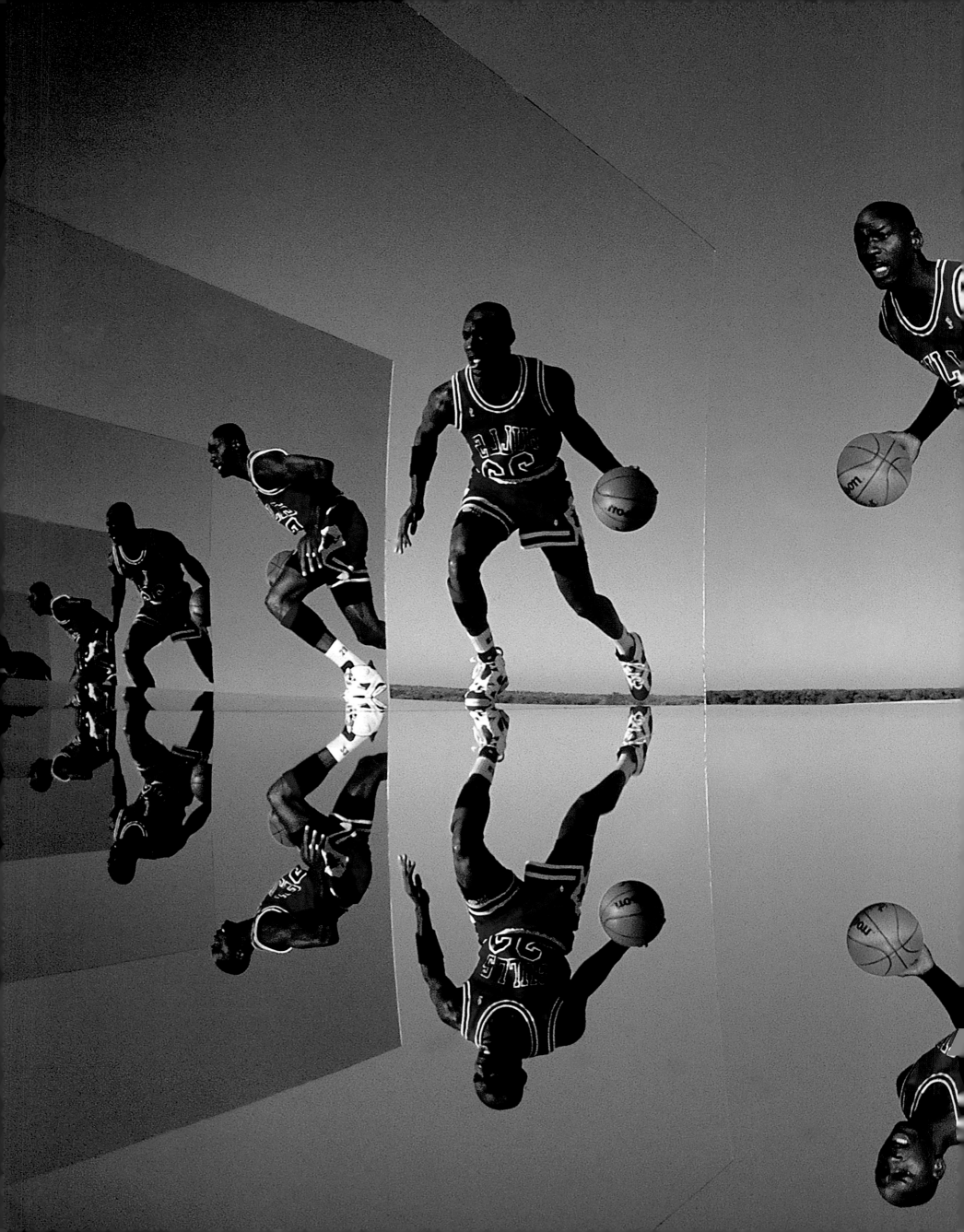

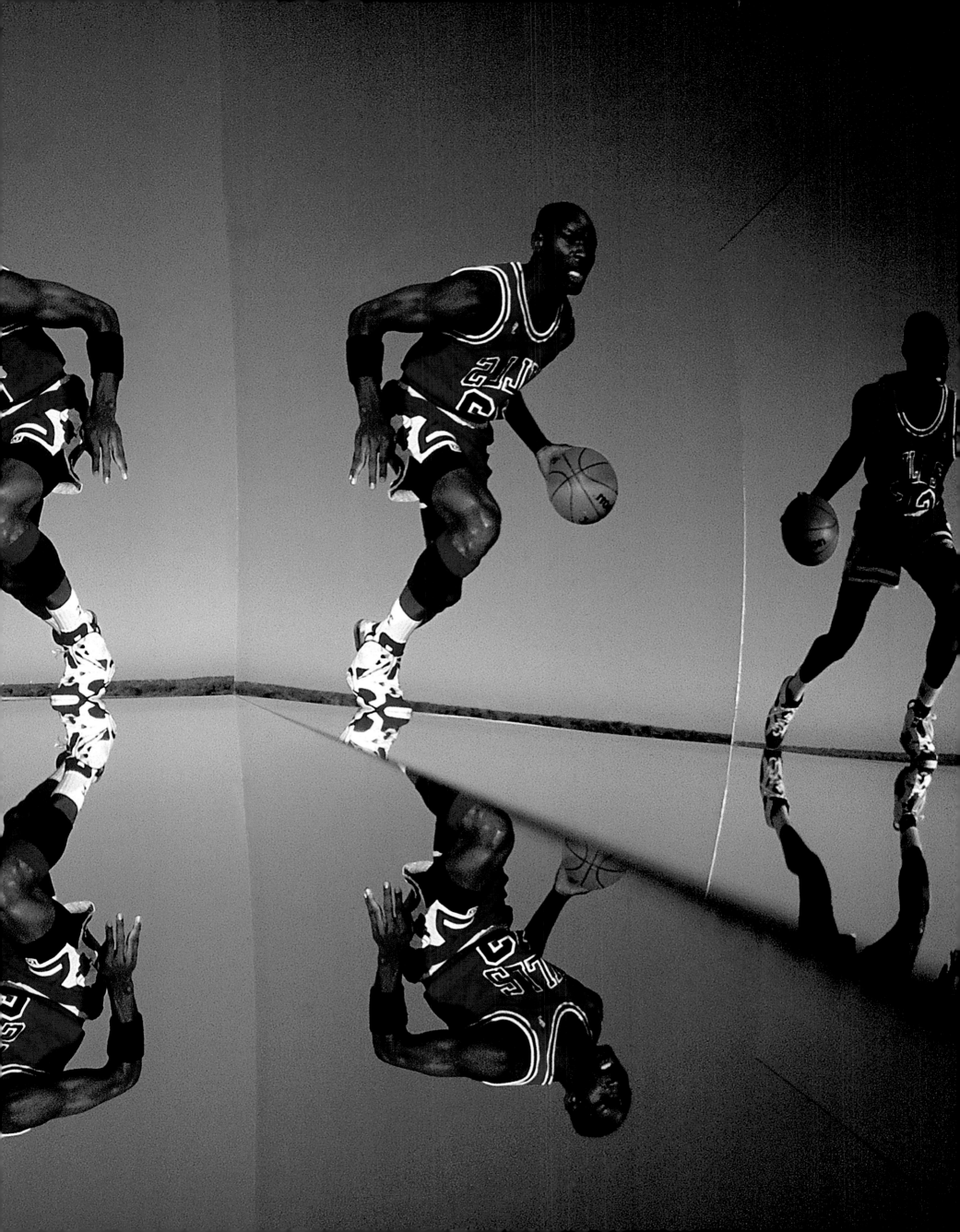

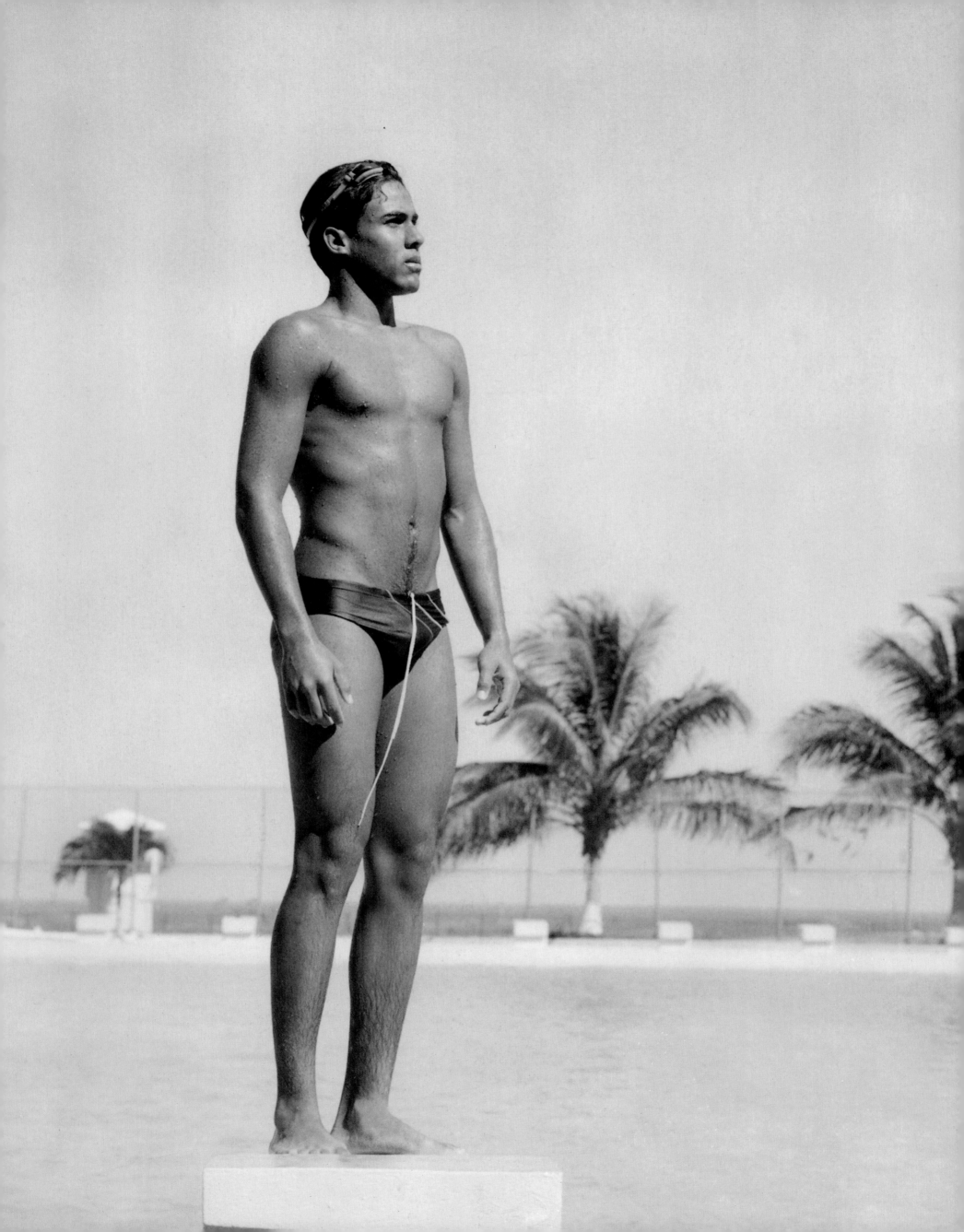

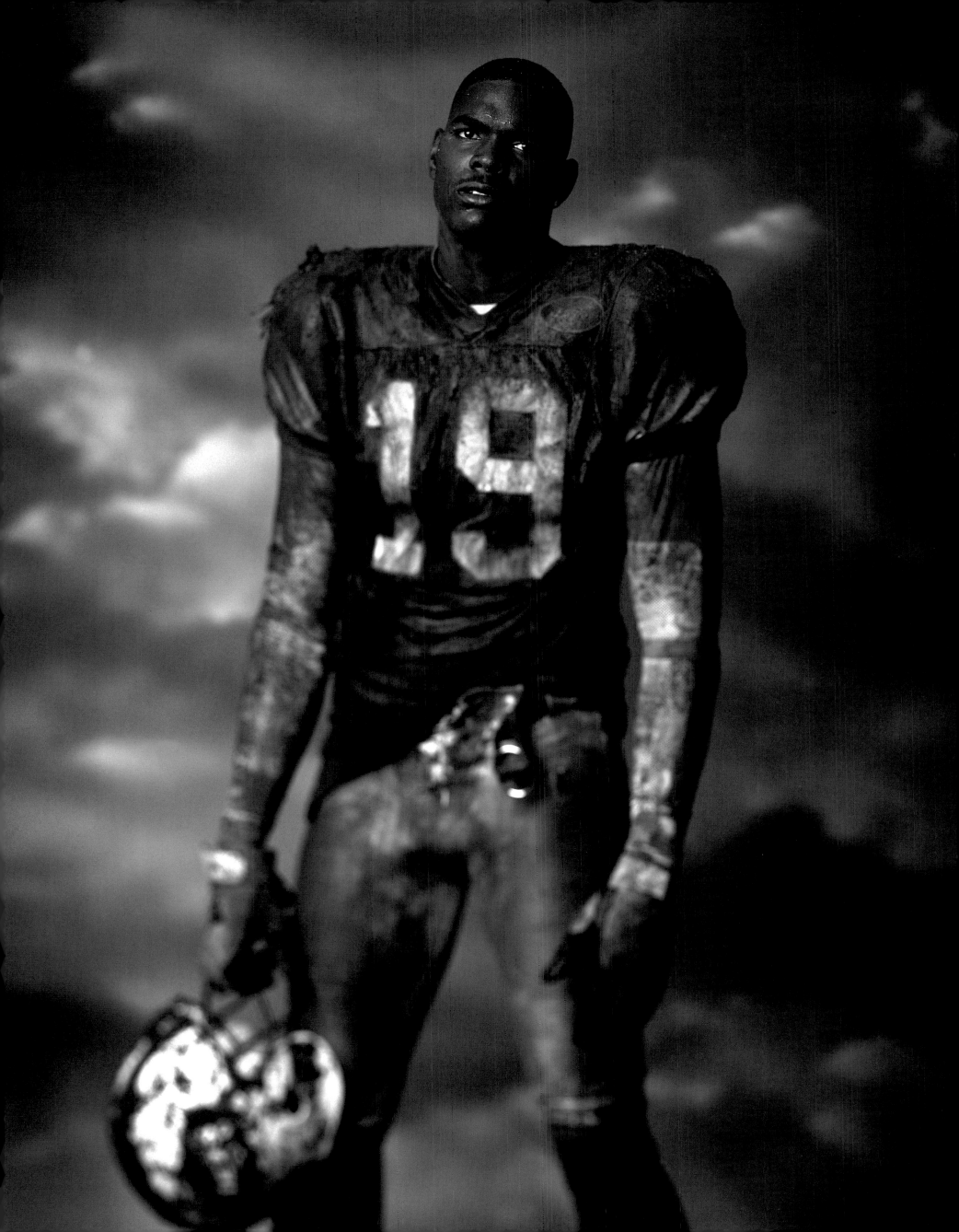

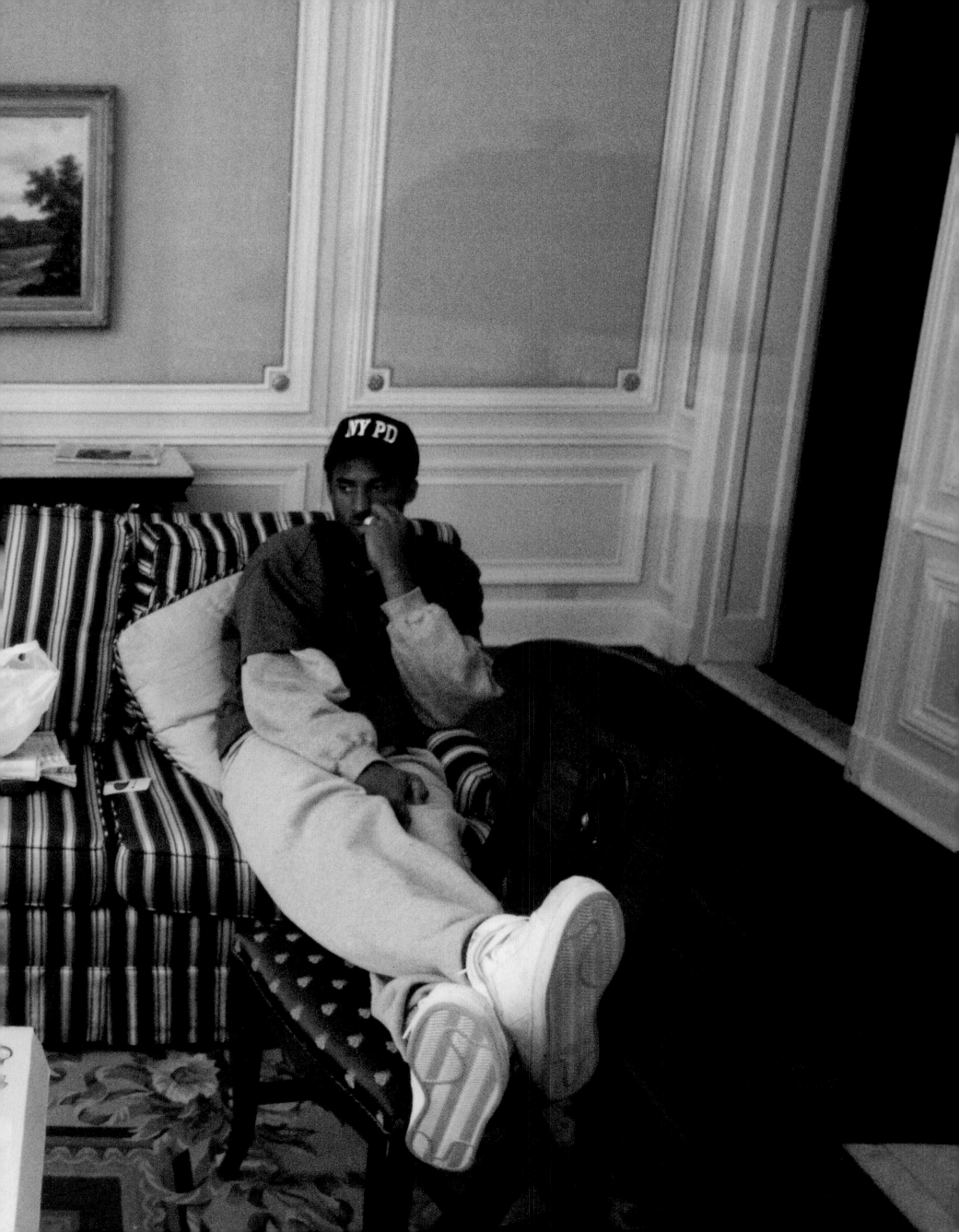

I wanted to do this *shoot at twilight,* but Joe arrived at 3 p.m. Sunset wouldn't be until 7 o'clock. He said, "I've got to meet my wife. When is this shoot going to end?" I said, "How about in three and a half hours?" He said, "No, I can't stay that long." I didn't know Joe, but I had heard he *liked to have a beer.* I had a six - pack of Corona in my truck with all my gear. We sat in the truck drinking one beer after another, talking. *You have to love Joe Montana;* he's one of the most engaging guys, a real man's man. *We became friends.* He was injured

at the time and he talked all about the controversy over Steve Young taking his starting job. I didn't ask about it, he just started to tell me. A couple of hours went by, and *I'm close to the magic hour.* At about five o'clock we started shooting. I had a dolly on a track that panned as he rolled out. I hit him with a flash at a *slow shutter speed and blurred the sky around him at twilight.* We're shooting, we're shooting, and then it's just about dark. He said, "What time is it? Oh, my god! *I've got to meet my wife."* Off went Joe, but by then we had the picture.

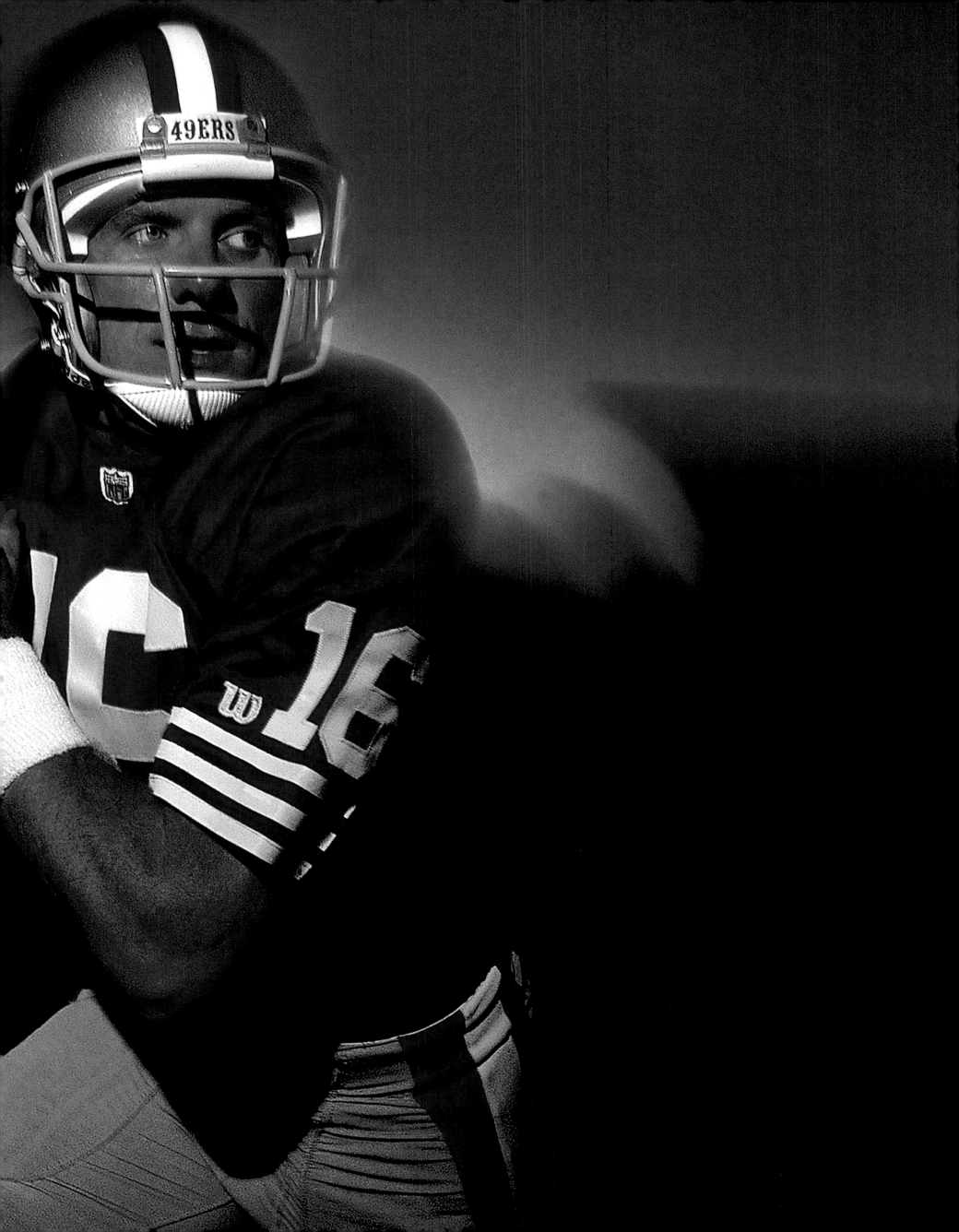

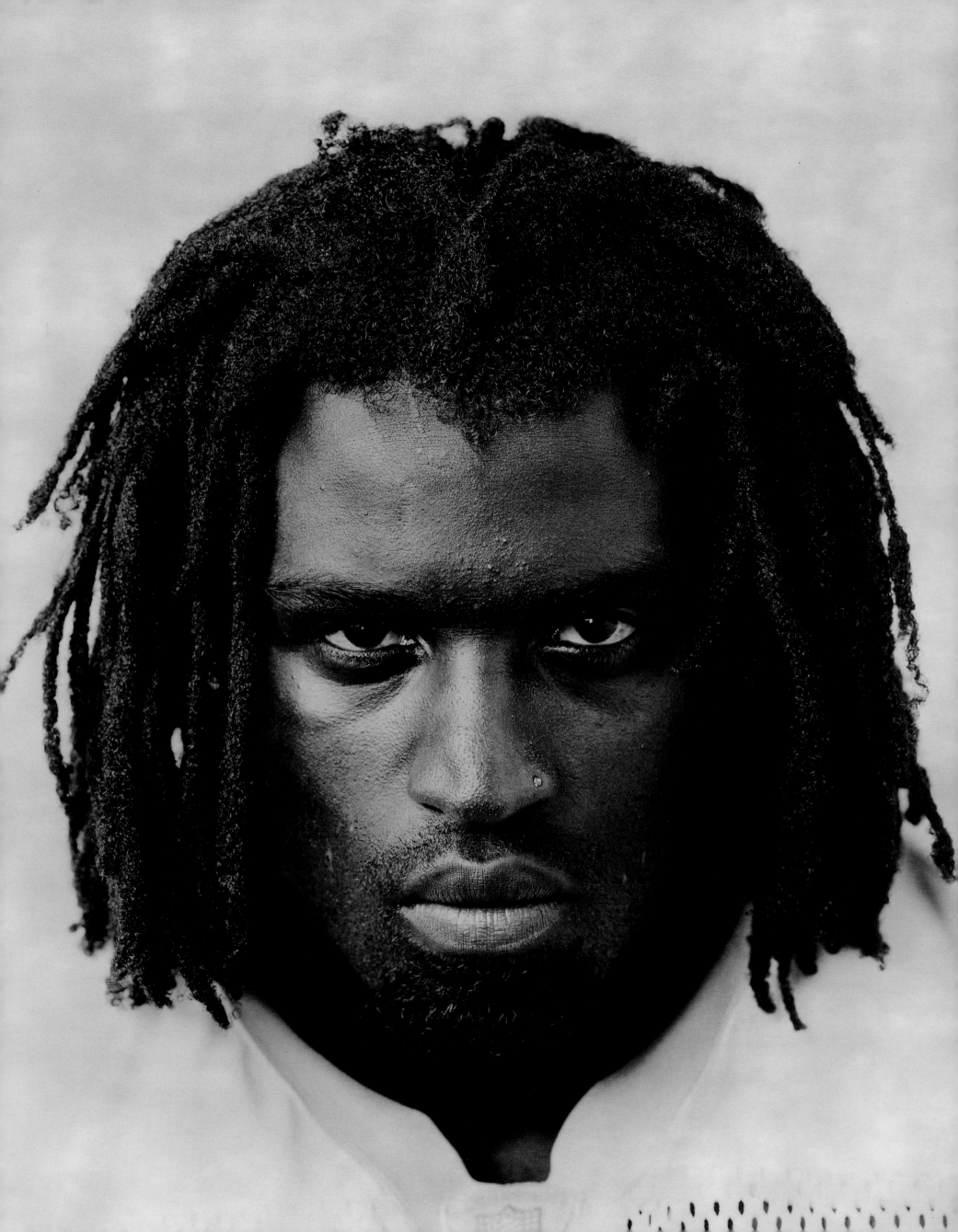

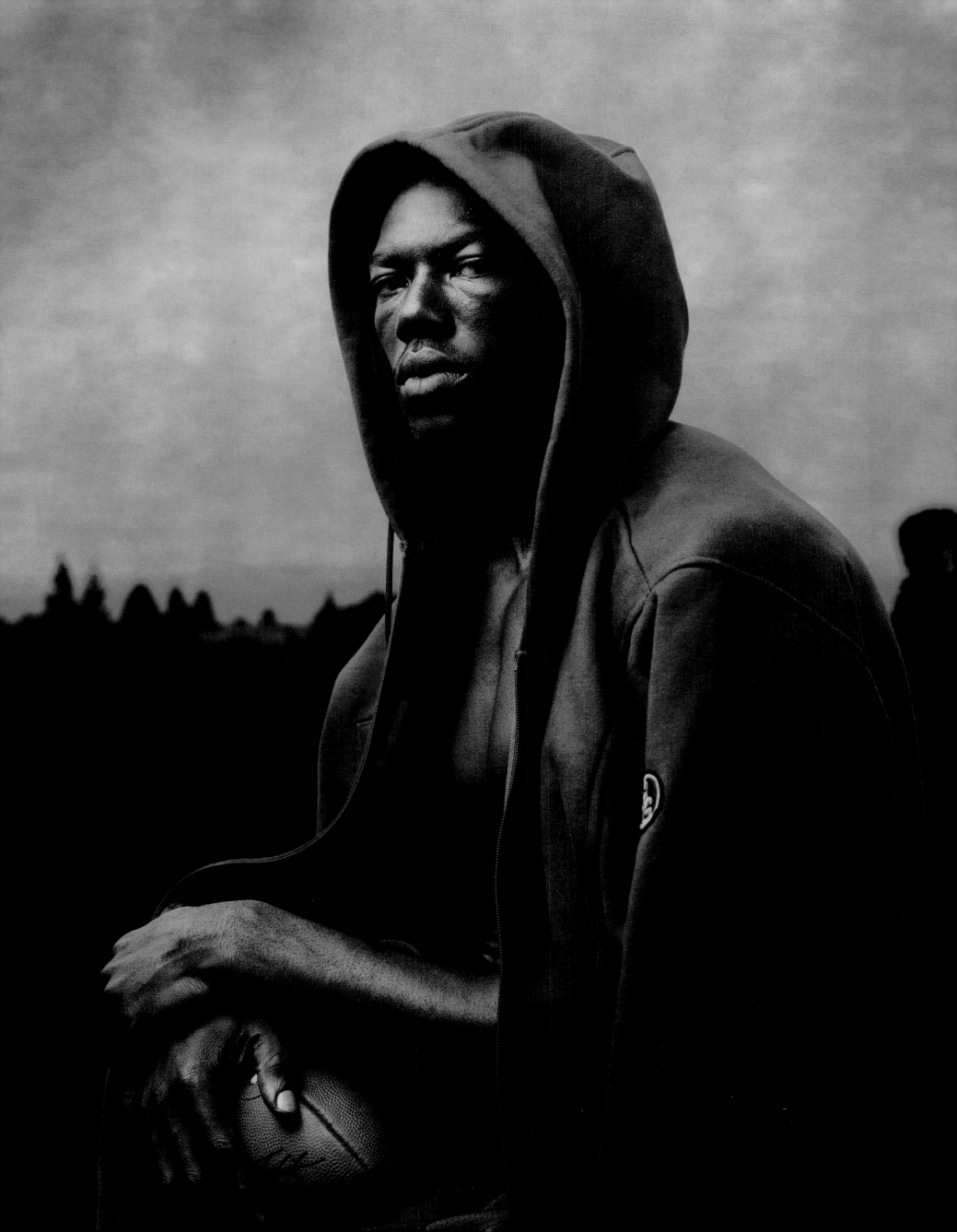

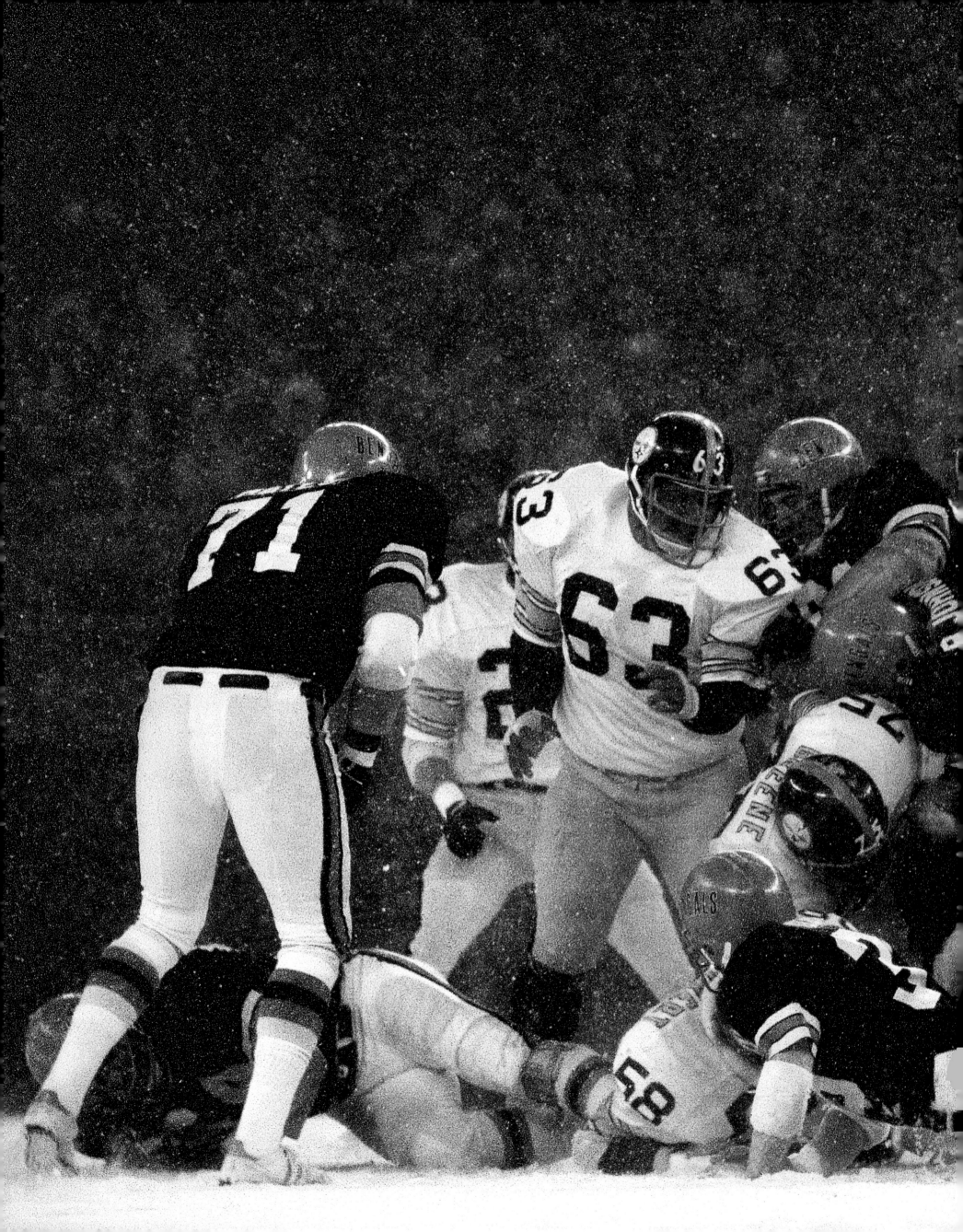

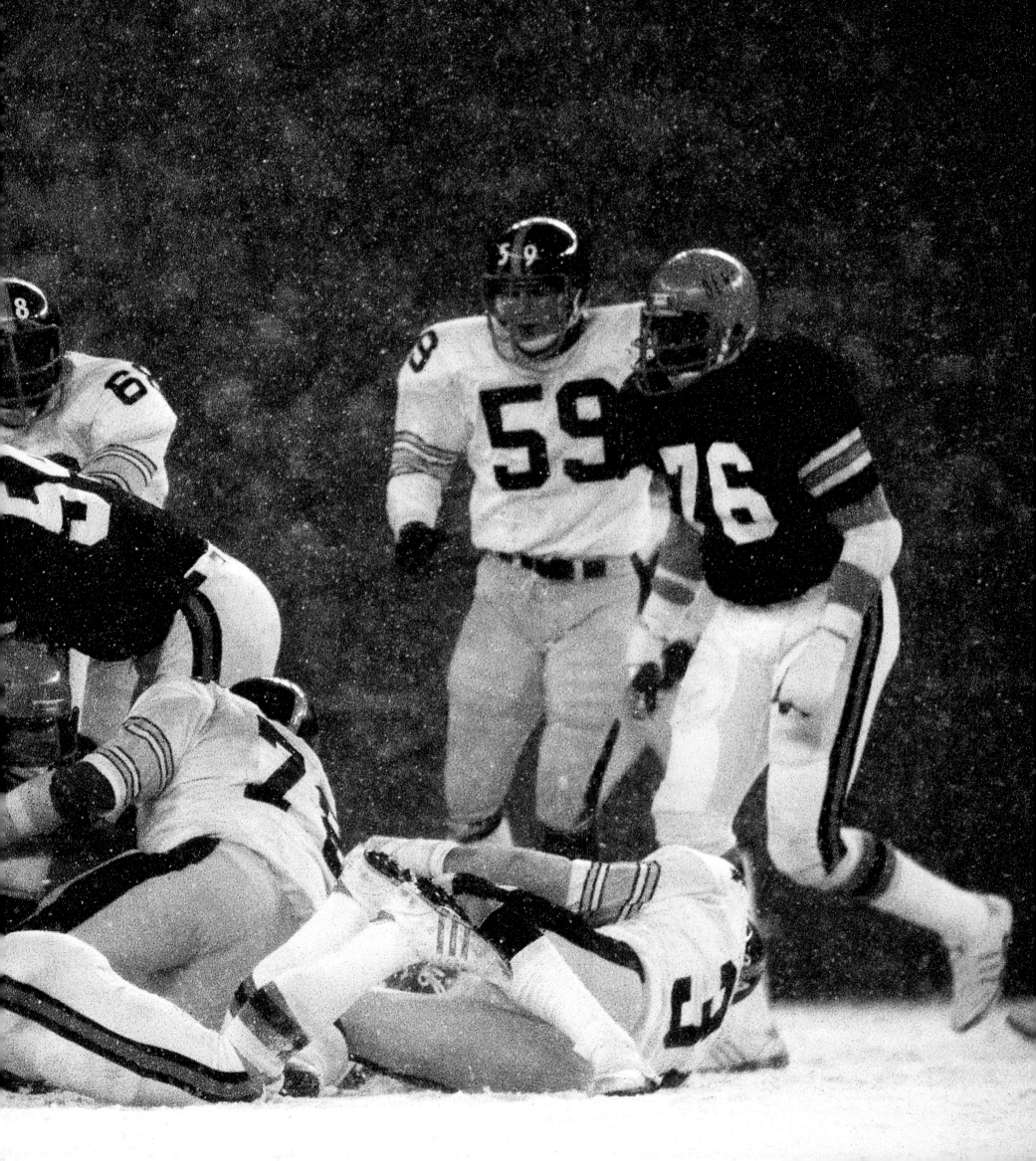

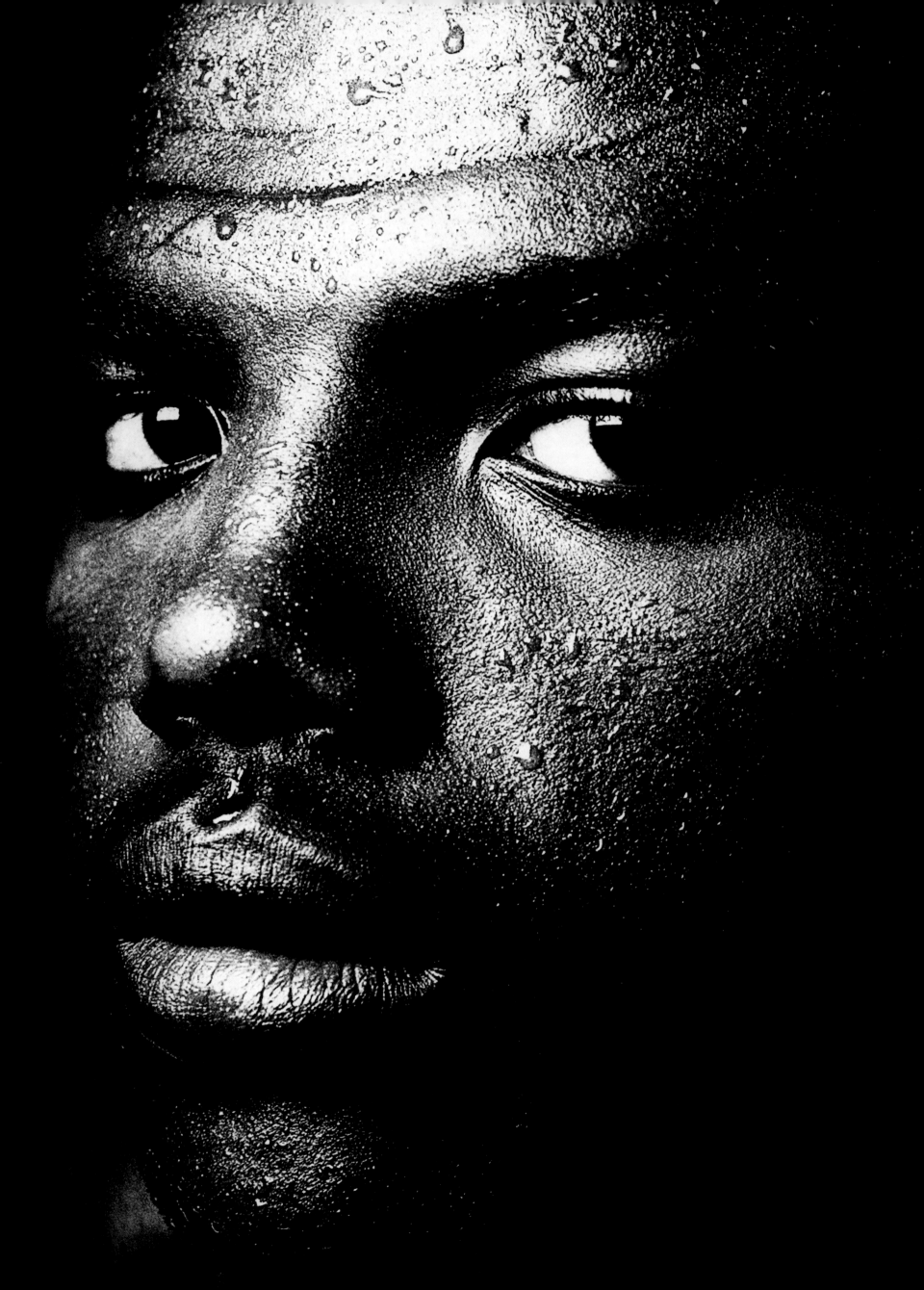

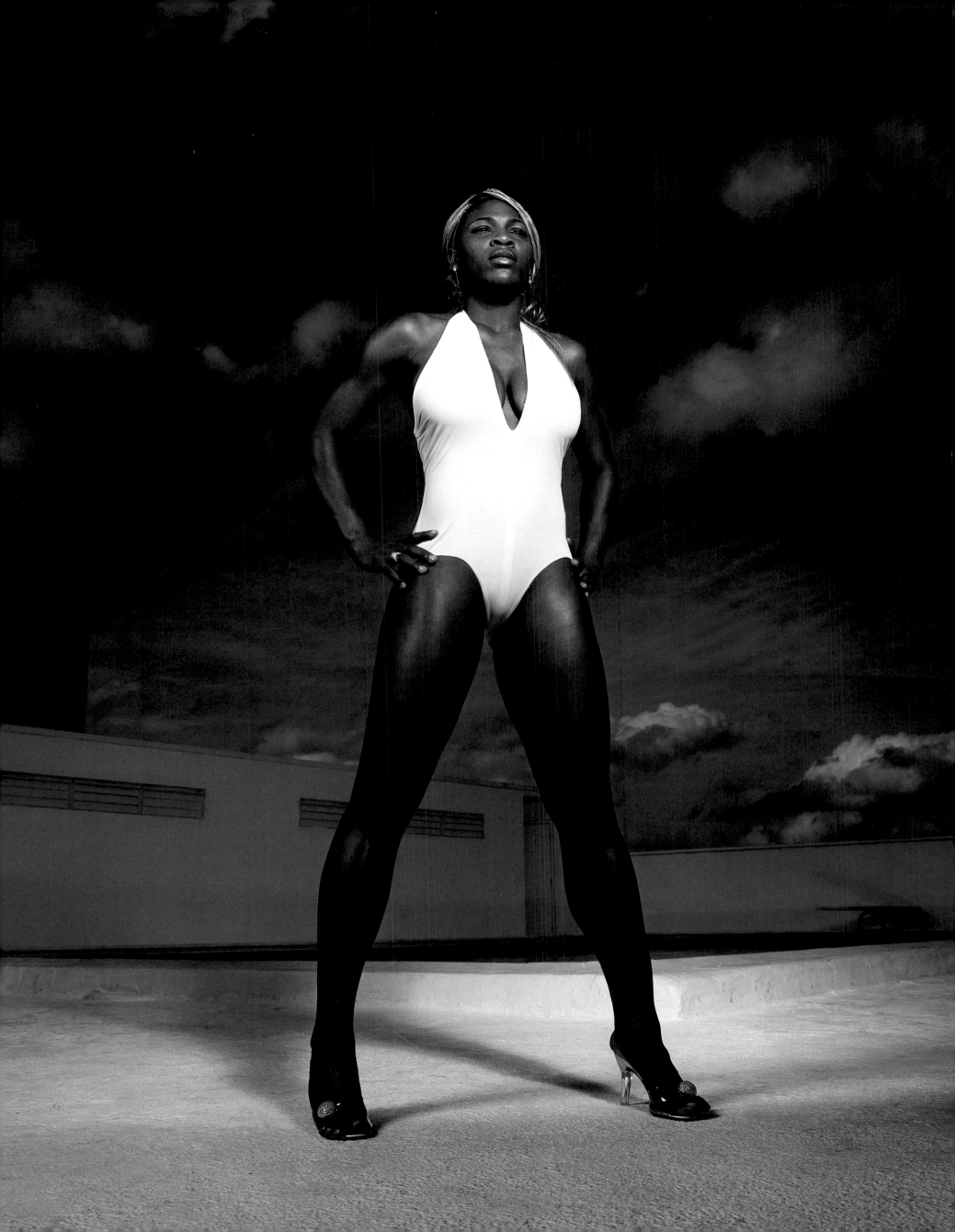

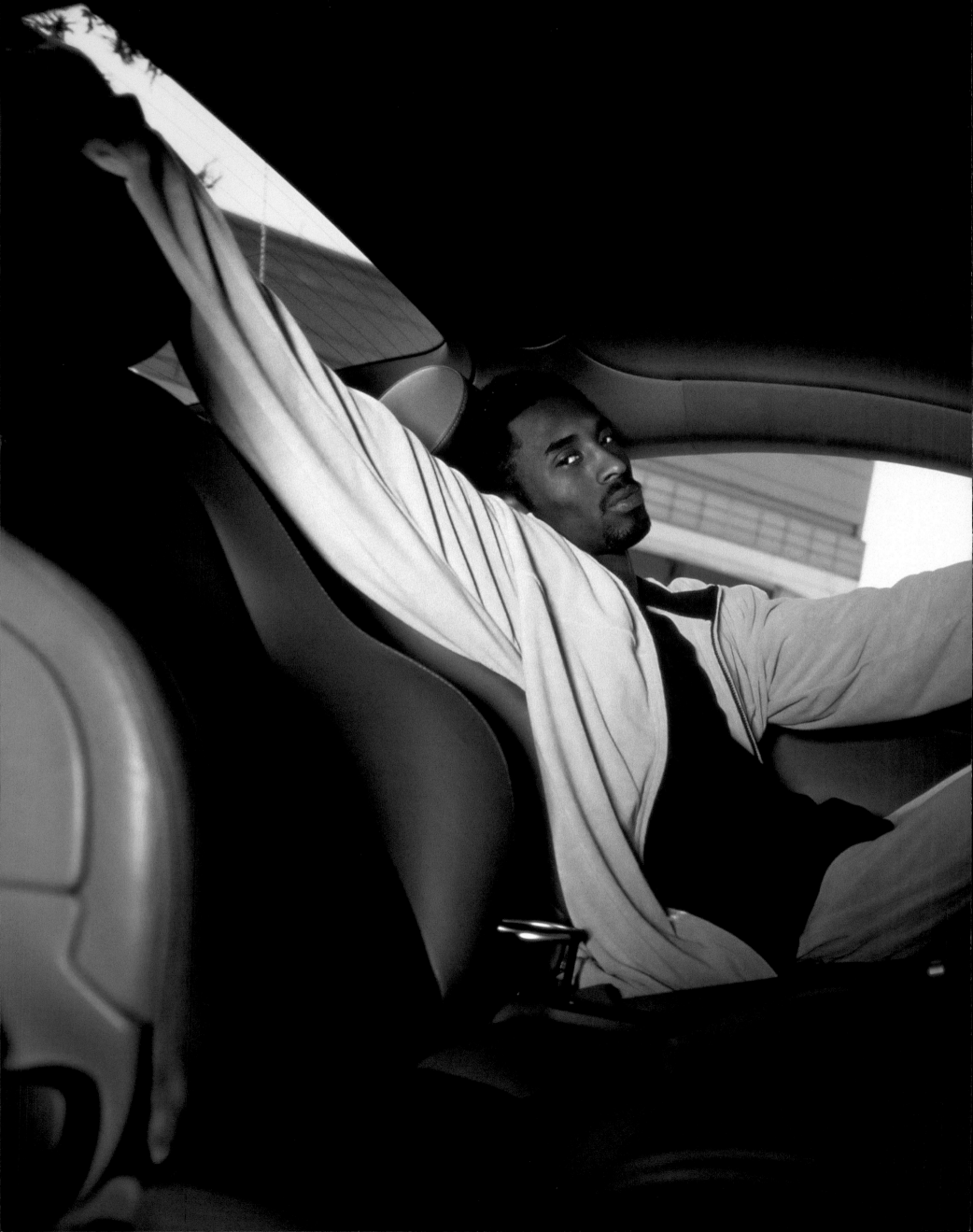

There's an old line from an R&B song that goes, *"Hollywood is a town of cars, women and stars"* – that's basically what's out there. It was down to a week before my deadline. I went to see Kobe at the Lakers' practice facility in *El Segundo* and said, "Kobe, are we going to do this picture?" He groaned. I said, "What's the problem? Is it the concept?" He looked me in the eyes, put his hands on my shoulders and said, *"Walter, I just can't pose for another picture."* I'c never heard an athlete say that. I was flcbbergasted. I said, "Kobe, please think it over. Come in tomorrow, dress like you're in Italy, *bring your black Ferrari,* and we'll do it in five, 10 minutes." He said he'd think about it. The next day I called the Lakers p.r. guy John Black and said, "Hey, any news from Kobe?" He laughed. "Are you kidding?" he said. *"Are you counting on a 22-year-old to remember something?"* Fifteen minutes later the phone rang in my hotel room: "Walter, Kobe's here. He just asked where you were." I called my assistant and we beelined over to El Segundo. Kobe got in the car. He wasn't *wearing any of his great Italian clothes,* just a sweatsuit. This was his way of giving in but stil not doing what I wanted. *It was the child in Kobe.* He said, "I'm going to tell you right now, I'm not looking in the camera." I said, "O.K., Kobe, pretend you're driving and about to make a right turn." He repeated, *"I'm not looking at the camera."* I said, "You don't have to look at the camera, just turn your head like you're making a right turn." He turned toward the camera, we shot for five minutes, and that was it. *Boom! 'Bye.* A week later he asked, "Hey, how'd those pictures turn out?" *That's Kobe.*

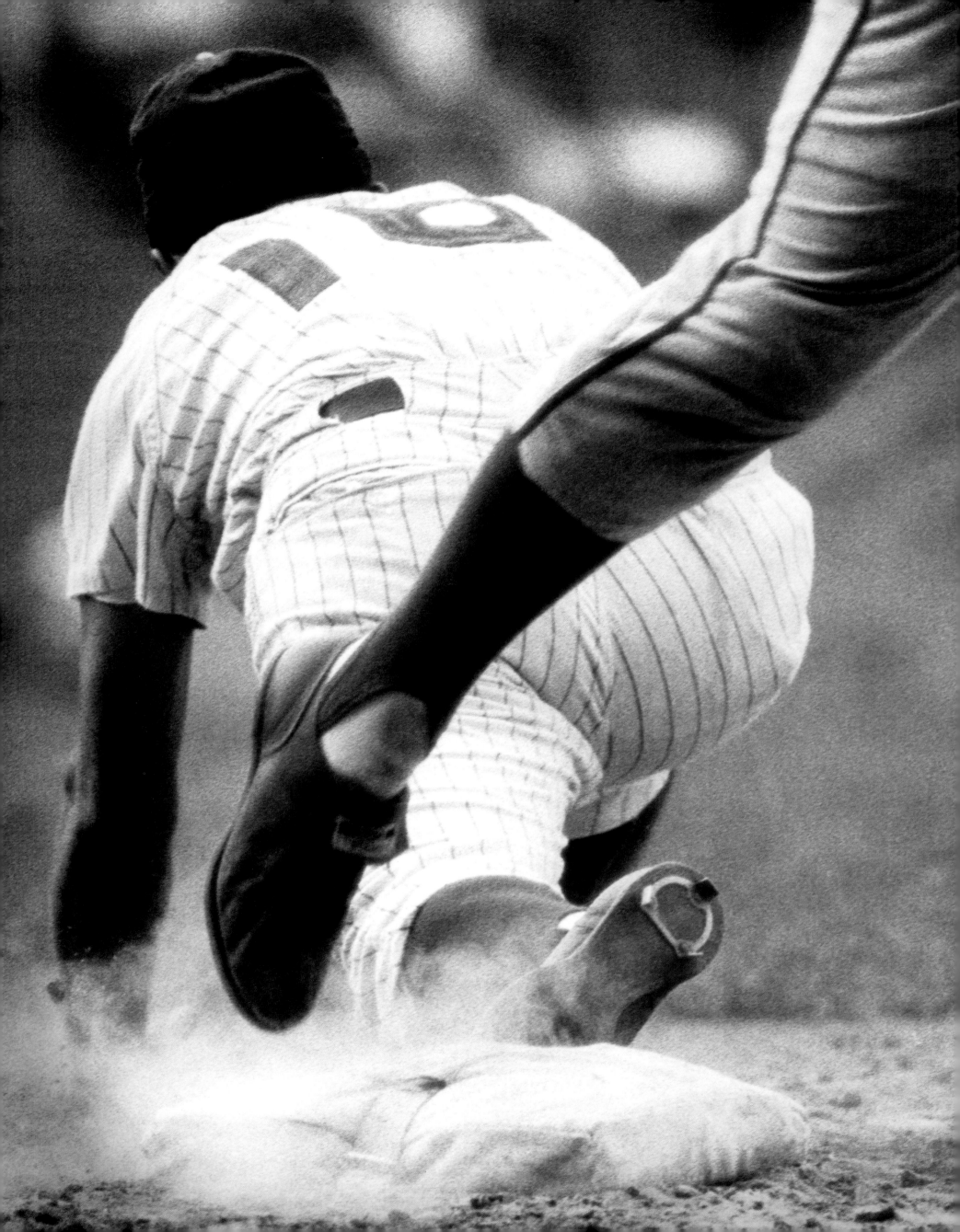

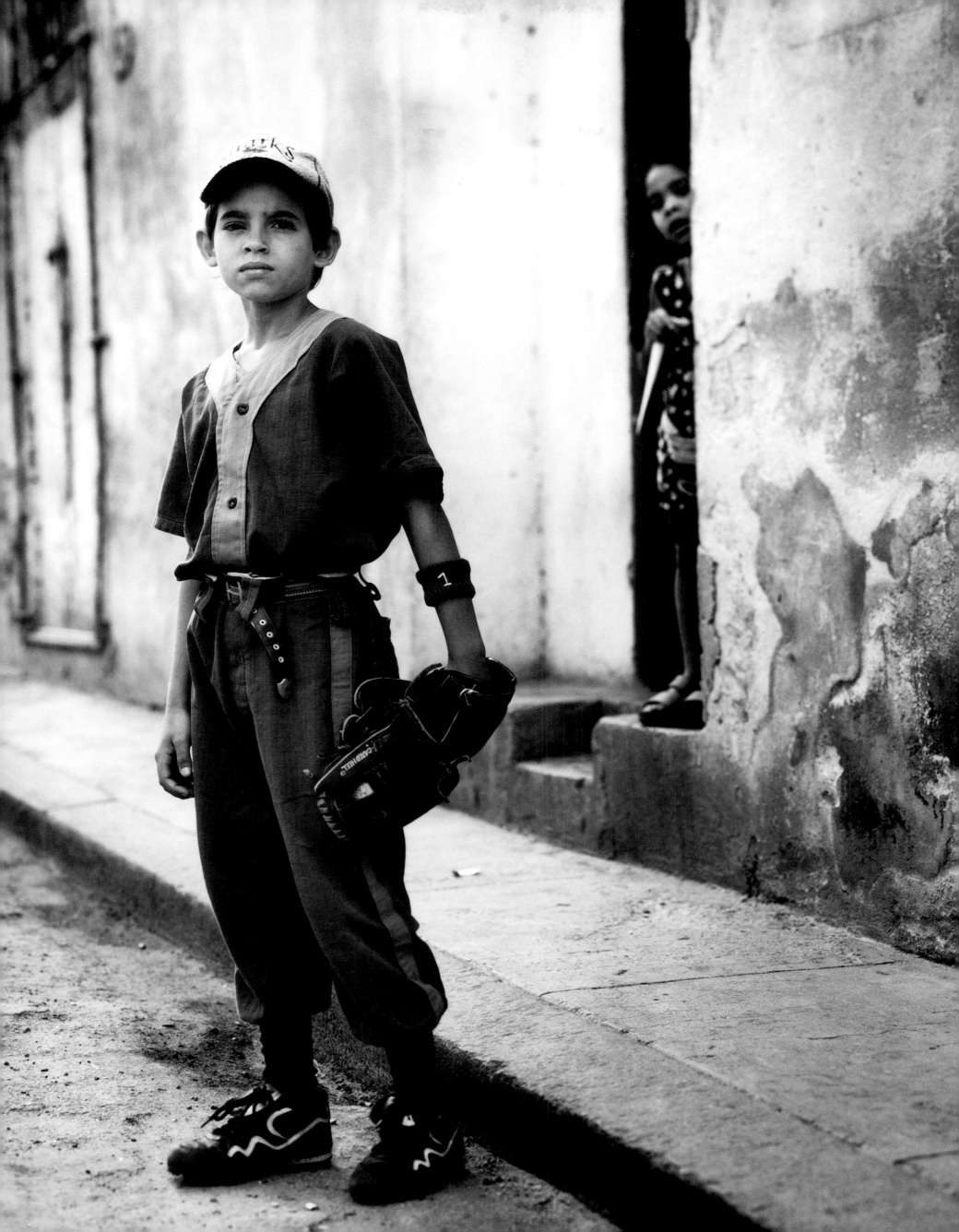

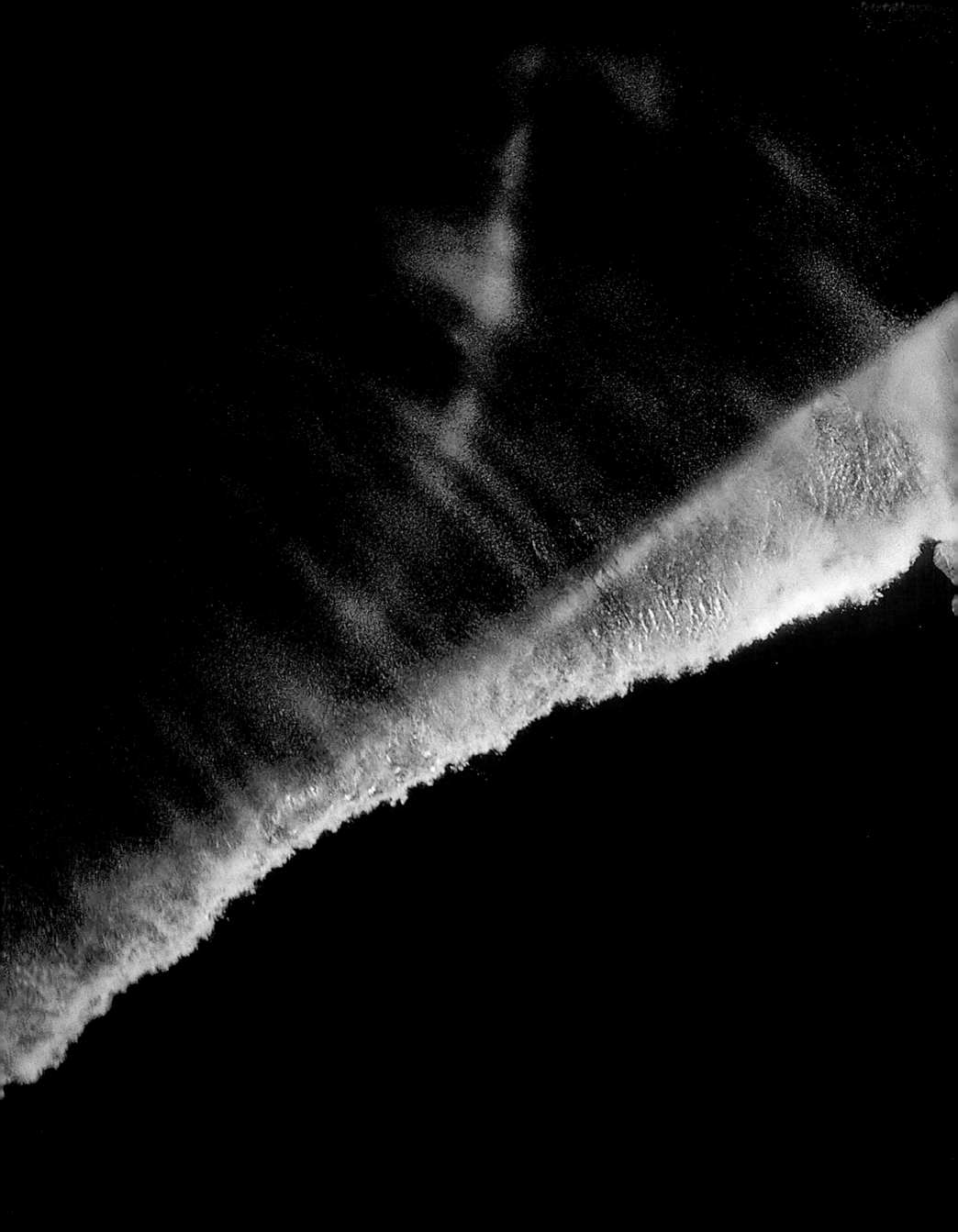

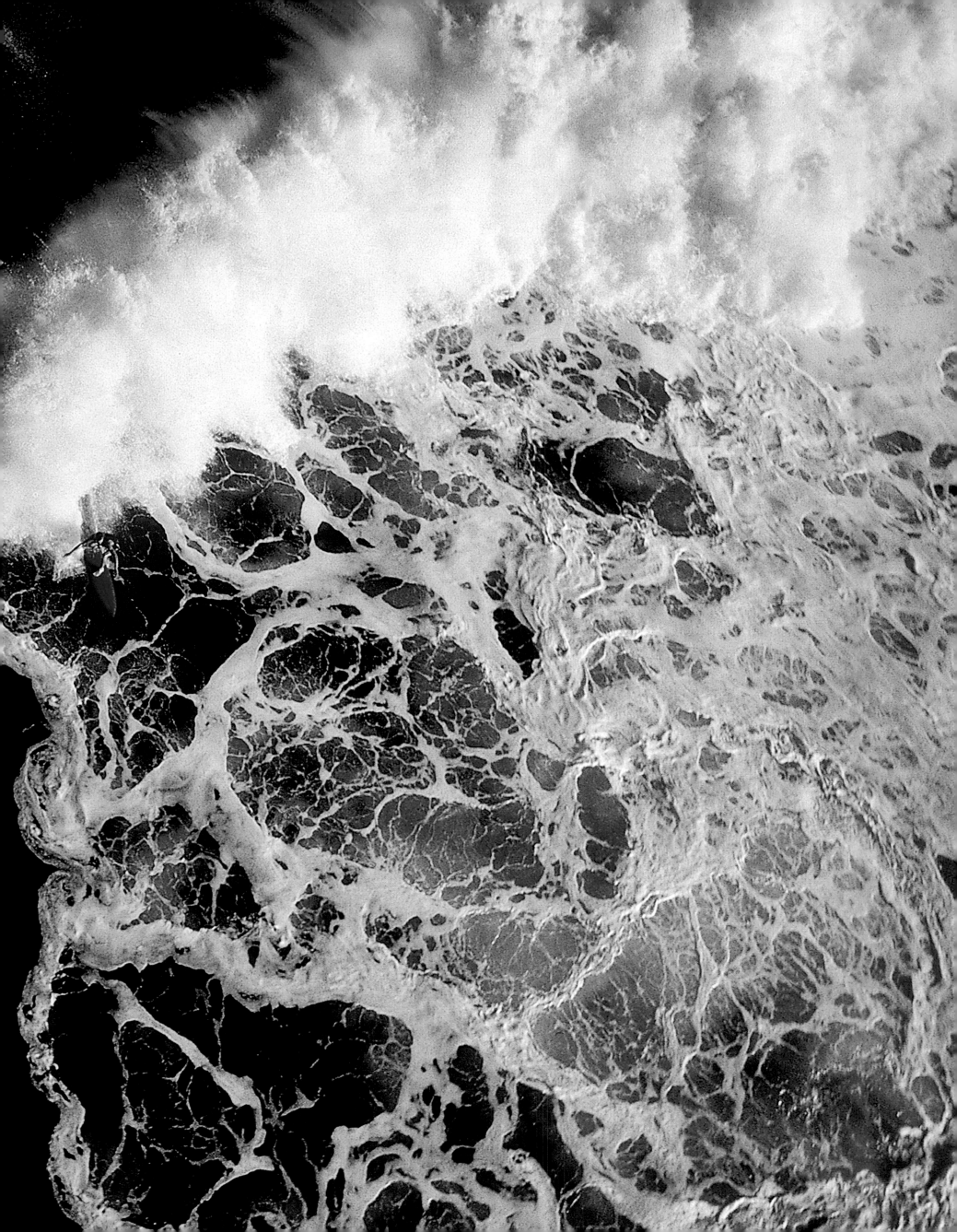

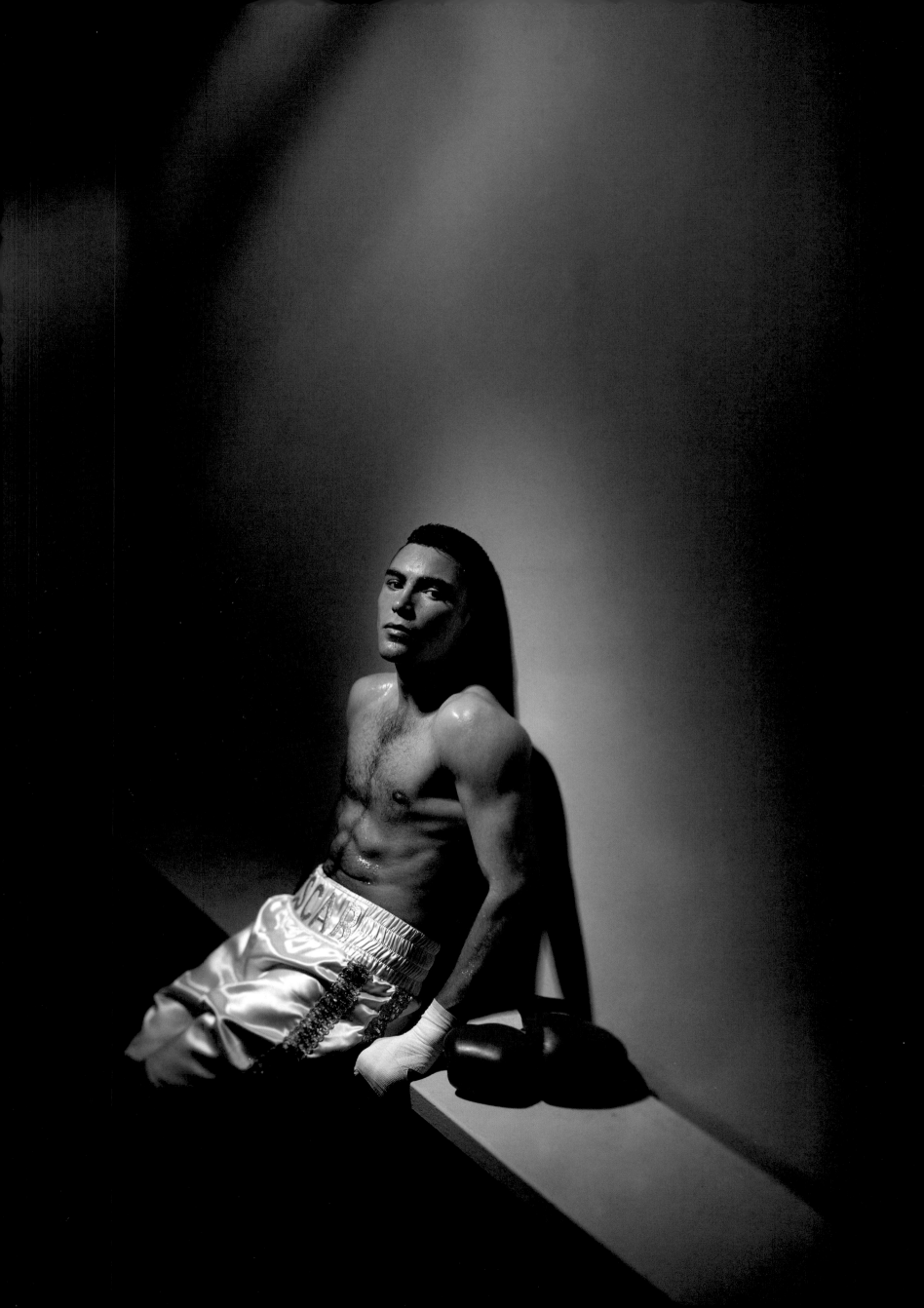

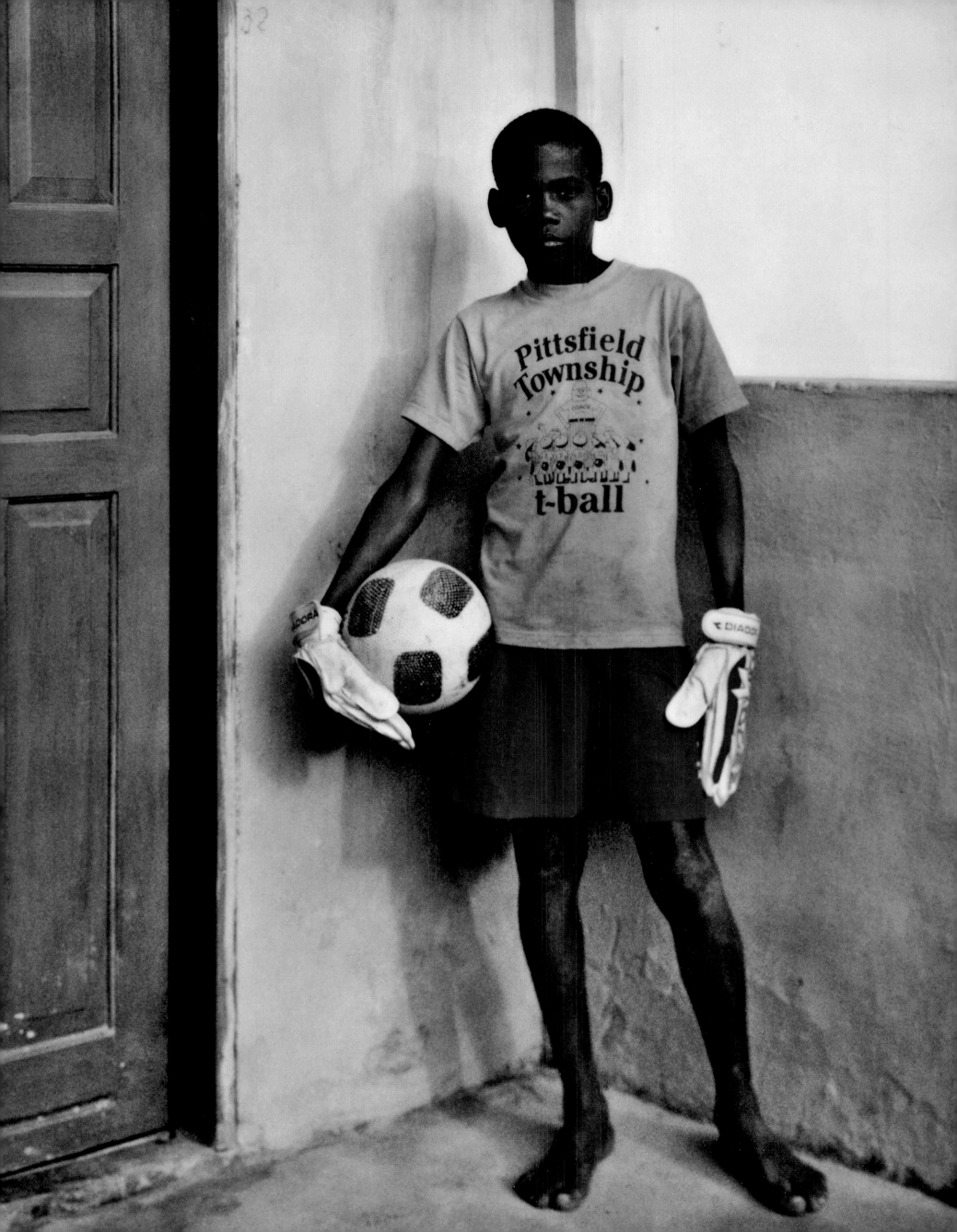

On this day I had my first field pass to a pro football game. I don't remember how I got it. I took the train from Newark to Baltimore. I was nervous. I would finally be on the same field as *my beloved Colts.* Every Thursday there was a show on TV called *Pro Football Highlights. I loved it,* you could see the photographers on the sideline. I thought, "If I wear all light-colored clothes maybe I can see myself on TV." So I wore khakis and a khaki-colored jacket. With about a minute left in the game, Johnny Unitas threw this pass to Jimmy Orr, who *bobbled the ball but held on to it as he fell into the end zone,* and the *Colts won.* In those days photographers could stand on the sideline, so I was right next to

Orr as he reached for the ball. I didn't have a motor drive on my camera, I didn't even own one. I took two or three steps backward, *cranked the focus* and took one frame. I was sure I'd missed the shot. When Orr finished catching the ball, *I jumped up in the air, like the teenage fan* I was, leaped on his back and patted him like a deranged stalker. I *completely forgot about being a journalist.* He brushed me aside. The next Thursday when they showed the highlights of that game on TV, there was Orr bobbling the ball, and me jumping on him and patting him on the back. I was part of the highlights and *I got my first great catch picture.* One frame, tack sharp — impossible. But there it was.

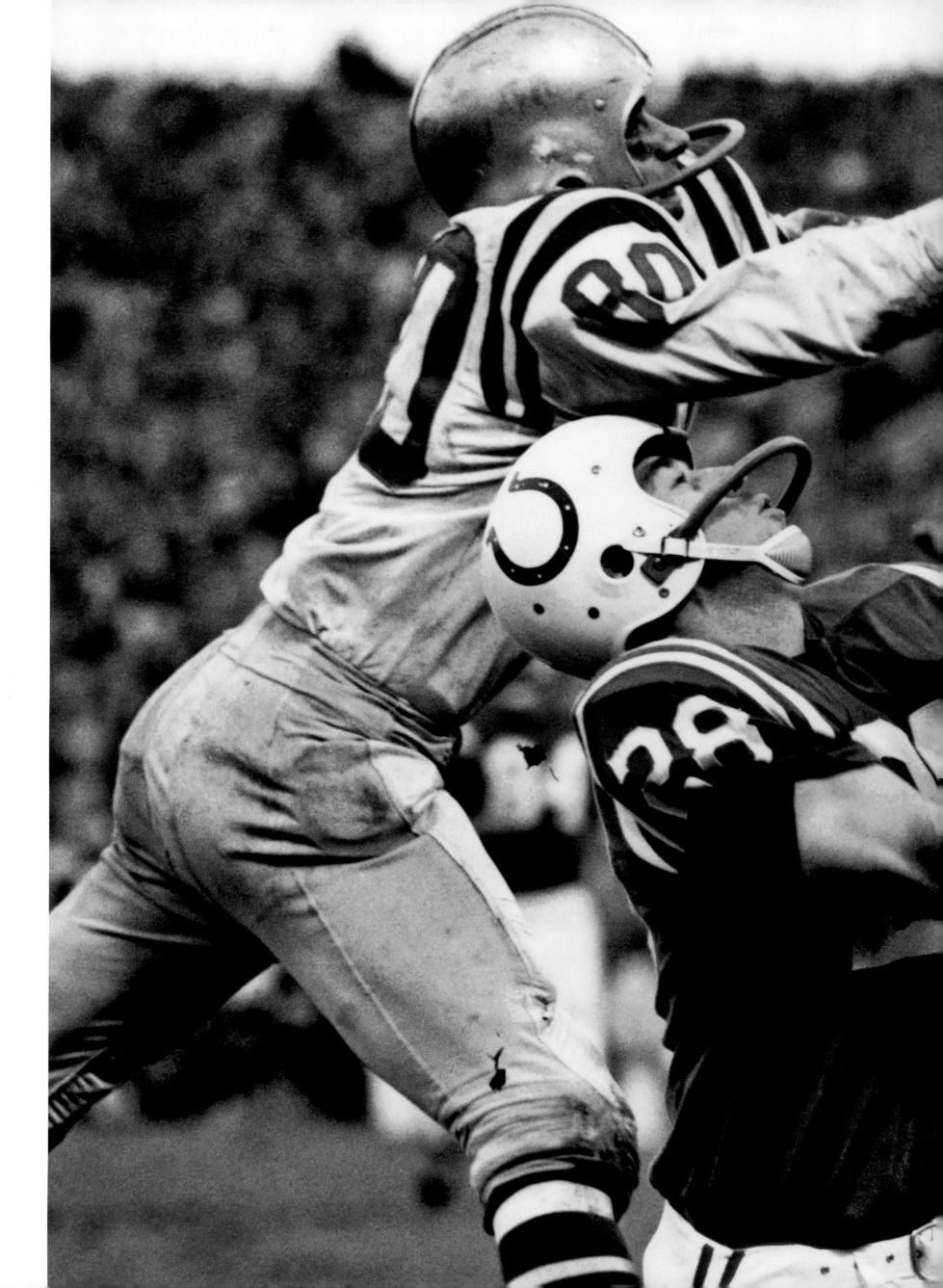

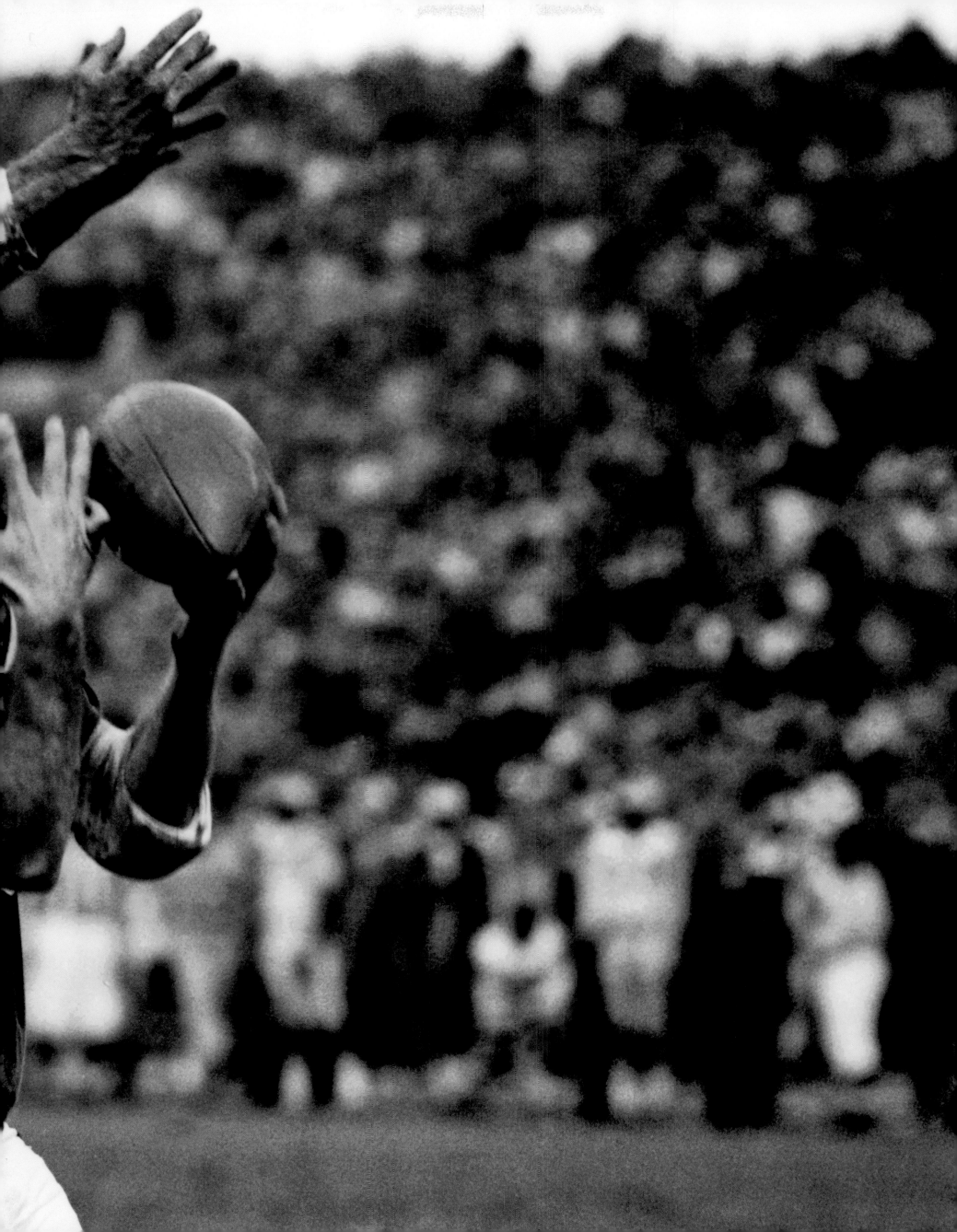

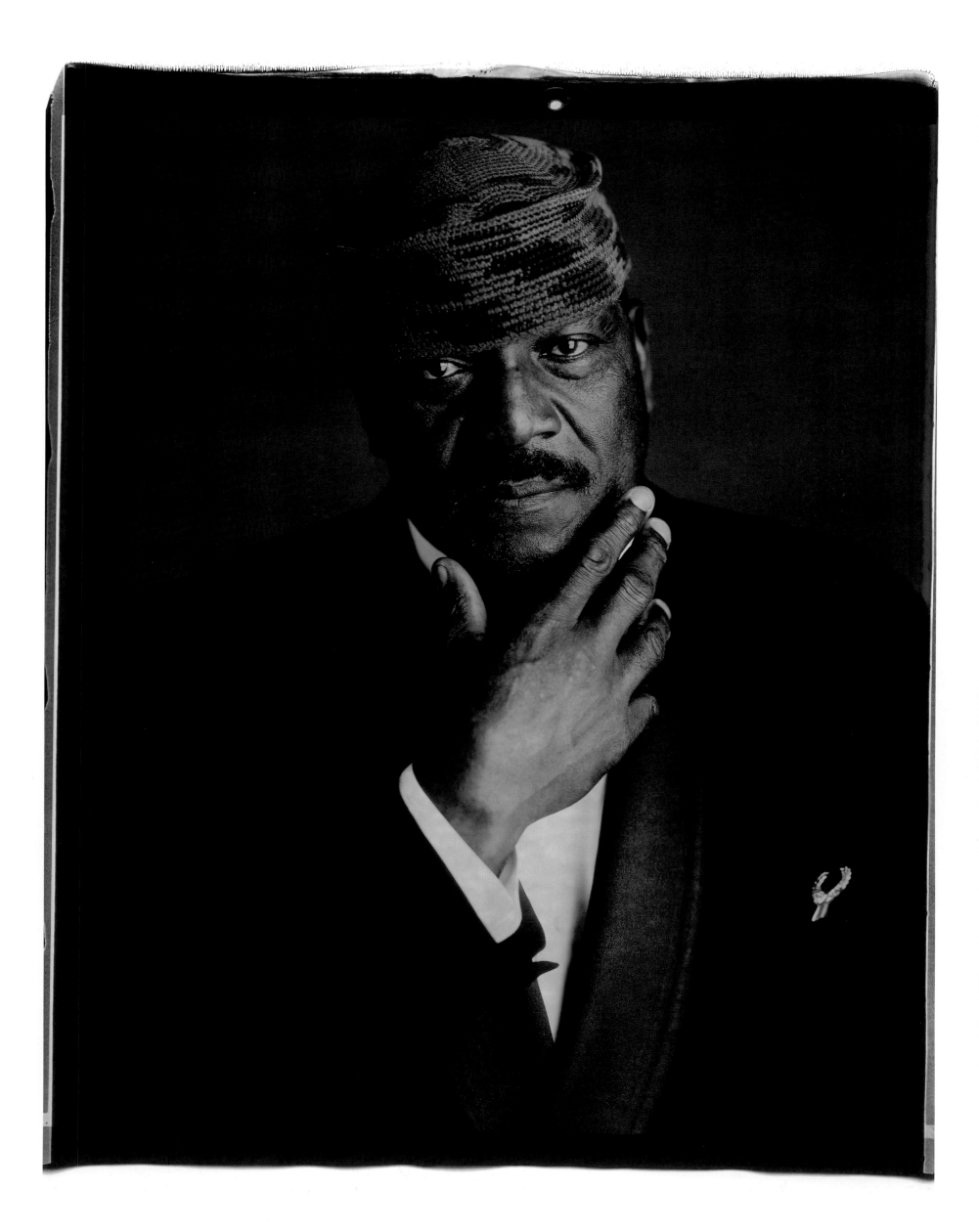

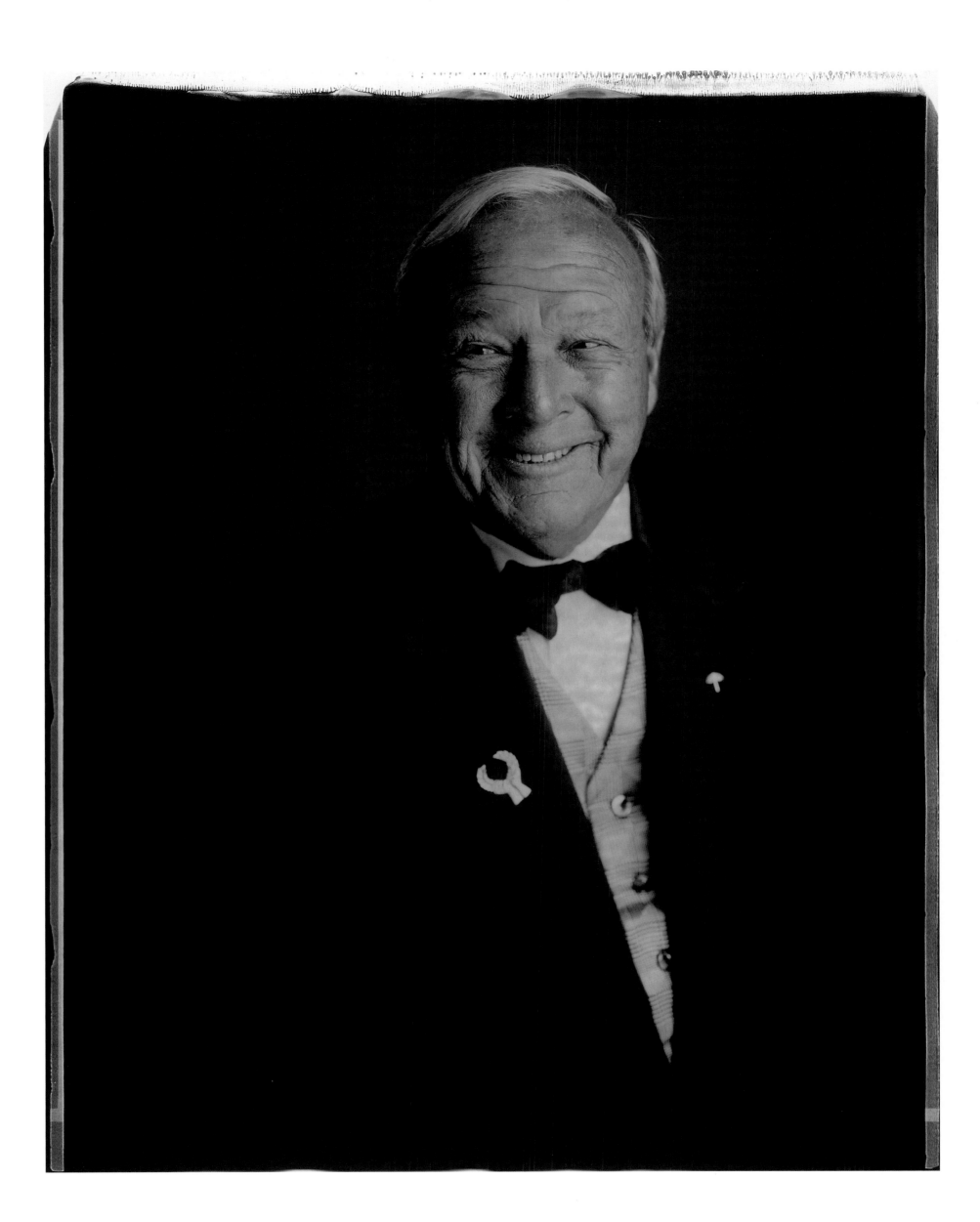

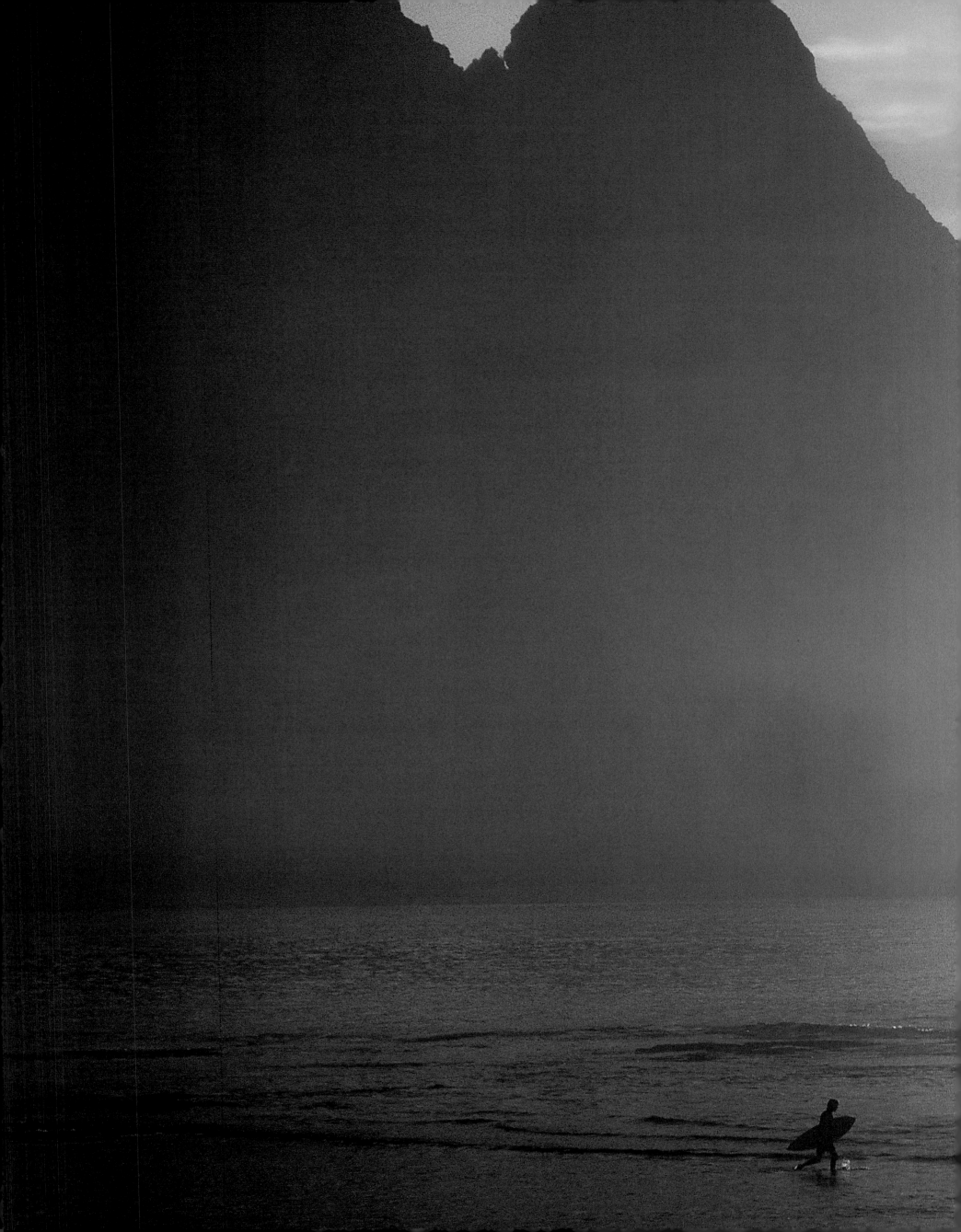

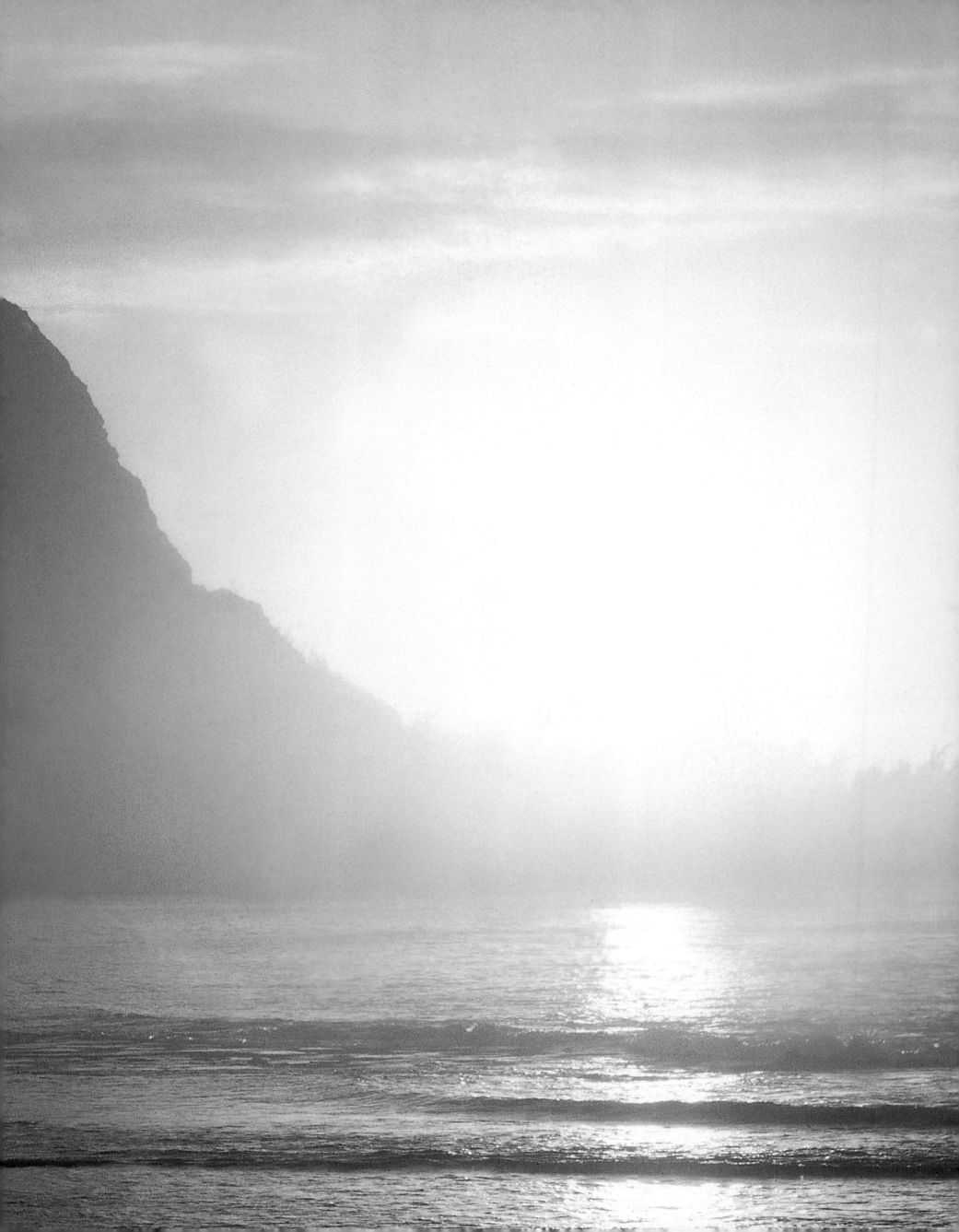

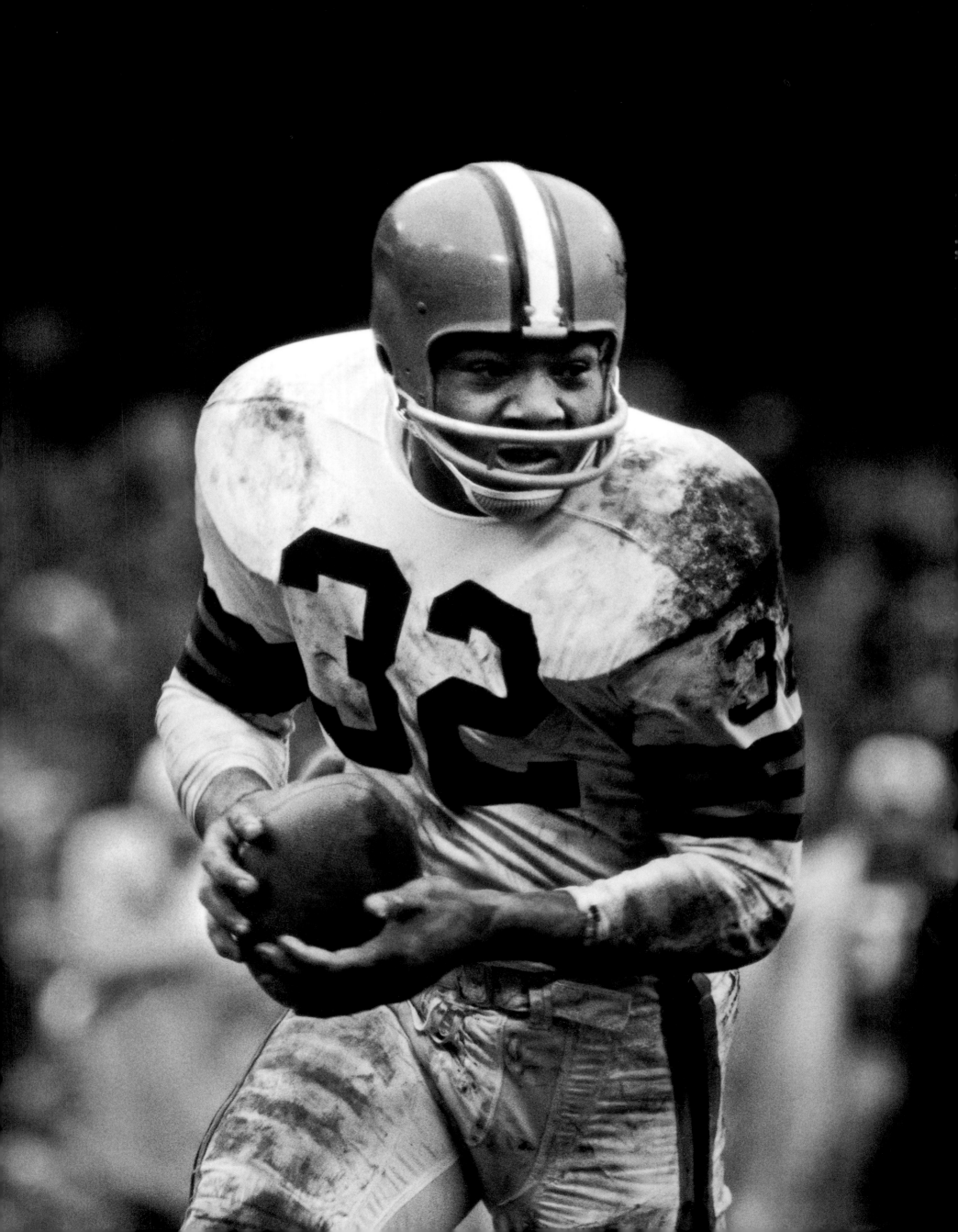

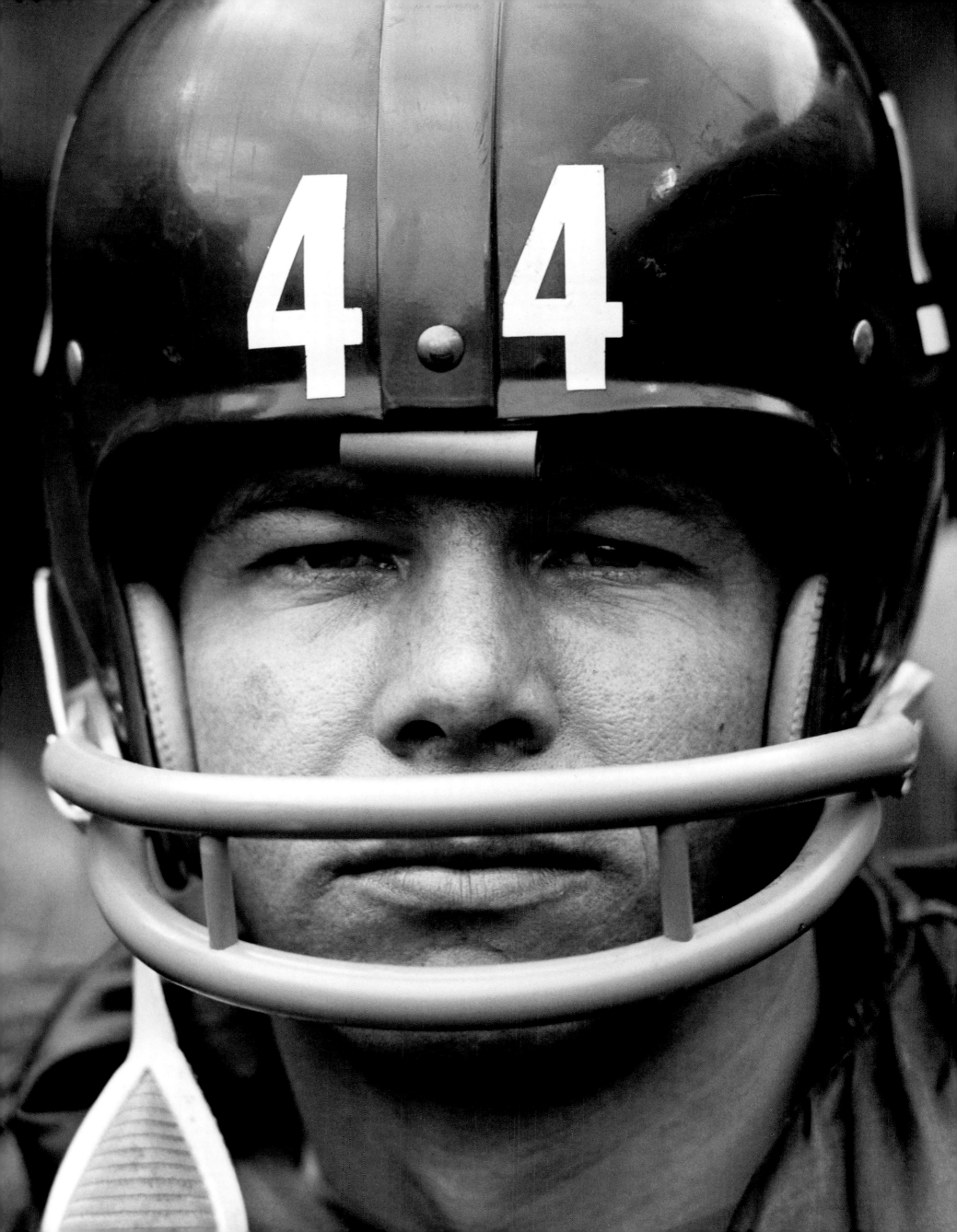

There's a famous picture taken in the '50s of *Willie Mays playing stickball* in Harlem. I played a lot of stickball growing up and *always loved it.* I wanted to replicate the Mays photo in Cuba because baseball is the *national sport* there. It's everywhere. Cuban children play ball in the streets like kids in U.S. cities used to do. It was my last Saturday on this trip and I was slowly weaving through *the streets of old Havana,* looking for kids playing ball, when I

came upon this corner, *La Esquina.* If you study the picture, you see that every eye, not just the kids' but even the dog's, is on that taped ball. *It's the decisive moment,* and there's no way to anticipate when you're going to get it. I had a *vision* of a picture that I'd tried and tried and tried to find but hadn't yet, and I came within a day of not finding it. To me it was all about getting the photograph *I'd been searching for* and I did it in 20 frames.

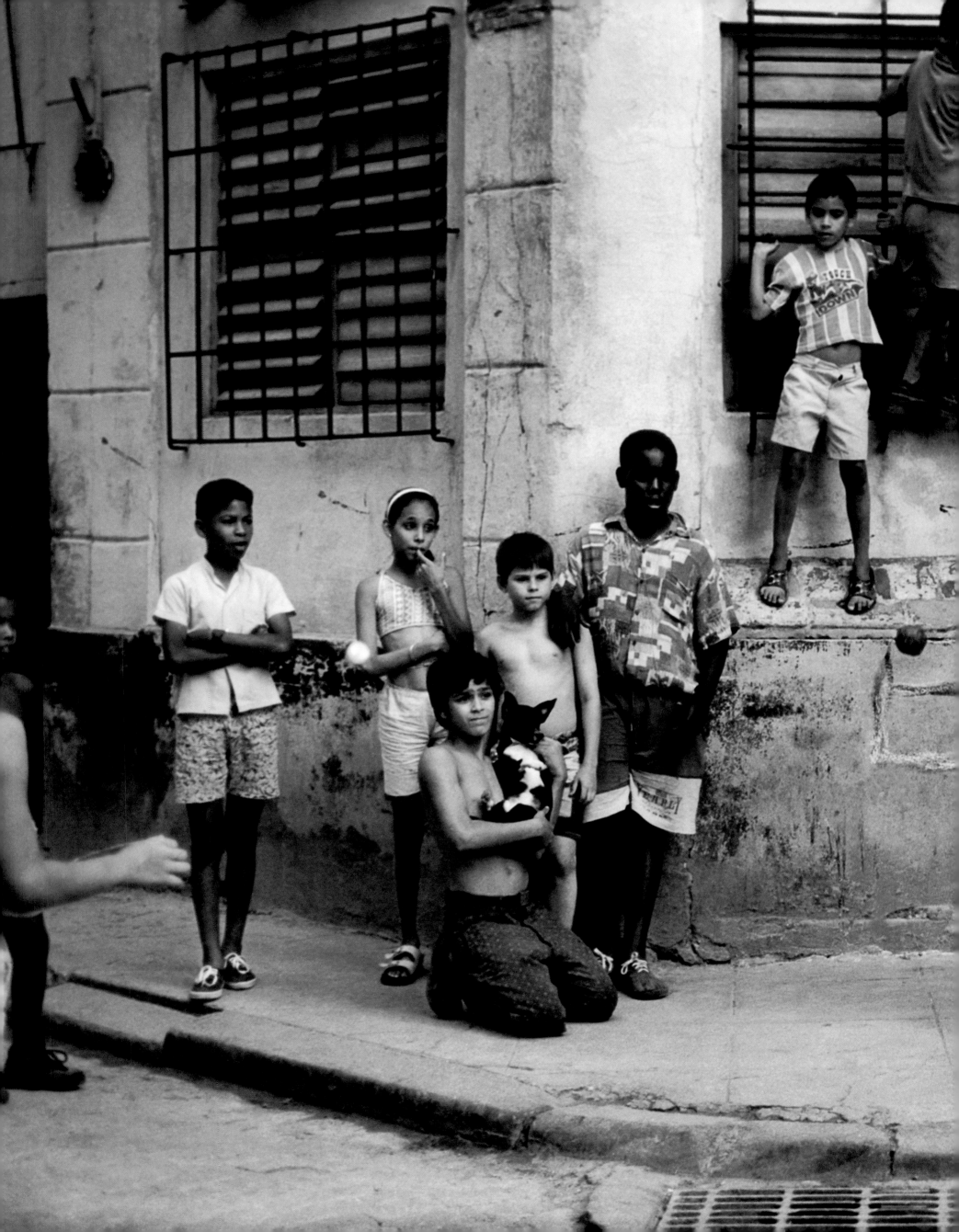

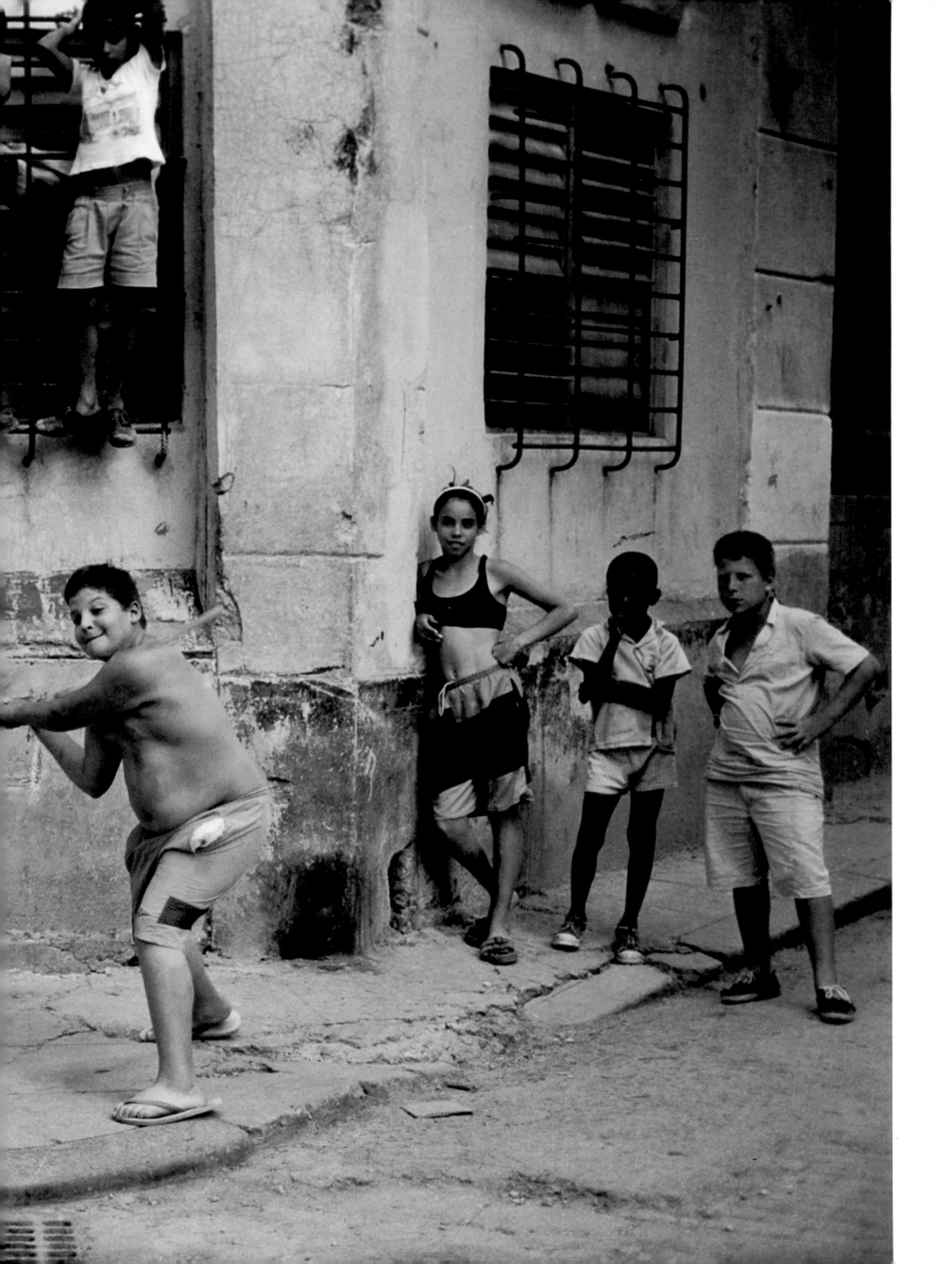

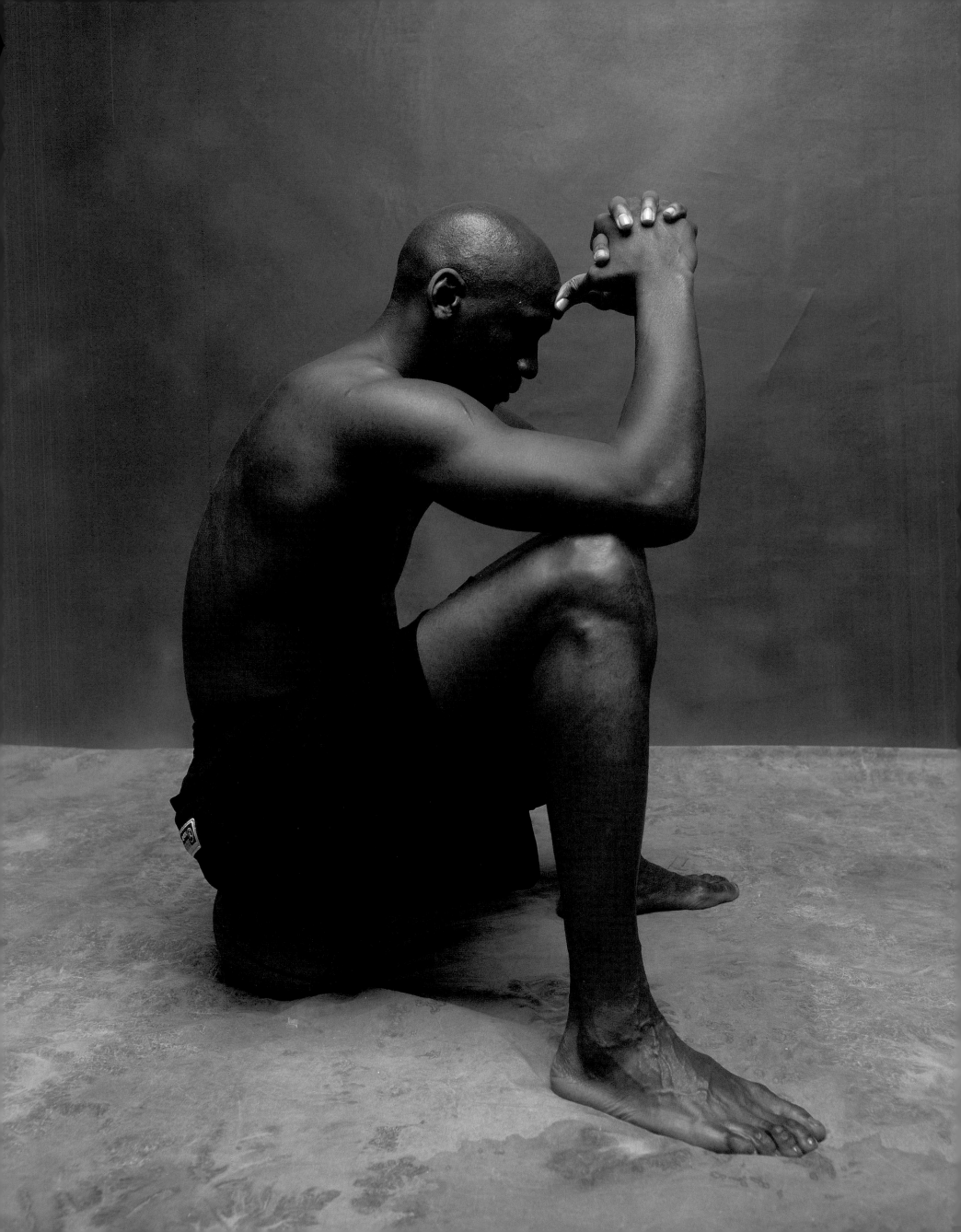

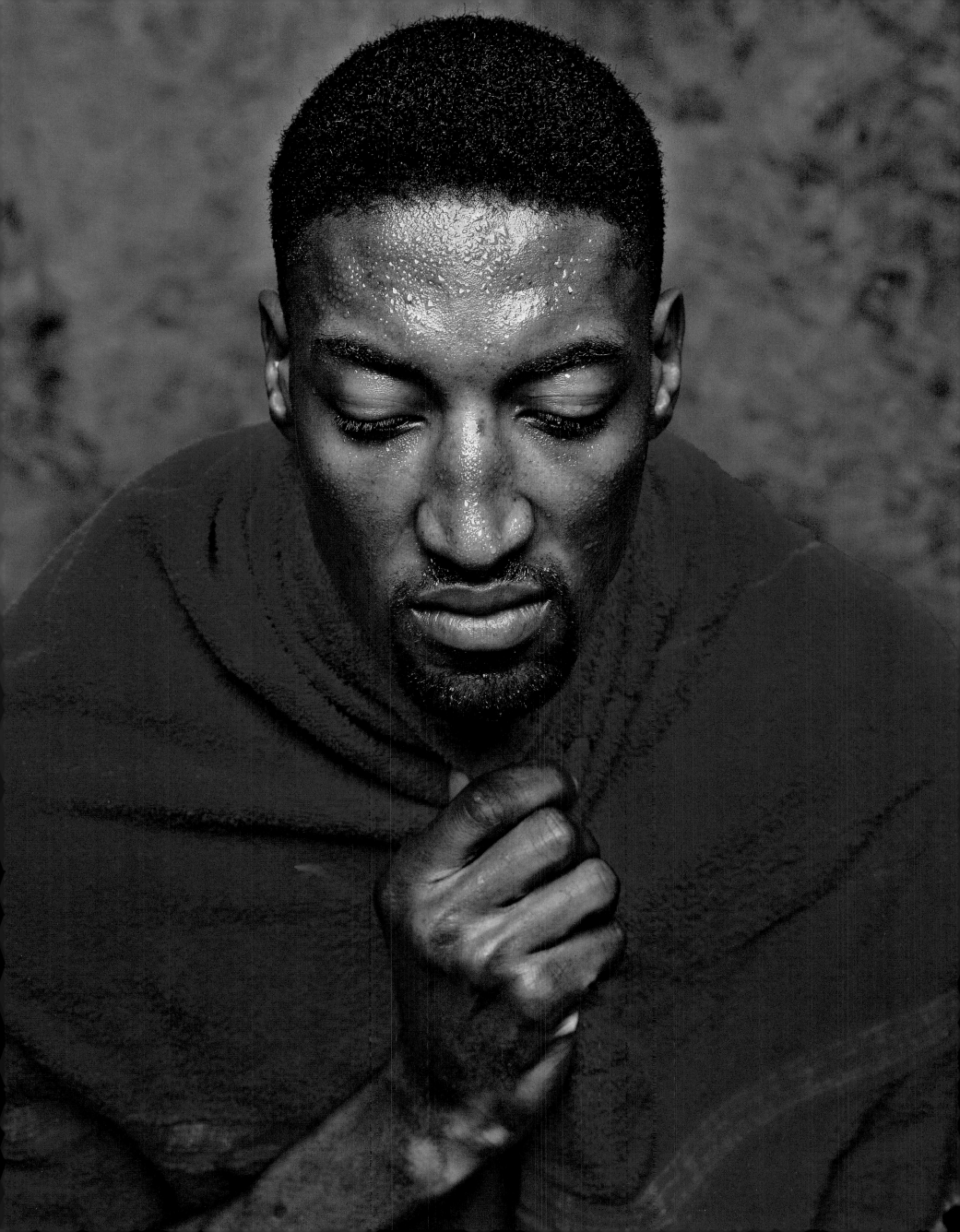

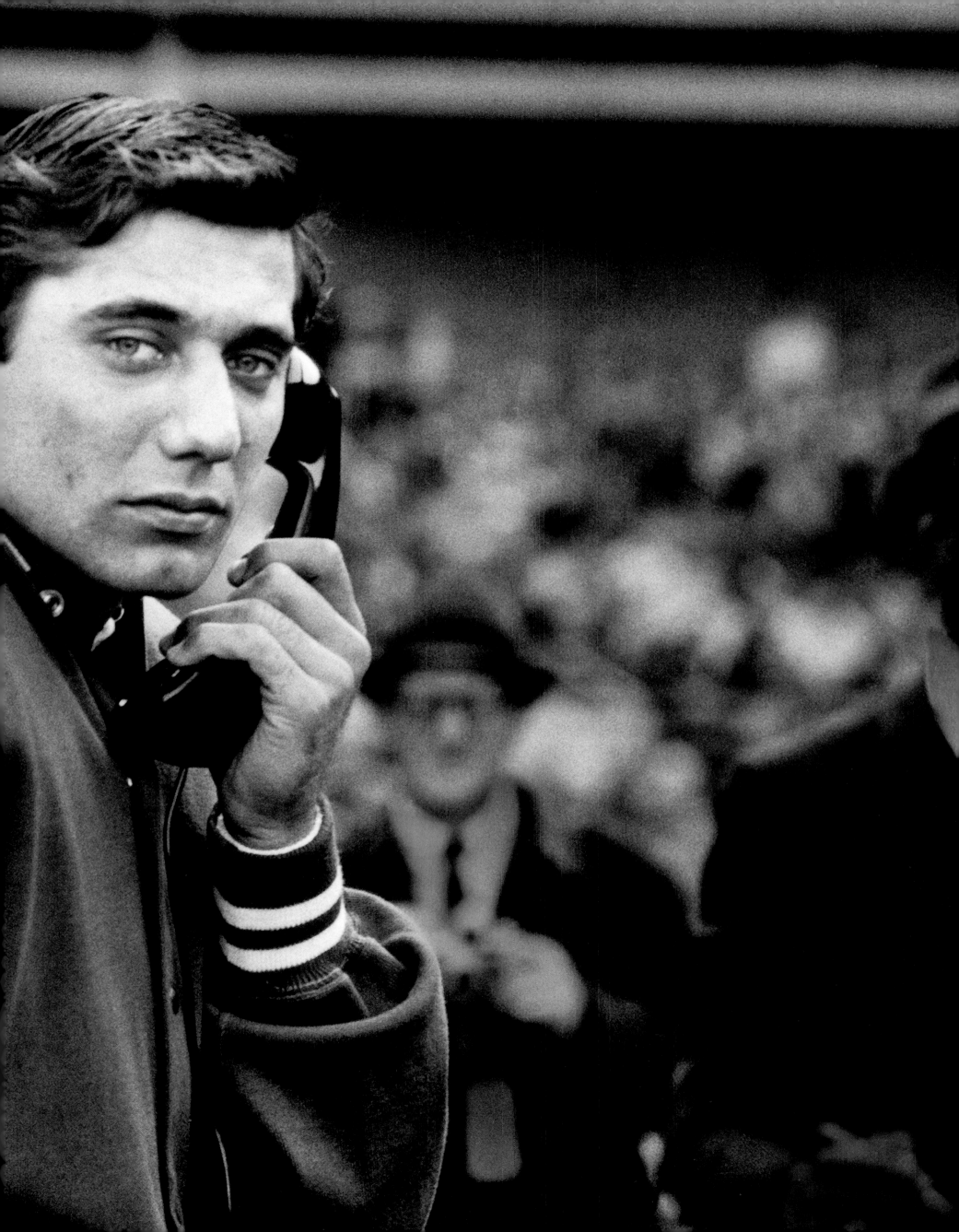

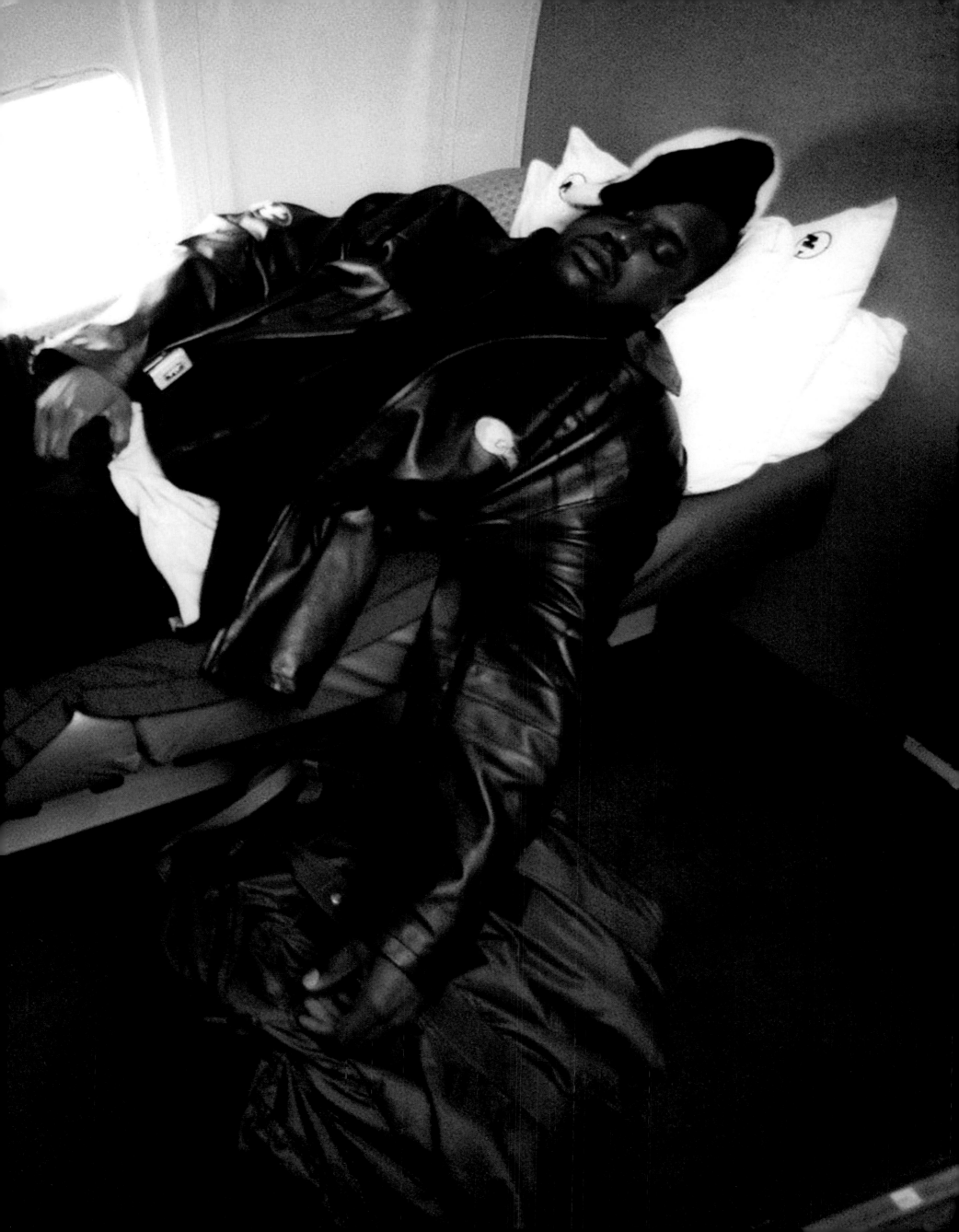

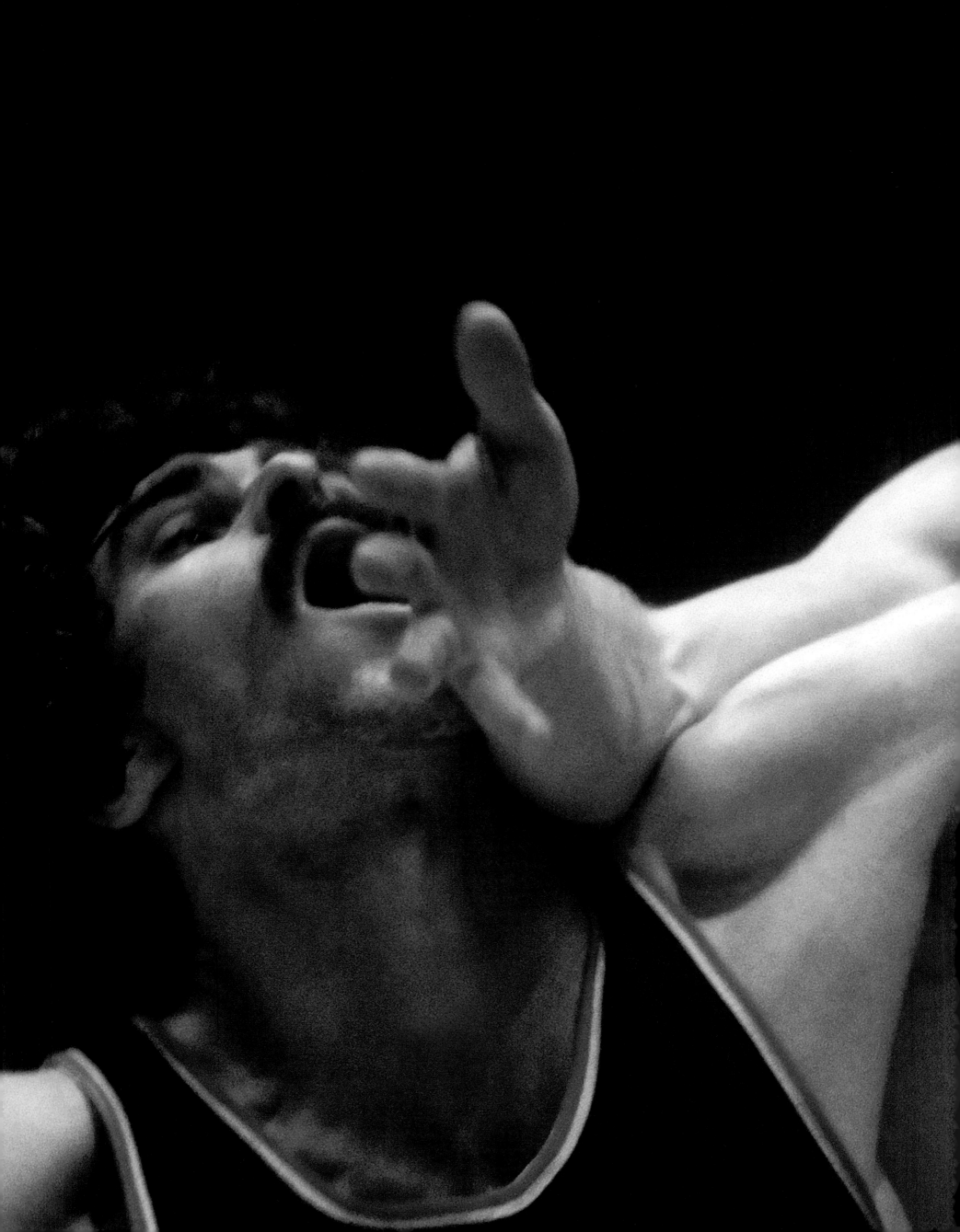

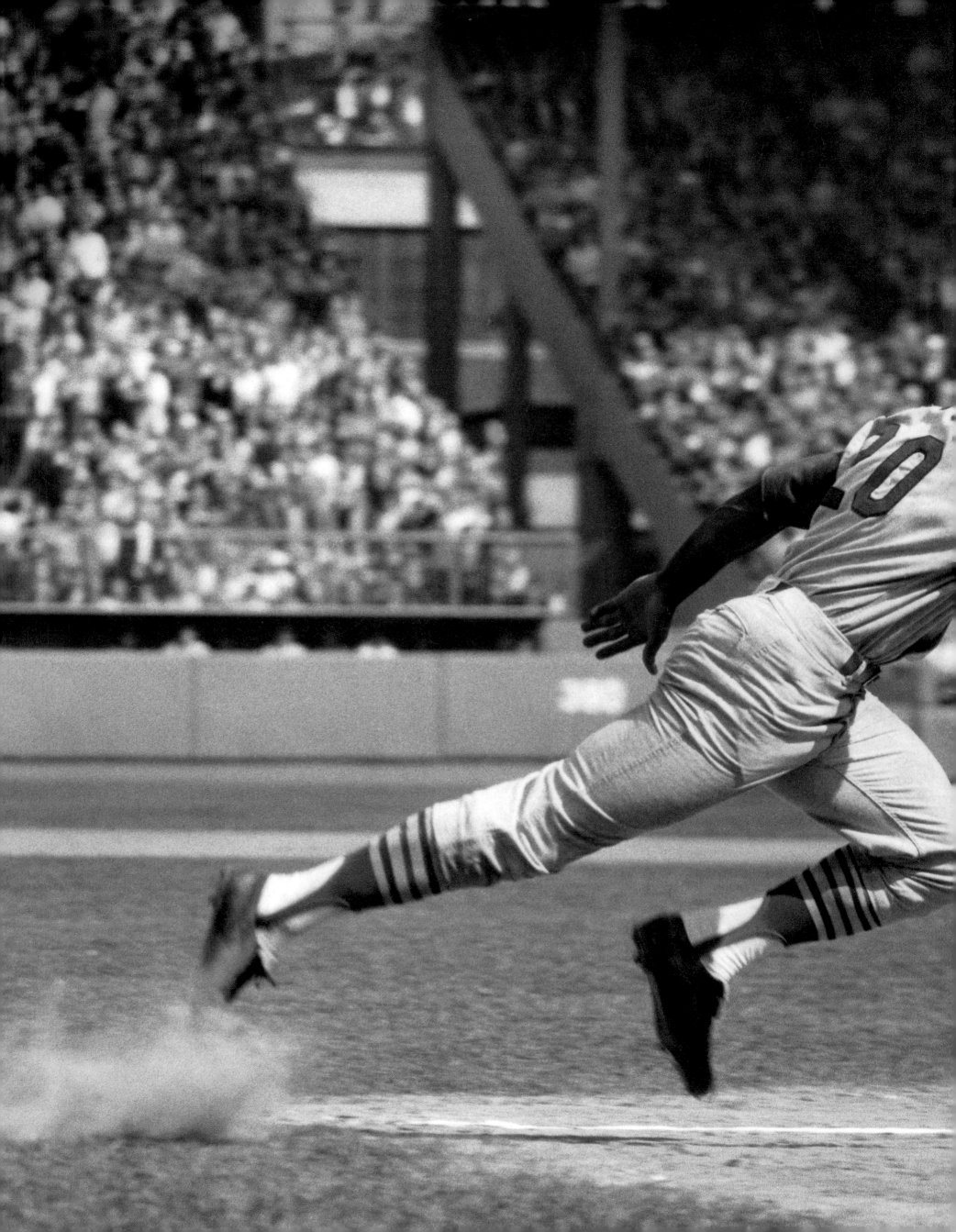

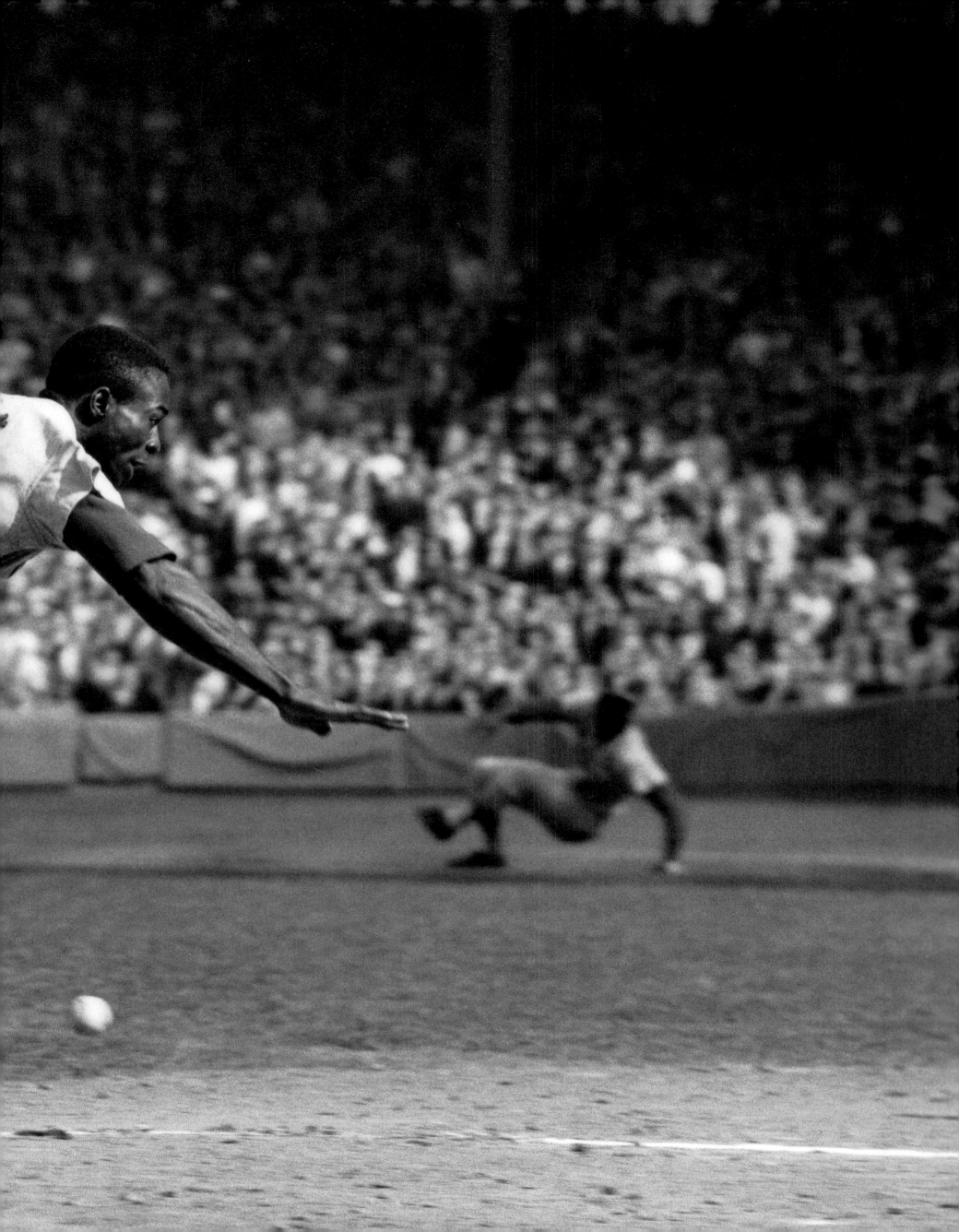

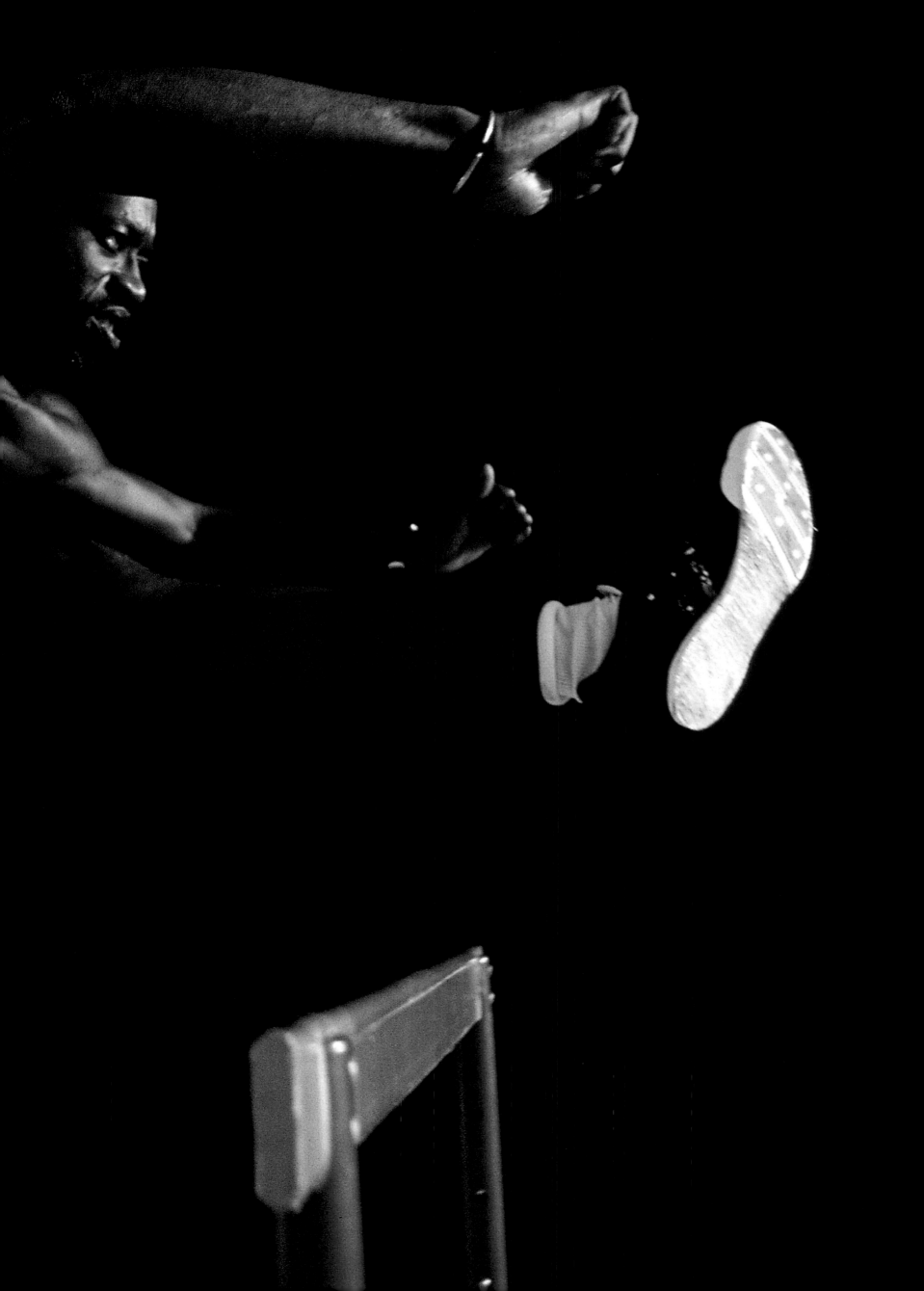

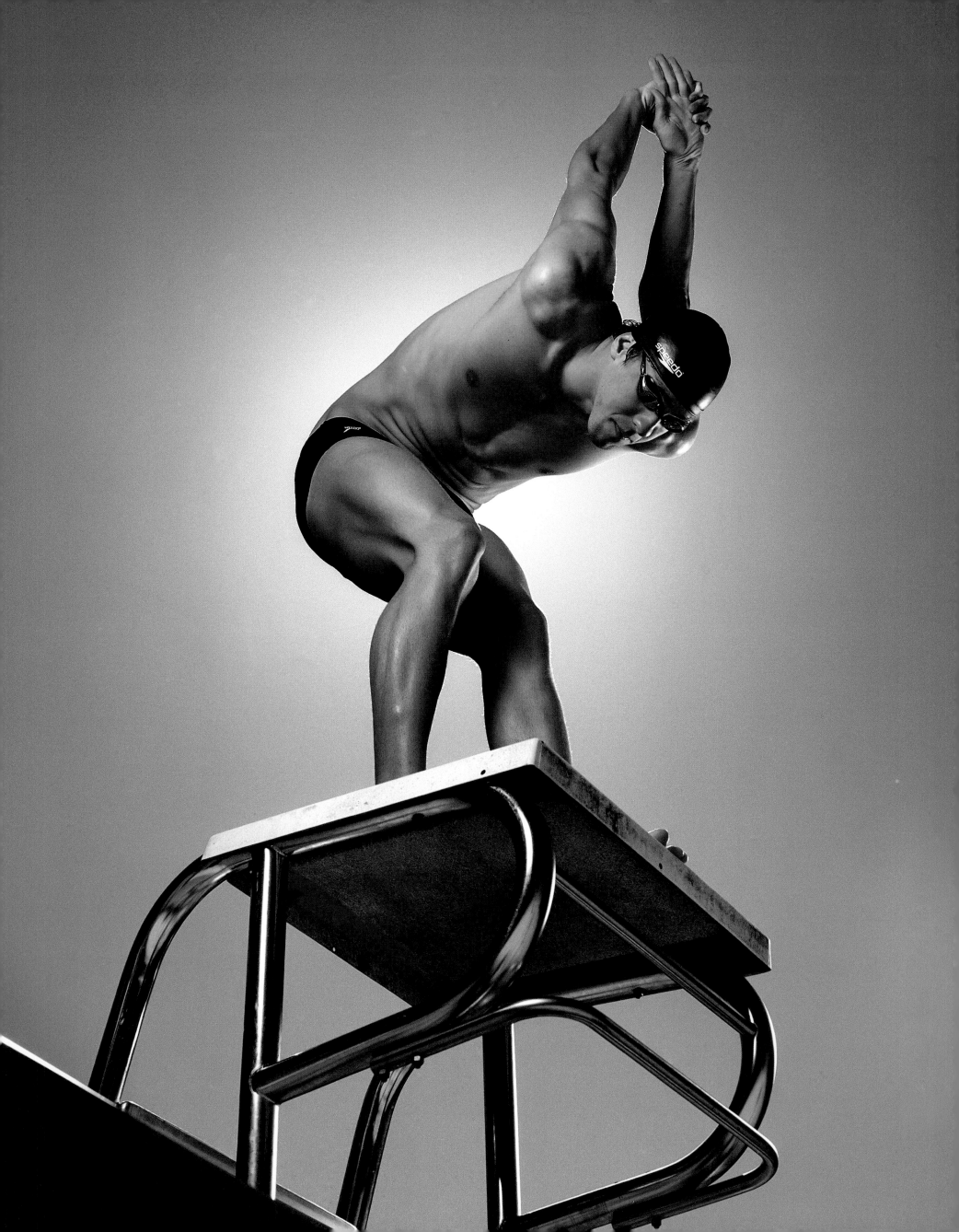

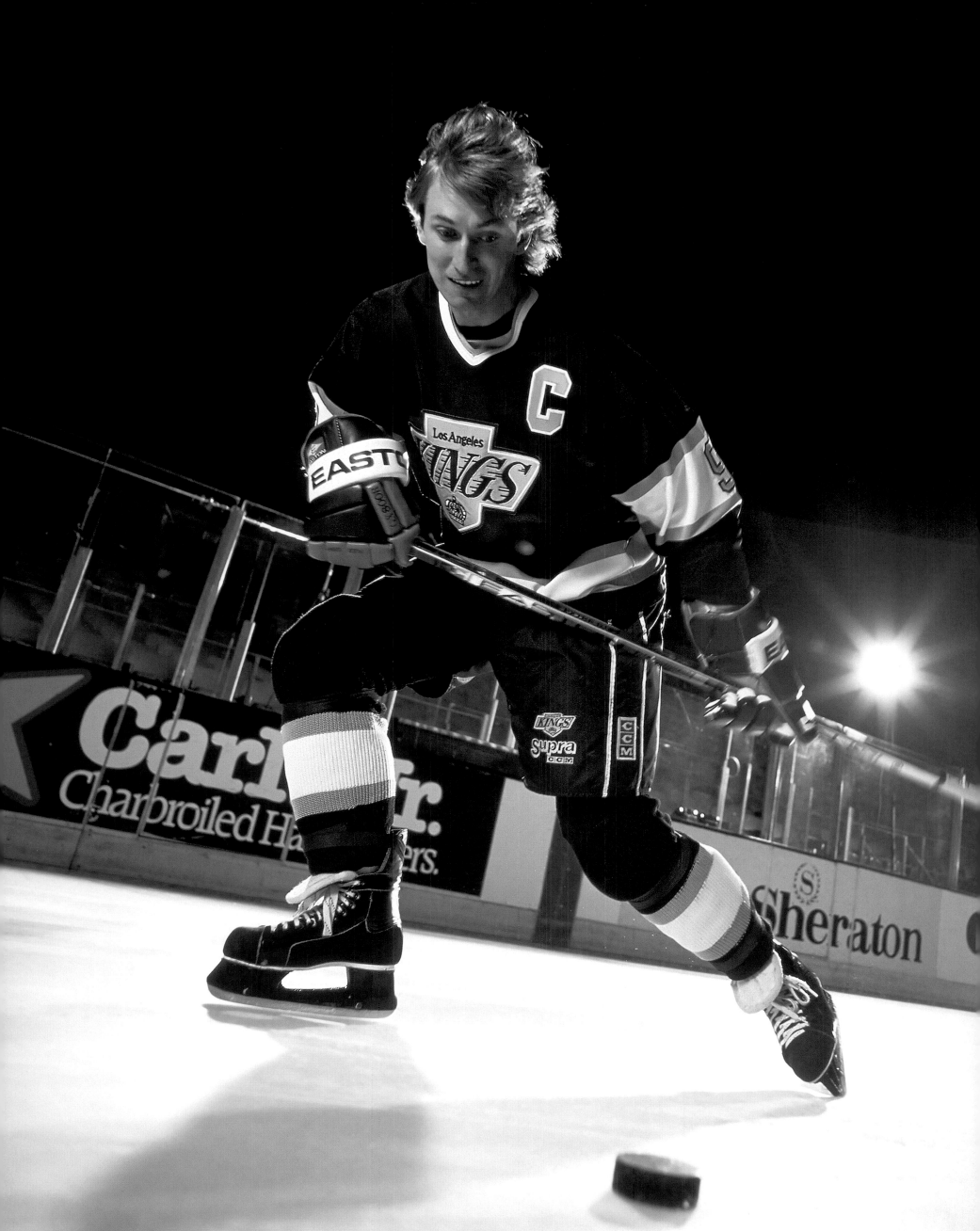

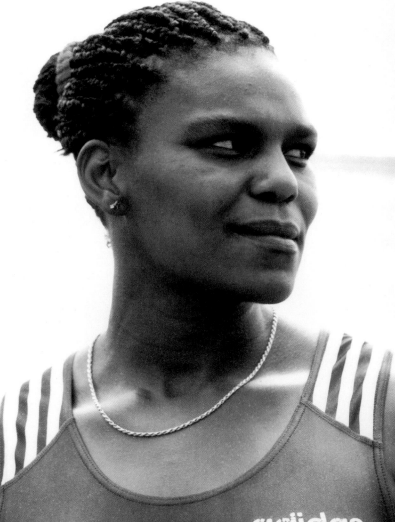

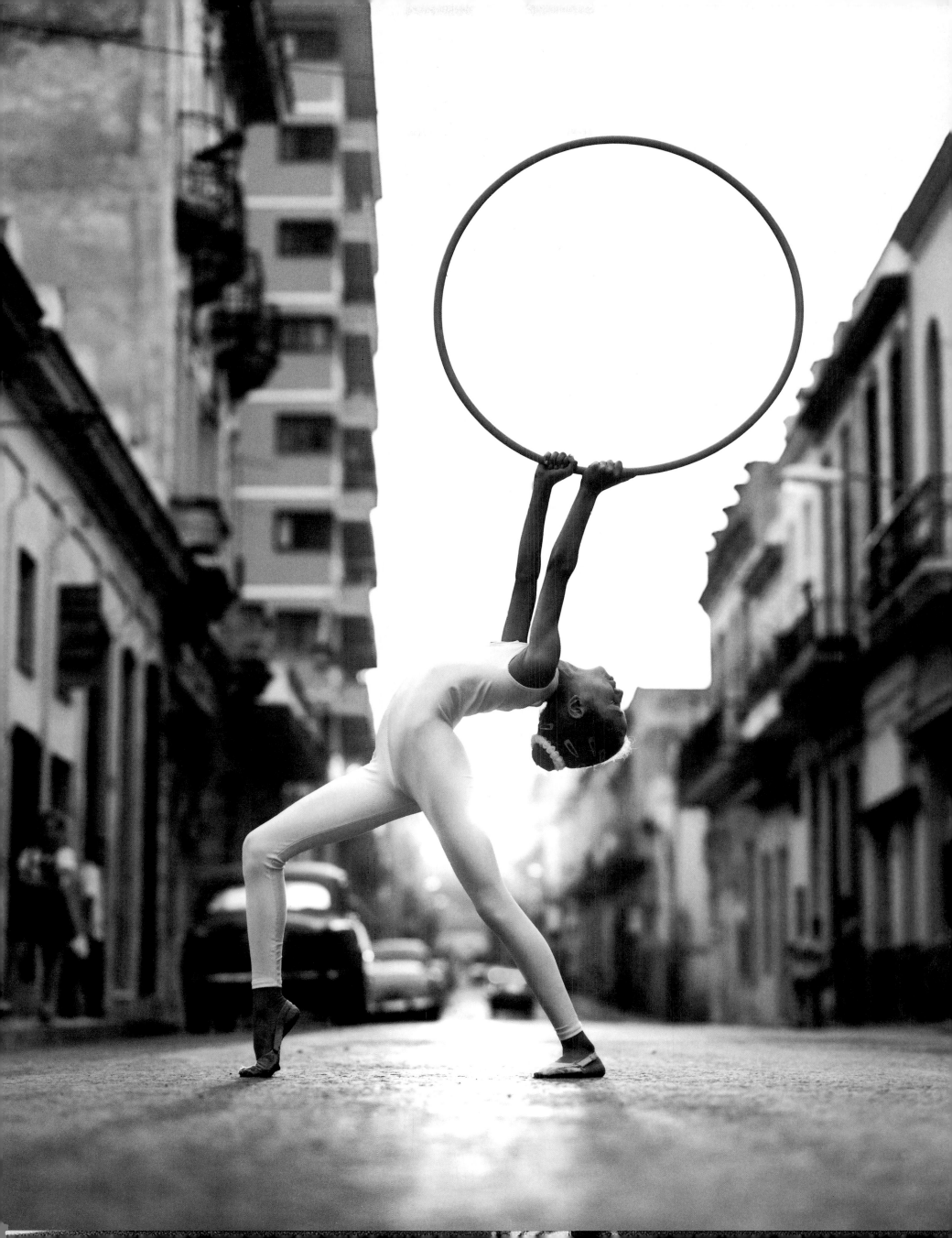

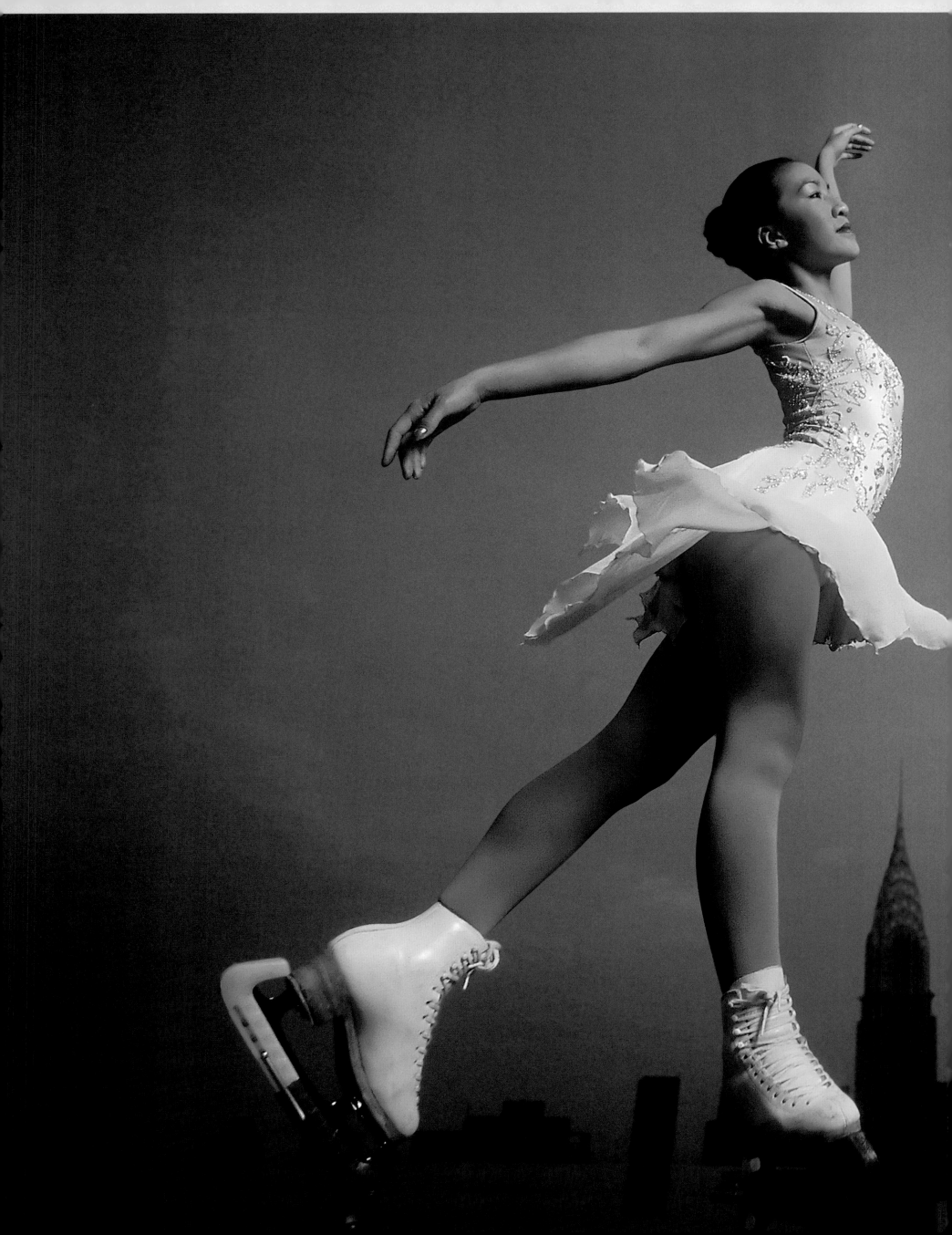

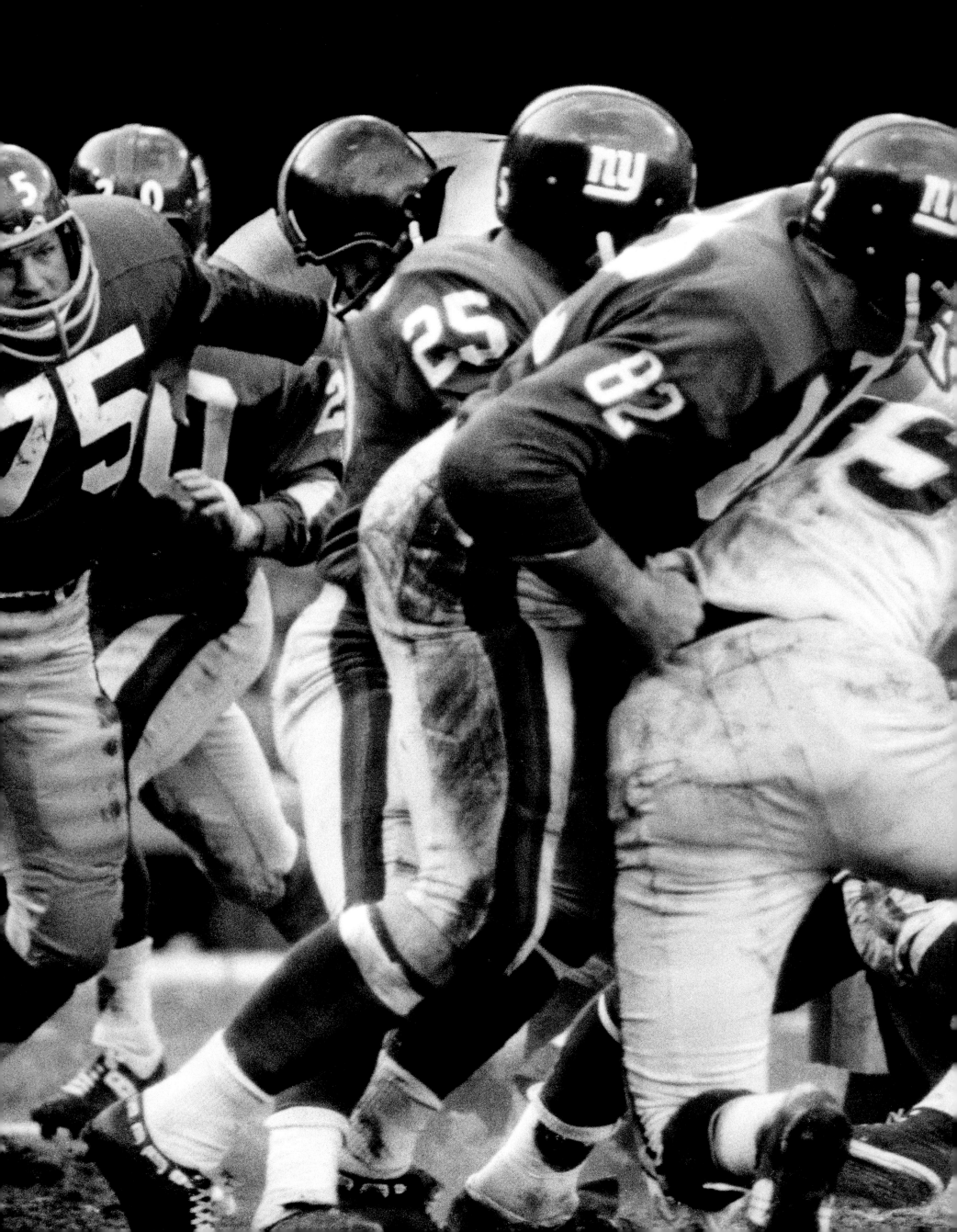

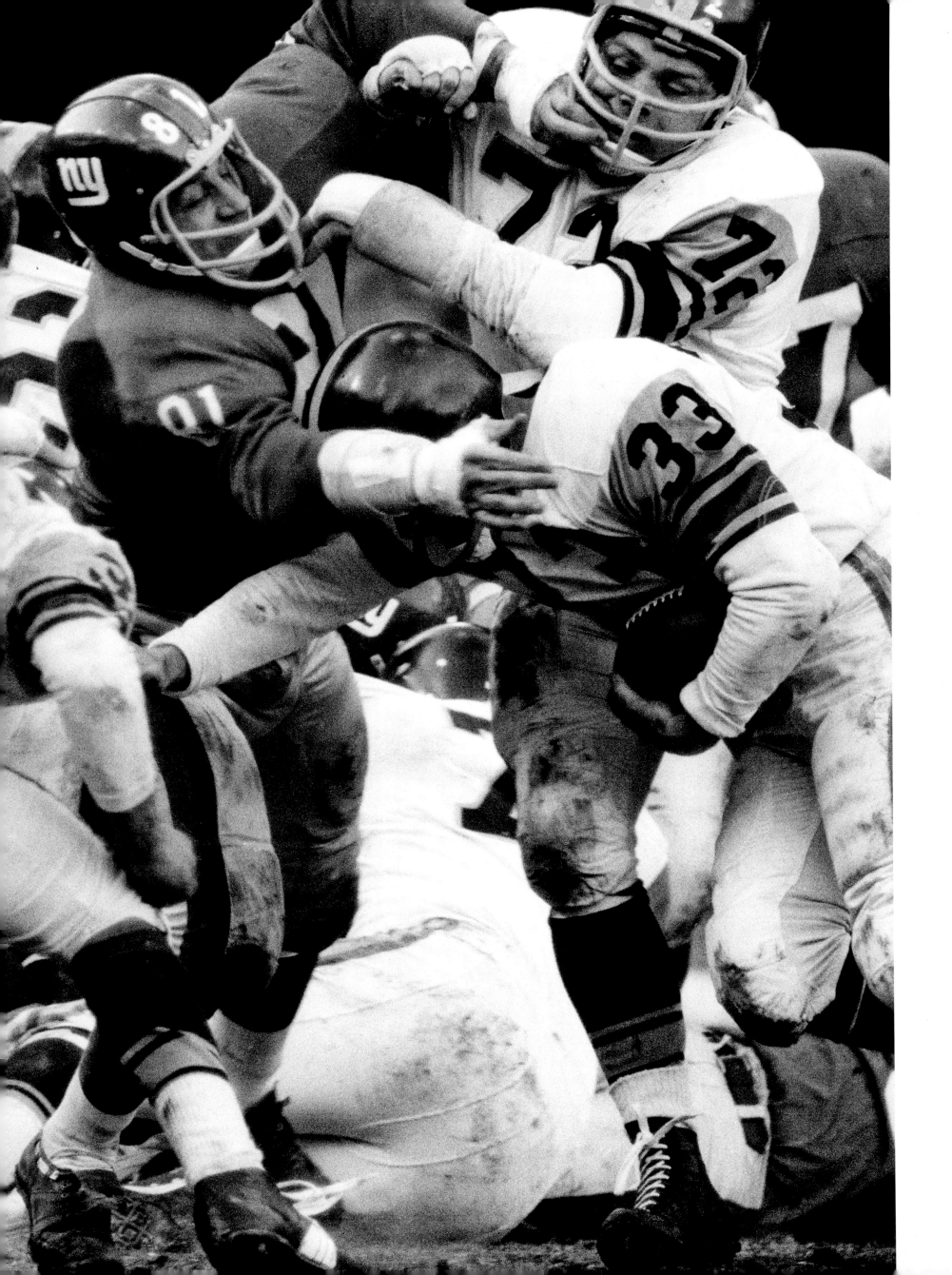

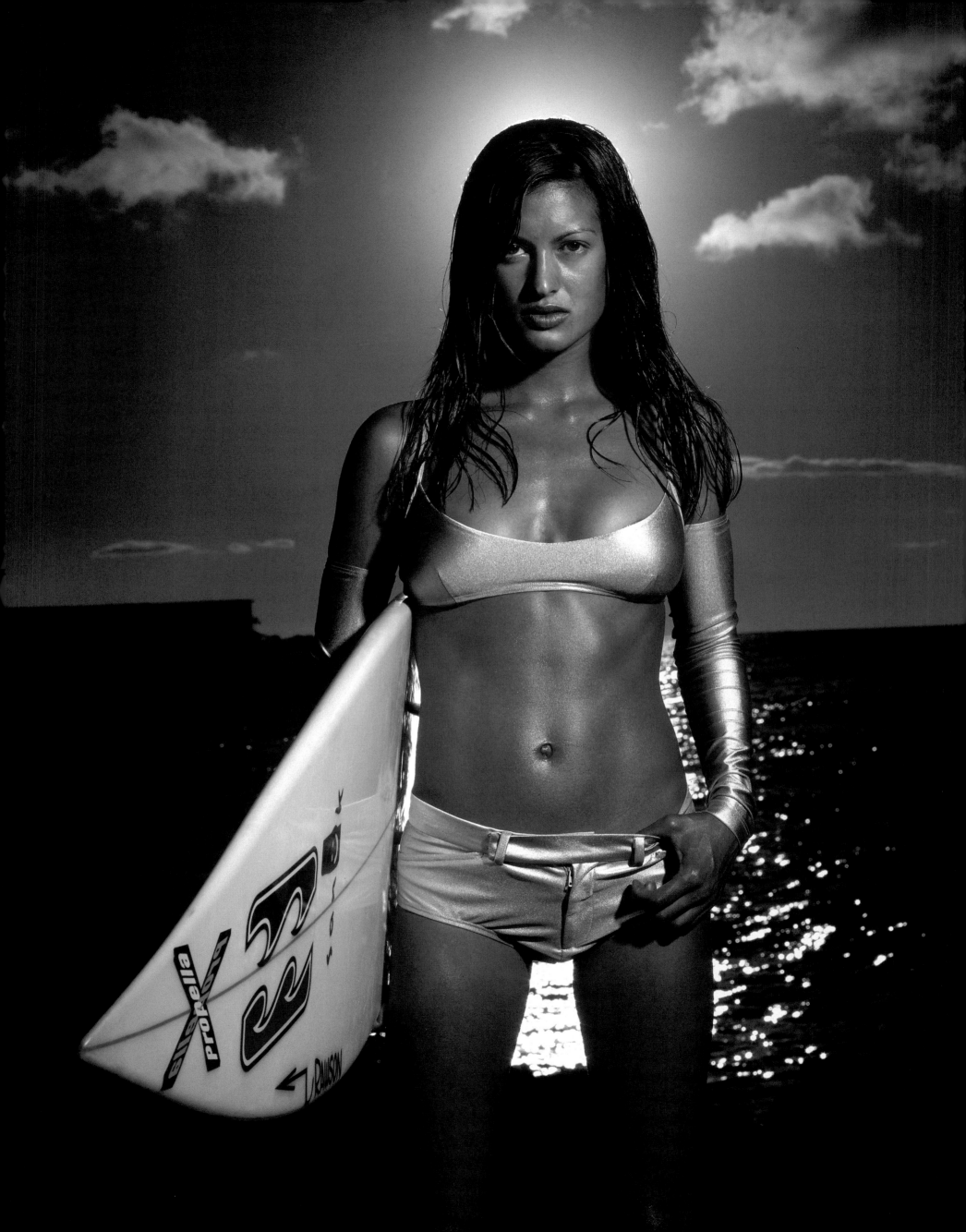

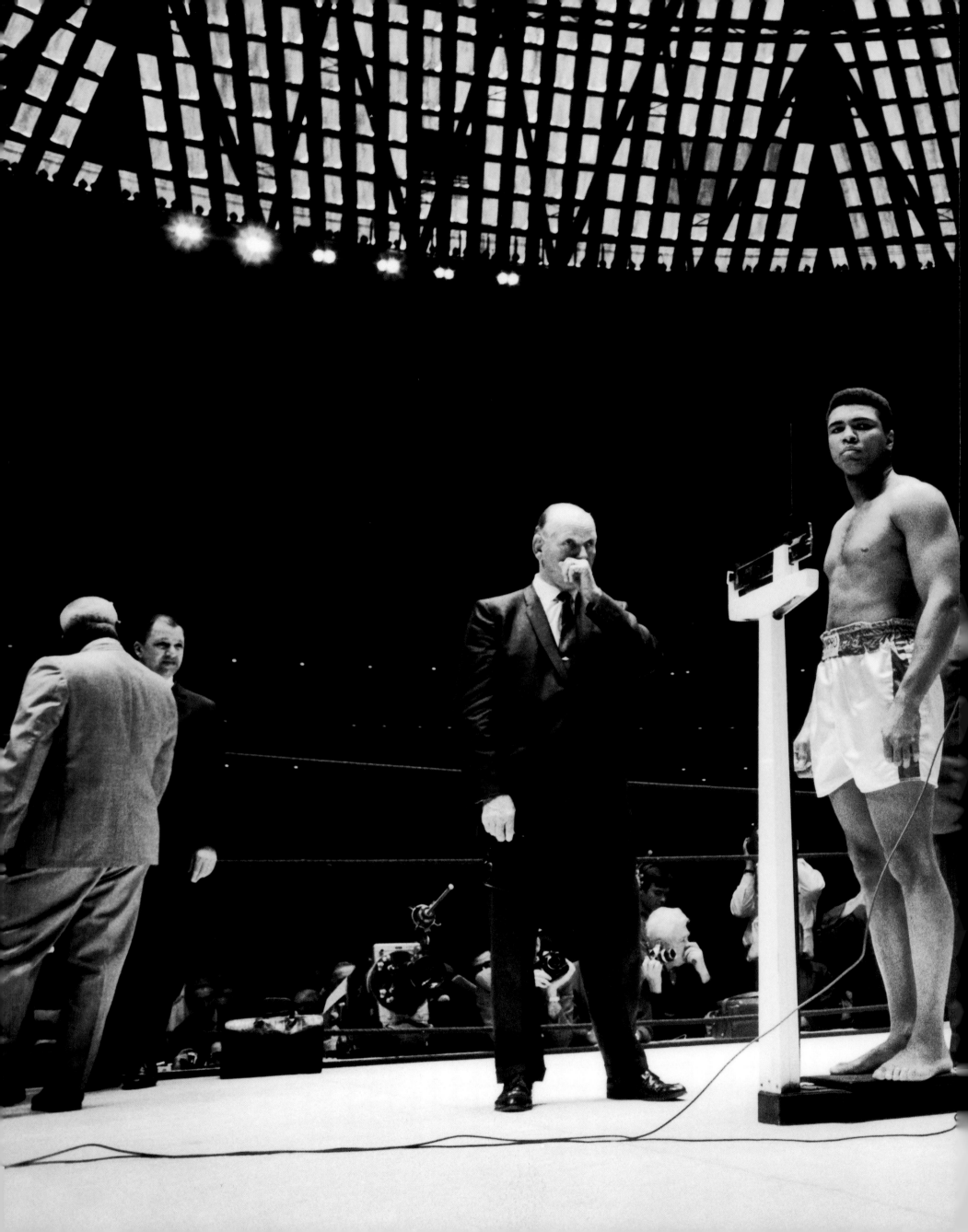

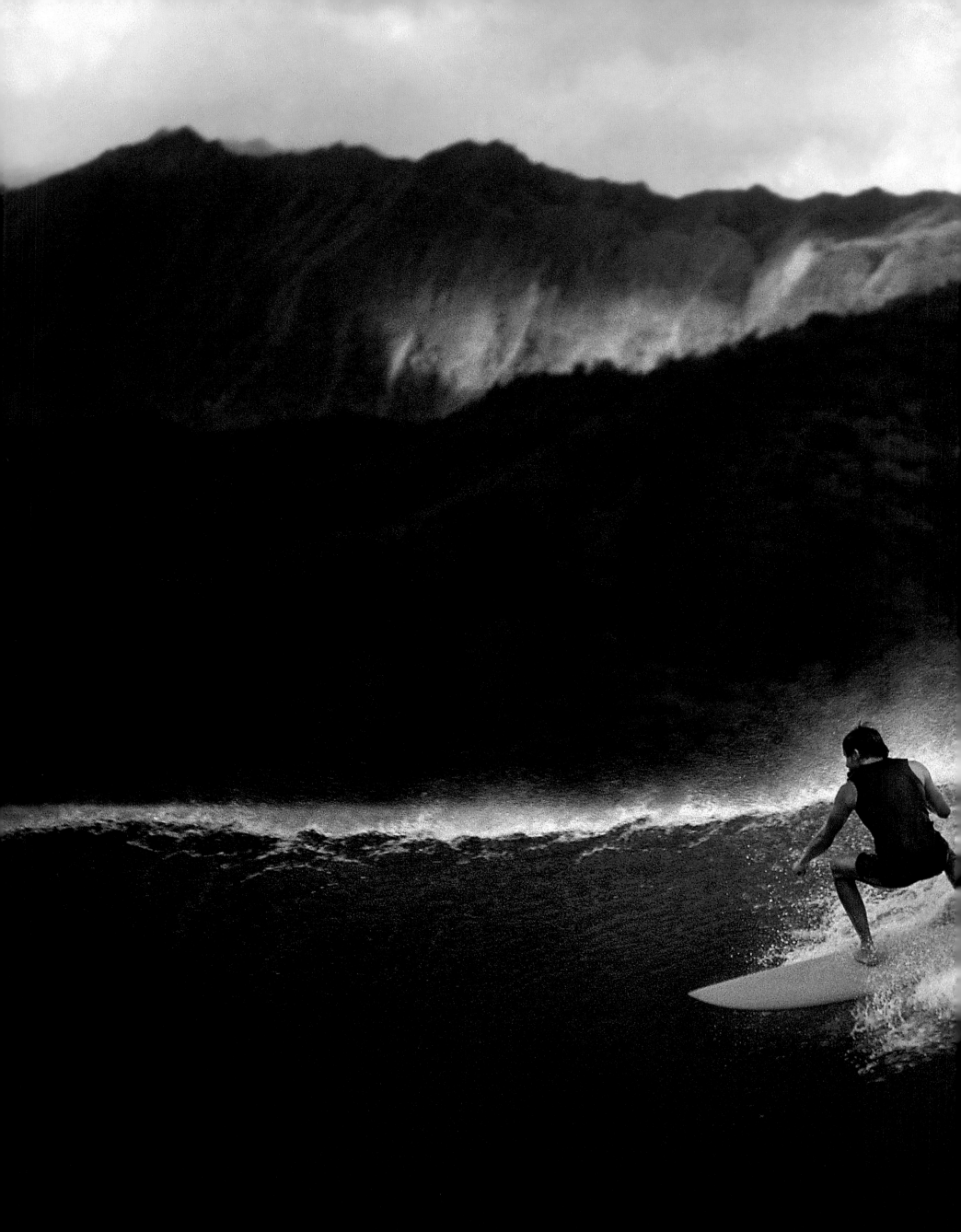

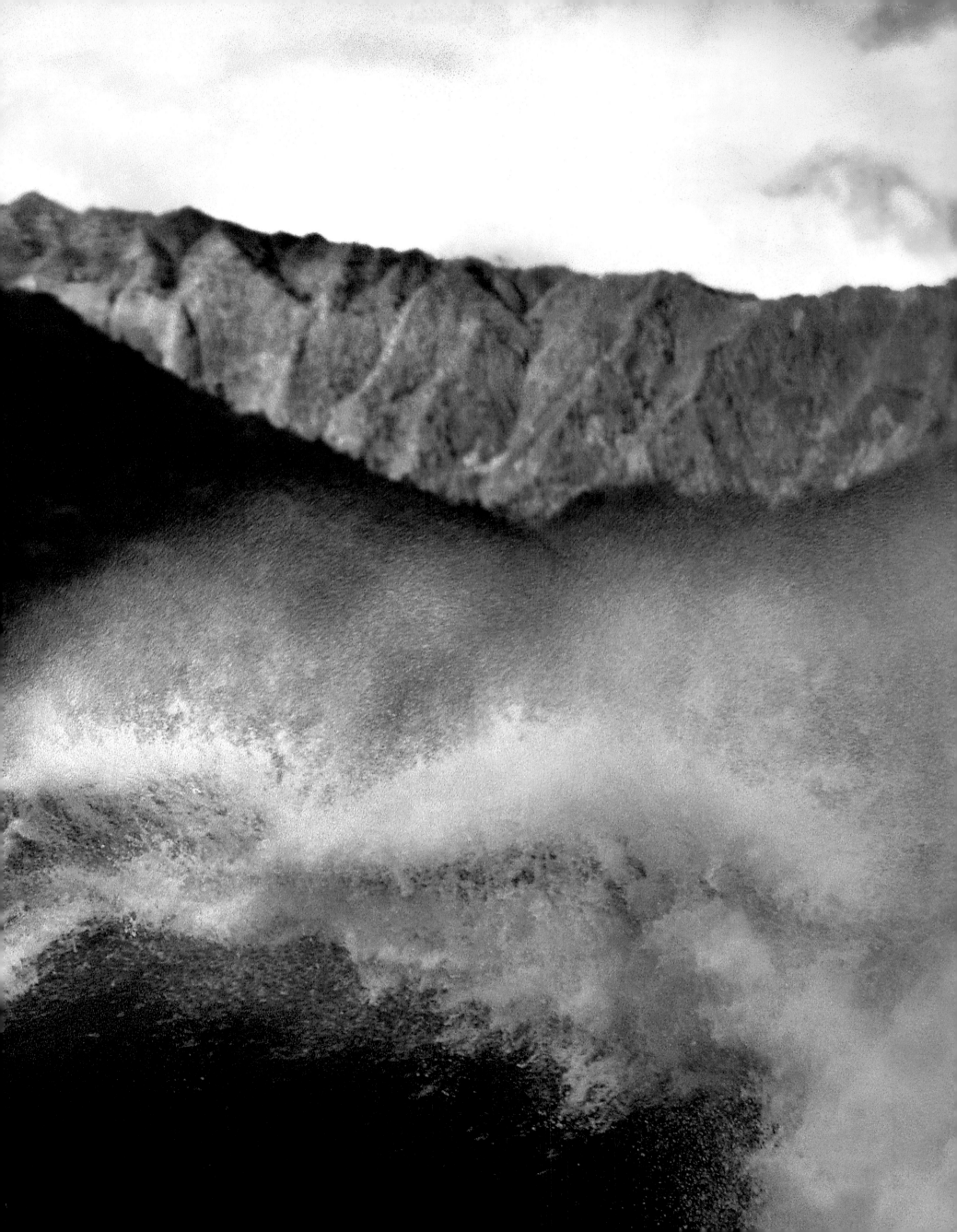

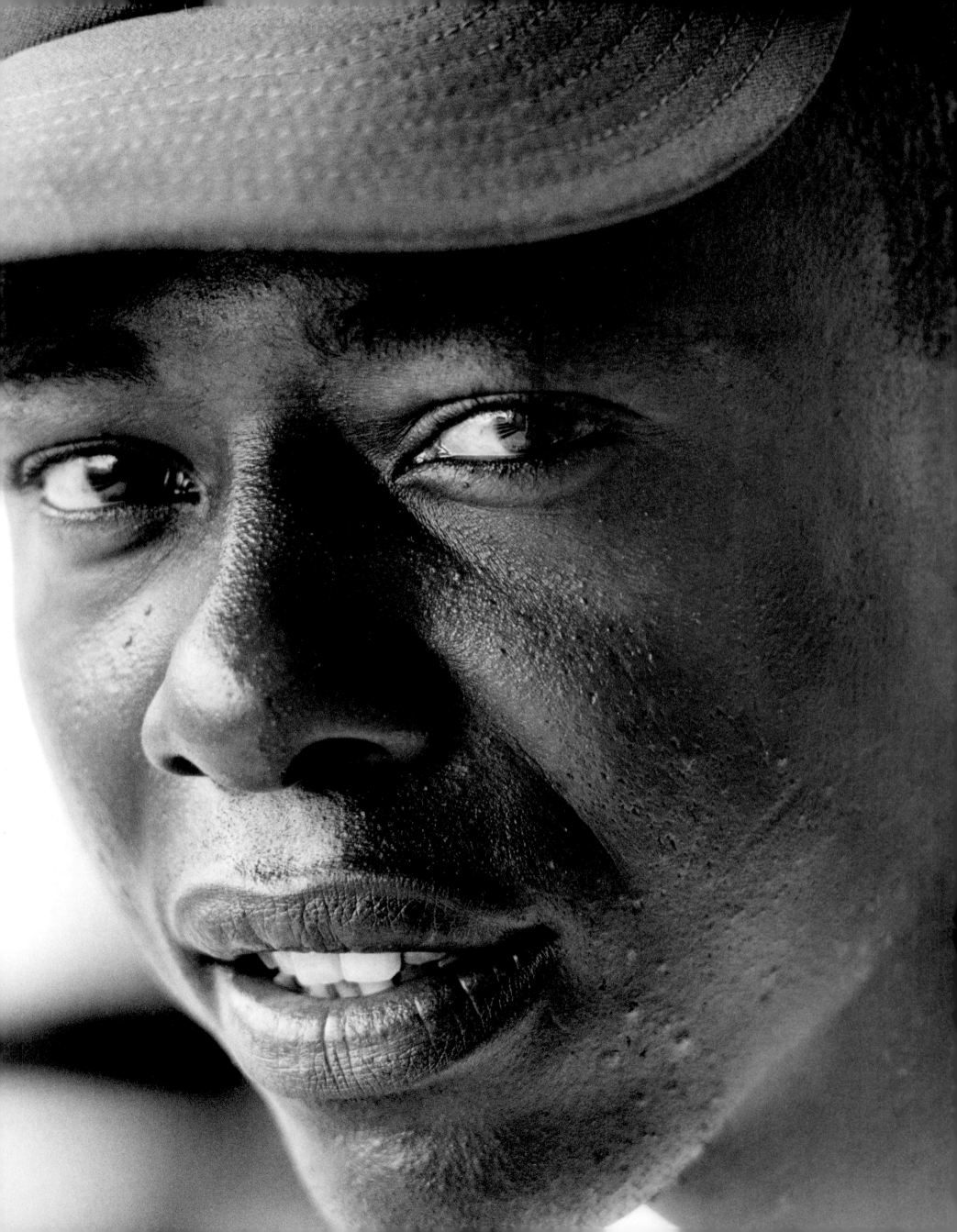

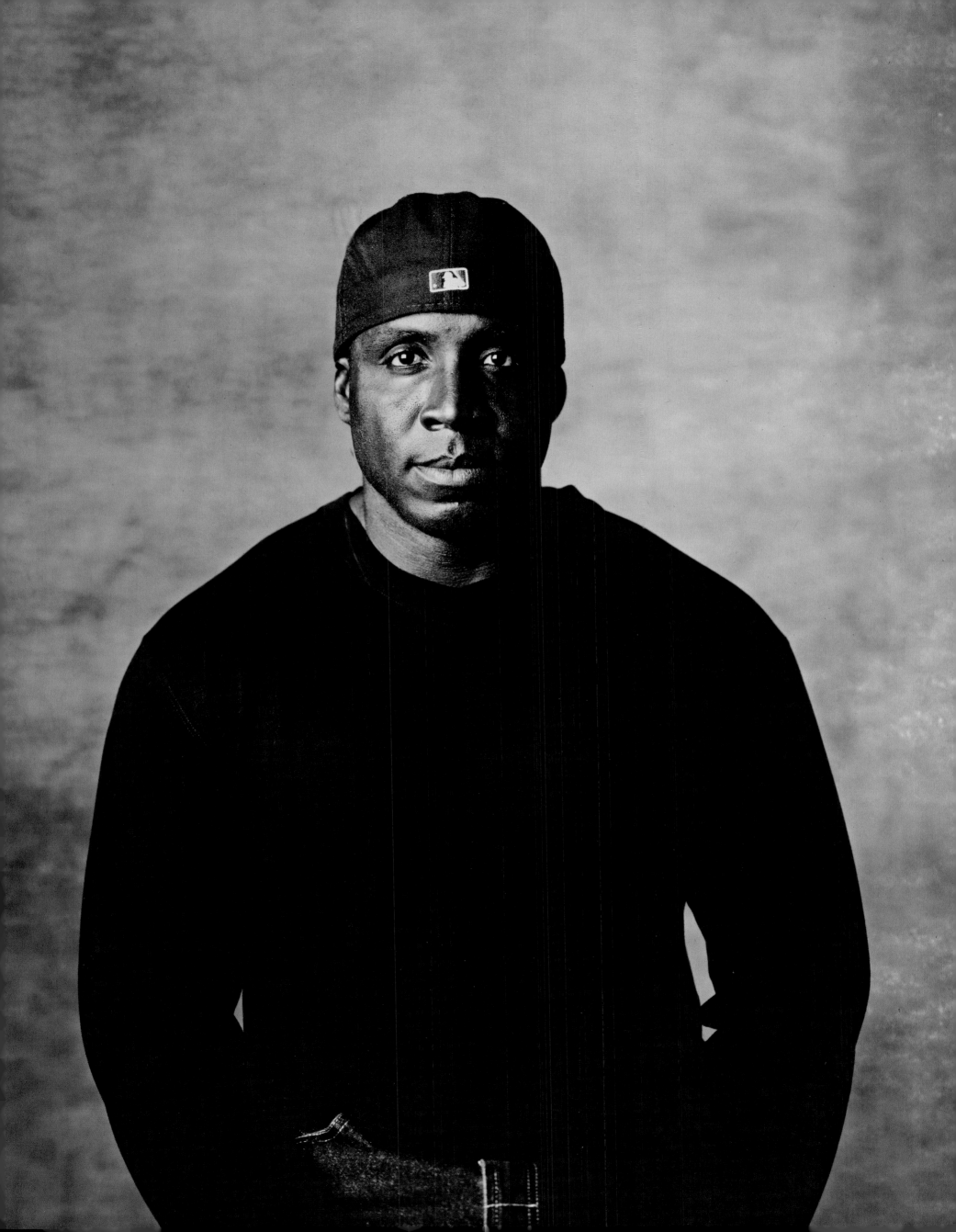

The problem with shooting the NBA slam-dunk contest was that you *never knew how the players were going to dunk,* especially Jordan. In 1997 he had twirled and dunked with his back to me. But by this time I knew him a little better. As he sat in the stands three hours before the contest, I said, "Michael, can you tell me which way you're going to go, so I can move and get your face in the picture?" He looked at me as if *I were crazy* but then said, "Sure. Before I go out to dunk I'll *put my index finger on my knee and point which way I'm going."* I said, "You're going to remember that?" And he said, "Sure." So later, when they announced his name, I looked over to him on the bench and there was his finger pointing left. I got up and moved to the right side of the basket so I could see his face. *He went left every time* he dunked. On his last two dunks he ran the length of the court, took off from the foul line and slammed the ball through. On the next-to-the-last one *he landed in my lap.* On the last one I set up in the same spot. He looked at me as if to say, "Go left a little, give me some room this time." And that was it, the picture was made: *1000th of a second frozen in time.*

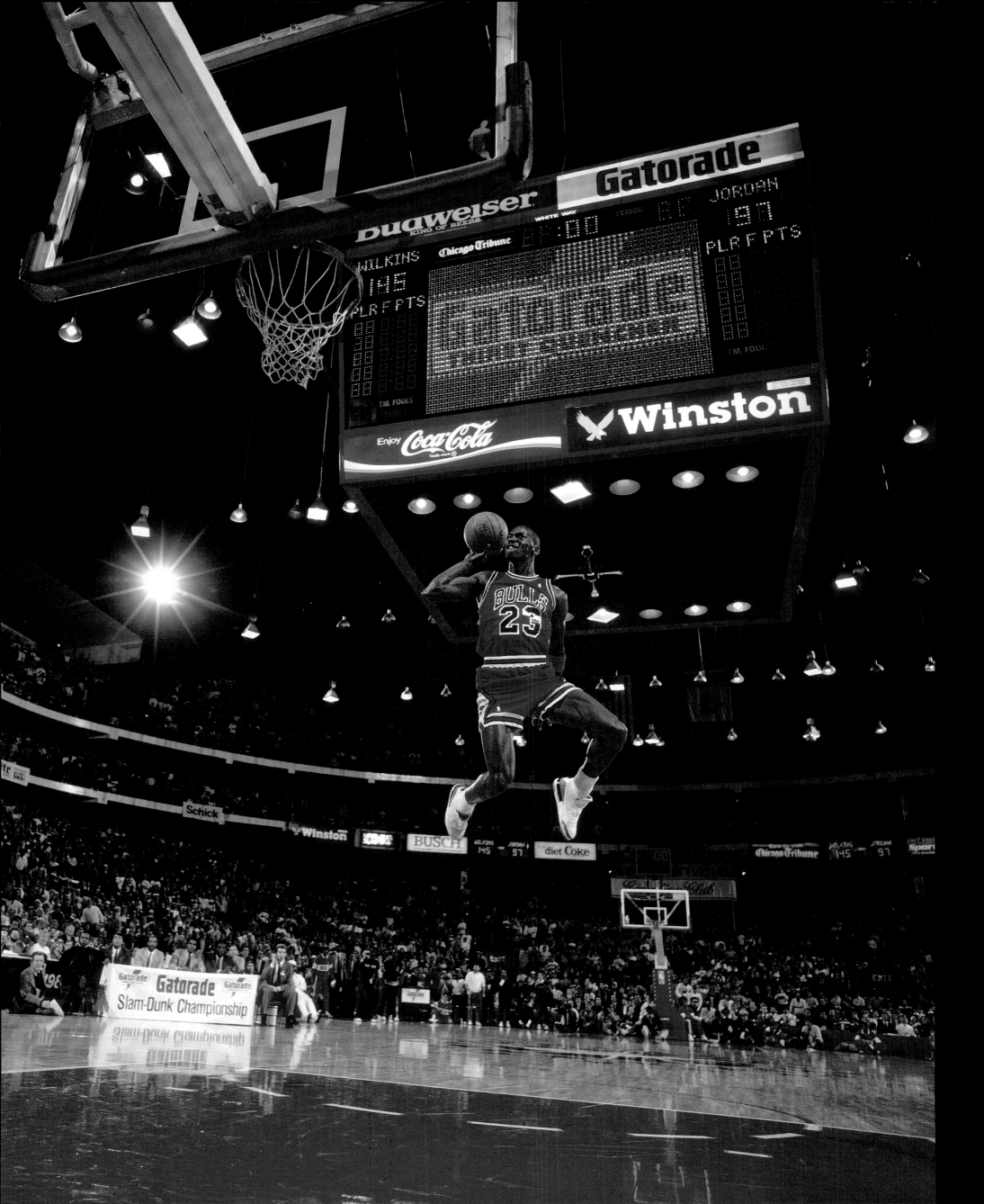

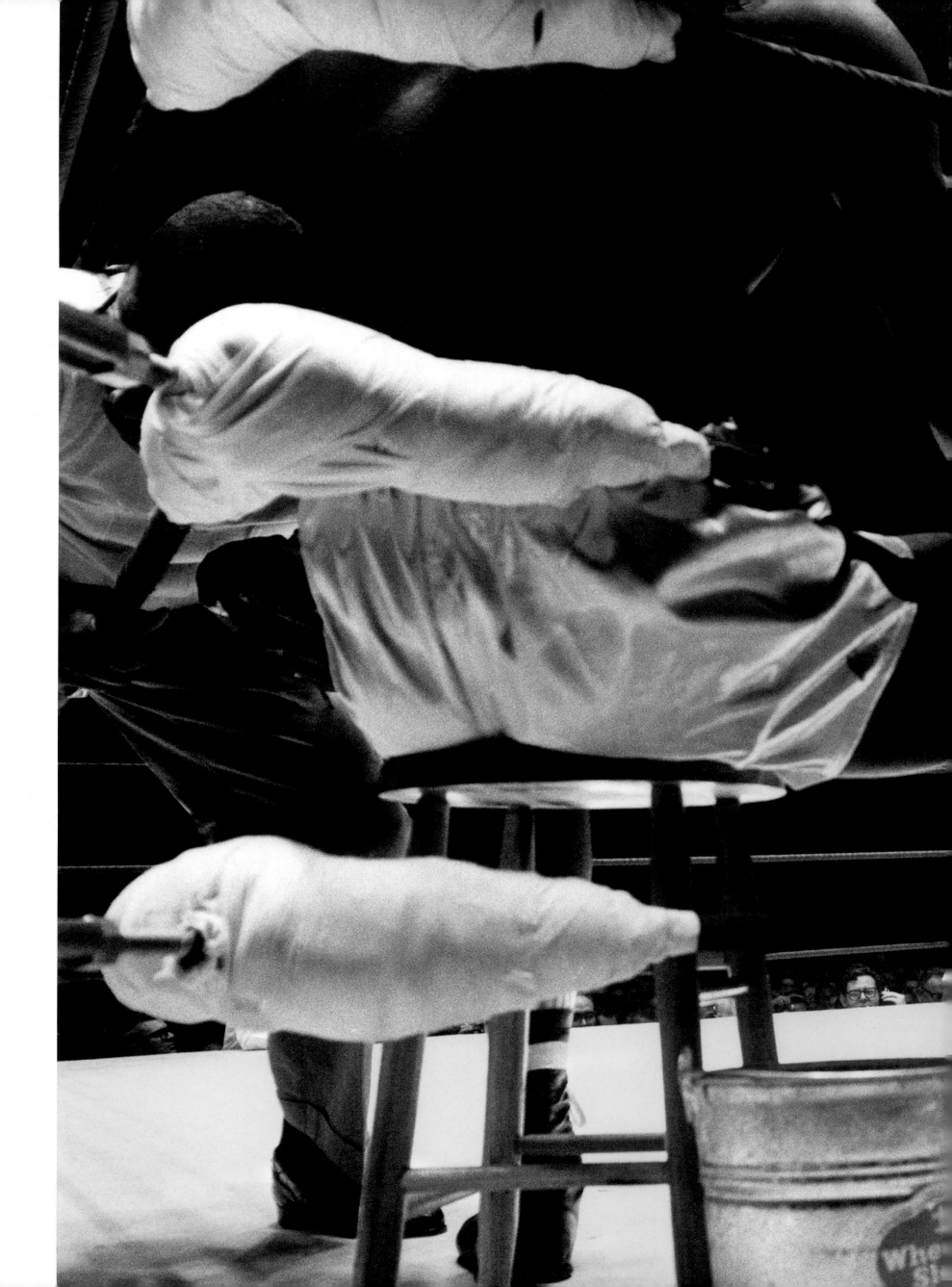

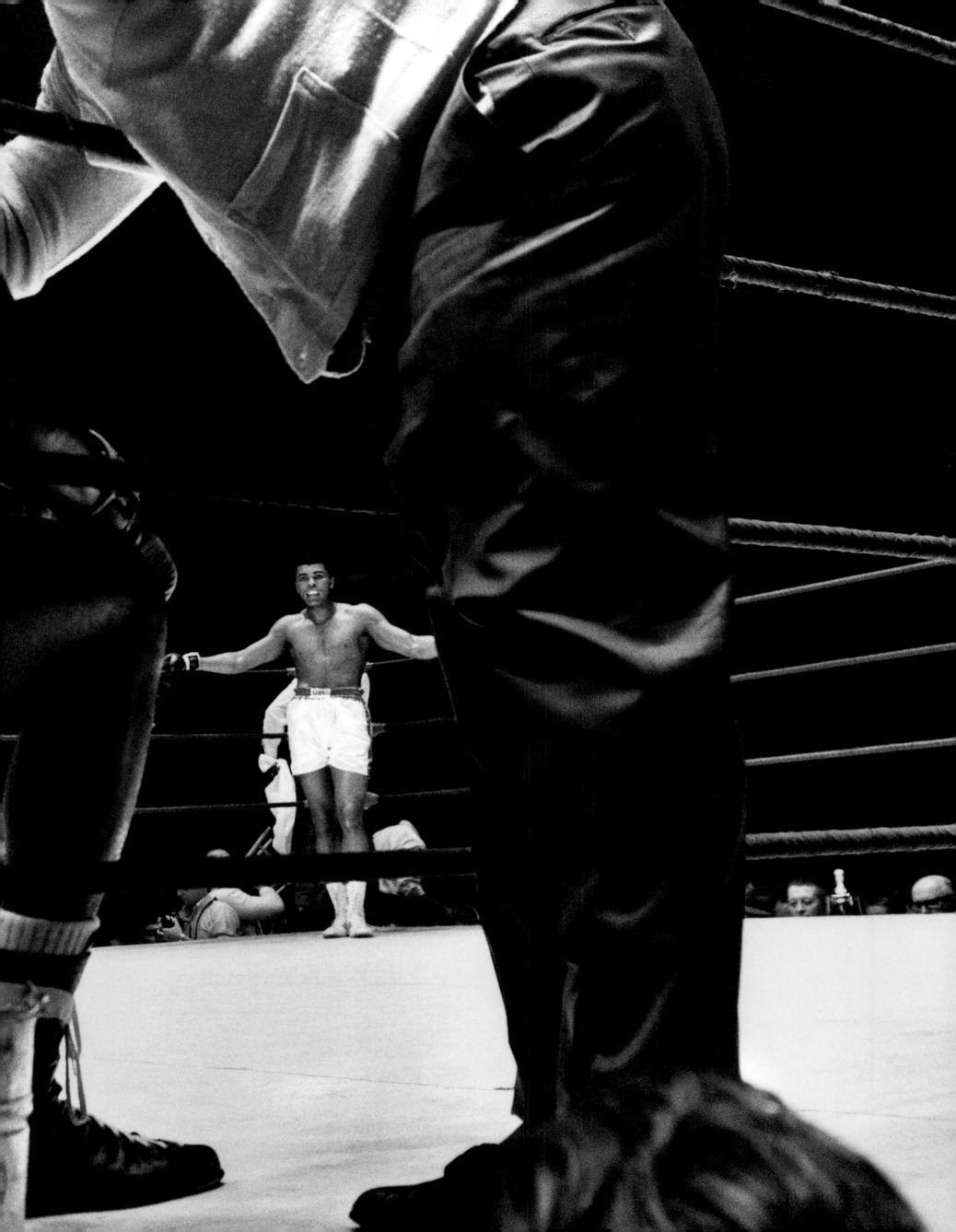

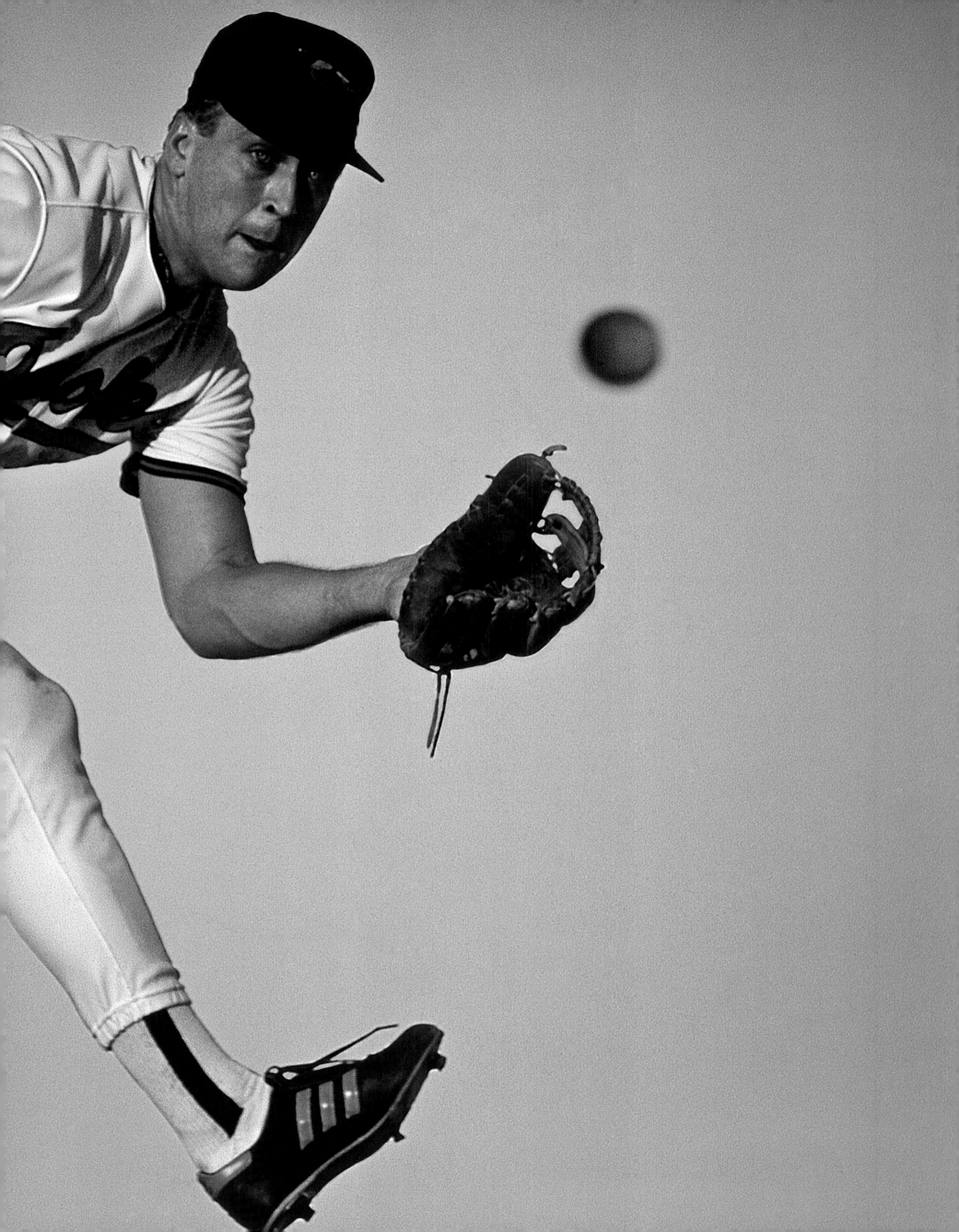

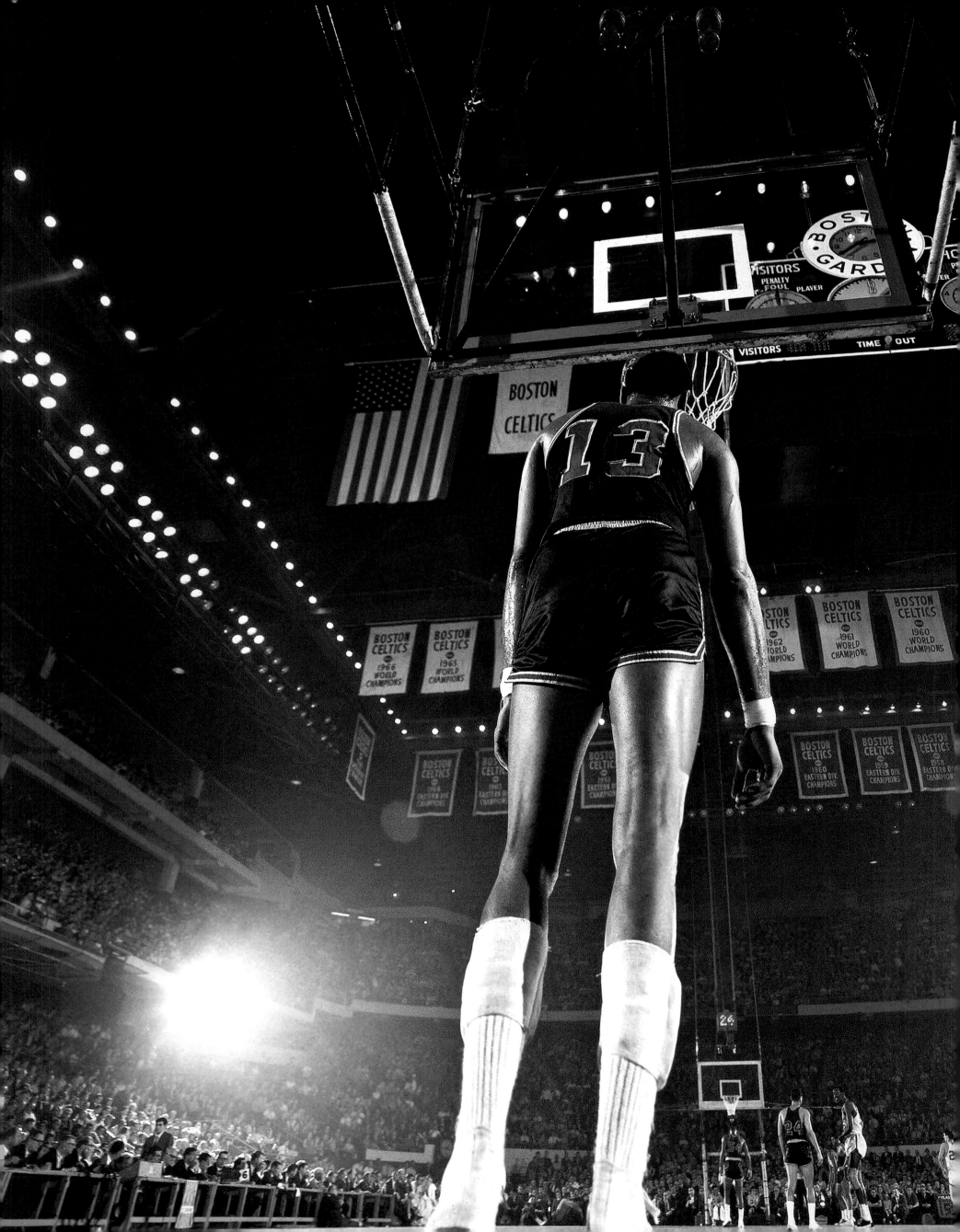

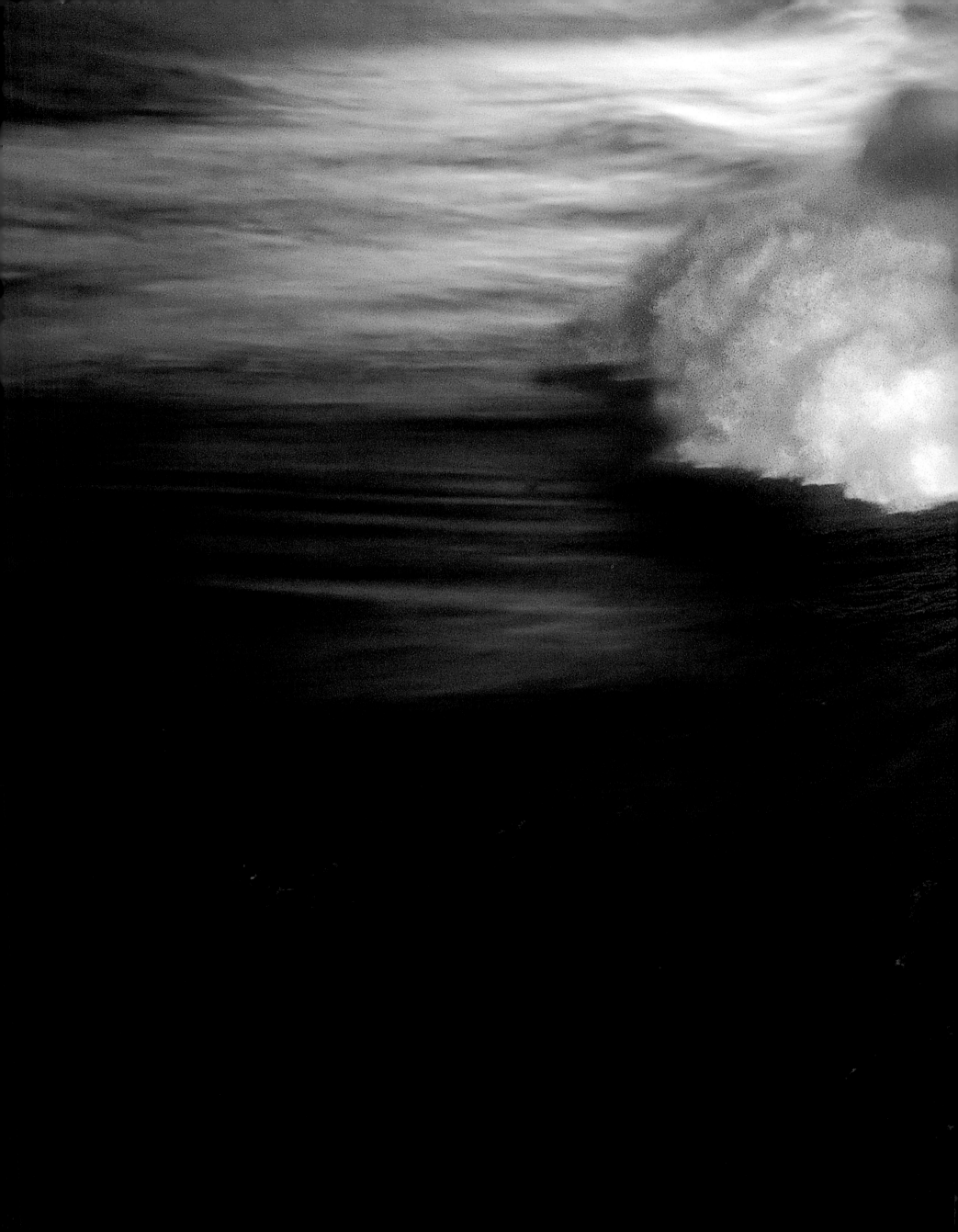

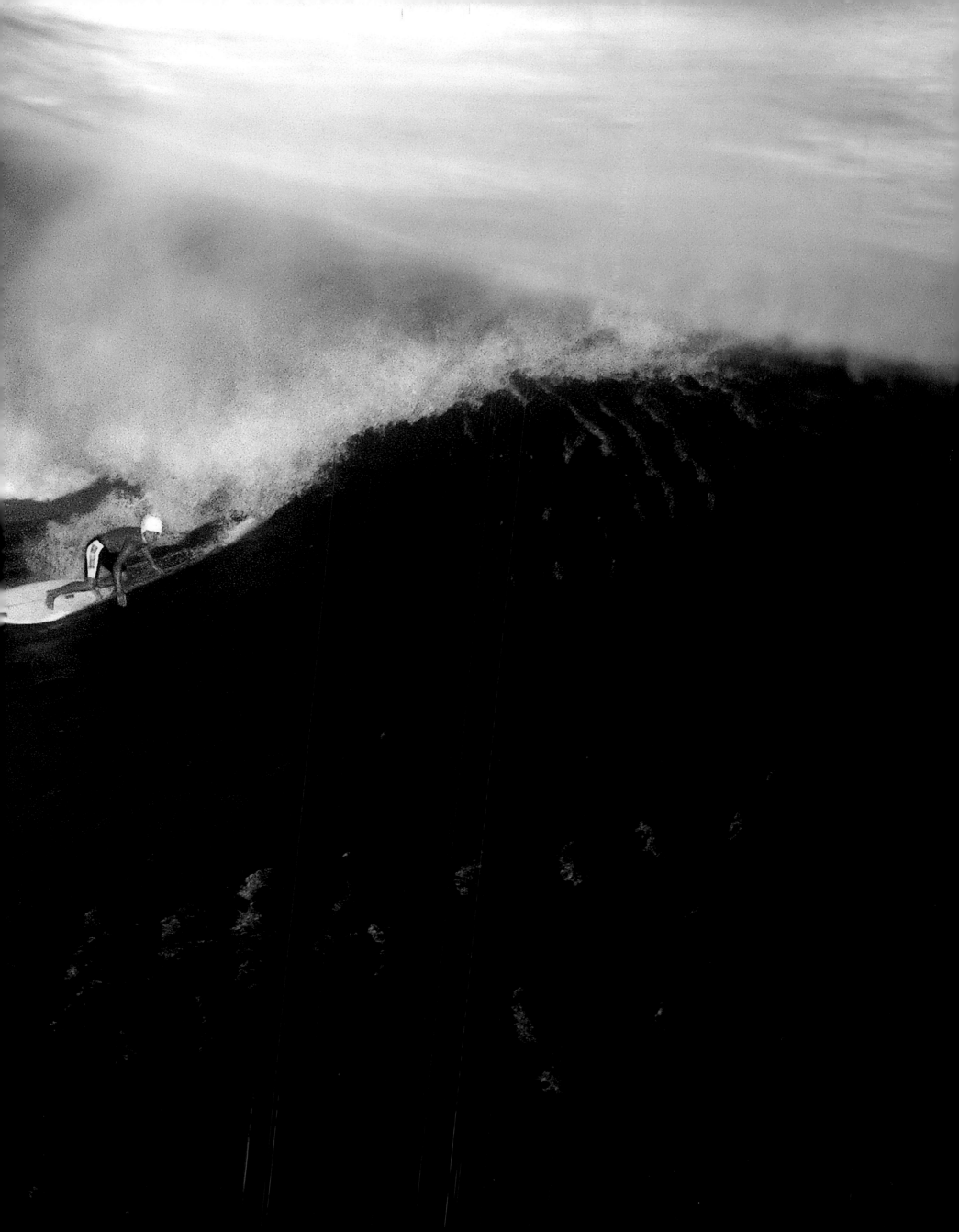

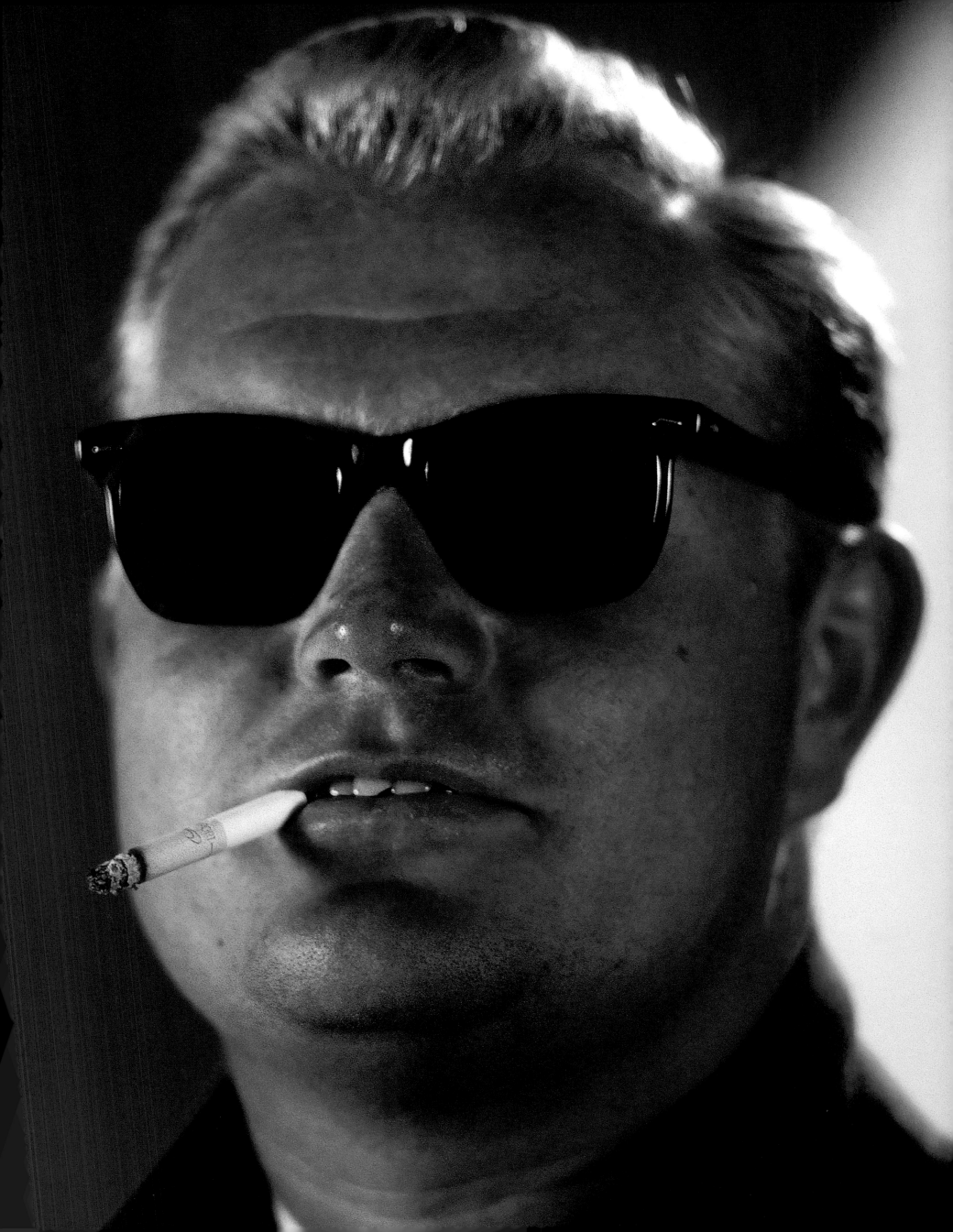

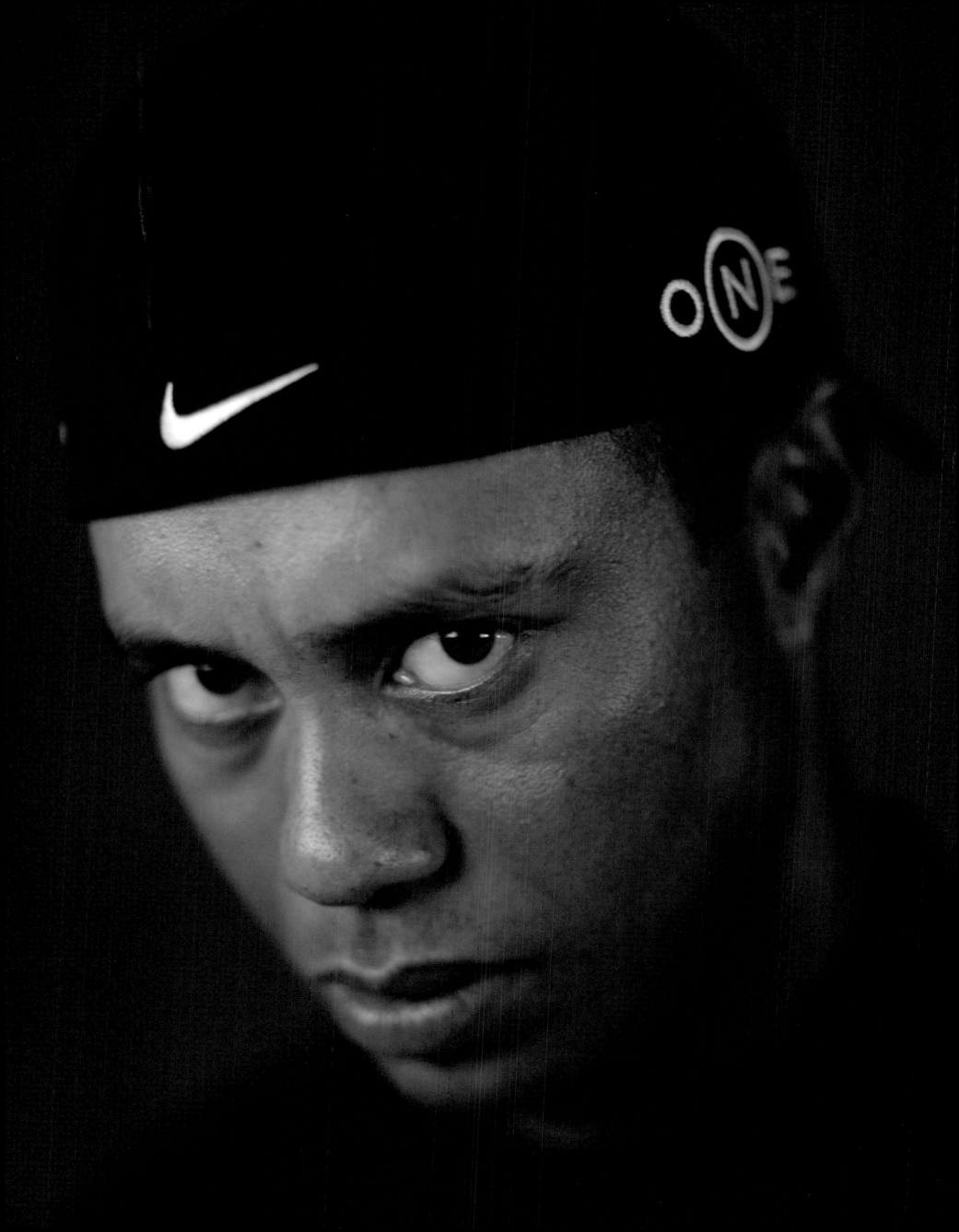

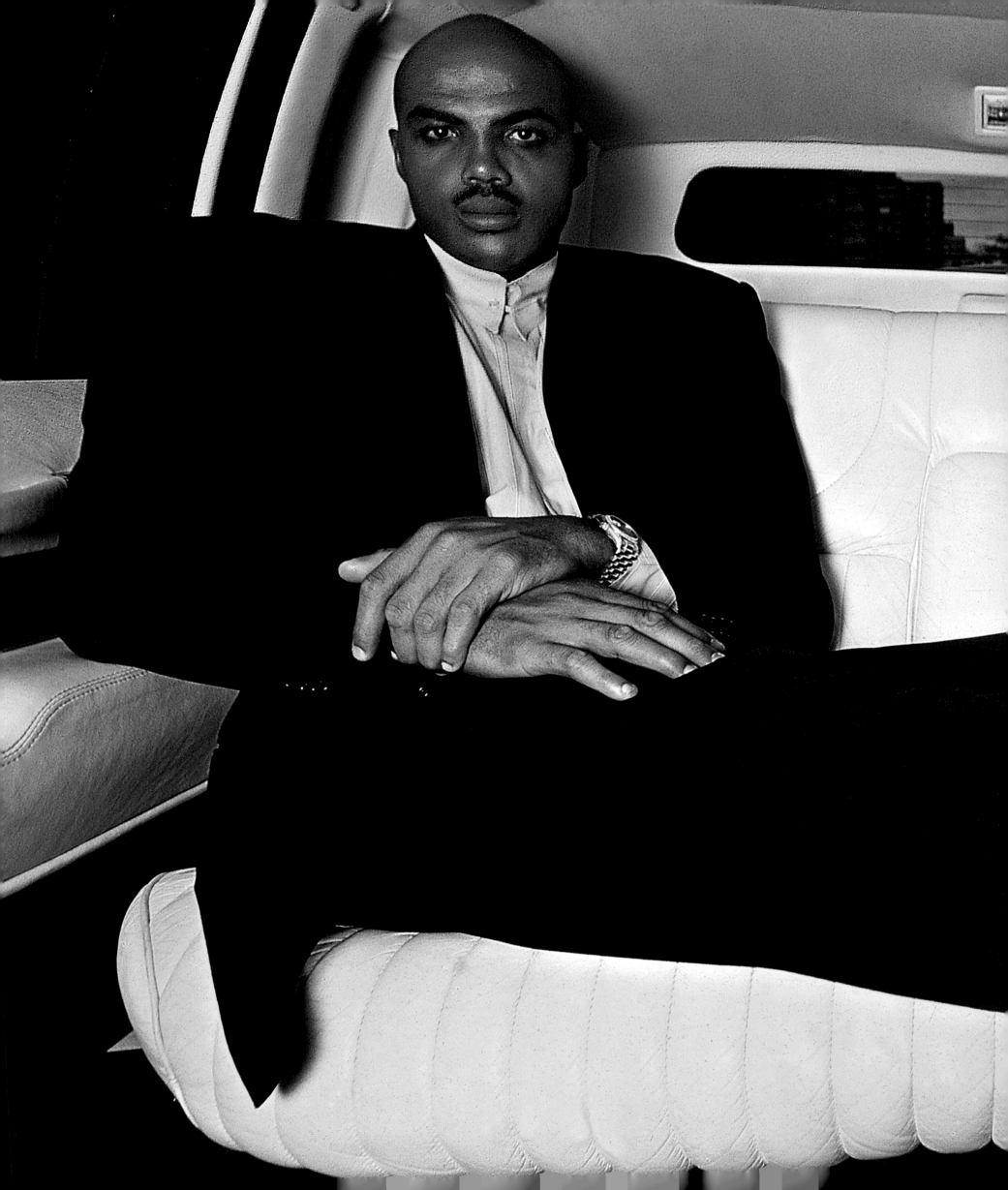

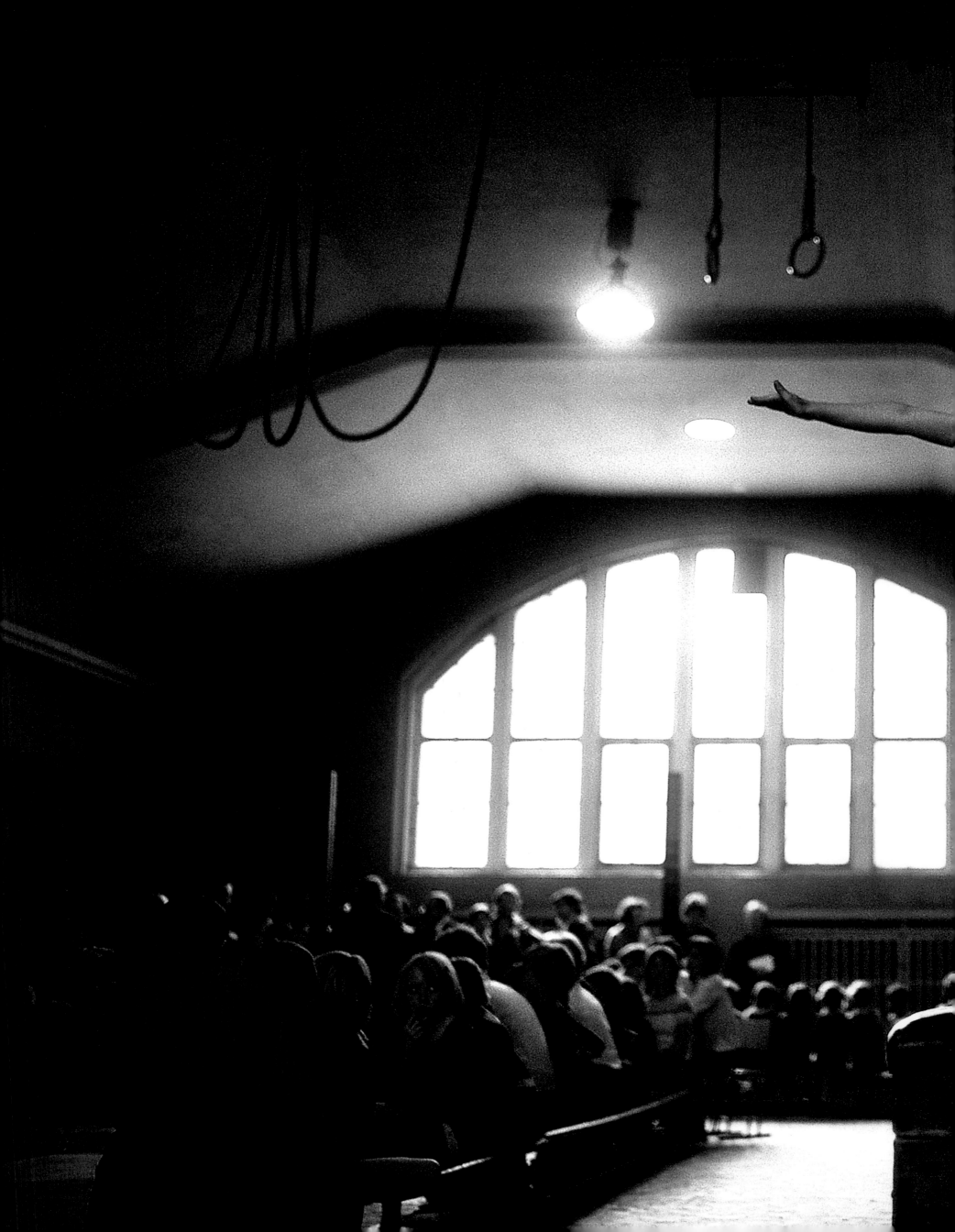

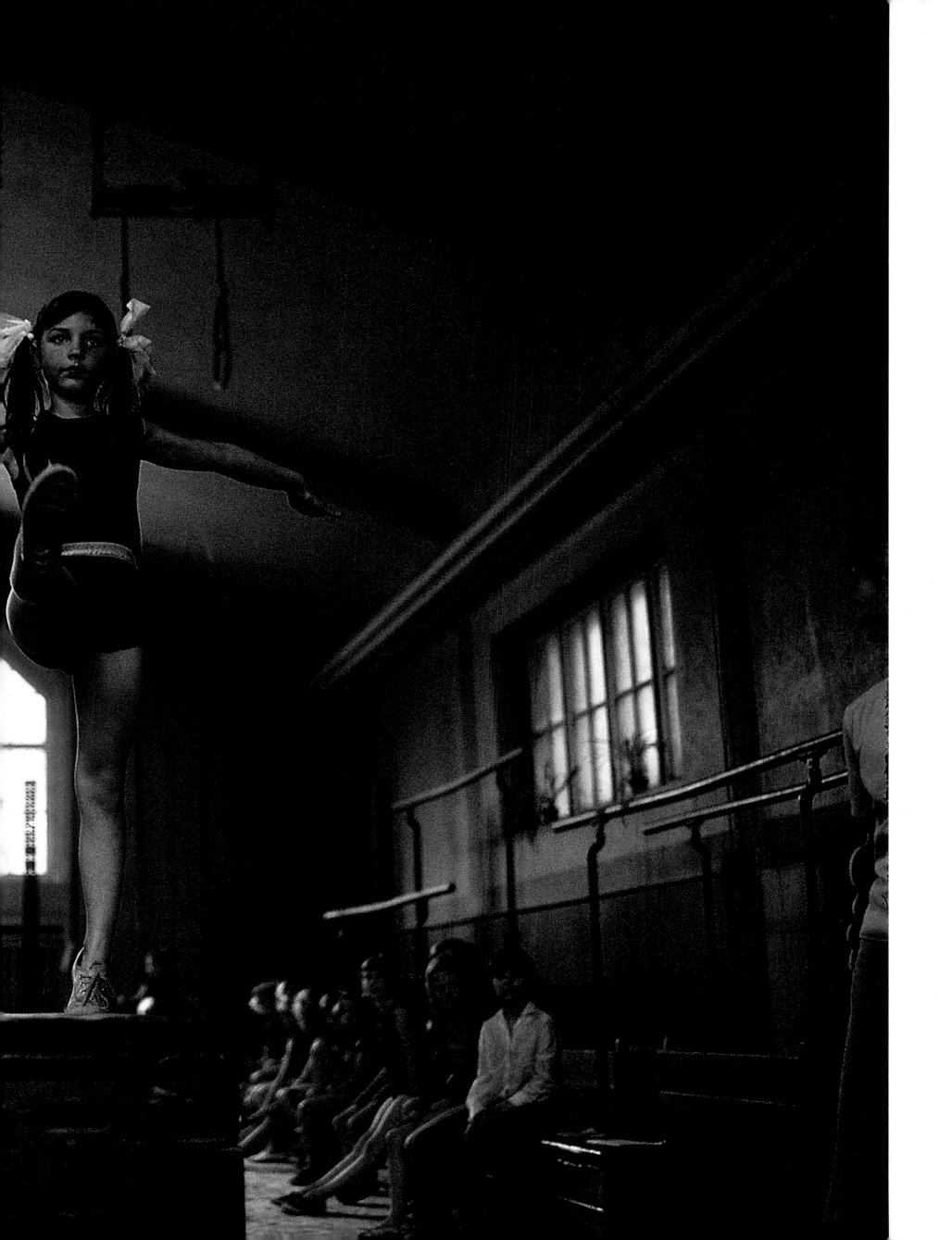

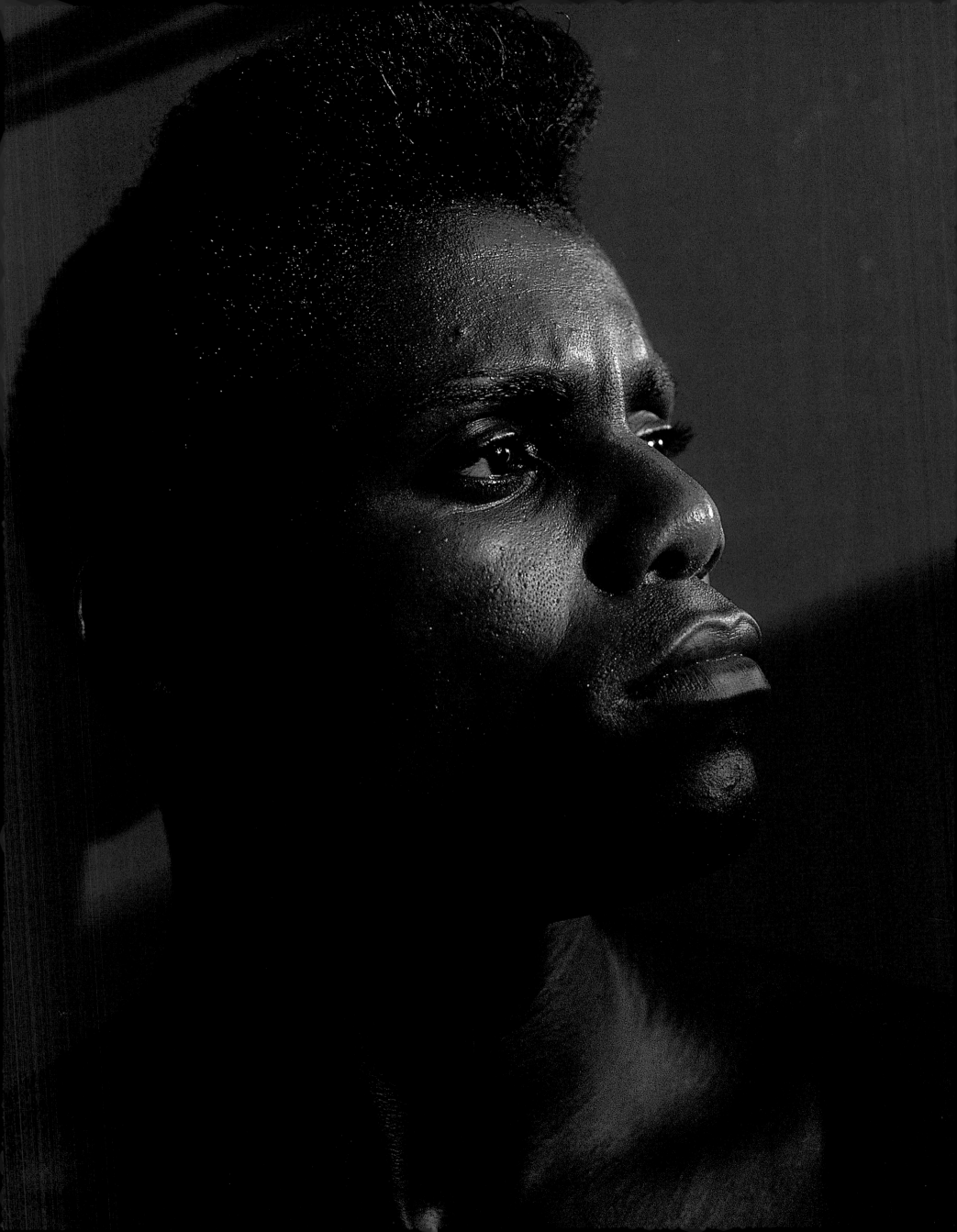

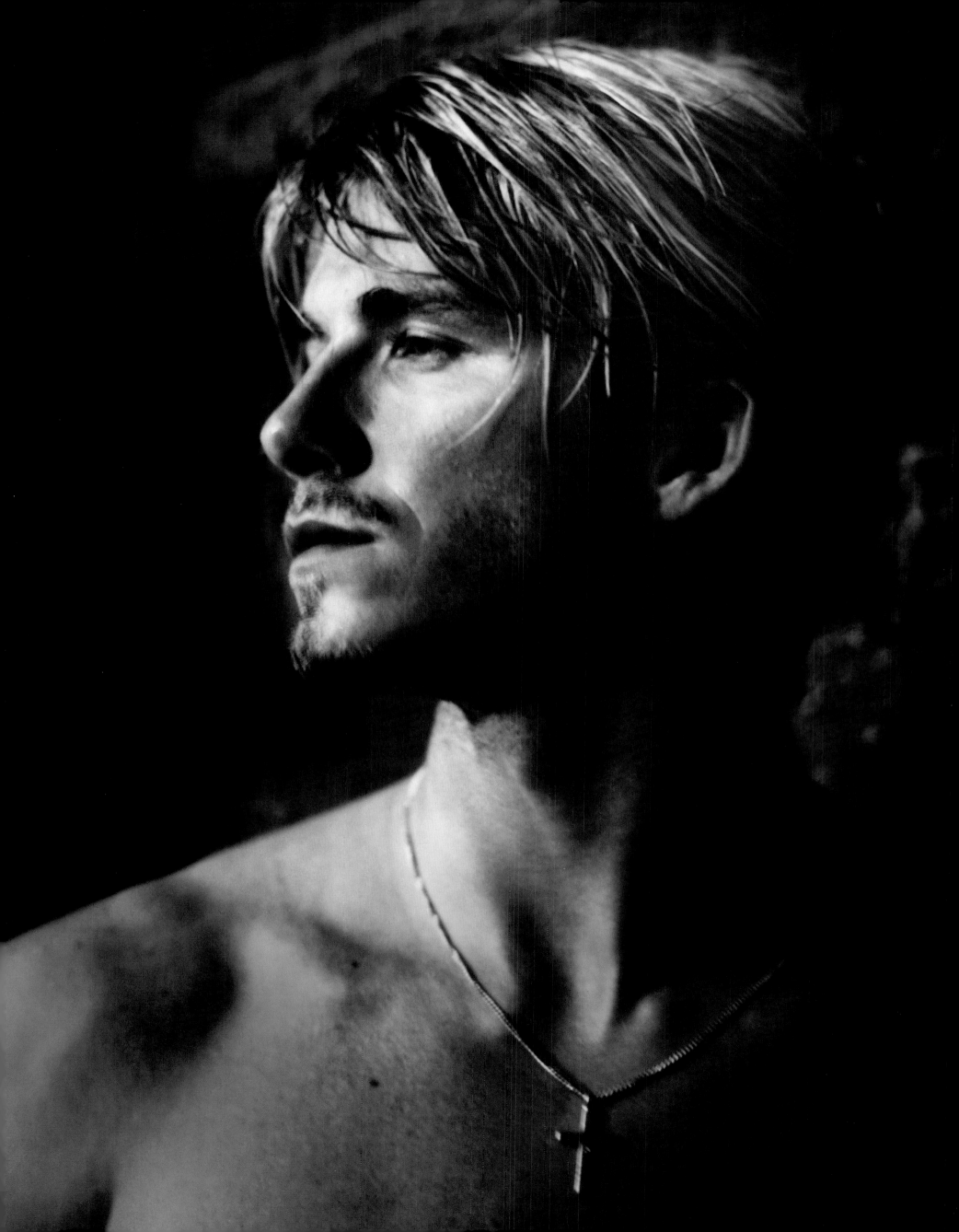

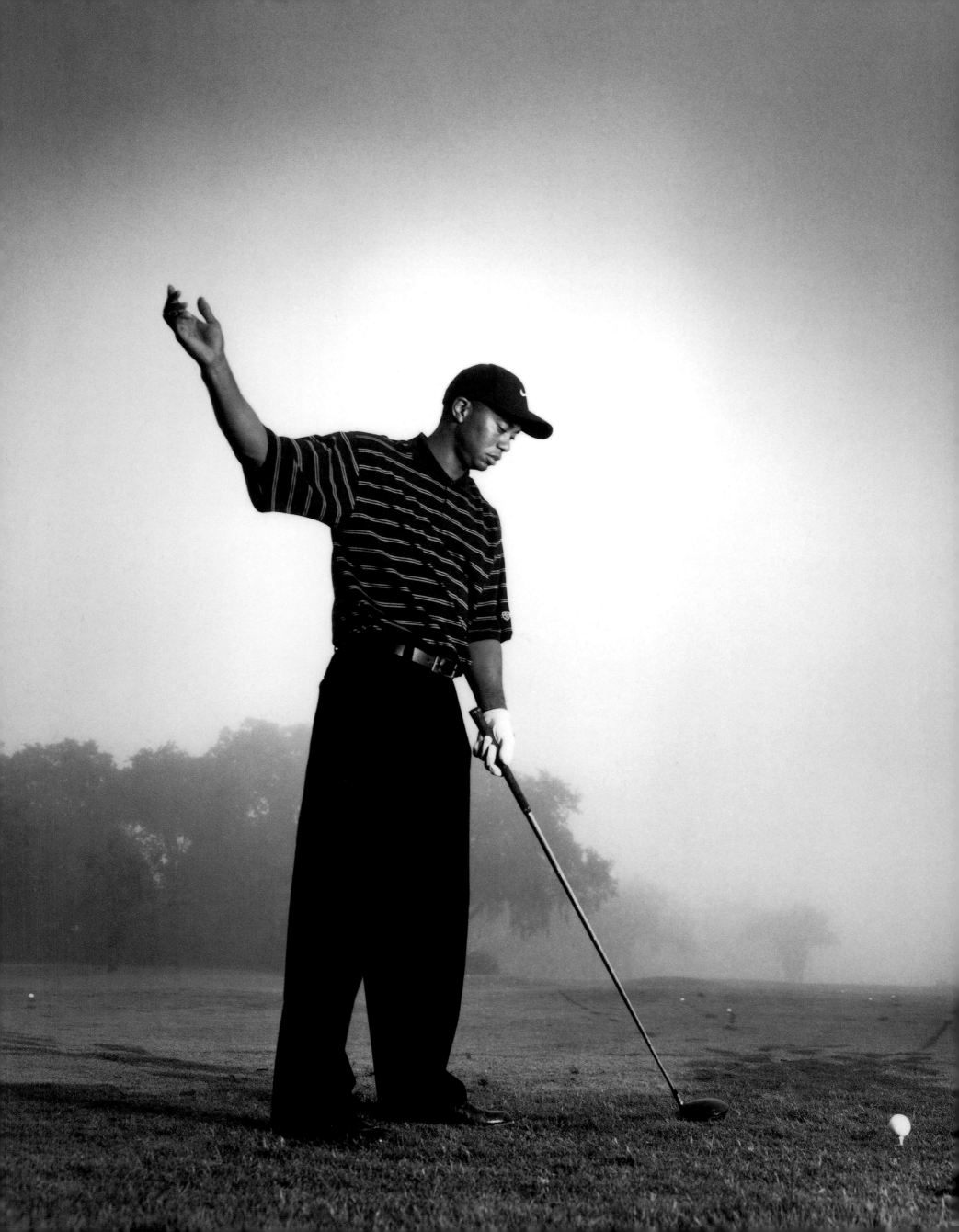

The first time *I followed Tiger, it was 2000* and I wanted to re-create a picture Hy Peskin once took of Ben Hogan swinging, with a view down the fairway. I wanted to do it with an old-fashioned *4x5 Crown Graphic camera,* which meant I had to get close. And getting close to Tiger is a problem. You have to deal with the PGA marshals, you have to deal with Tiger and, especially, you have to *deal with his caddy, Steve Williams.* I had to be between six and 15 feet from Tiger all the time. I was really on the *edge of the rules.* At one point Williams came over to me and said, "Excuse me, mate, have you ever *covered a golf tournament before?"* I'd covered about *15 majors,* but I just said, "Yes sir," and he walked away. From that point on he and Tiger kept looking at me because I was still too close. I had my sunglasses on because I didn't want them to see my eyes.

About *six months later I shot Tiger* for the cover of SPORTS ILLUSTRATED and finally met him. I mentioned how I'd covered him that day and said, "Did you notice me?" He looked at me and said, *"Every hole."*

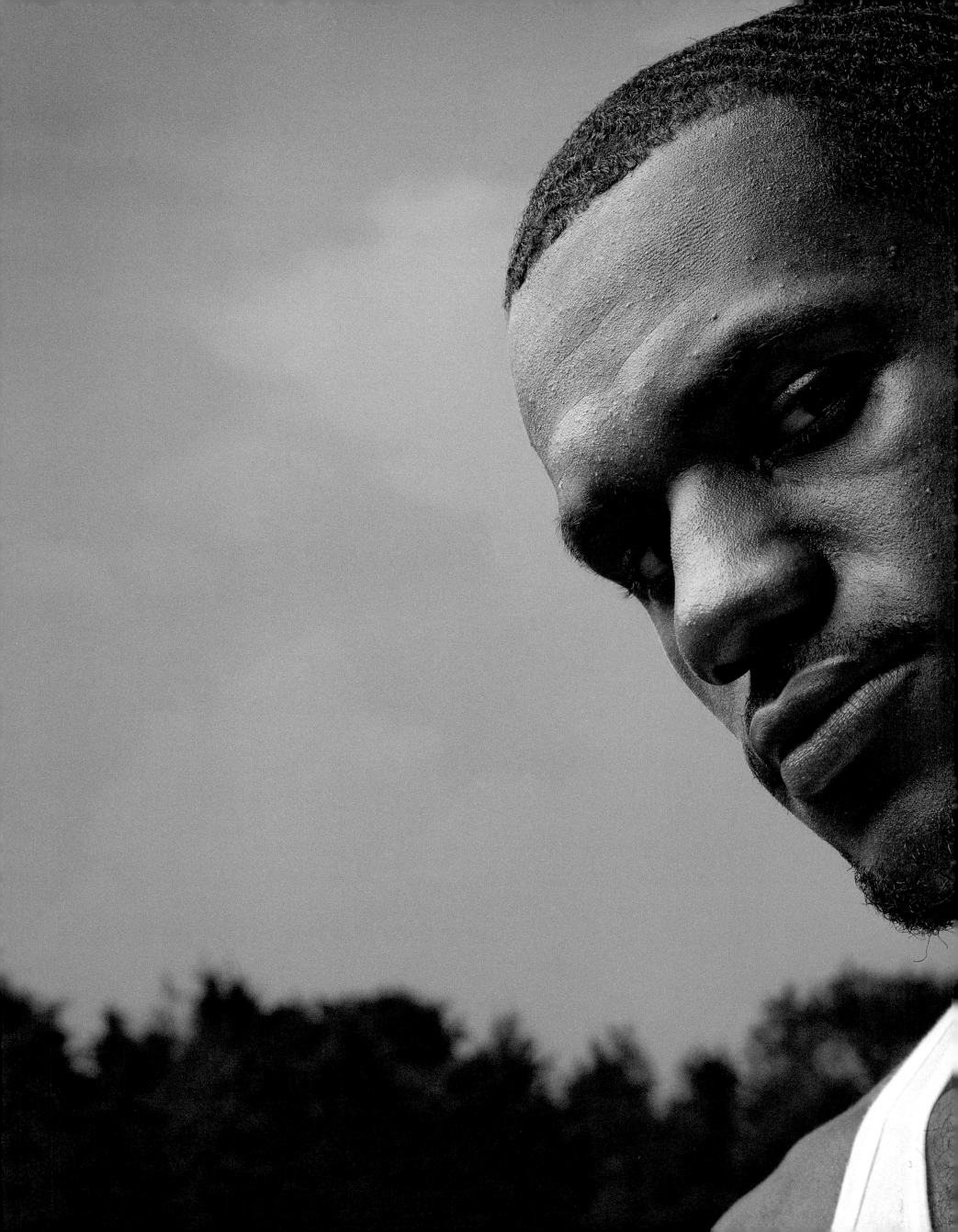

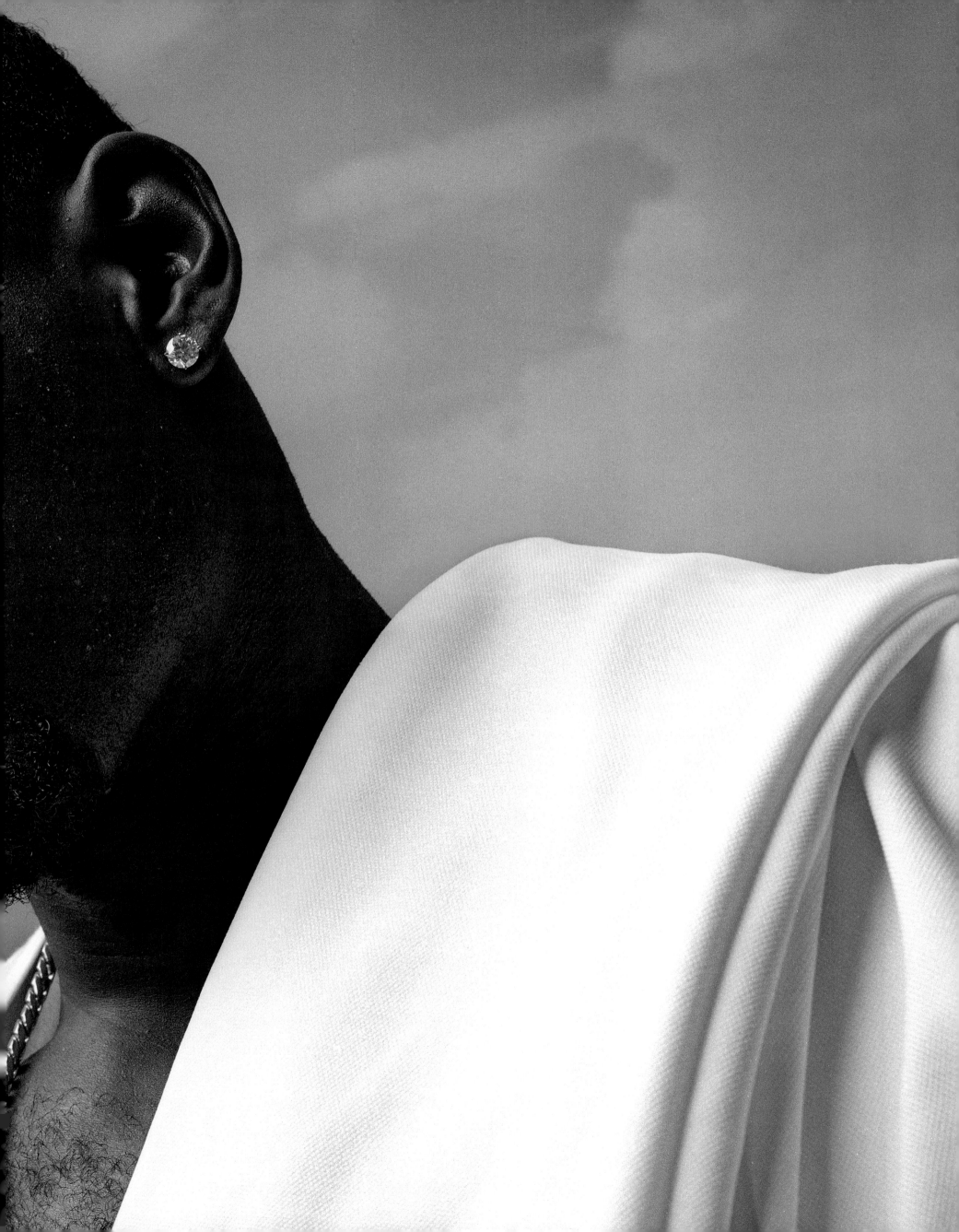

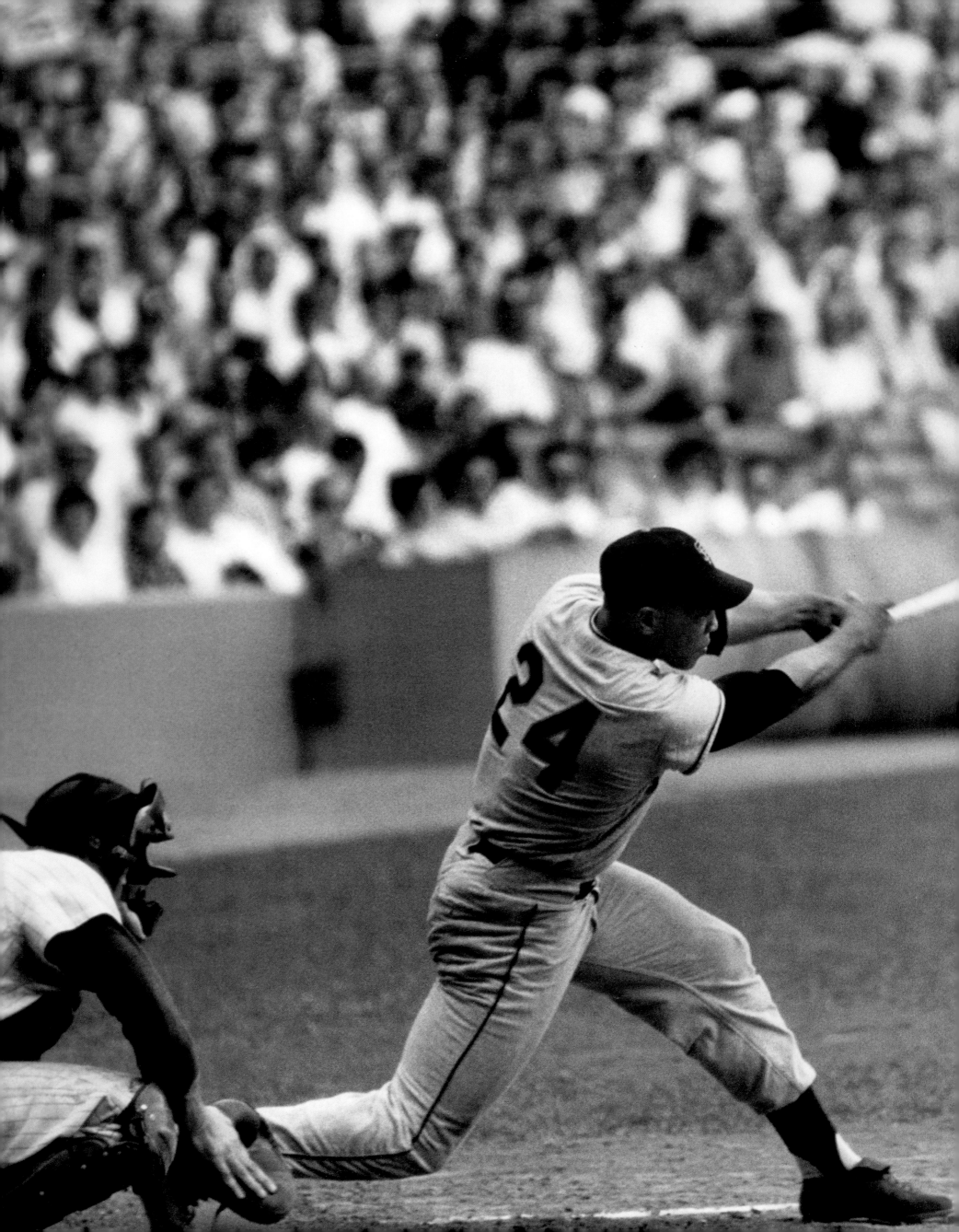

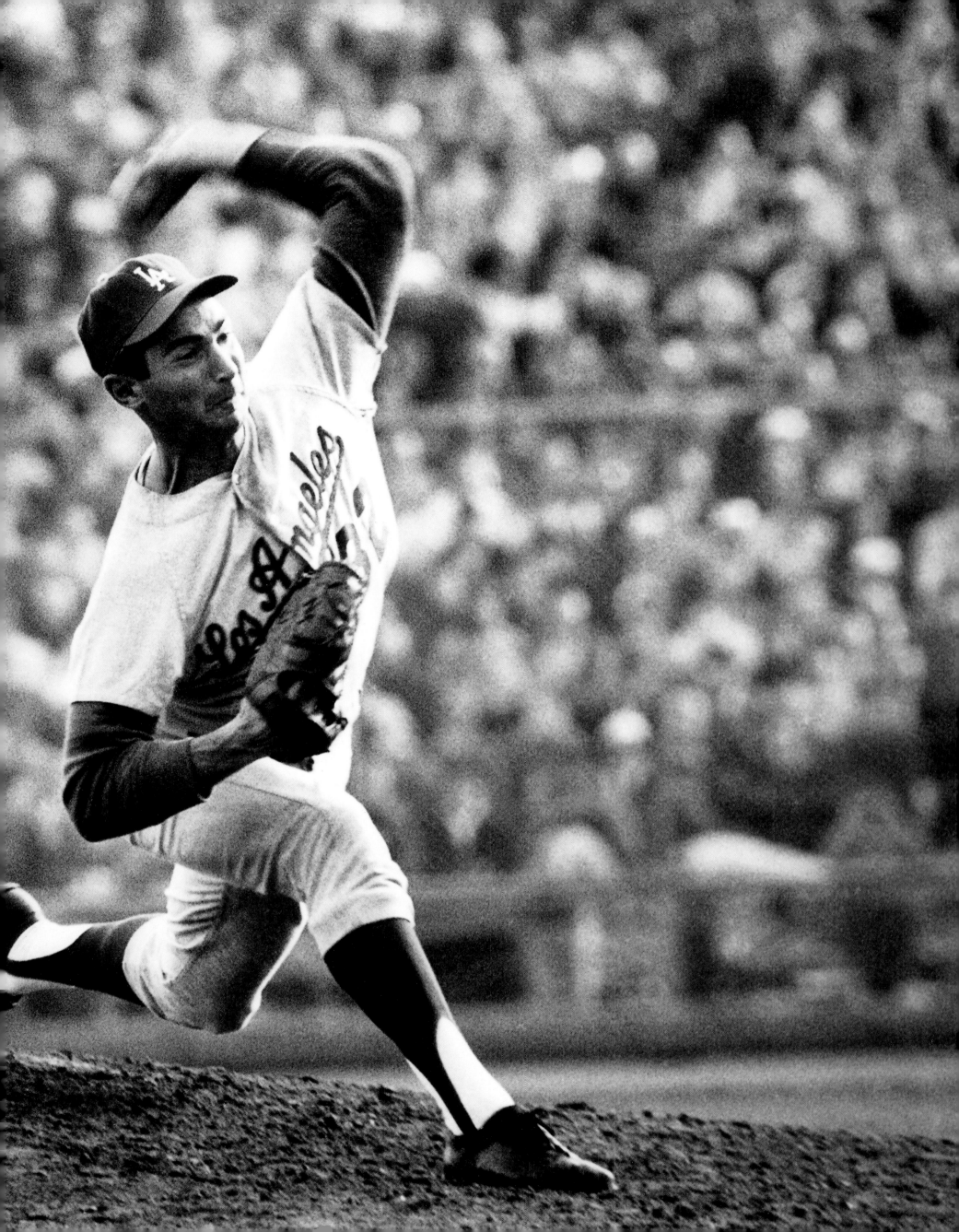

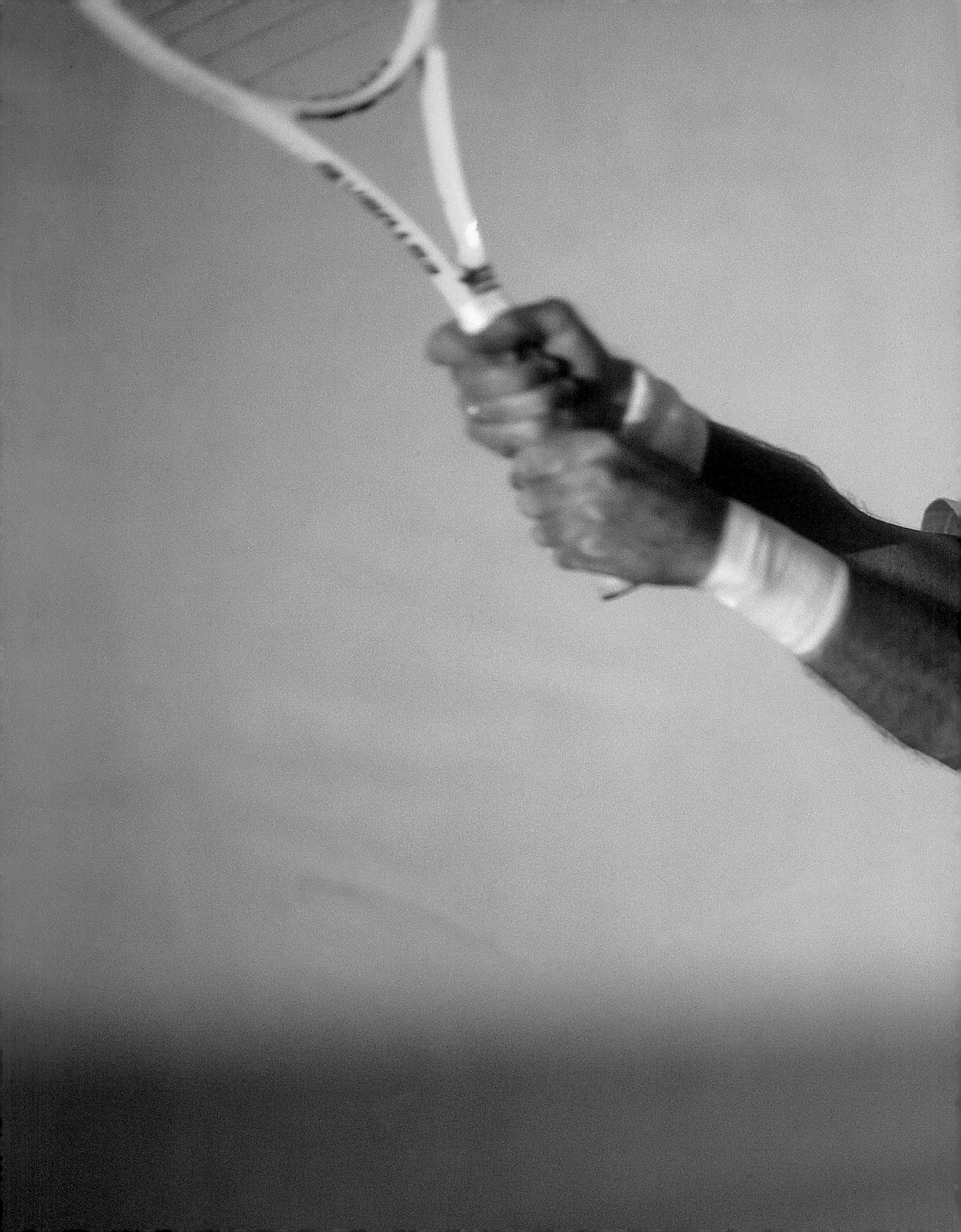

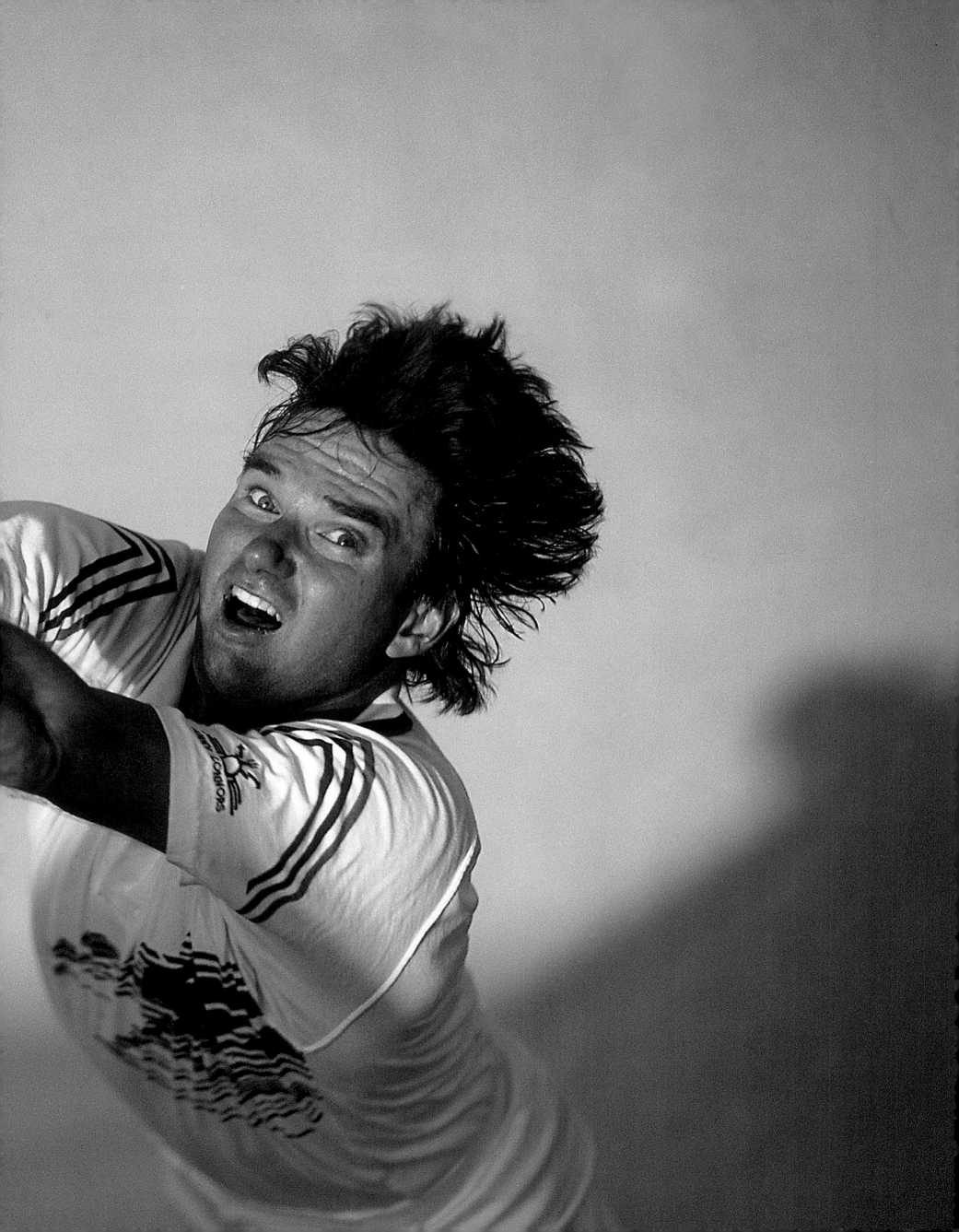

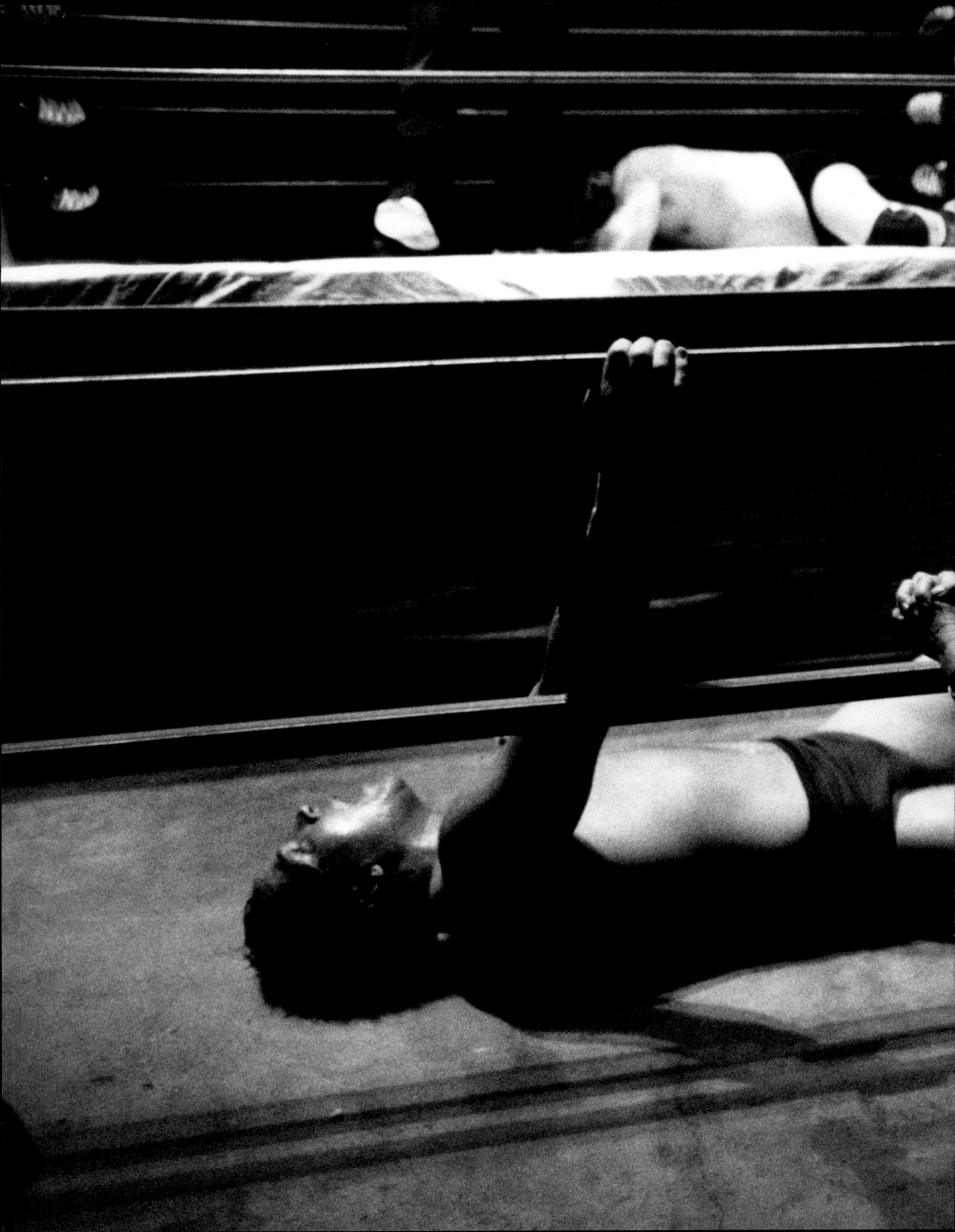

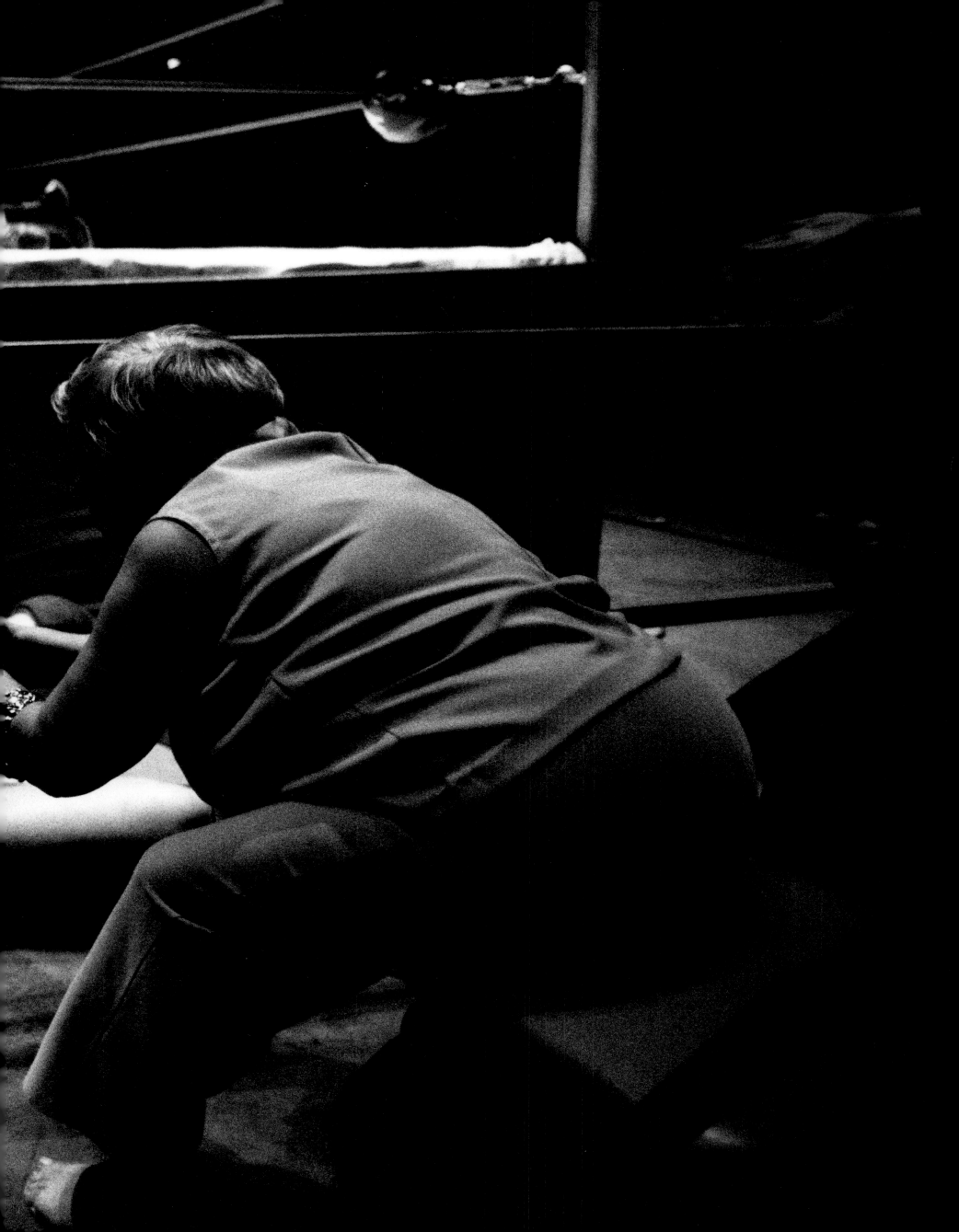

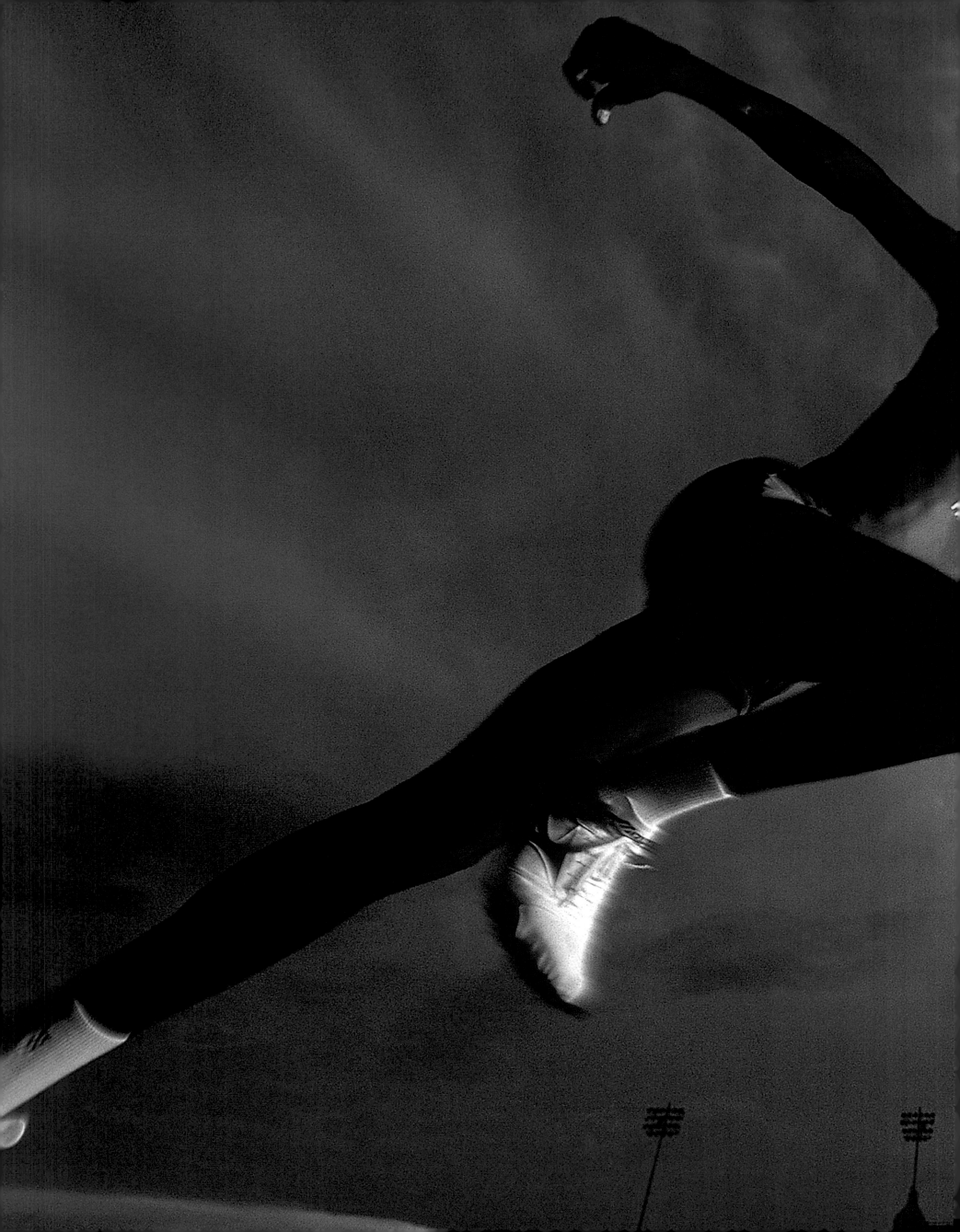

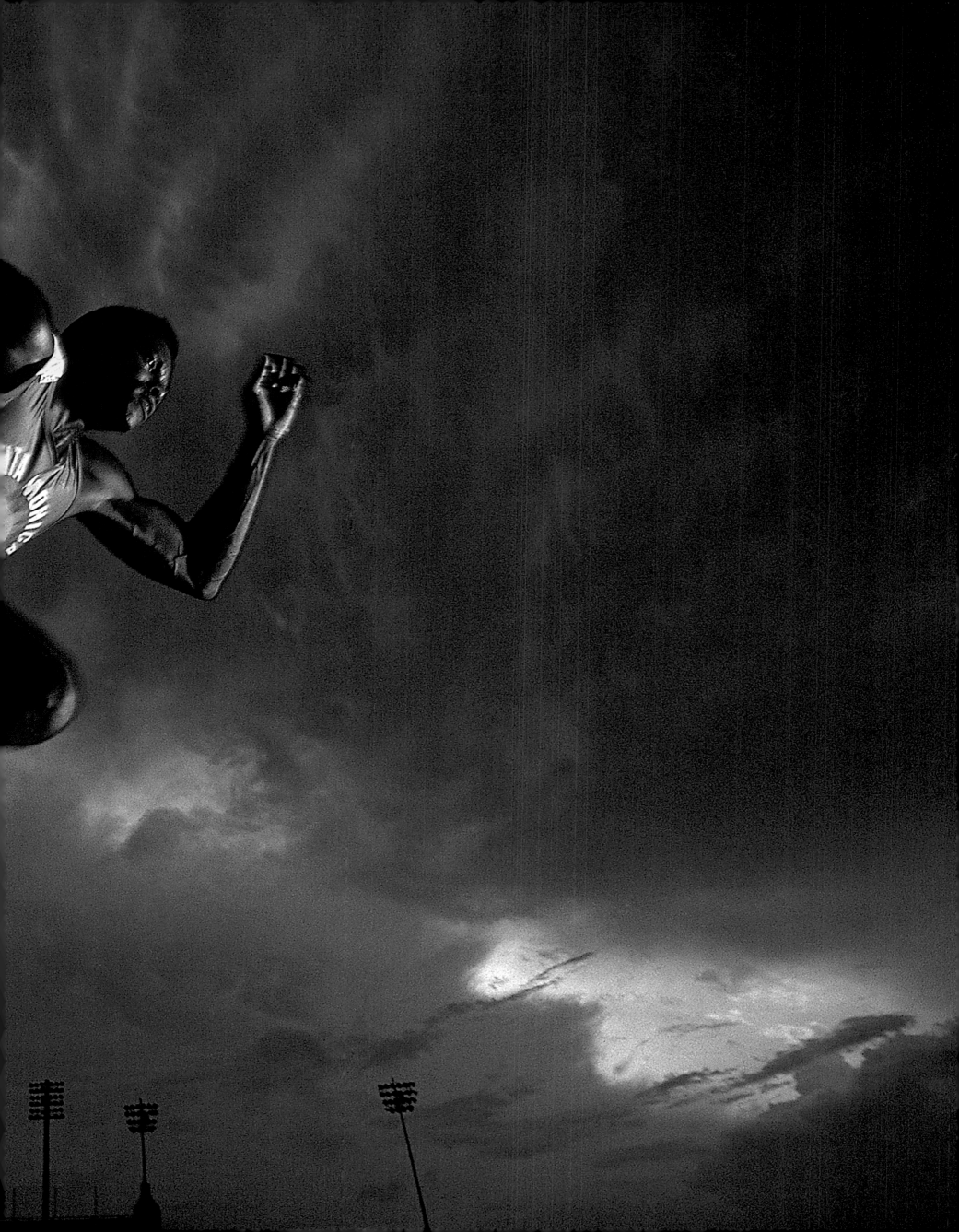

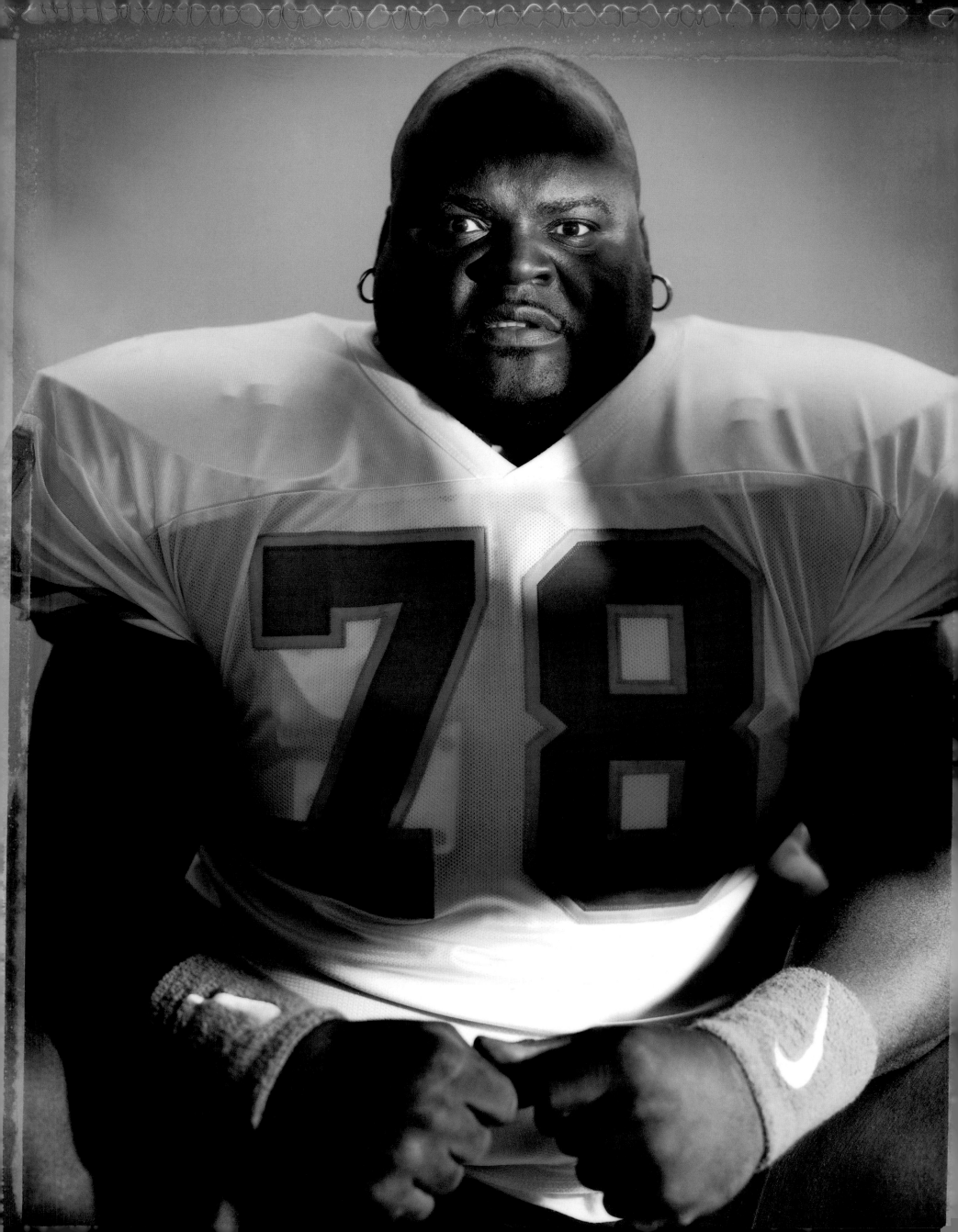

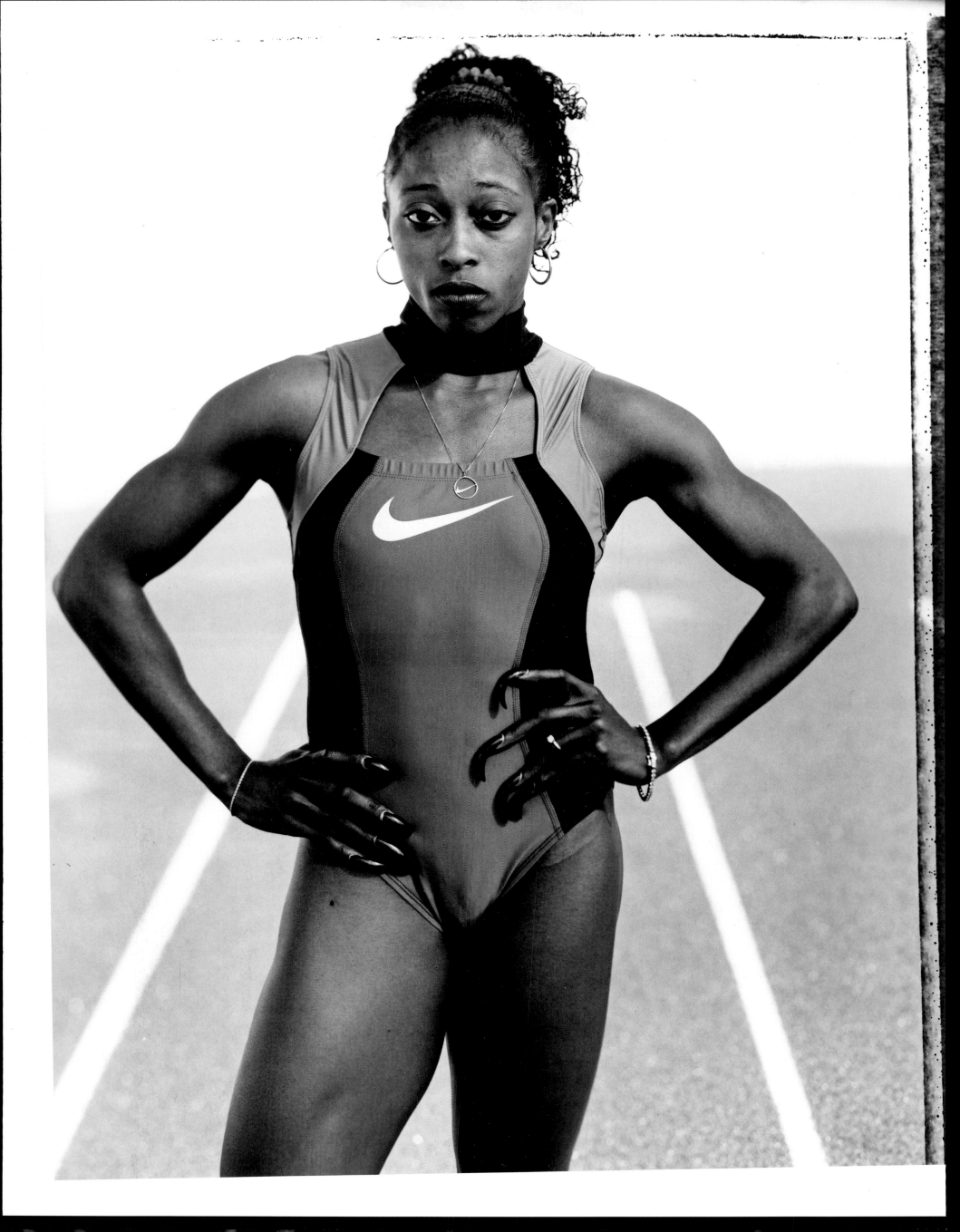

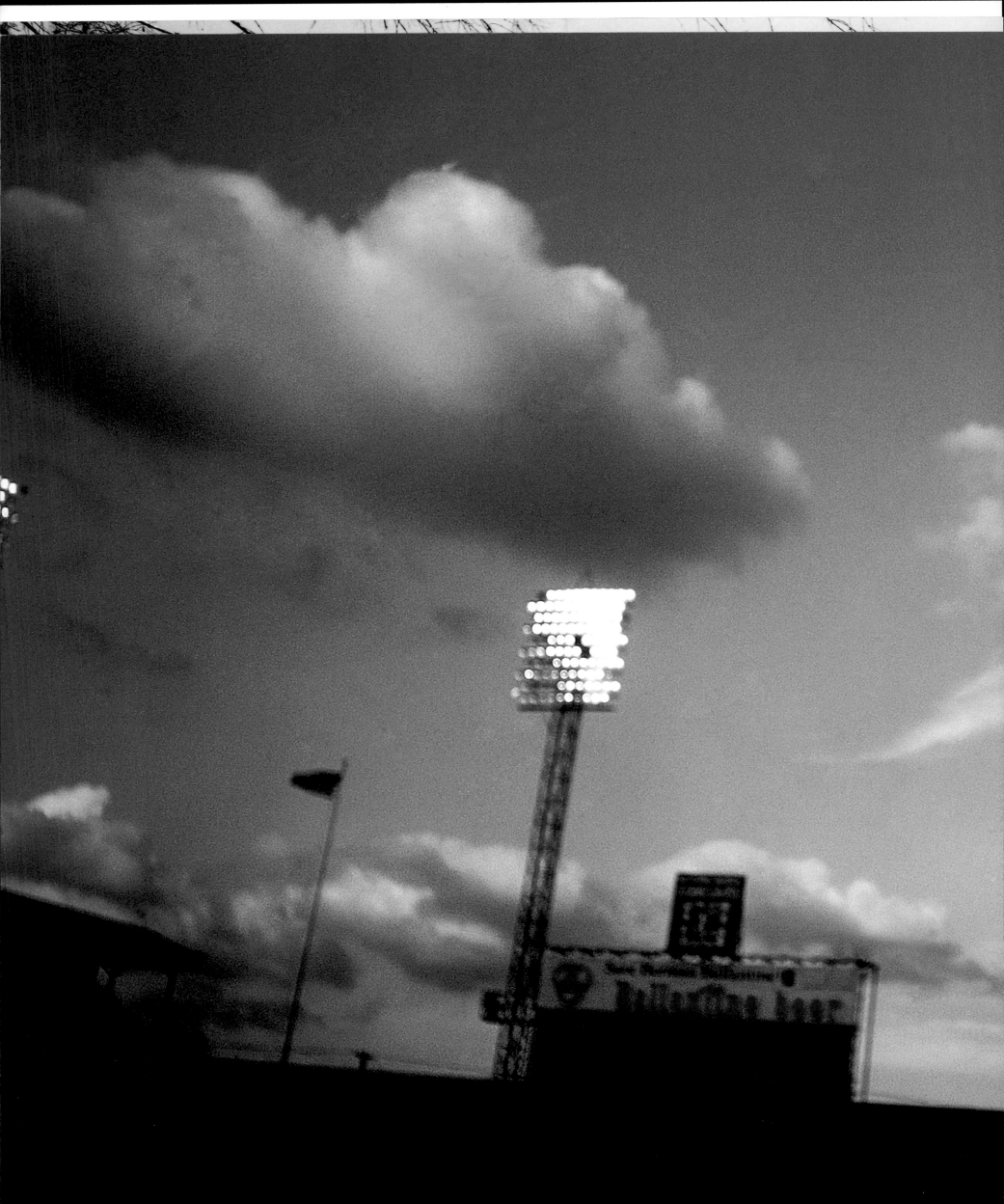

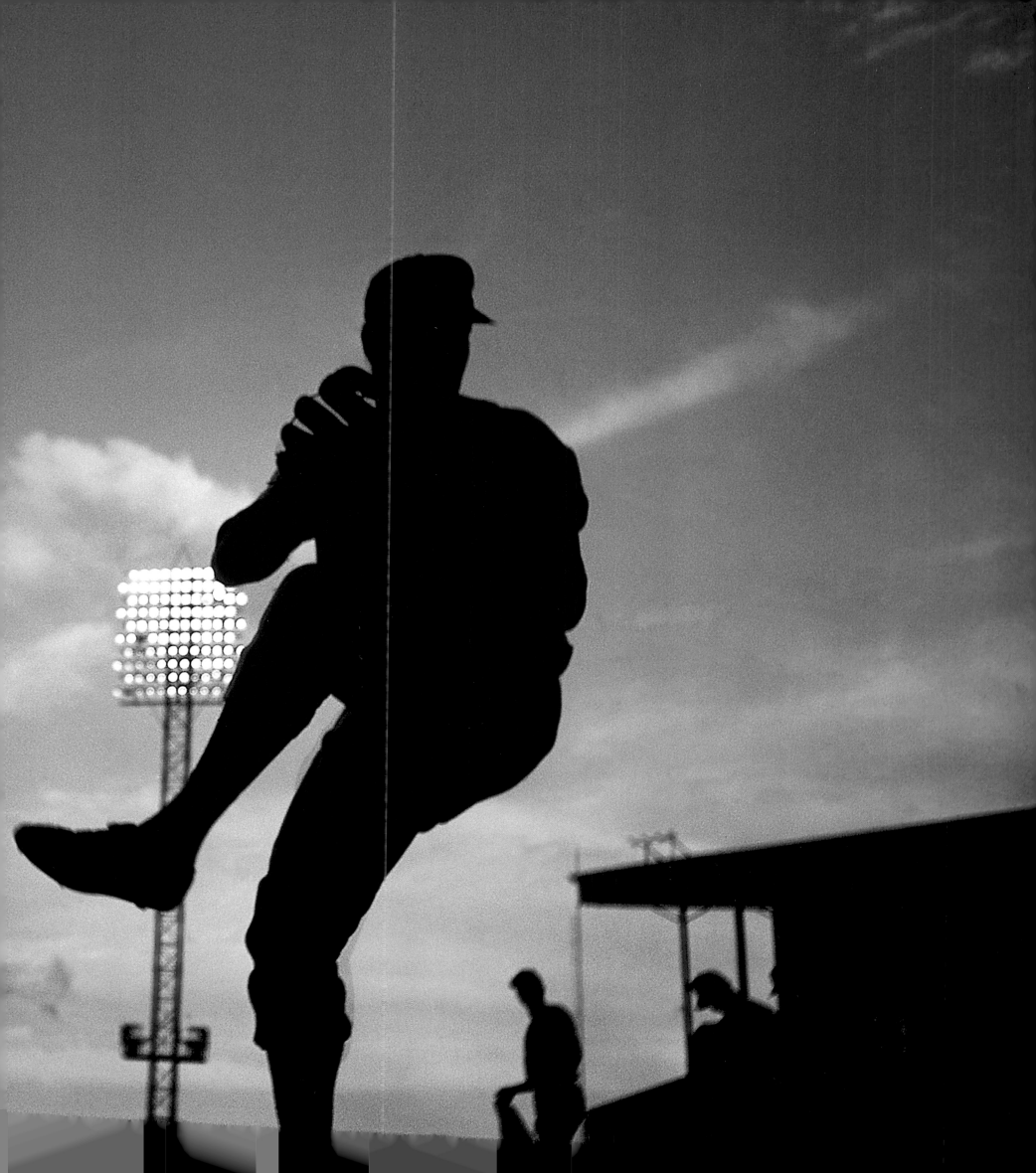

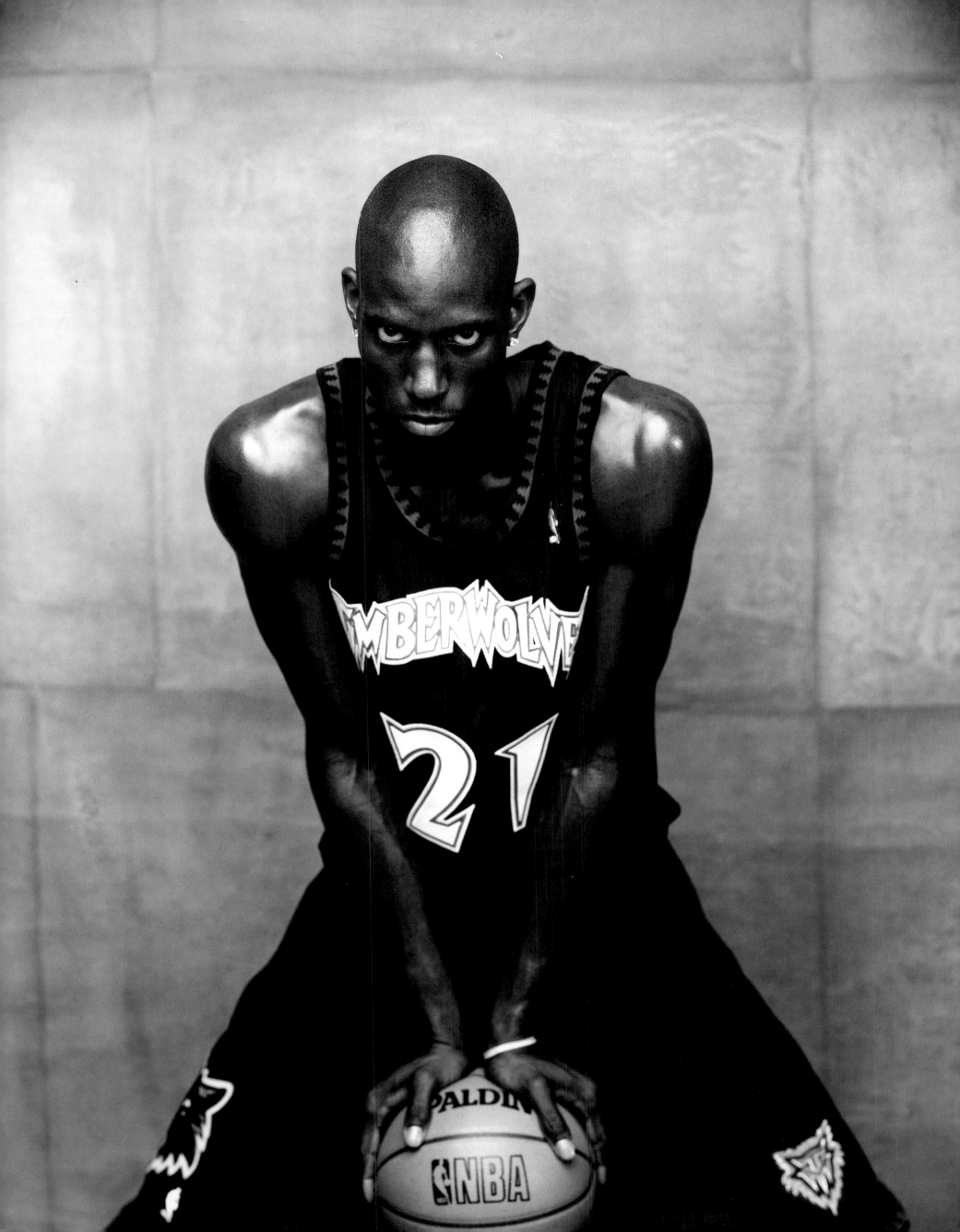

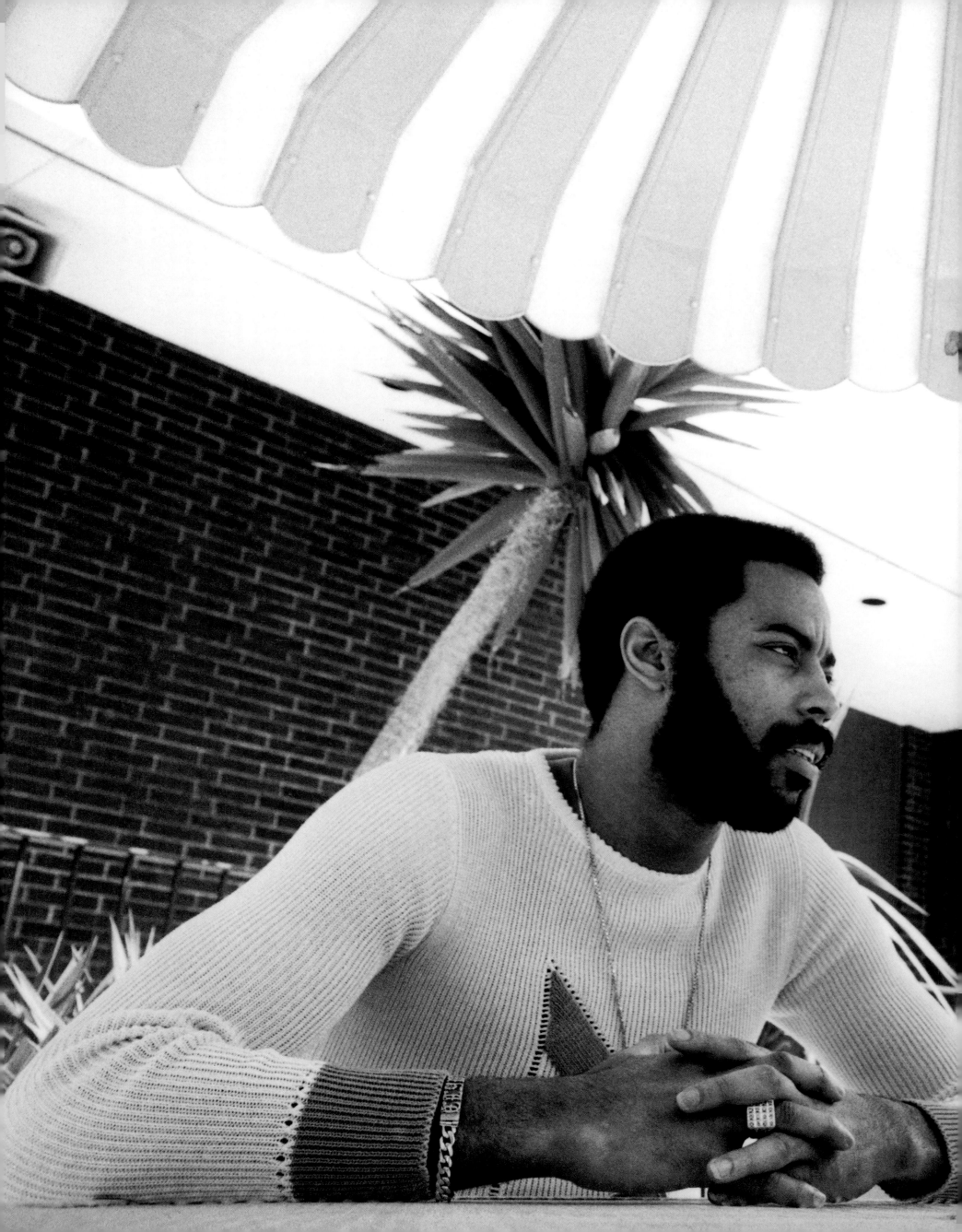

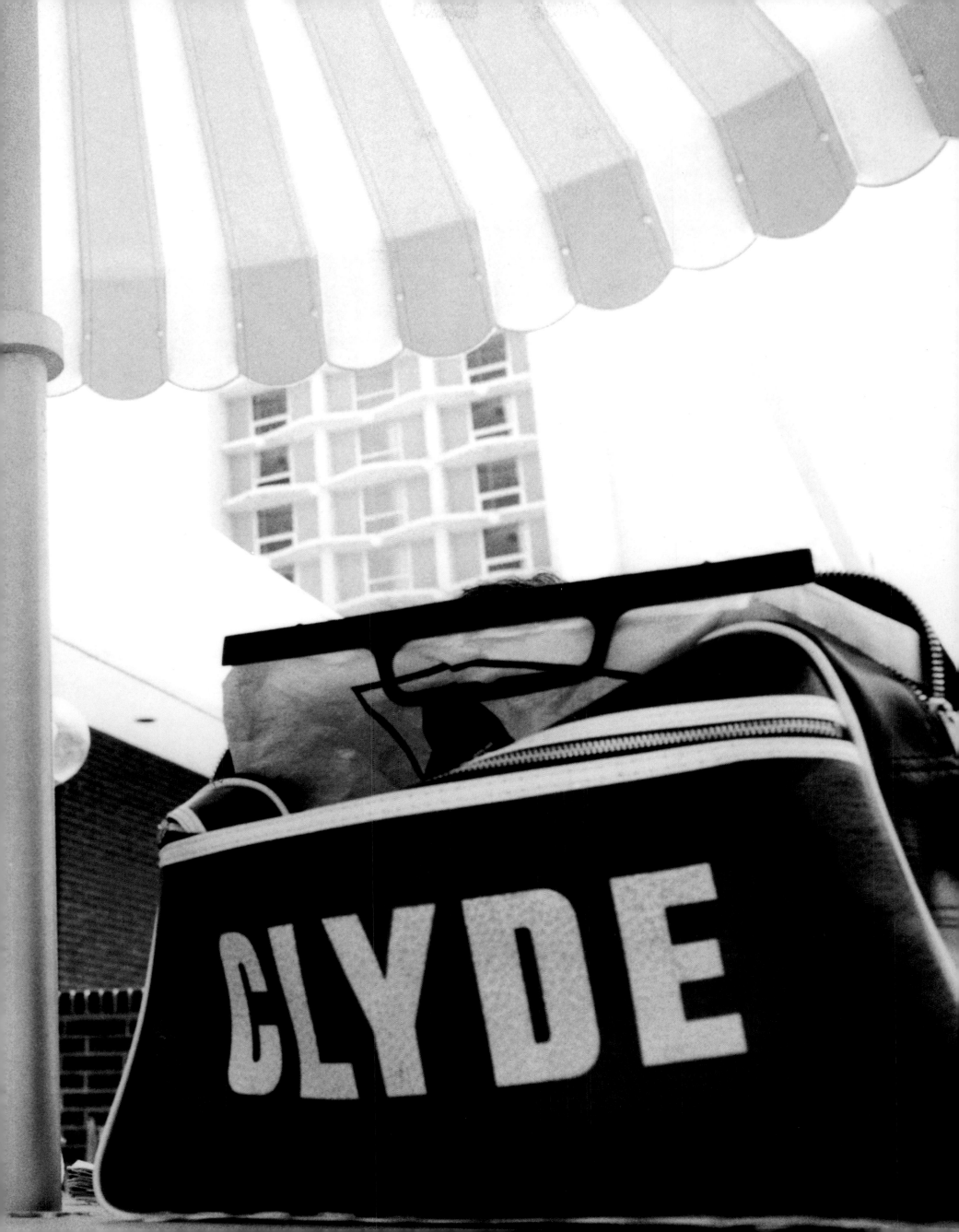

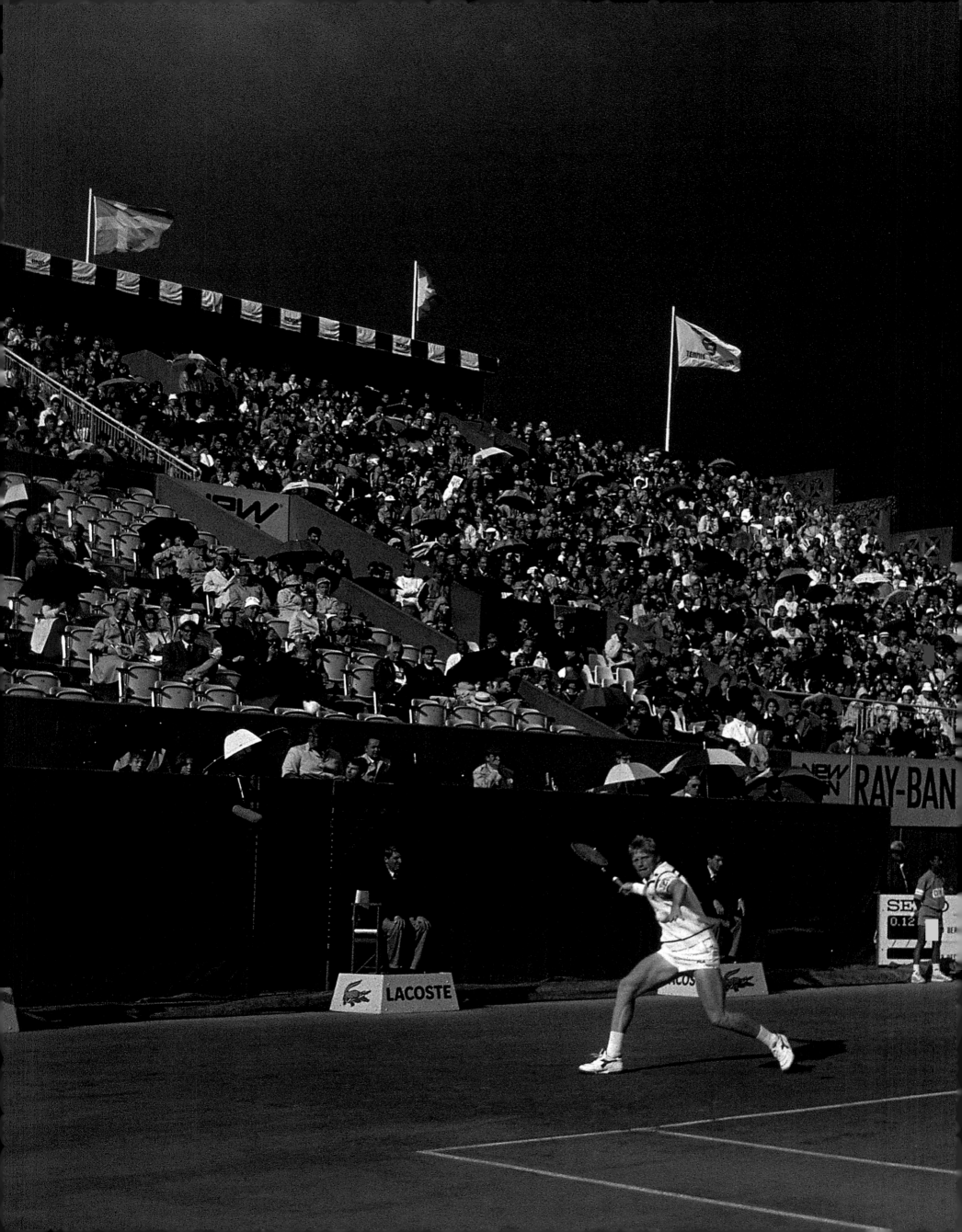

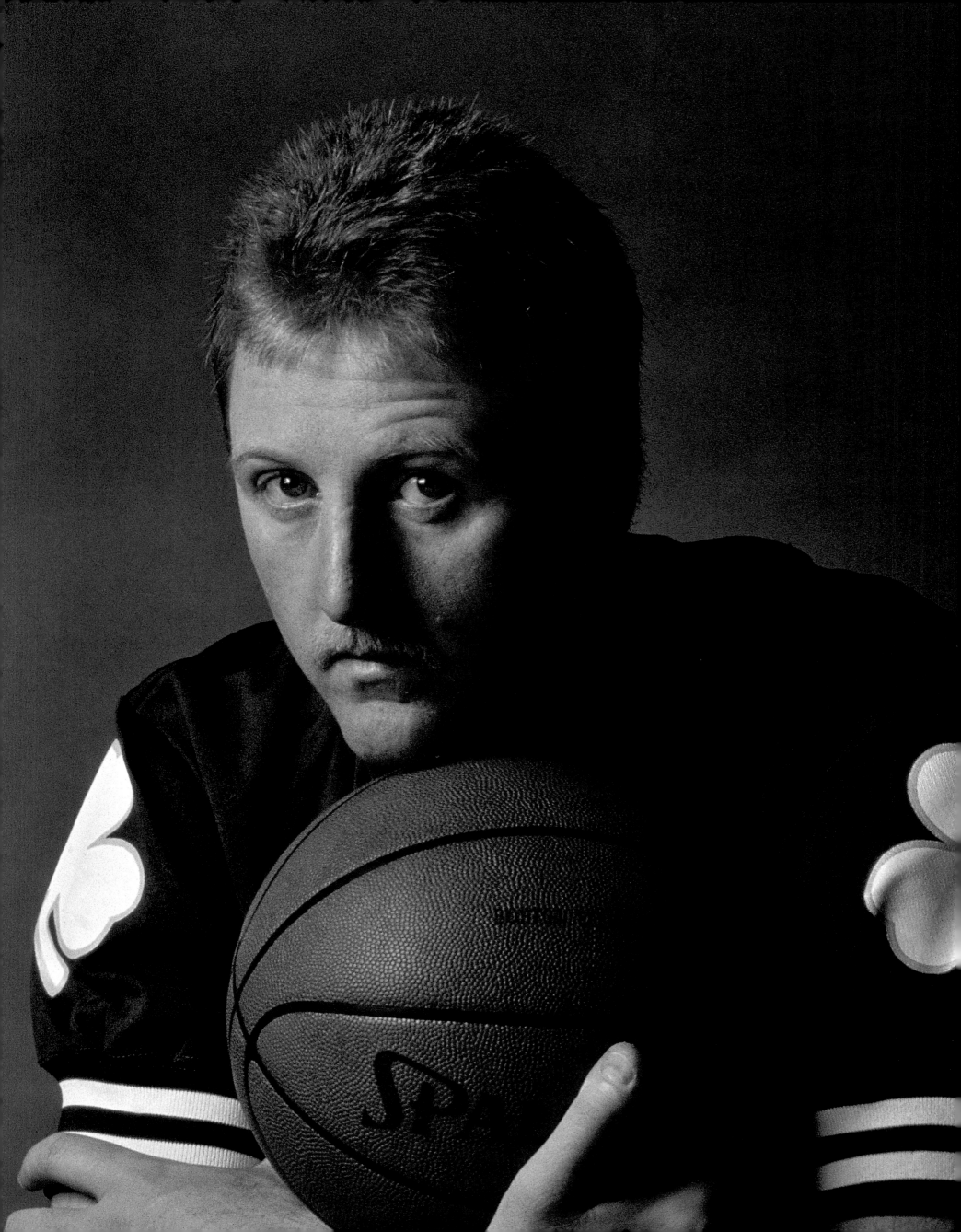

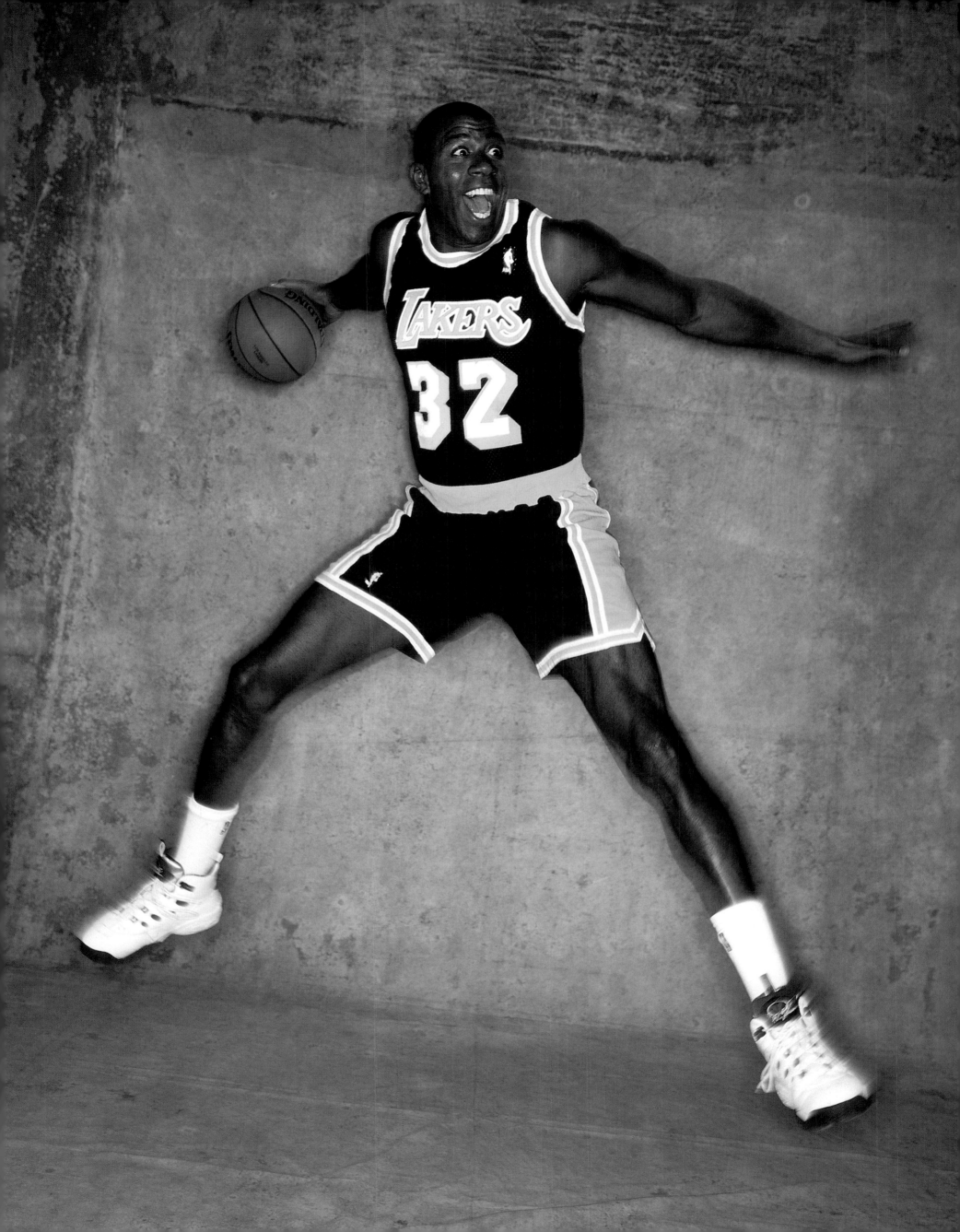

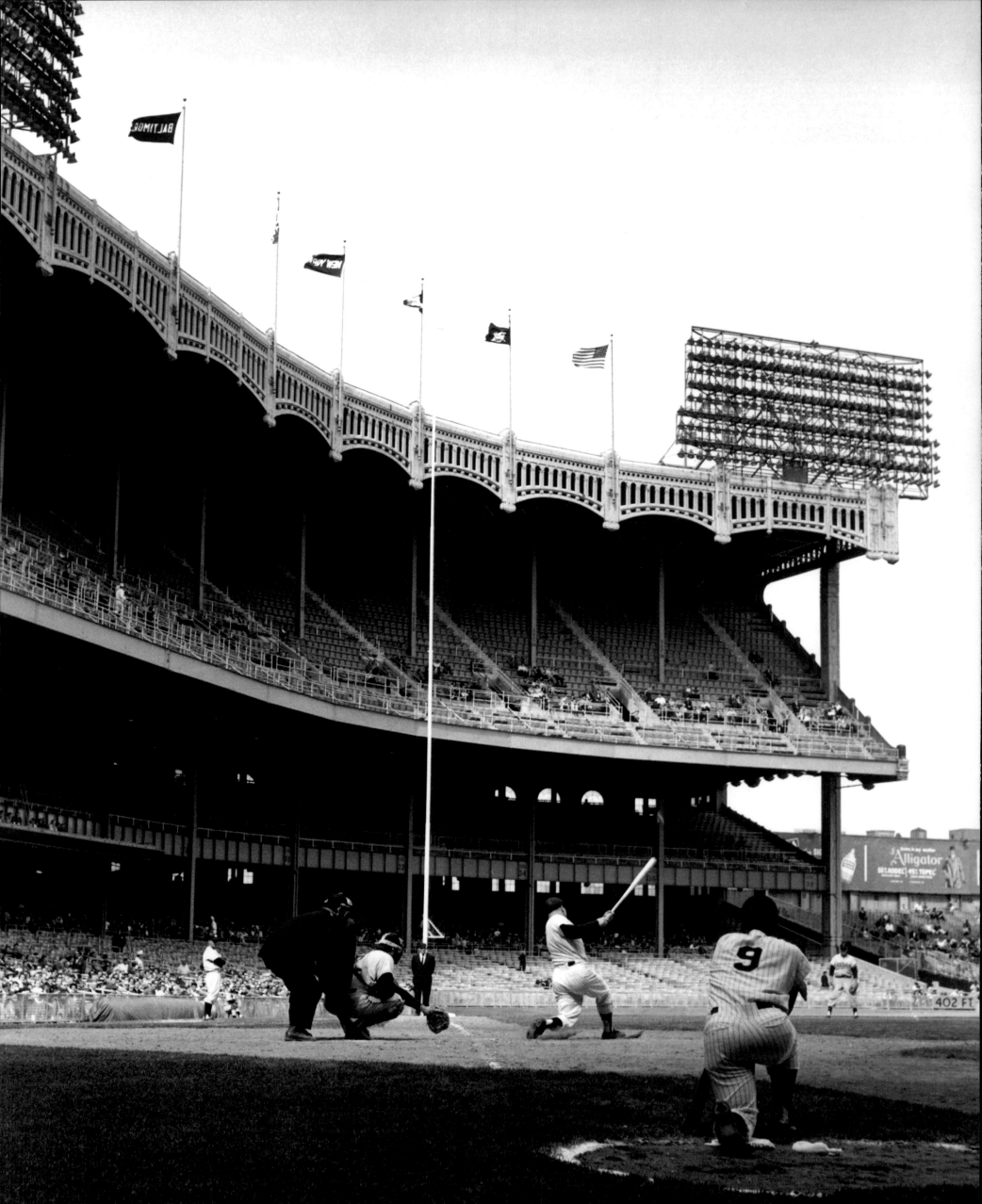

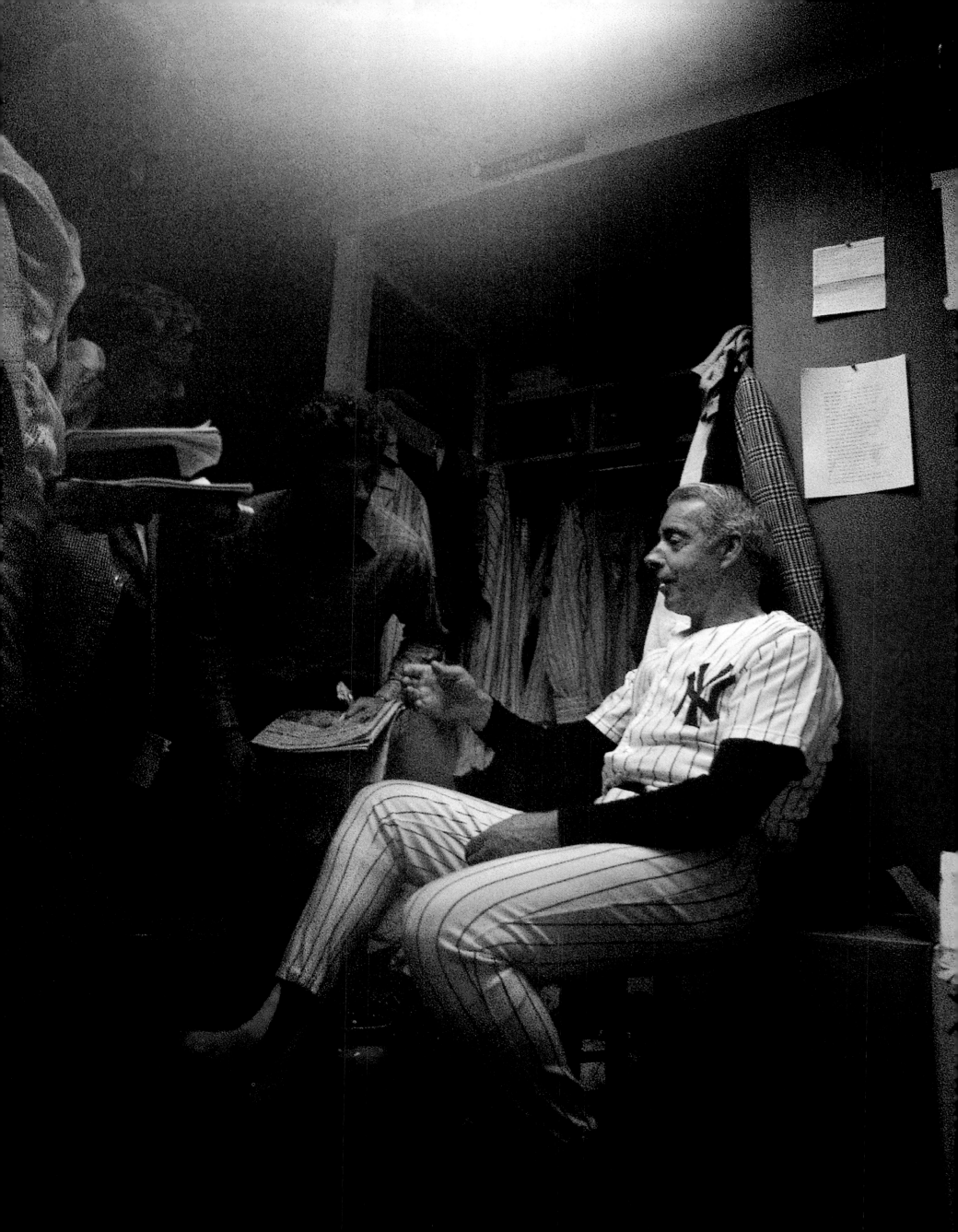

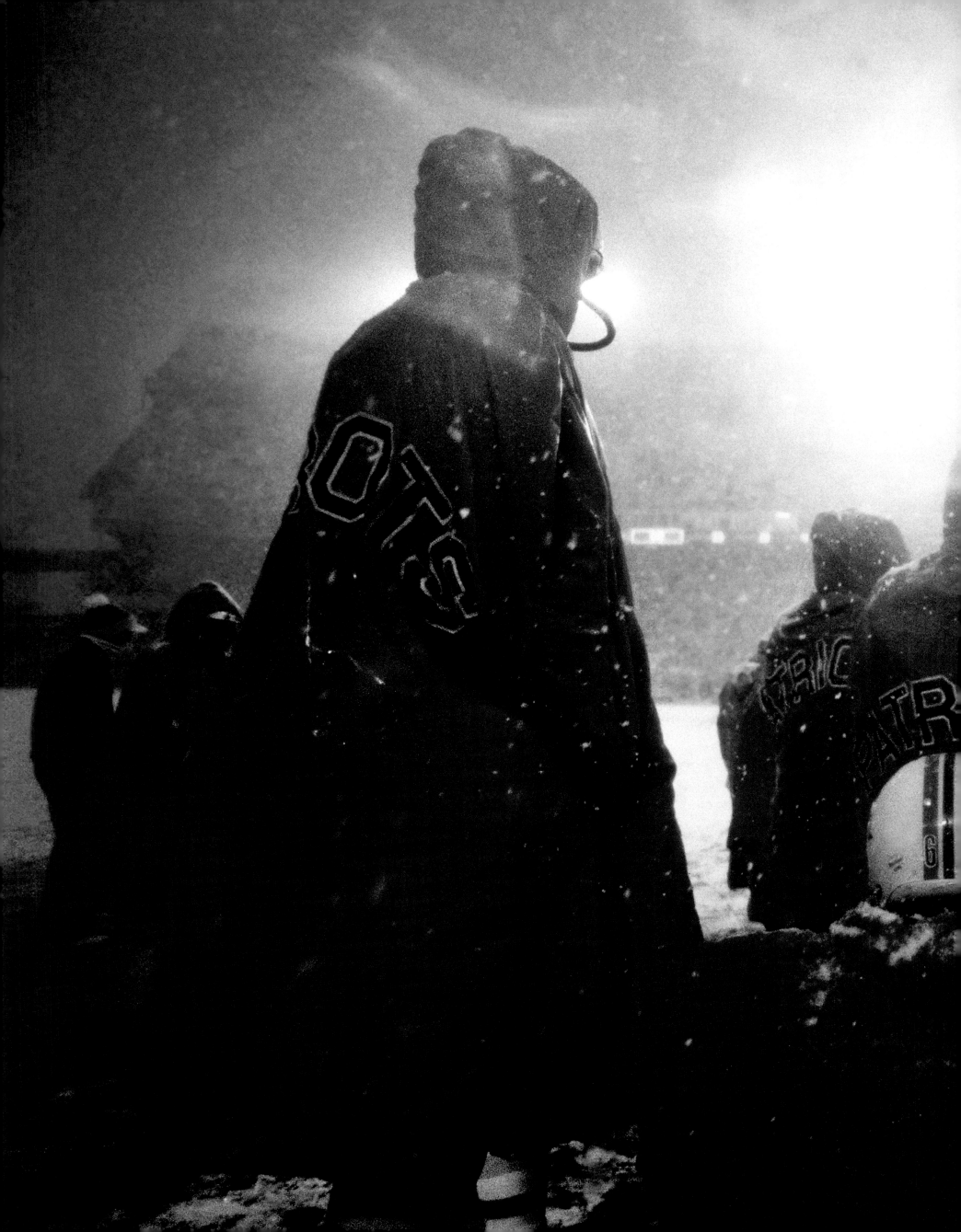

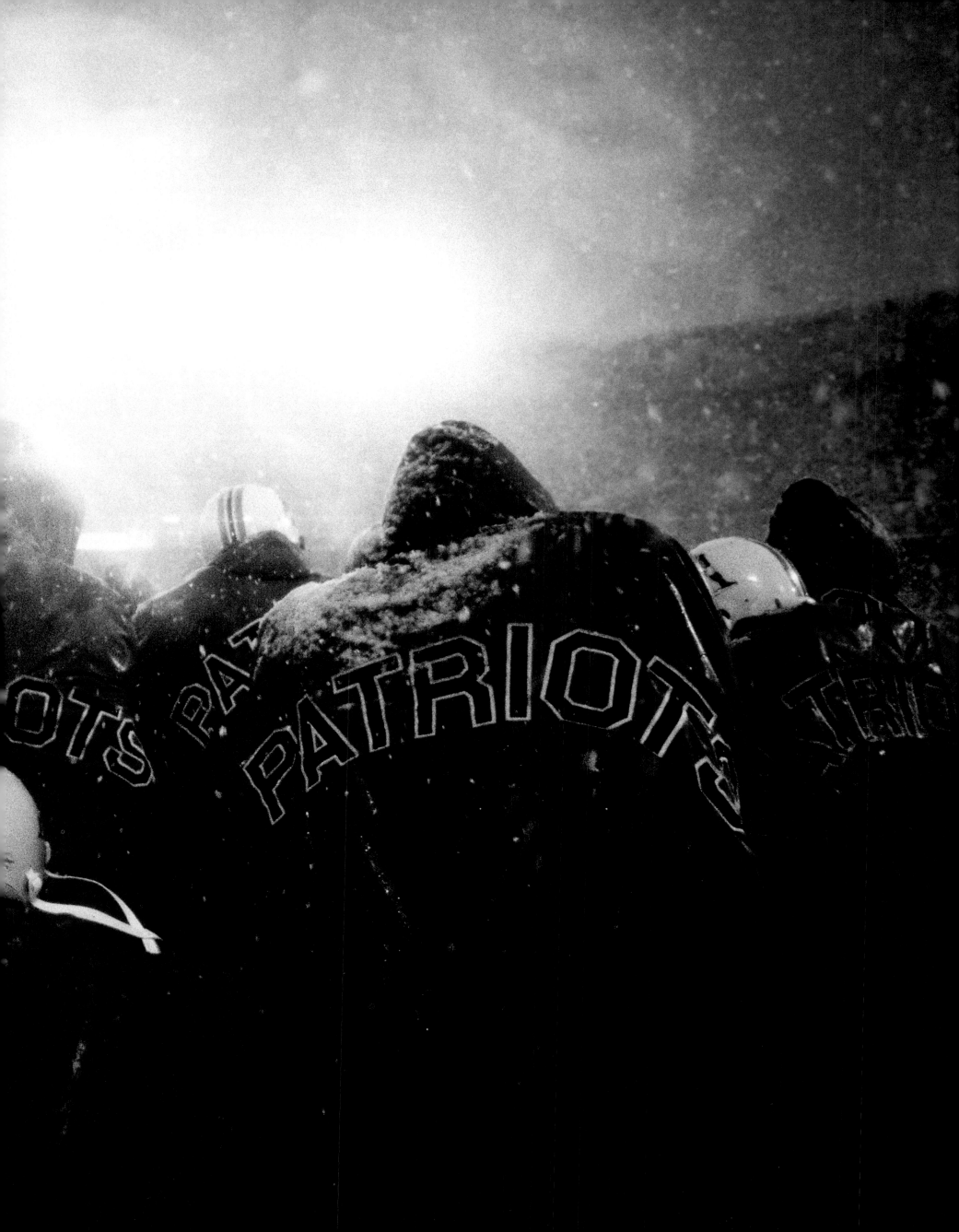

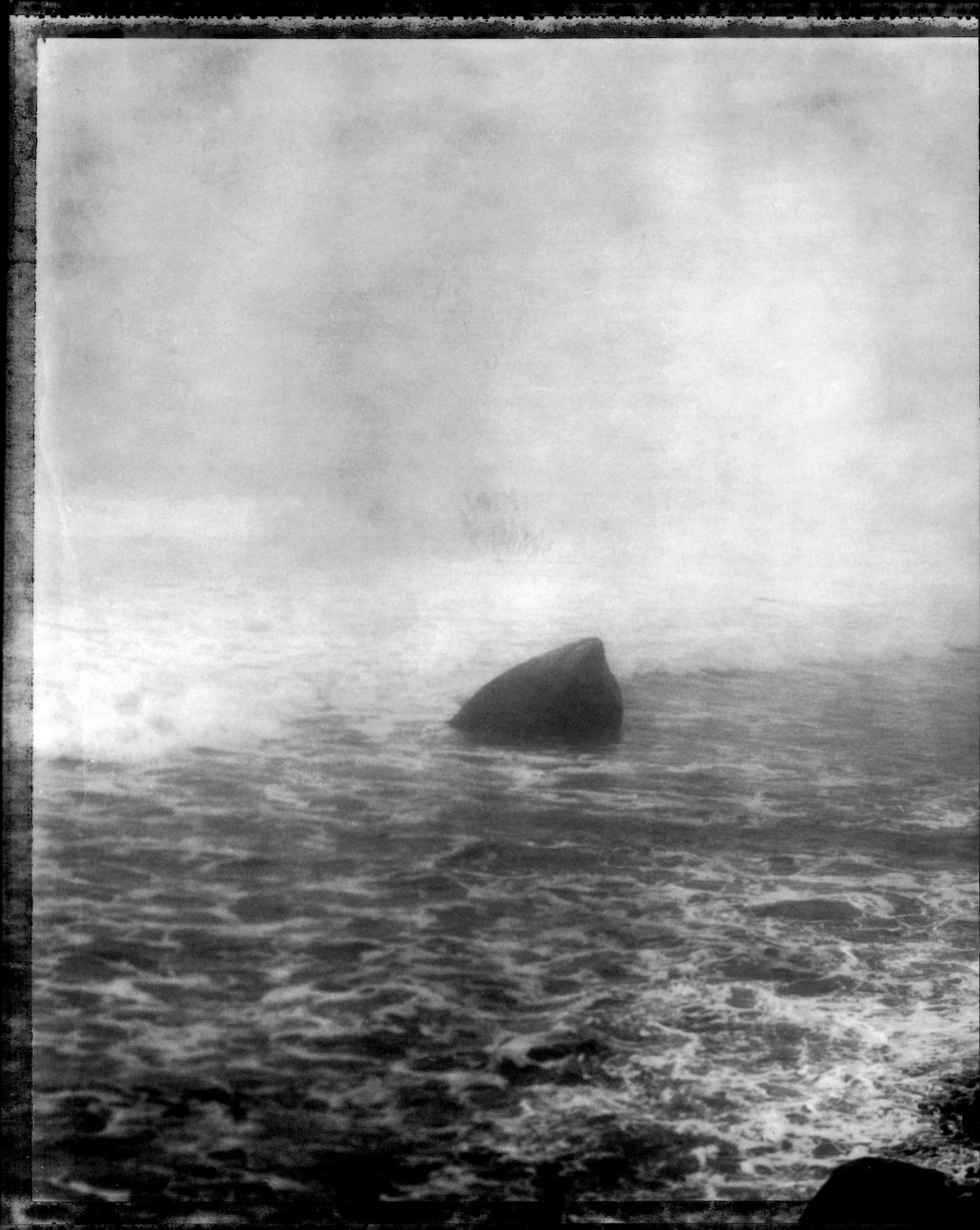

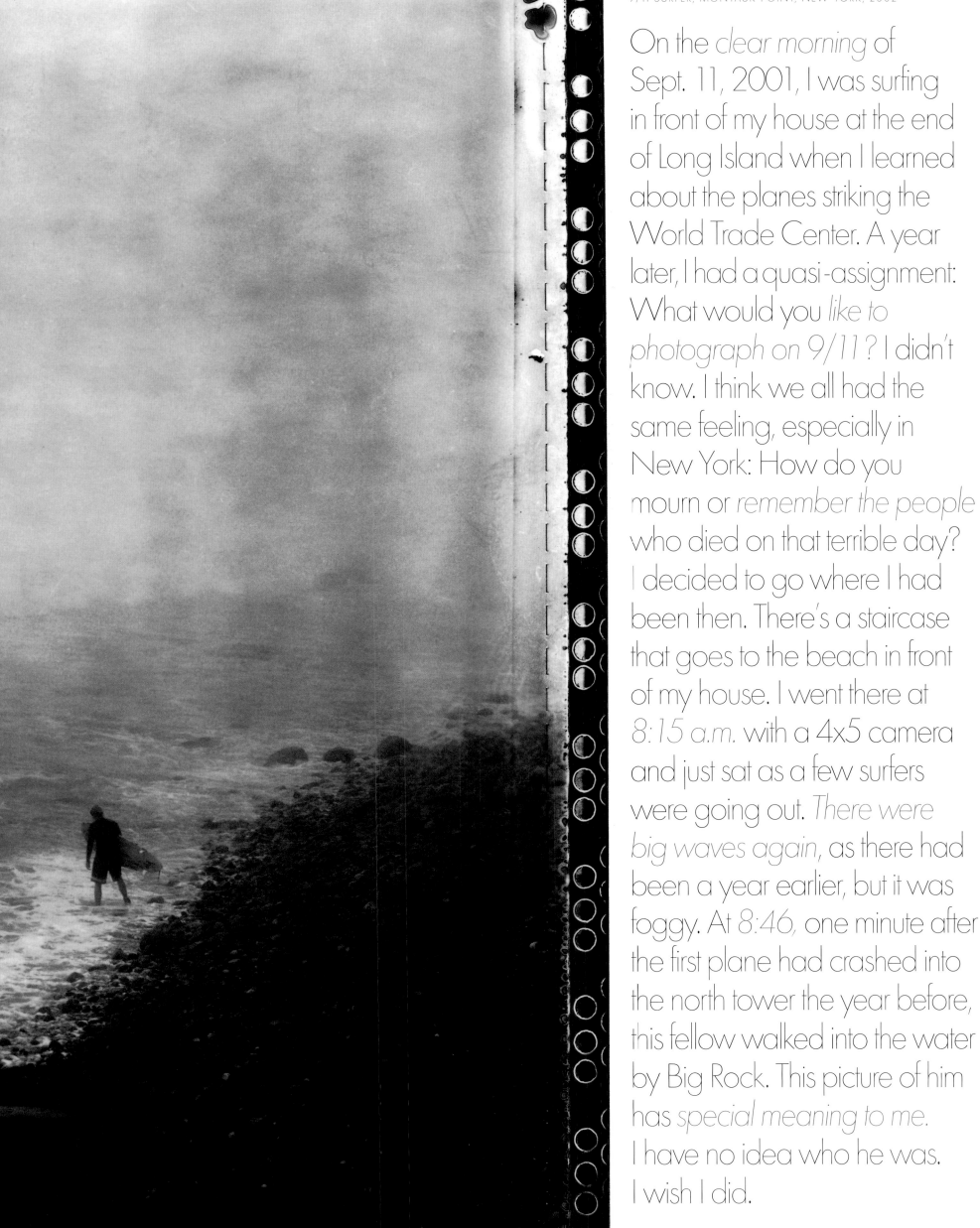

On the *clear morning* of Sept. 11, 2001, I was surfing in front of my house at the end of Long Island when I learned about the planes striking the World Trade Center. A year later, I had a quasi-assignment: What would you *like to photograph on 9/11*? I didn't know. I think we all had the same feeling, especially in New York: How do you mourn or *remember the people* who died on that terrible day? I decided to go where I had been then. There's a staircase that goes to the beach in front of my house. I went there at *8:15 a.m.* with a 4x5 camera and just sat as a few surfers were going out. *There were big waves again*, as there had been a year earlier, but it was foggy. At *8:46,* one minute after the first plane had crashed into the north tower the year before, this fellow walked into the water by Big Rock. This picture of him has *special meaning to me.* I have no idea who he was. I wish I did.

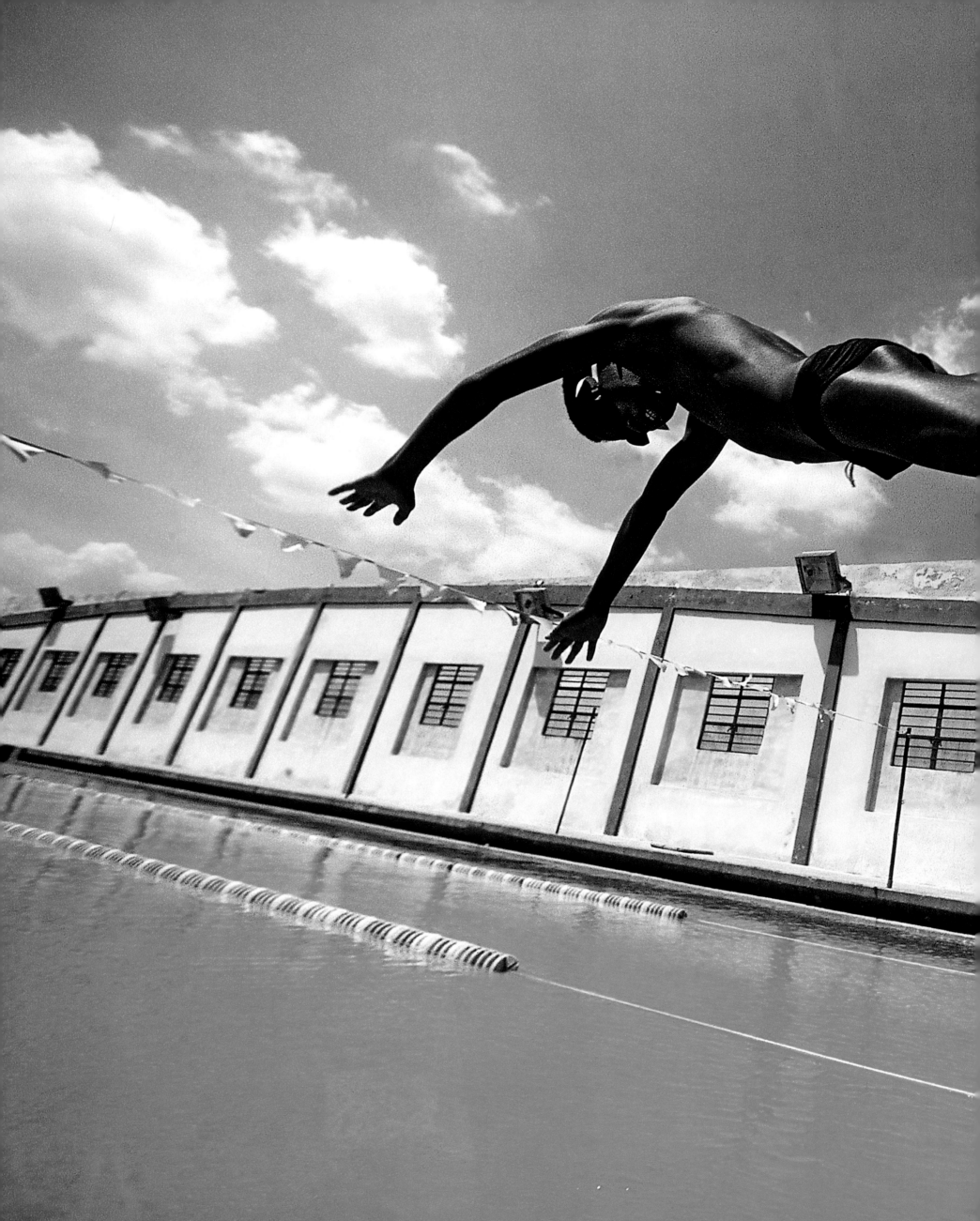

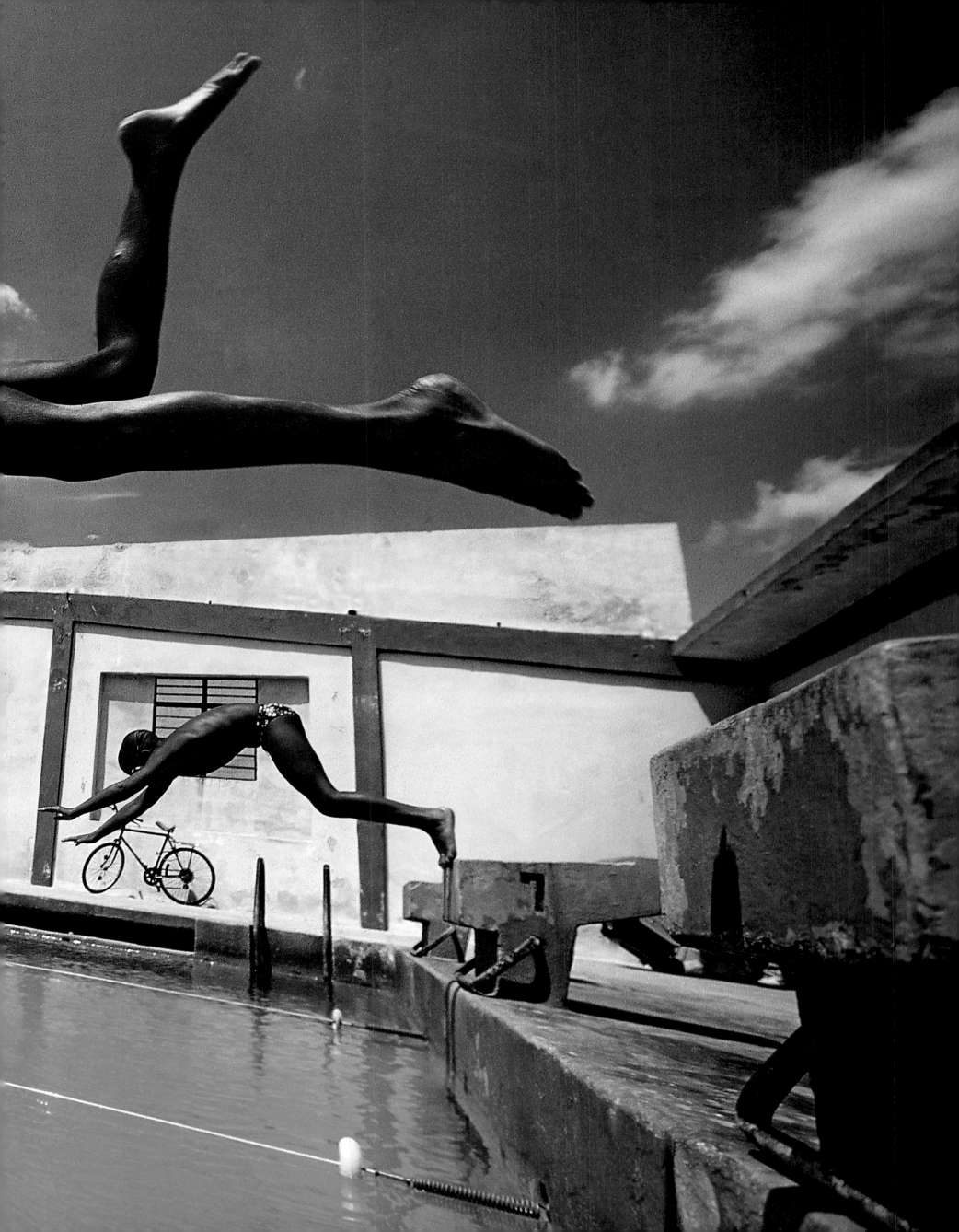

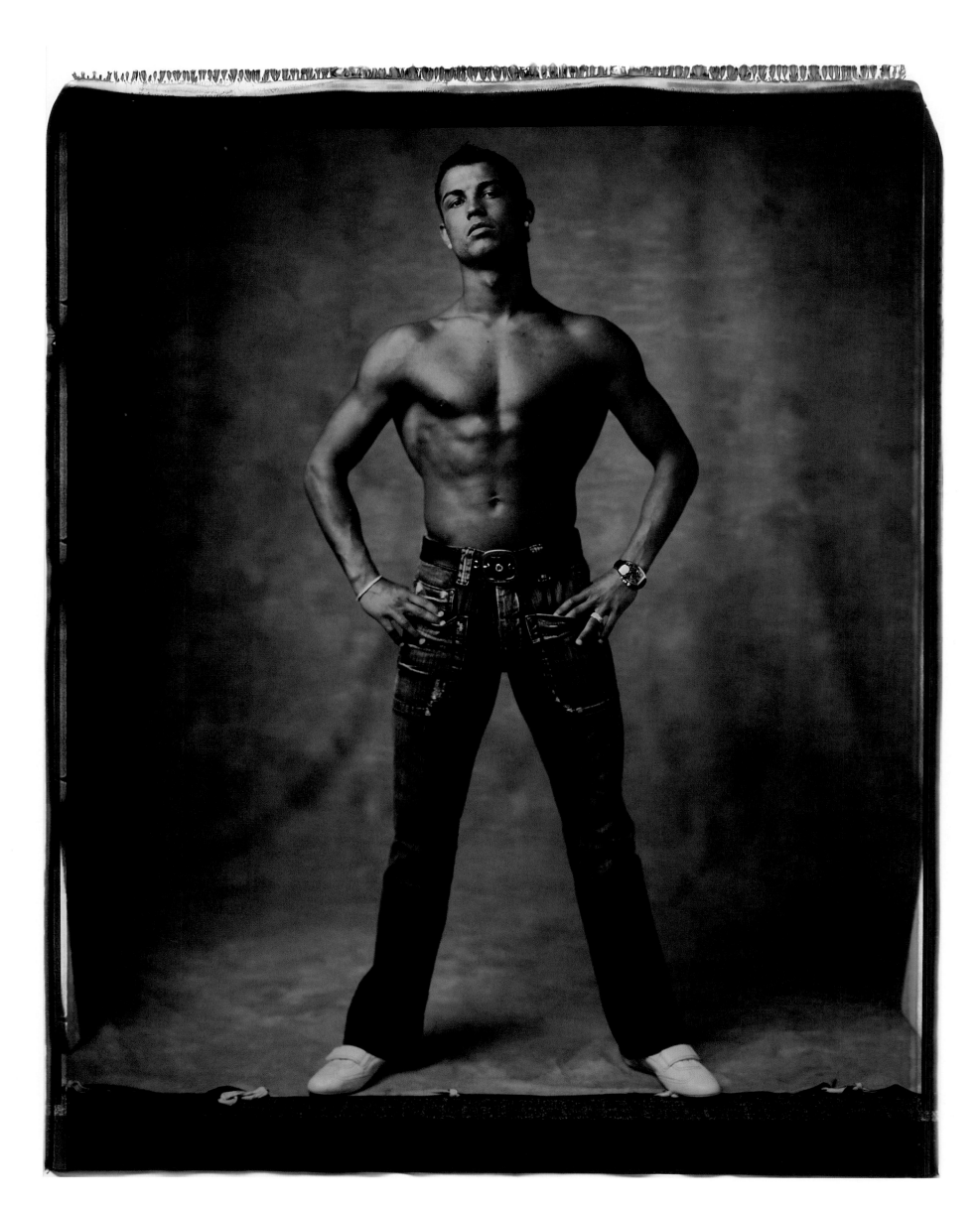

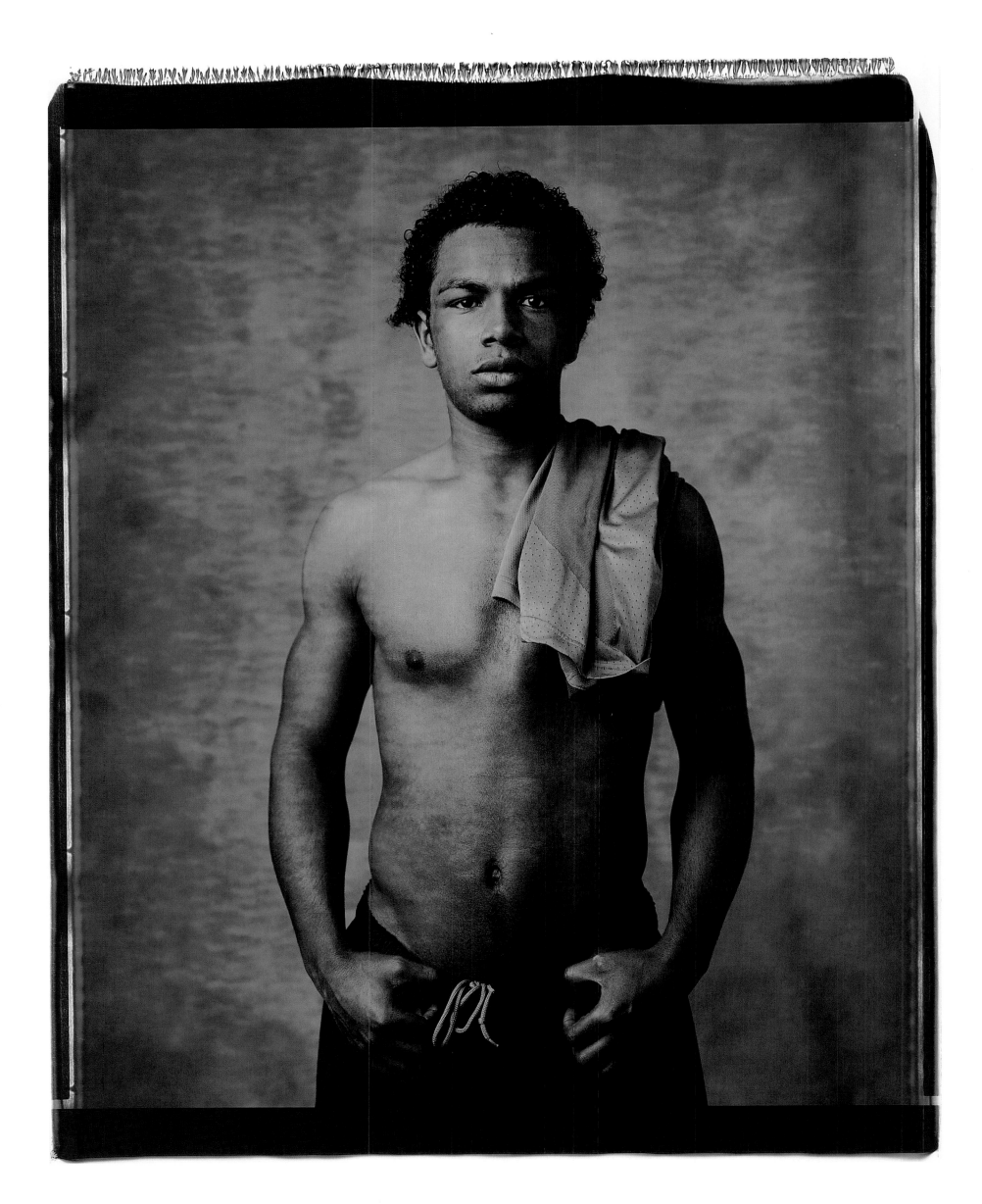

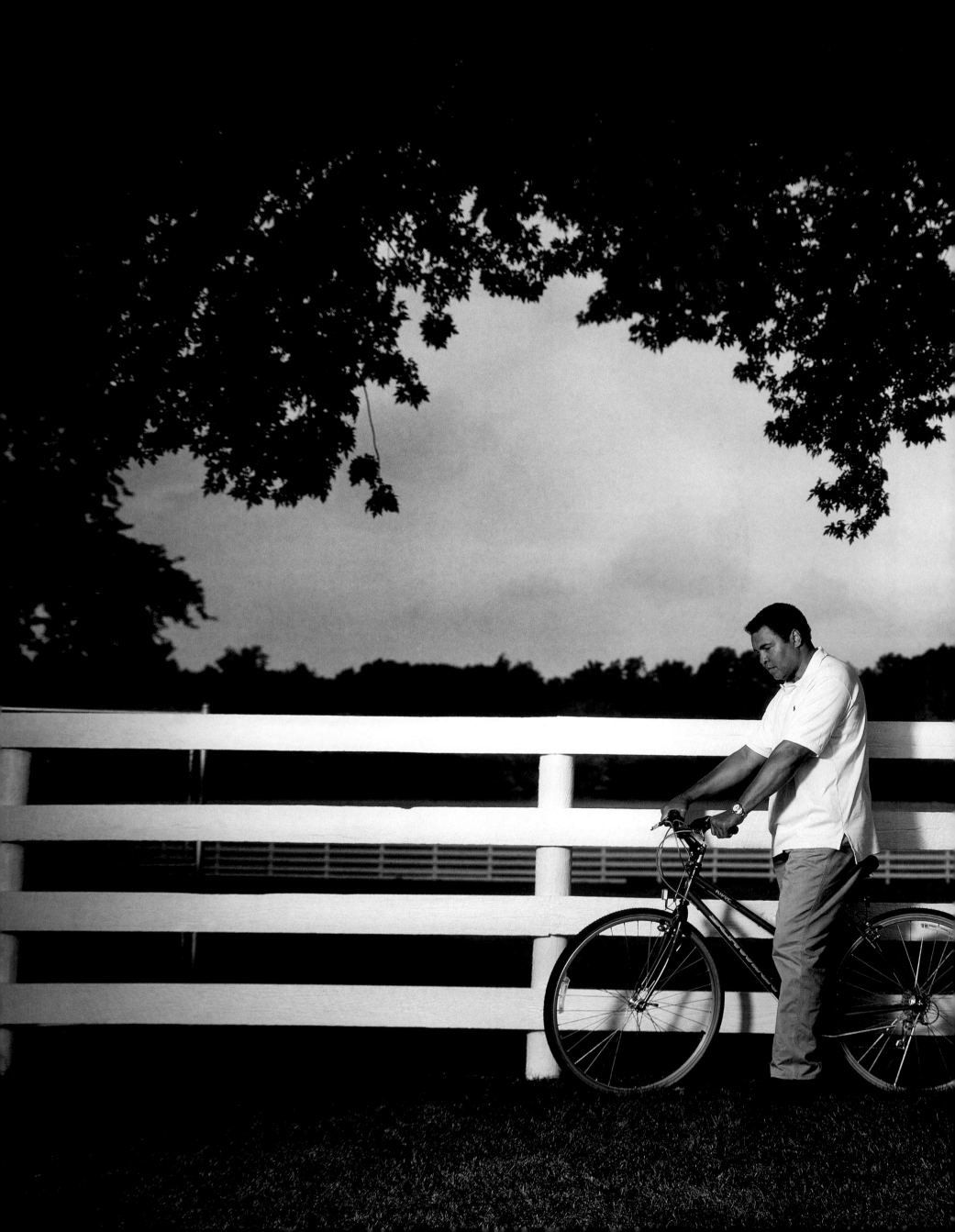

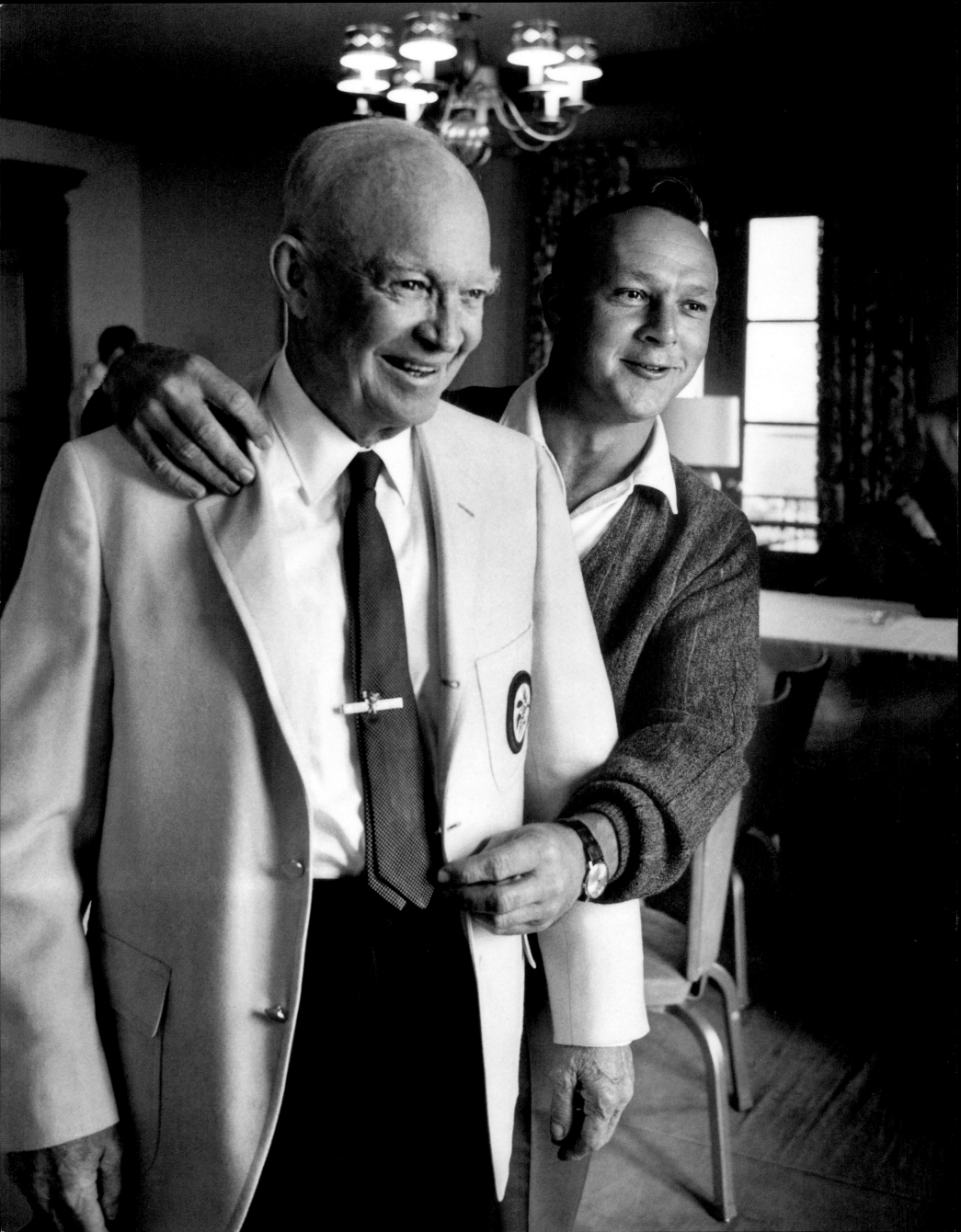

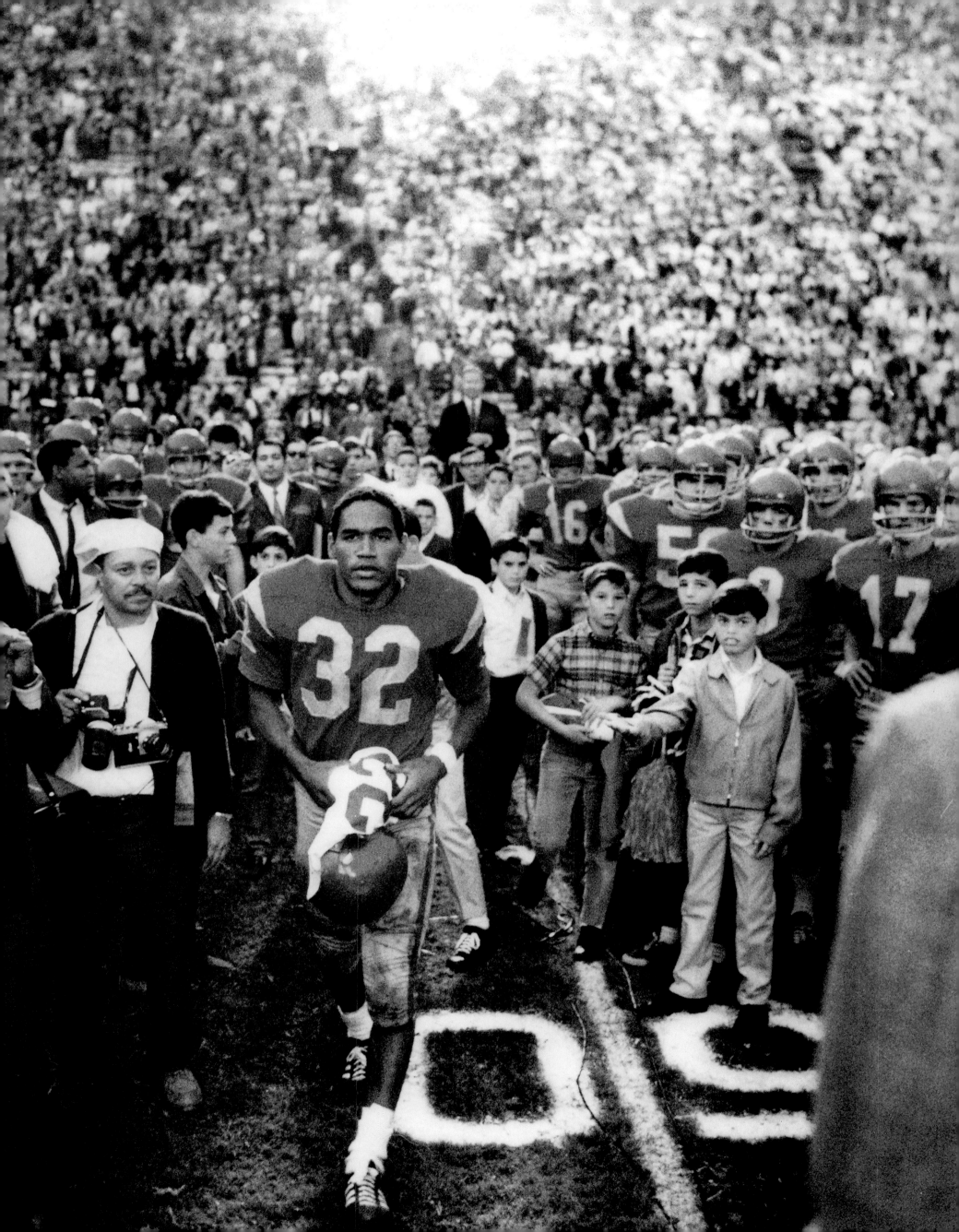

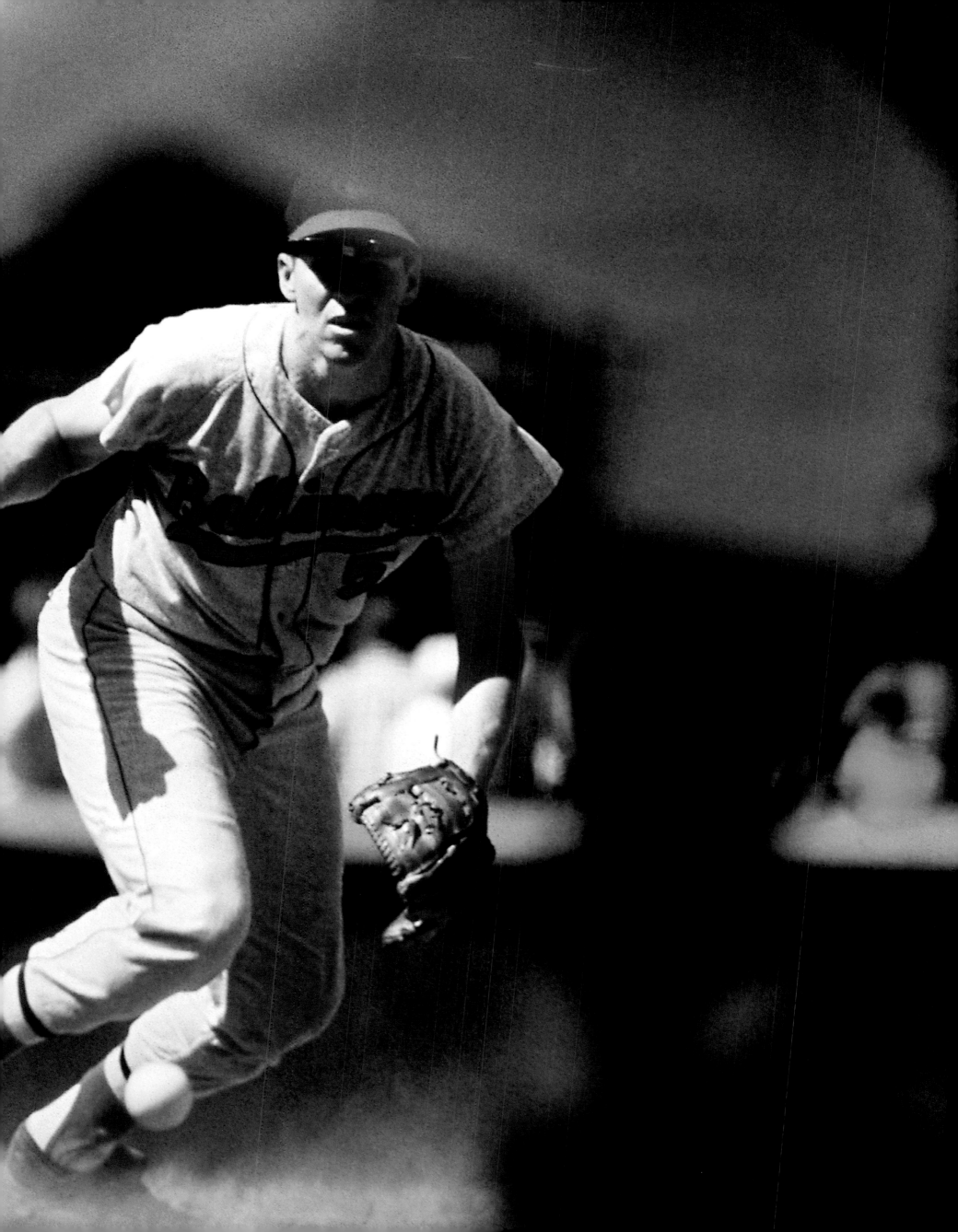

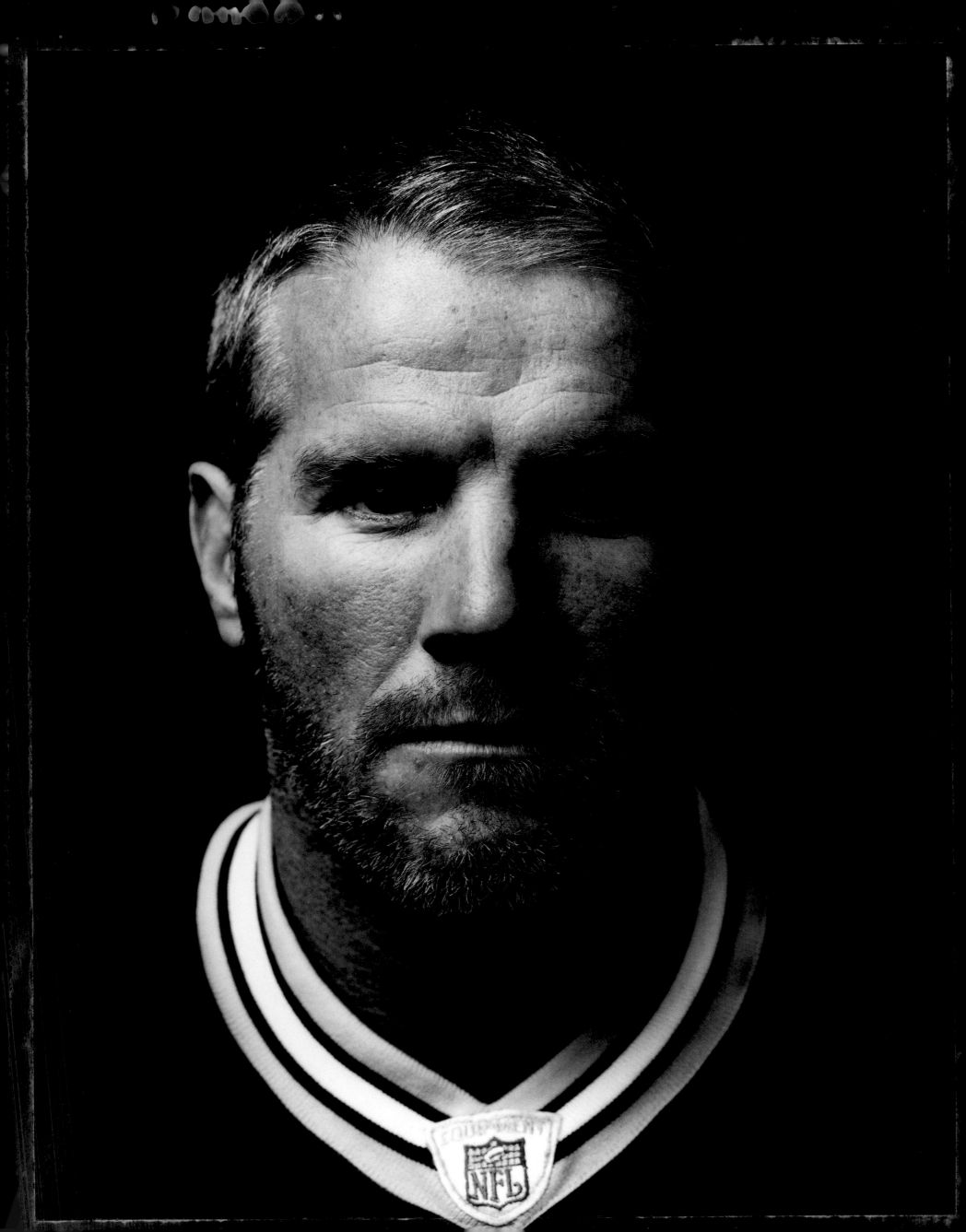

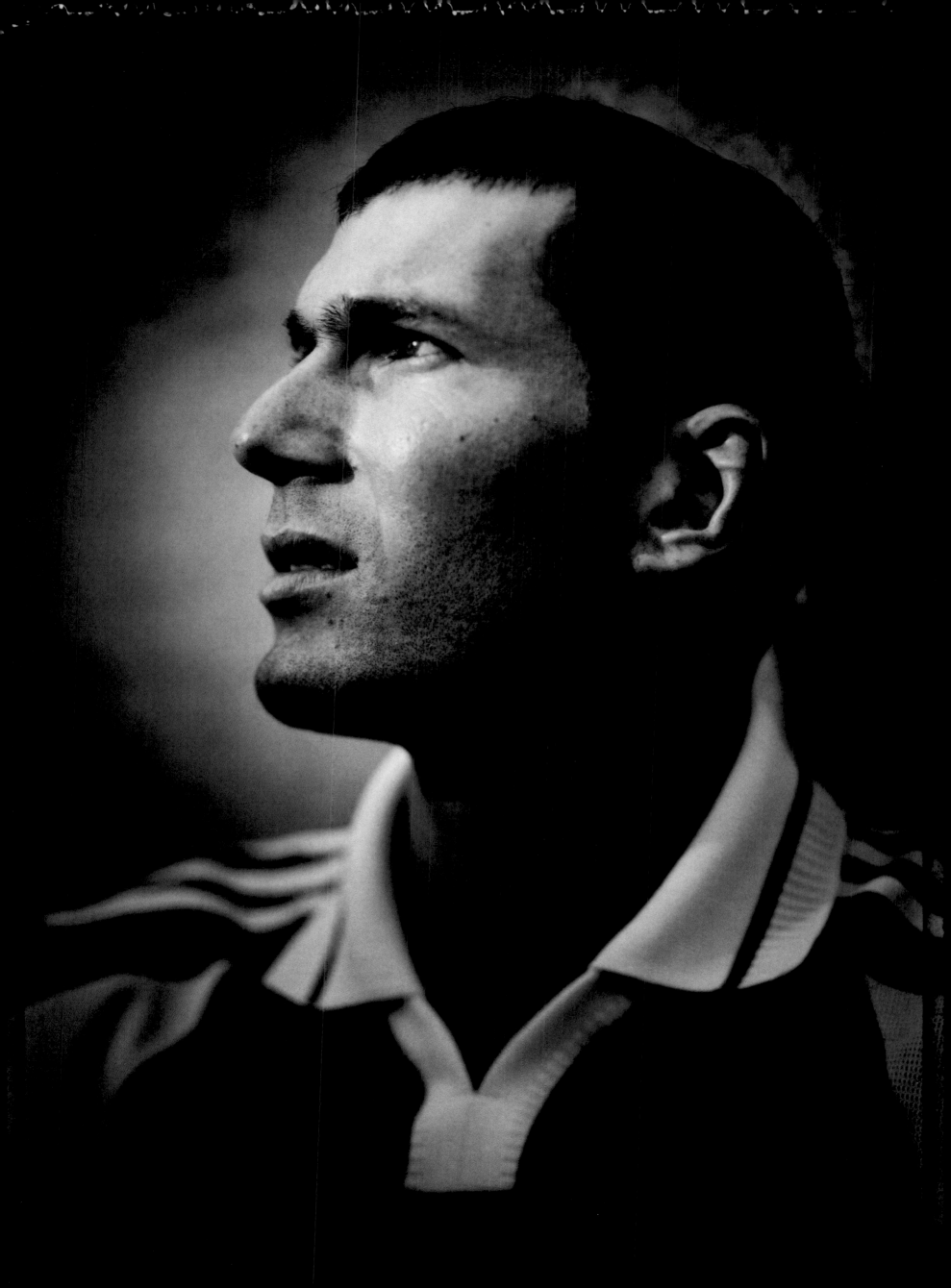

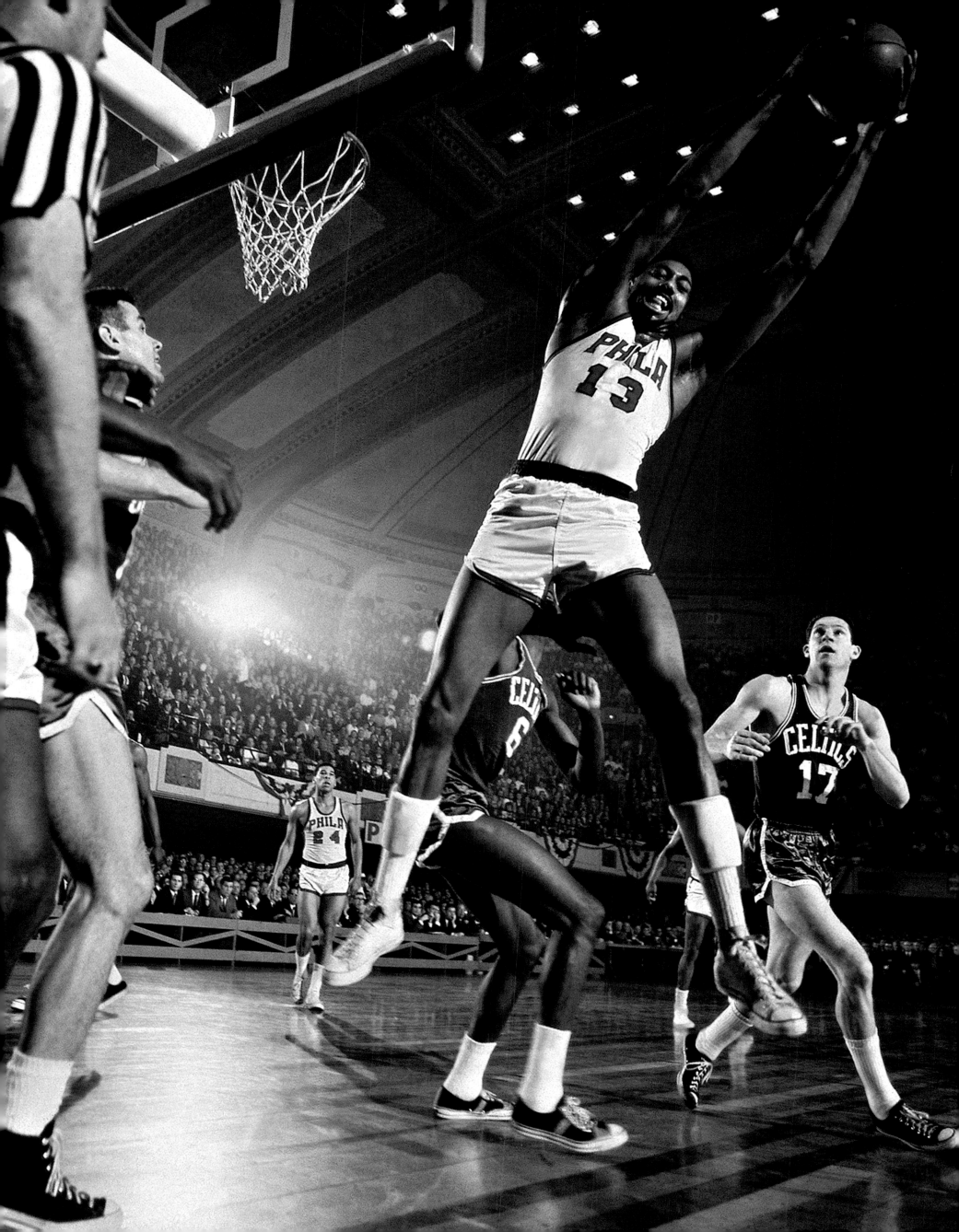

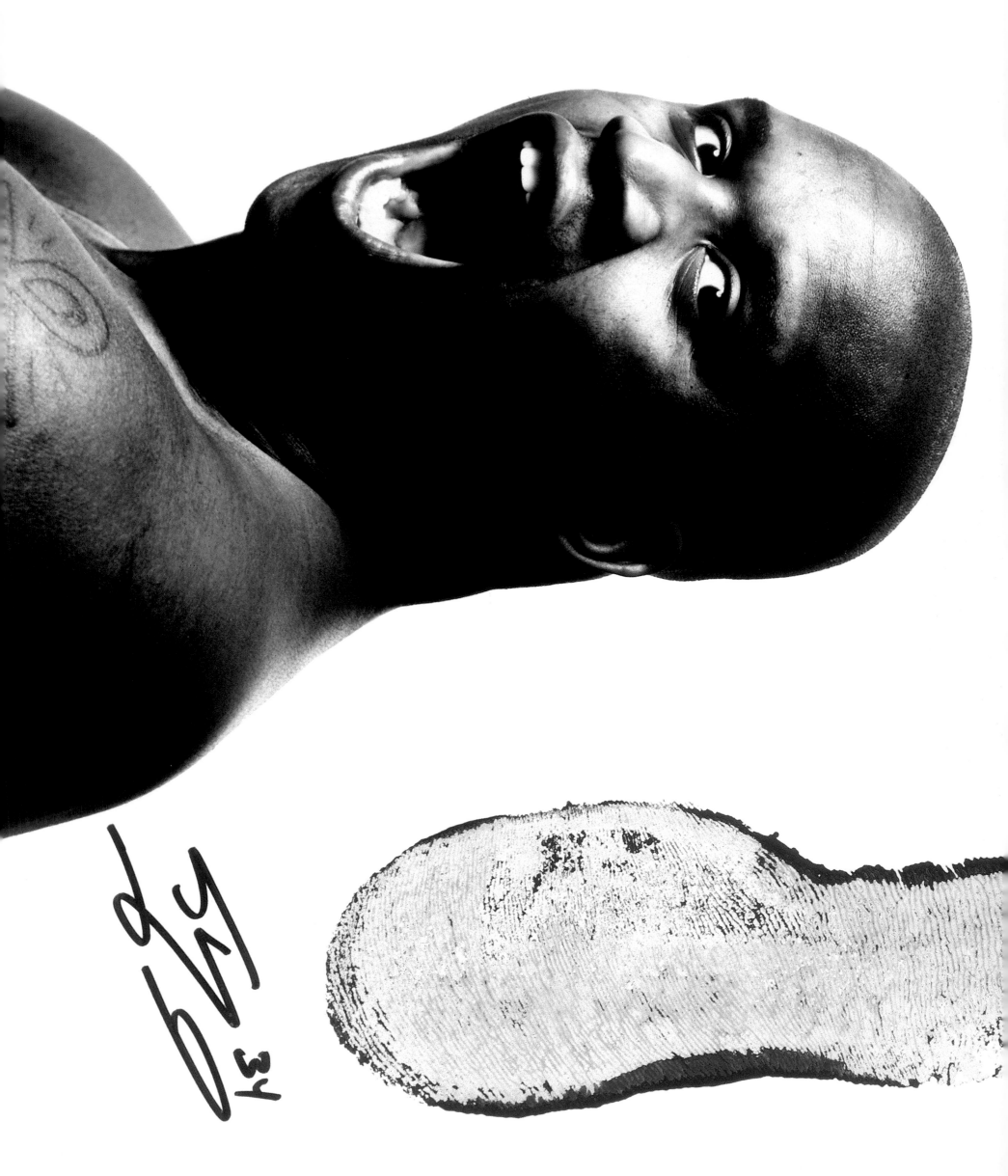

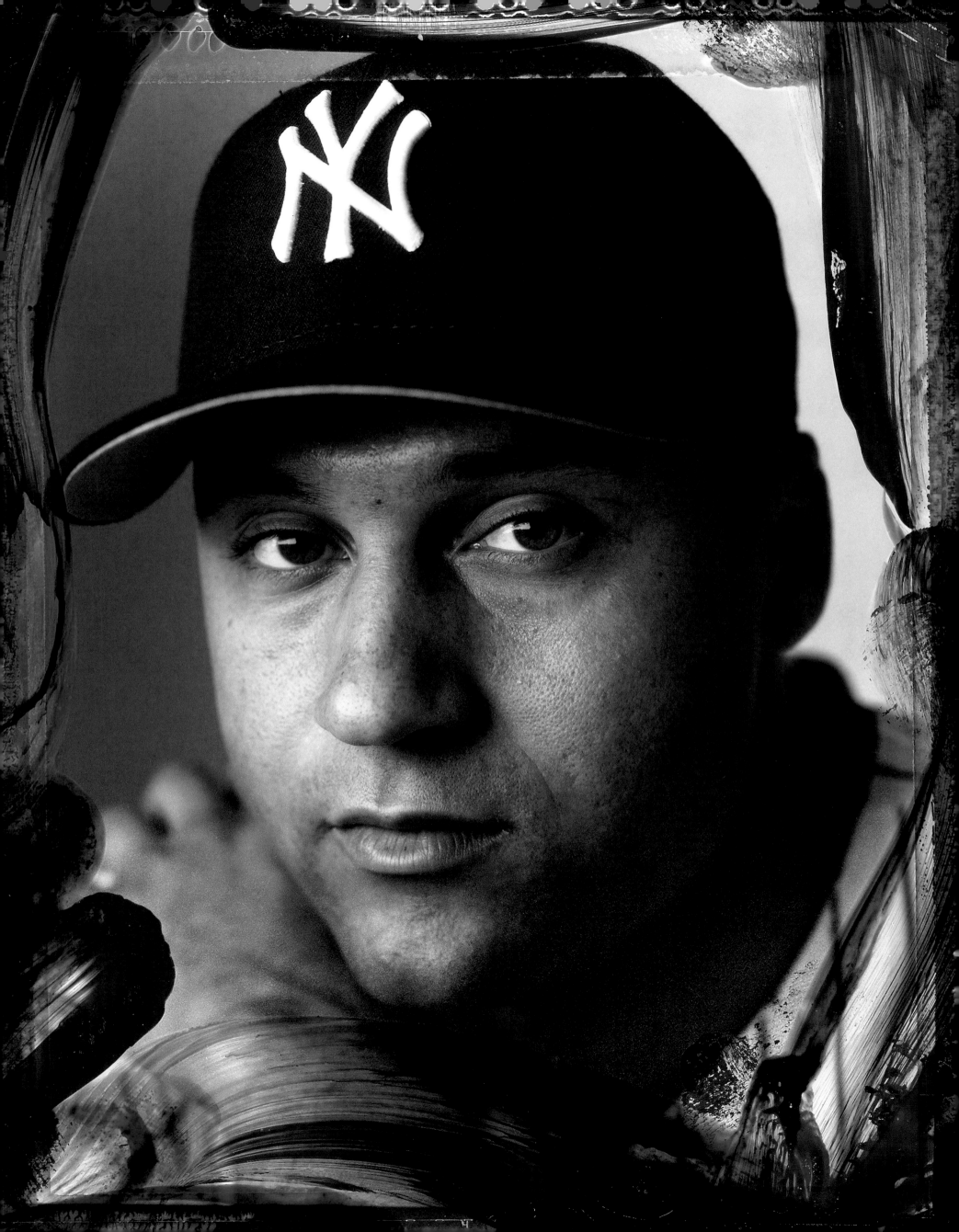

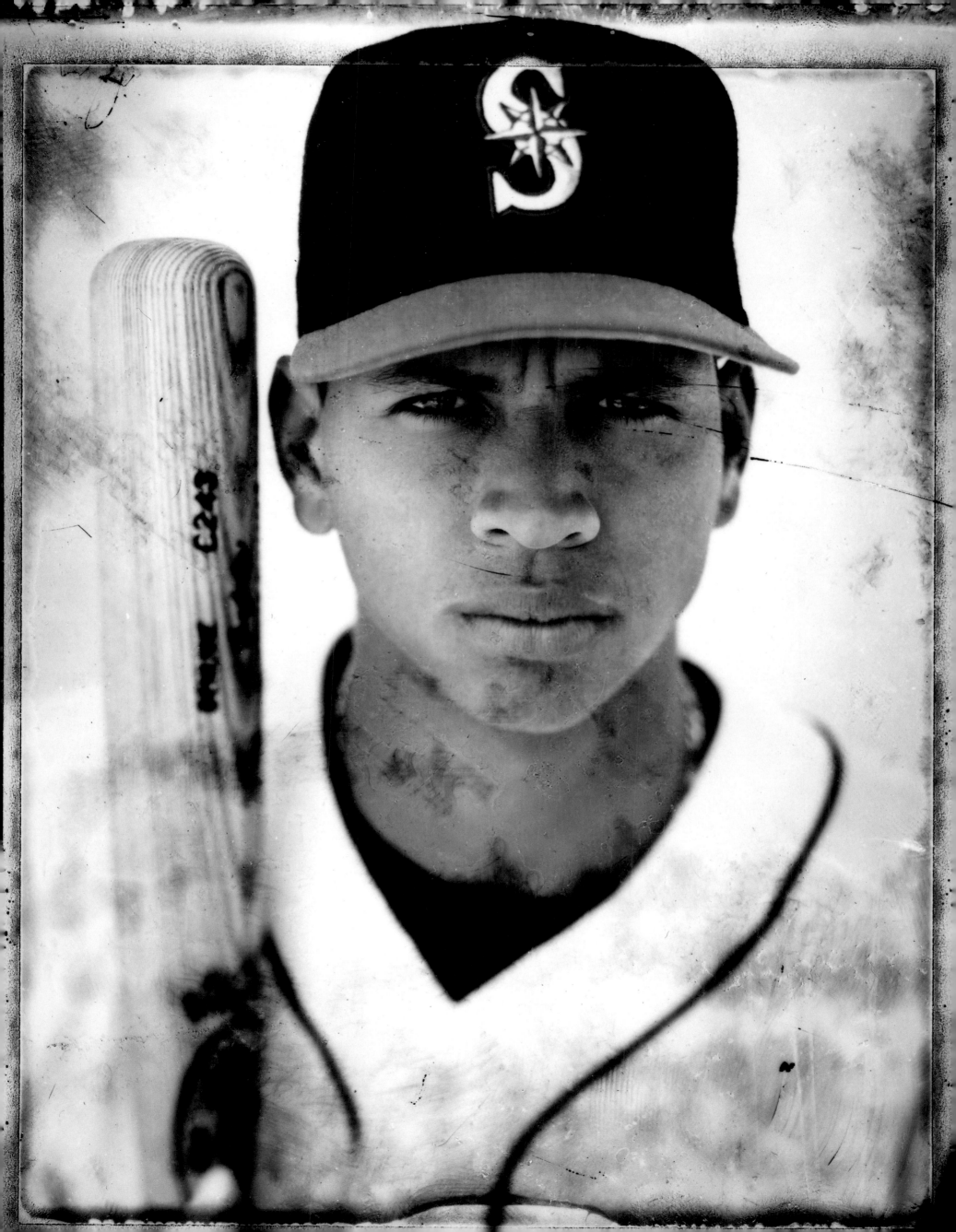

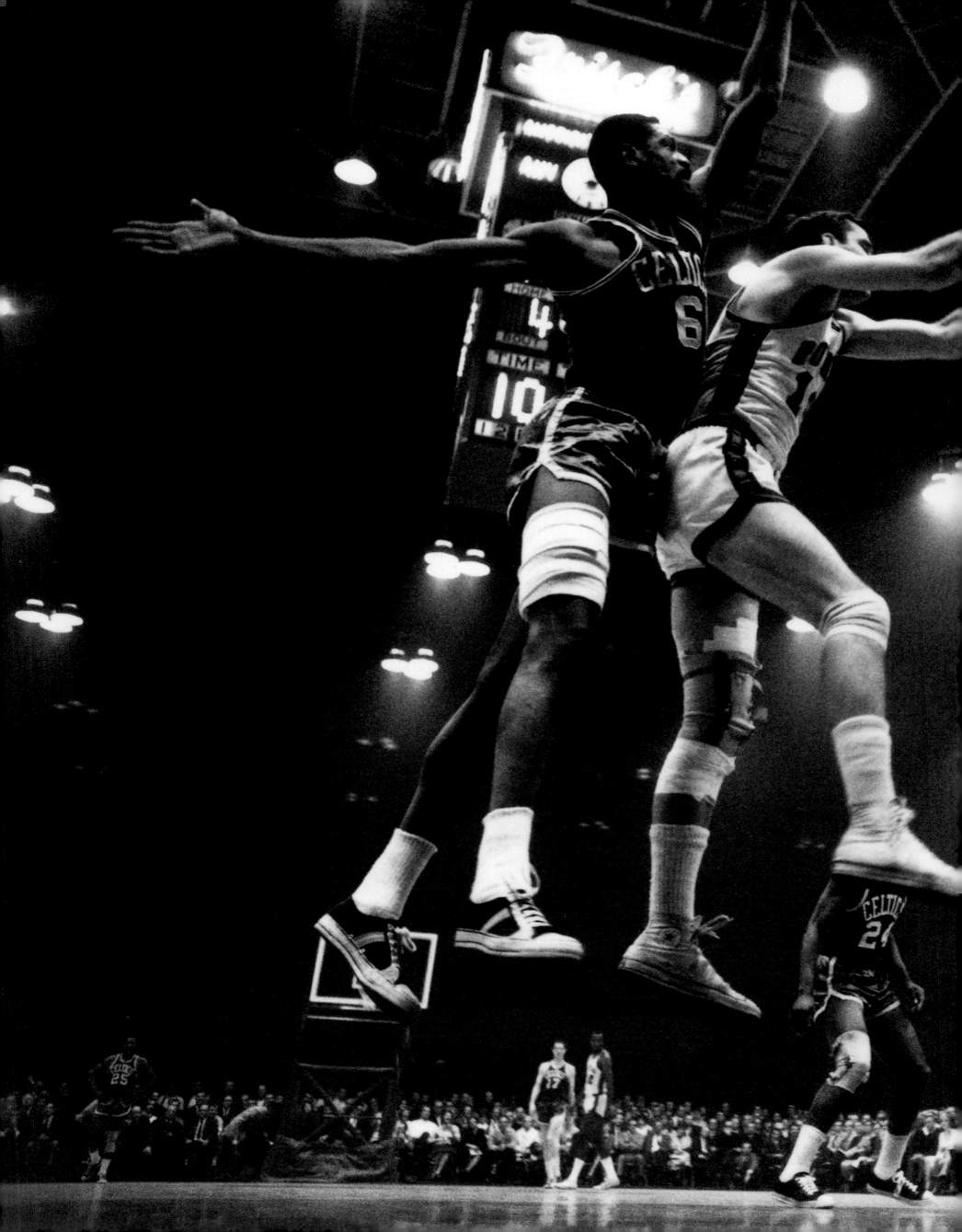

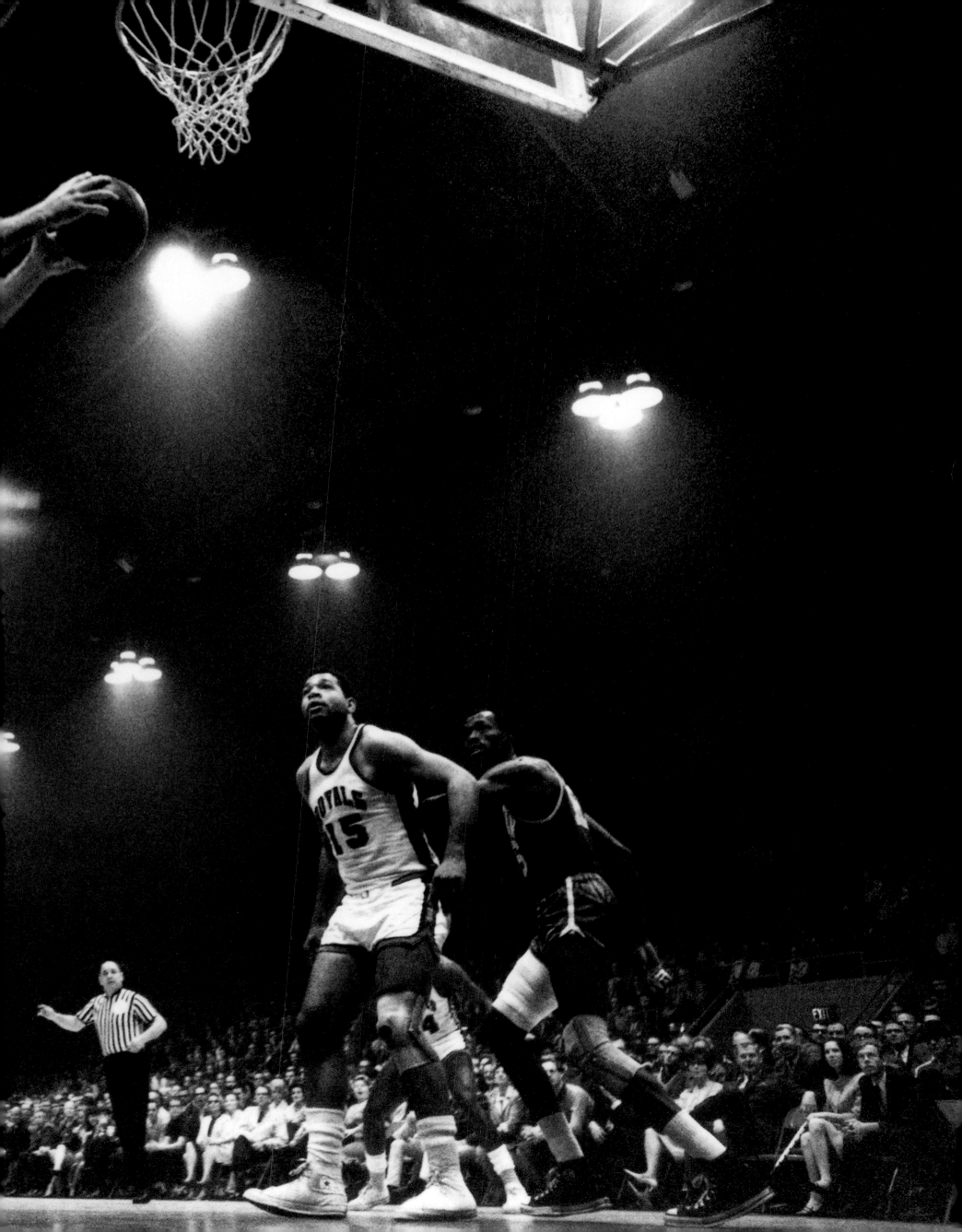

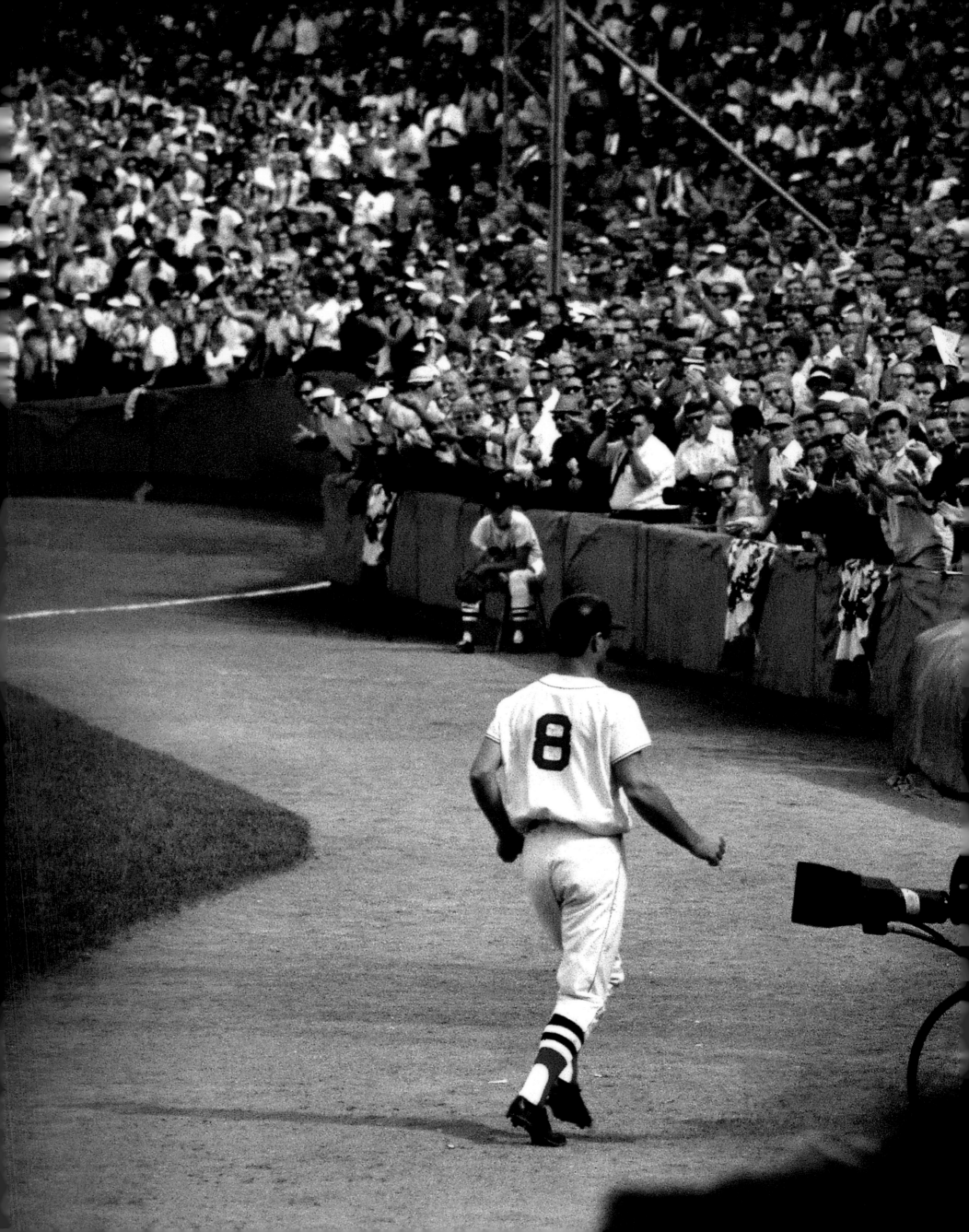

This was for a story in SI about *Hall of Fame baseball players* who were getting up in age. We did Warren Spahn, Willie Mays, Ernie Banks, Bob Feller among others. I shot 8x10 sepia Polaroids. I got *Whitey Ford and Yogi Berra* to pose during spring training. I had never met Whitey before, but I'd worked with Yogi a few times, and *he hated posing.* He couldn't sit still. He was *like a butterfly,* whenever you got next to him he'd move away. *I love this picture.* For two guys in their 70s, they look cute; there was a *little - boy quality* to them. A couple of years went by, and I was at spring training again. I hadn't seen Yogi or Whitey since we'd taken the picture. I said to Yogi, "Walter Iooss, remember, I took that picture of you..." And he said, "Hey Whitey, here's the guy who took *that horrible picture of us."* Whitey came over and said, "Oh, my family *hated that picture.* Said you made me look like a little old guy." I thought they were putting me on. I said, "Are you kidding me? I love that picture." Whitey said, "Love it? We hate that picture." *You can't win all the time.*

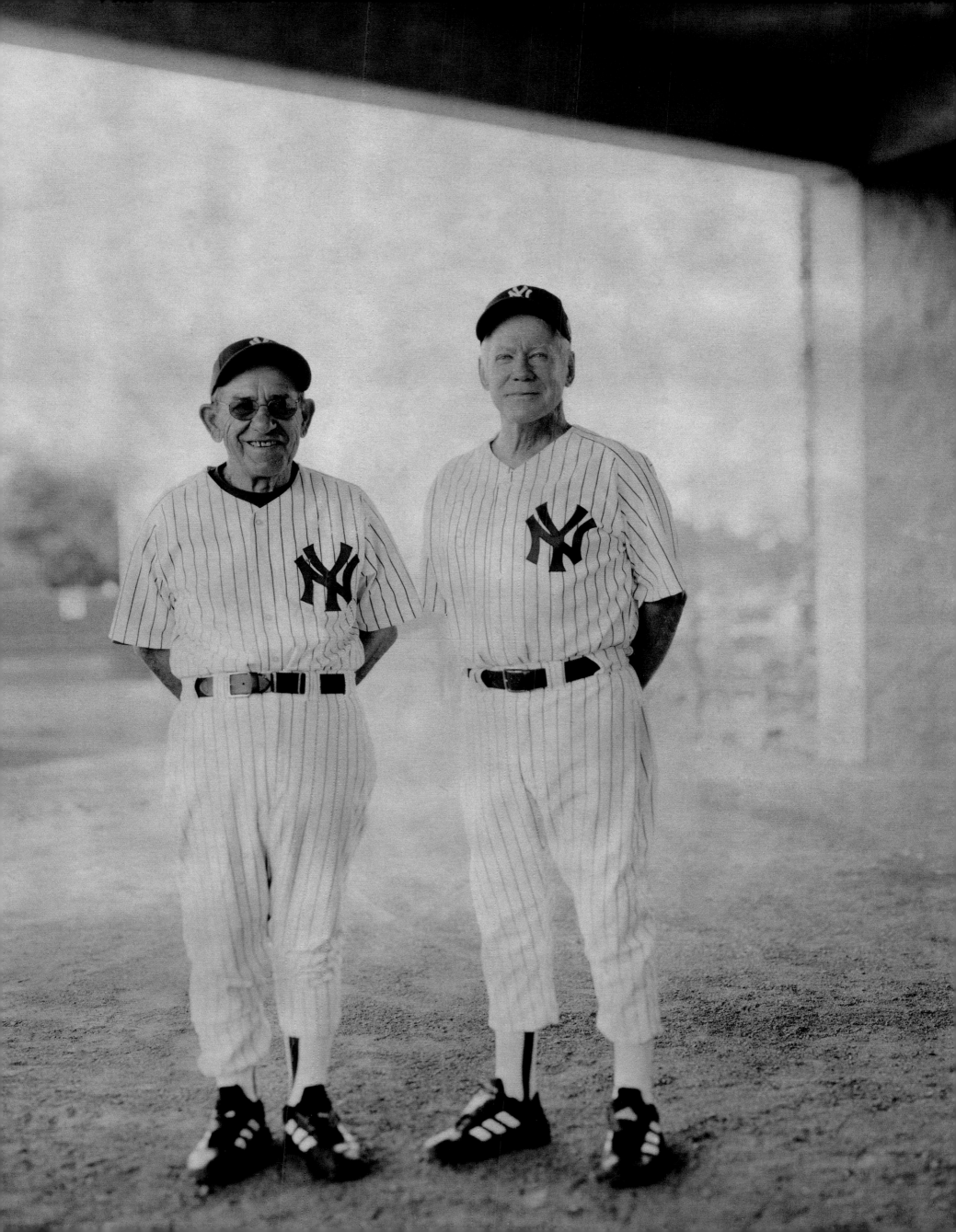

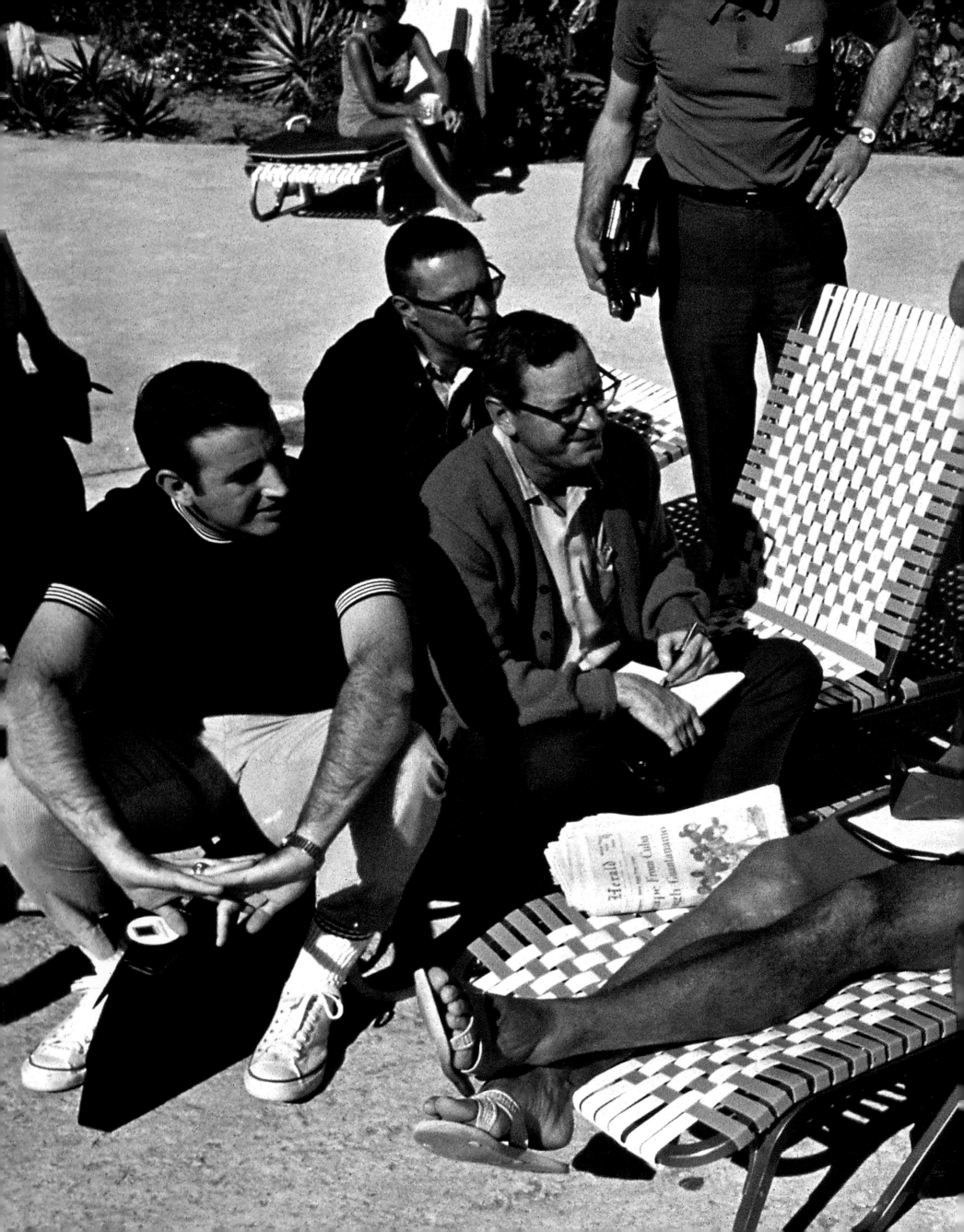

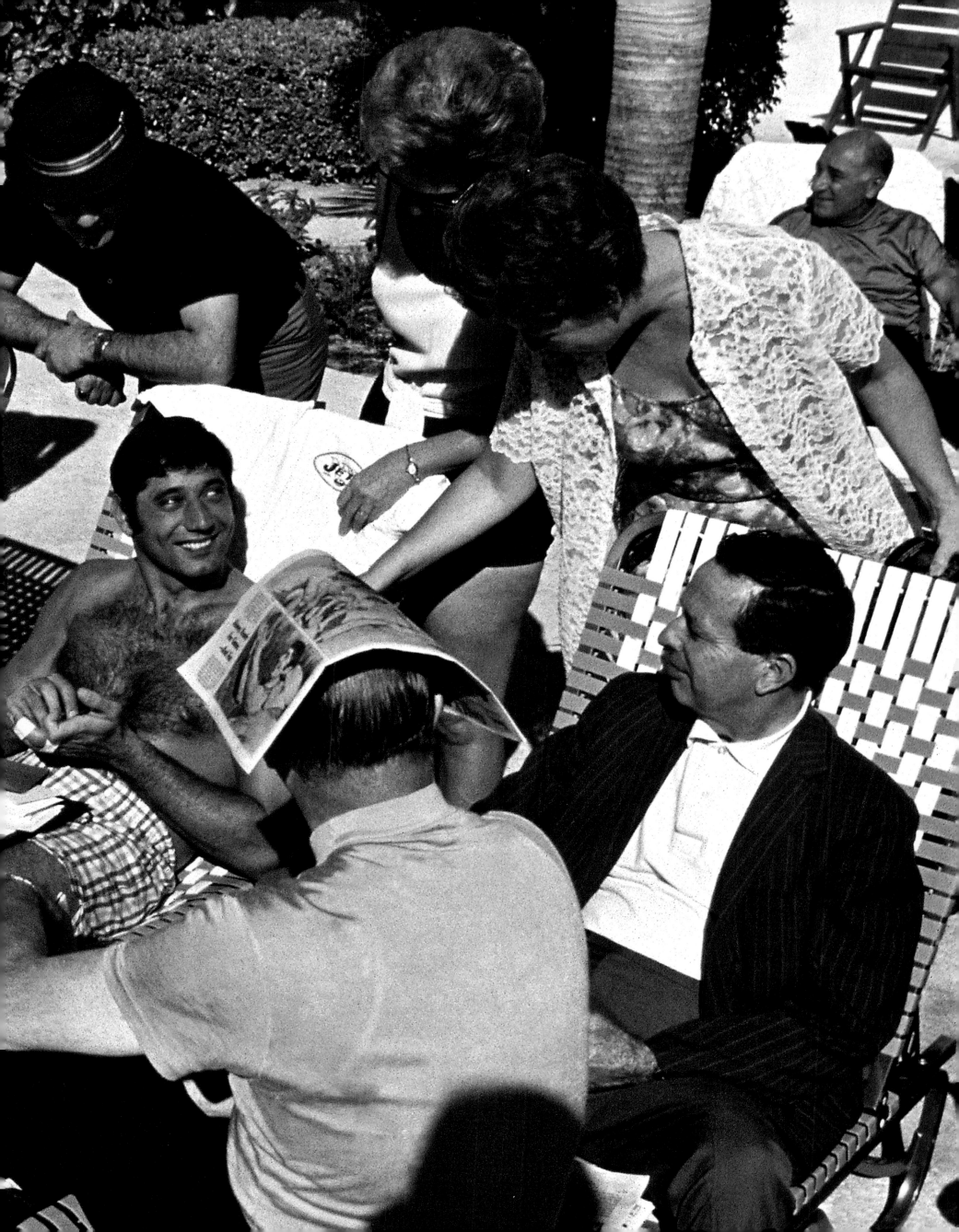

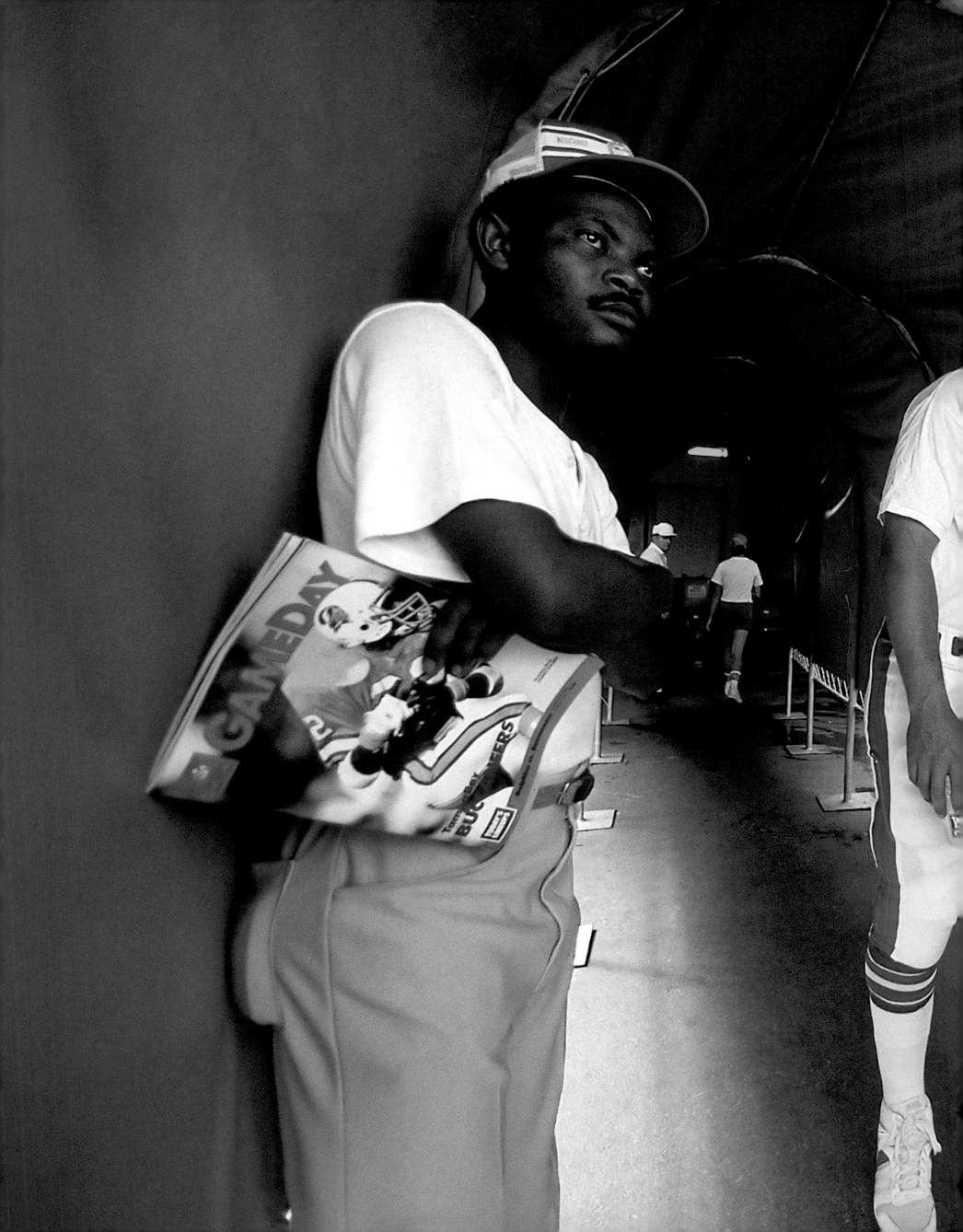

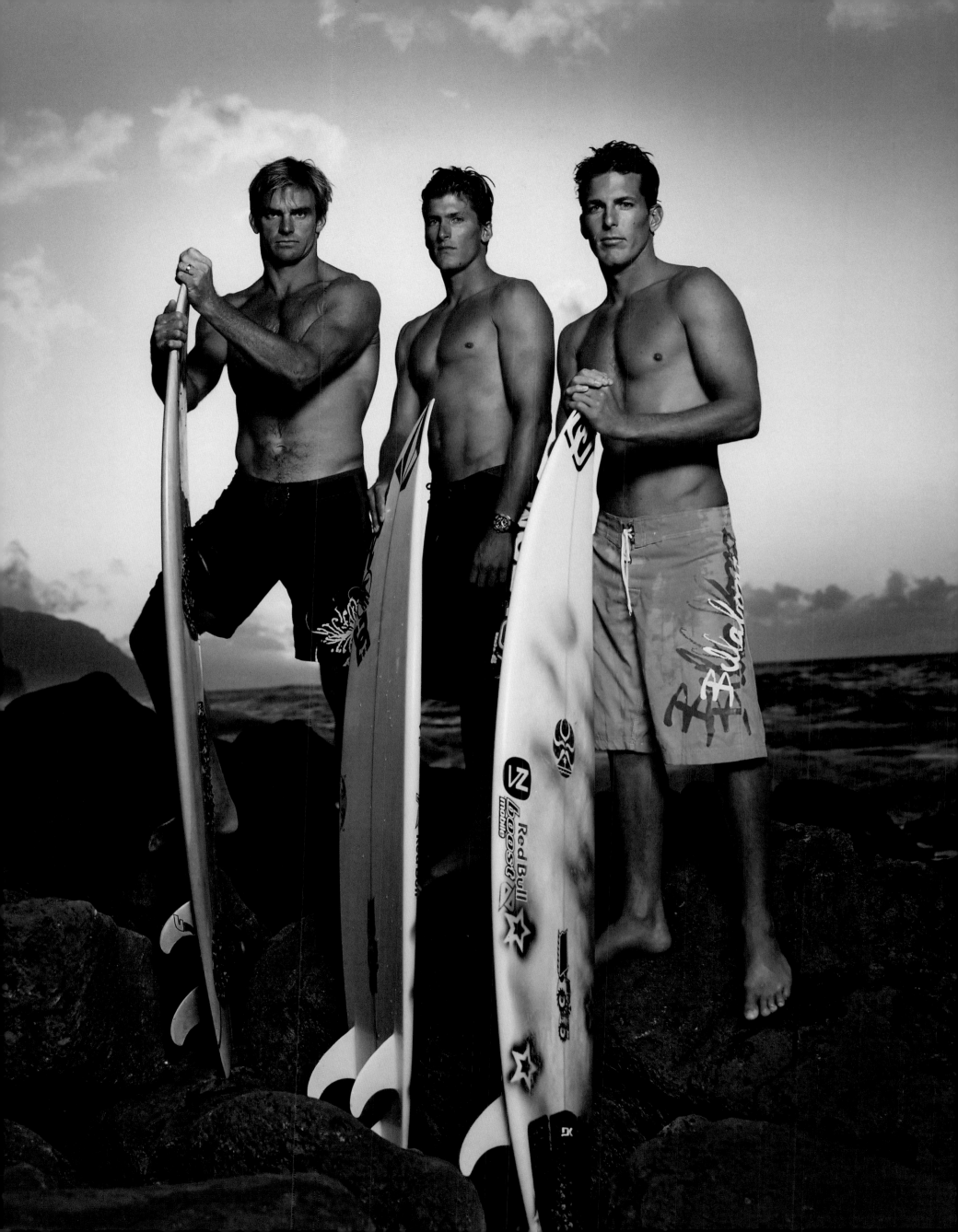

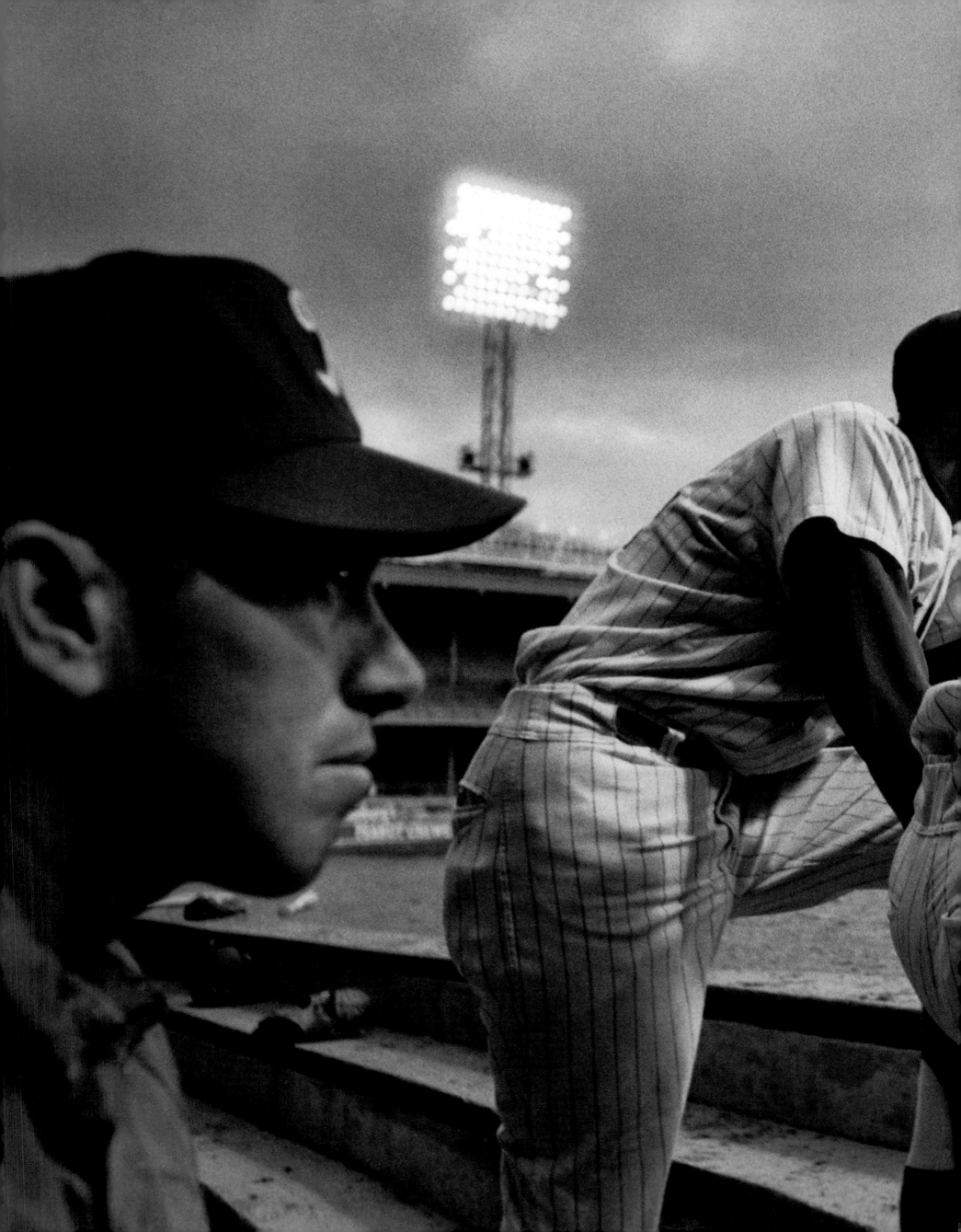

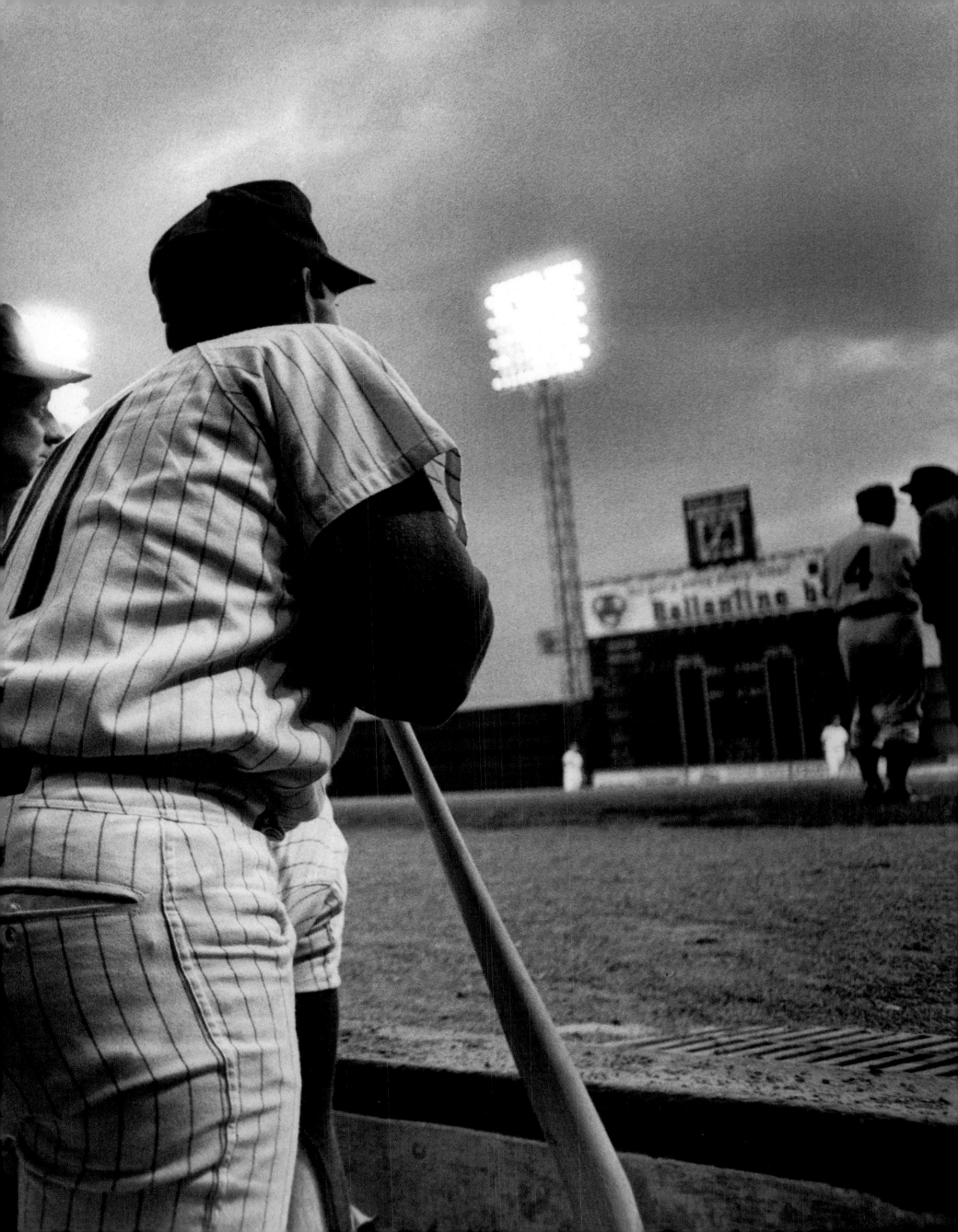

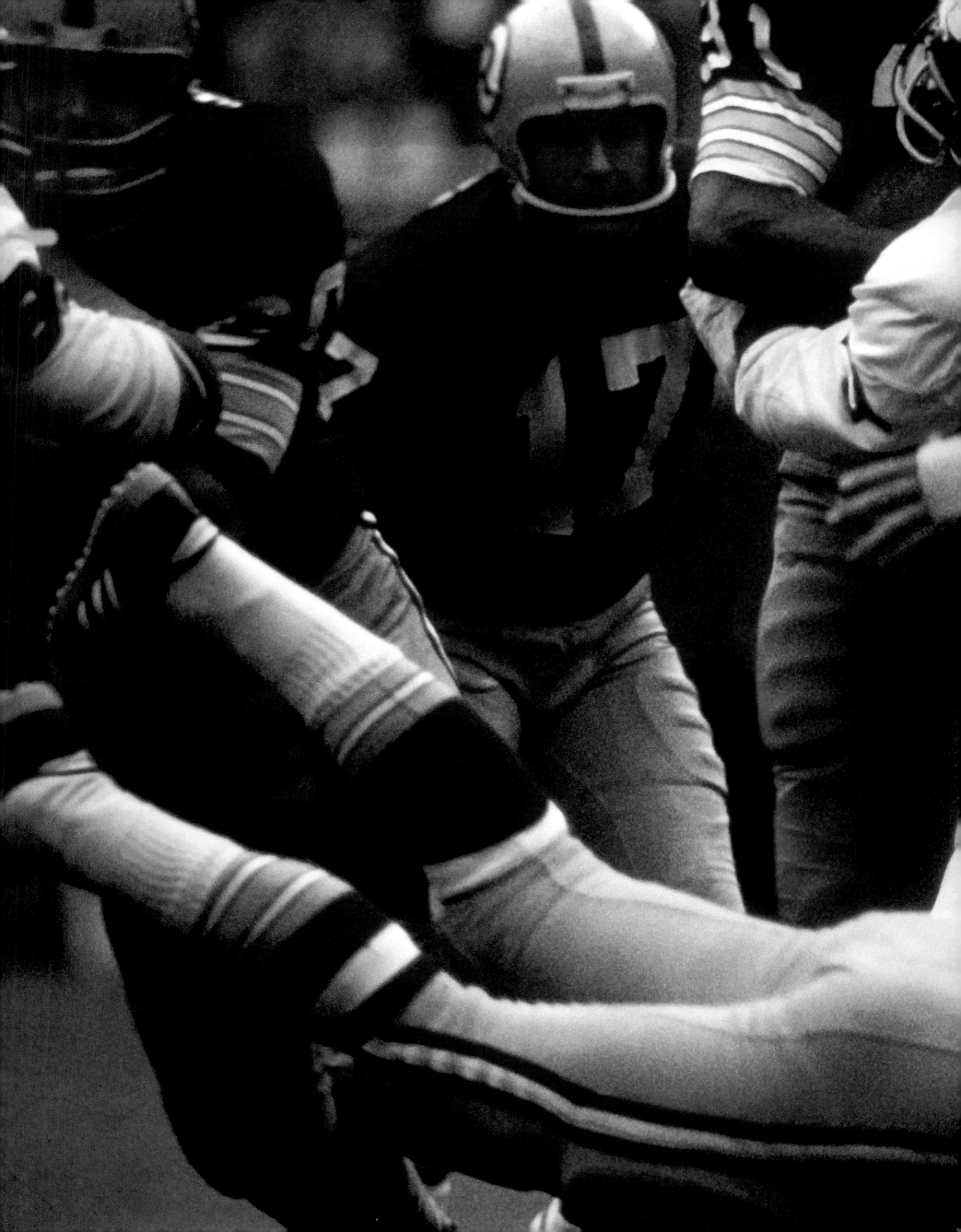

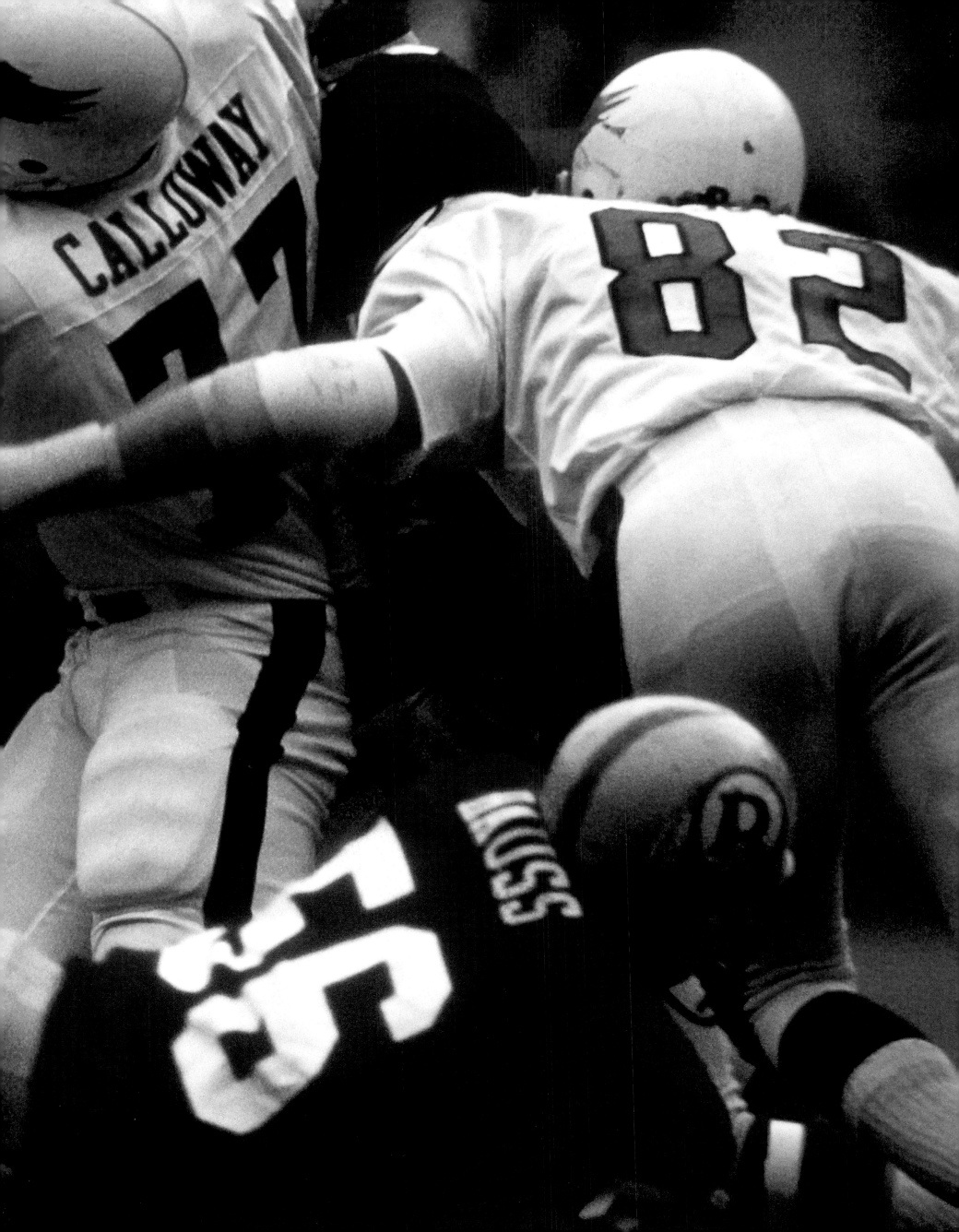

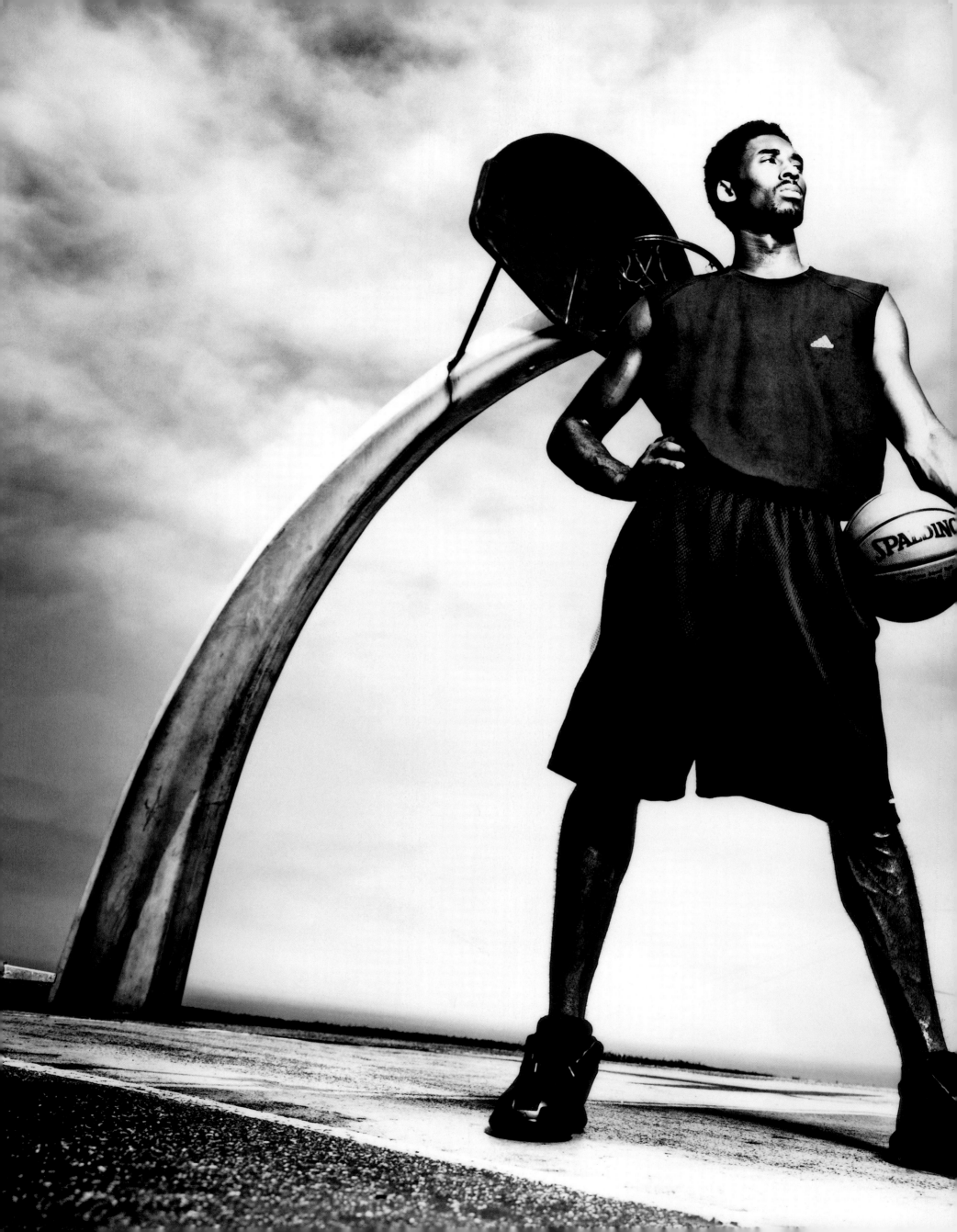

During his playing days I never really had a chance to meet Johnny Unitas. I kept asking the magazine's editors, "You've got to send me to do Johnny Unitas. *I've got to photograph him once."* Finally, in 2001, a story came up about the health problems of great veterans of football. Johnny of *the golden arm had* hurt his hand so badly during his career that he couldn't brush his teeth, he couldn't lift a cup of coffee anymore. They sent me to his home outside of Baltimore. *I was nervous* because he was the *last of my boyhood heroes still alive.* There were photographs in his study, all these memories of Johnny, including two action covers I had shot of him. And then in walked the incomparable number 19. All I wanted to do was *talk to him;* I couldn't have cared less about the picture. After the shoot *I teared up in the car.* It was so moving for me; all these emotions from childhood. *There was no one else like him for me.*

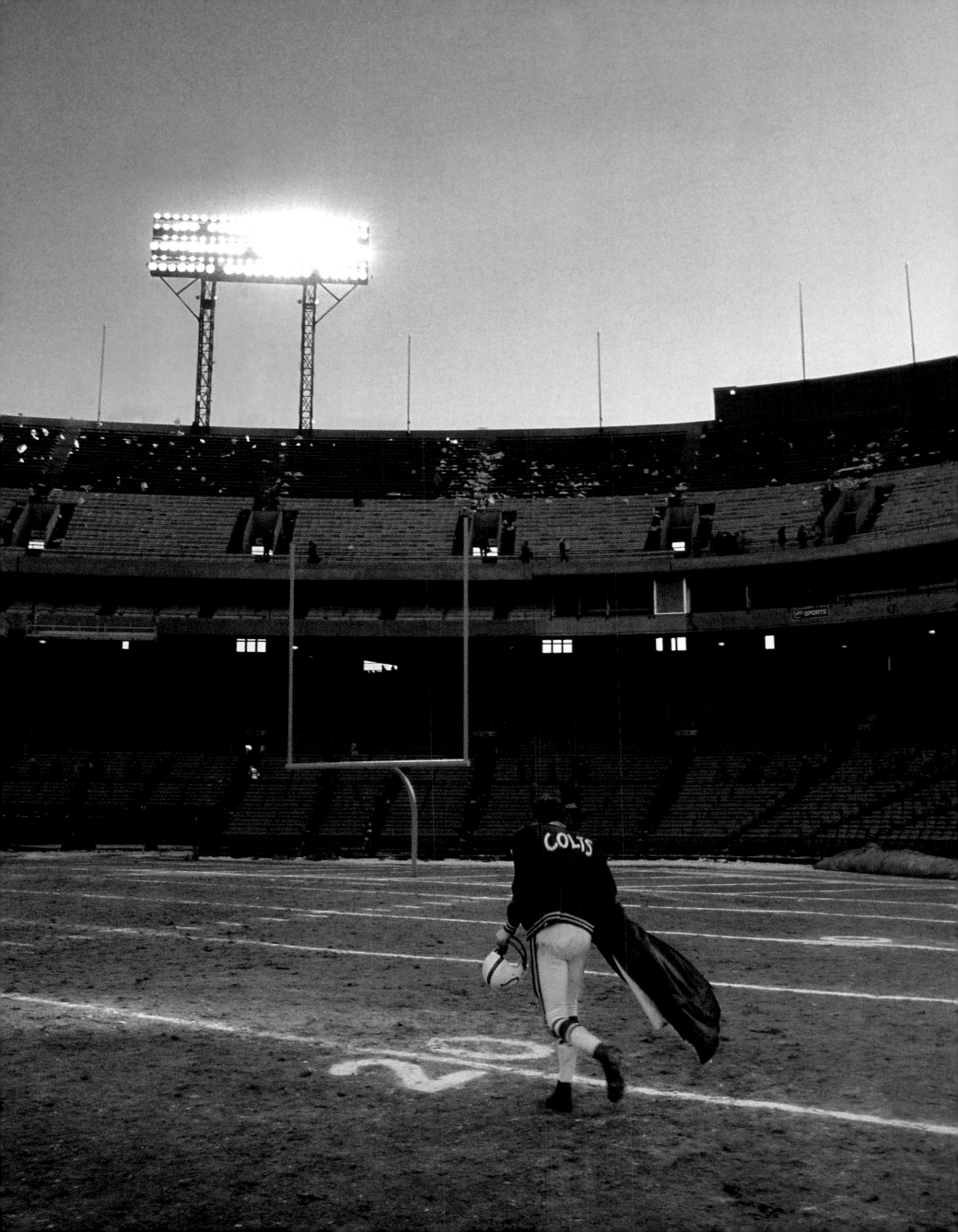

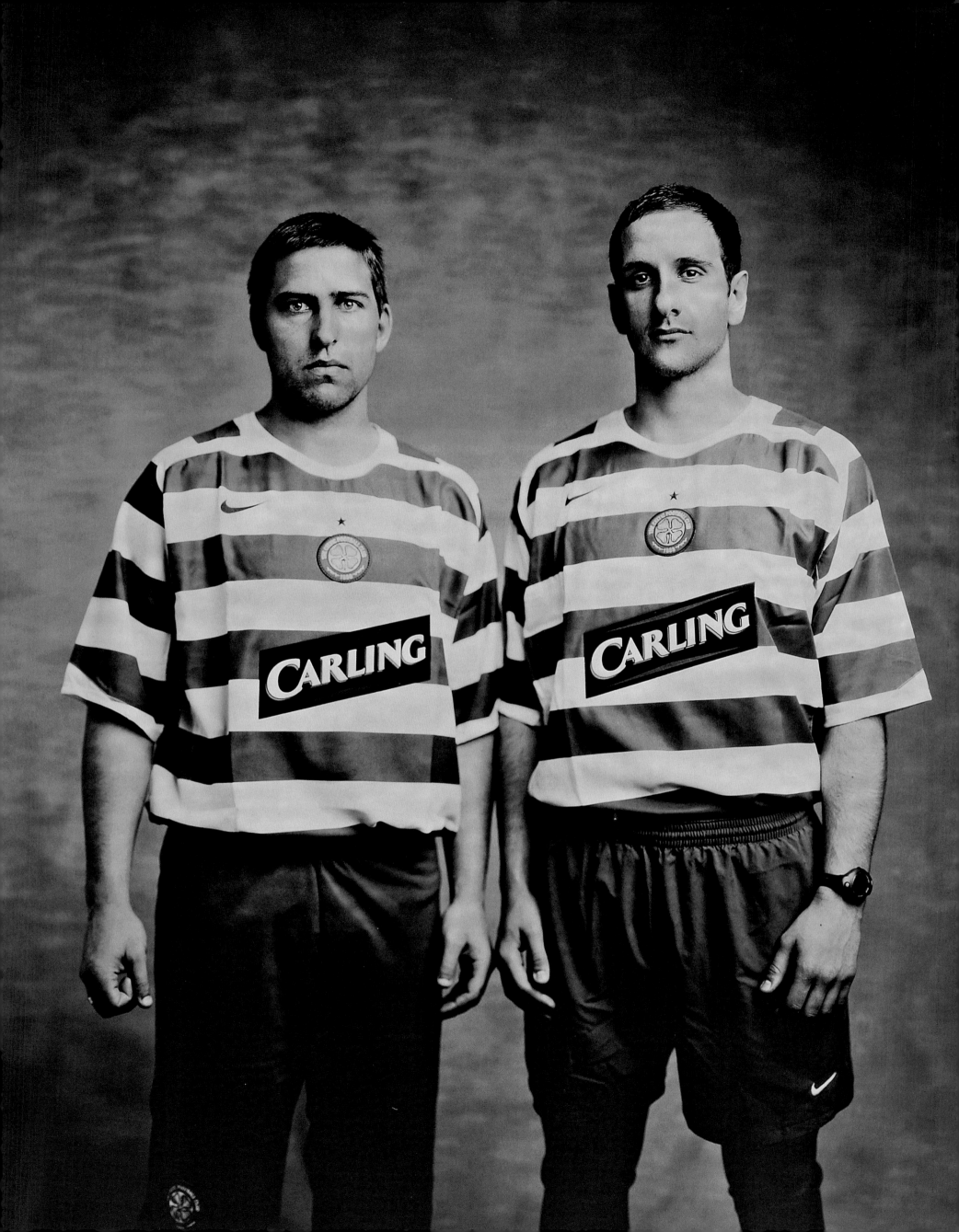

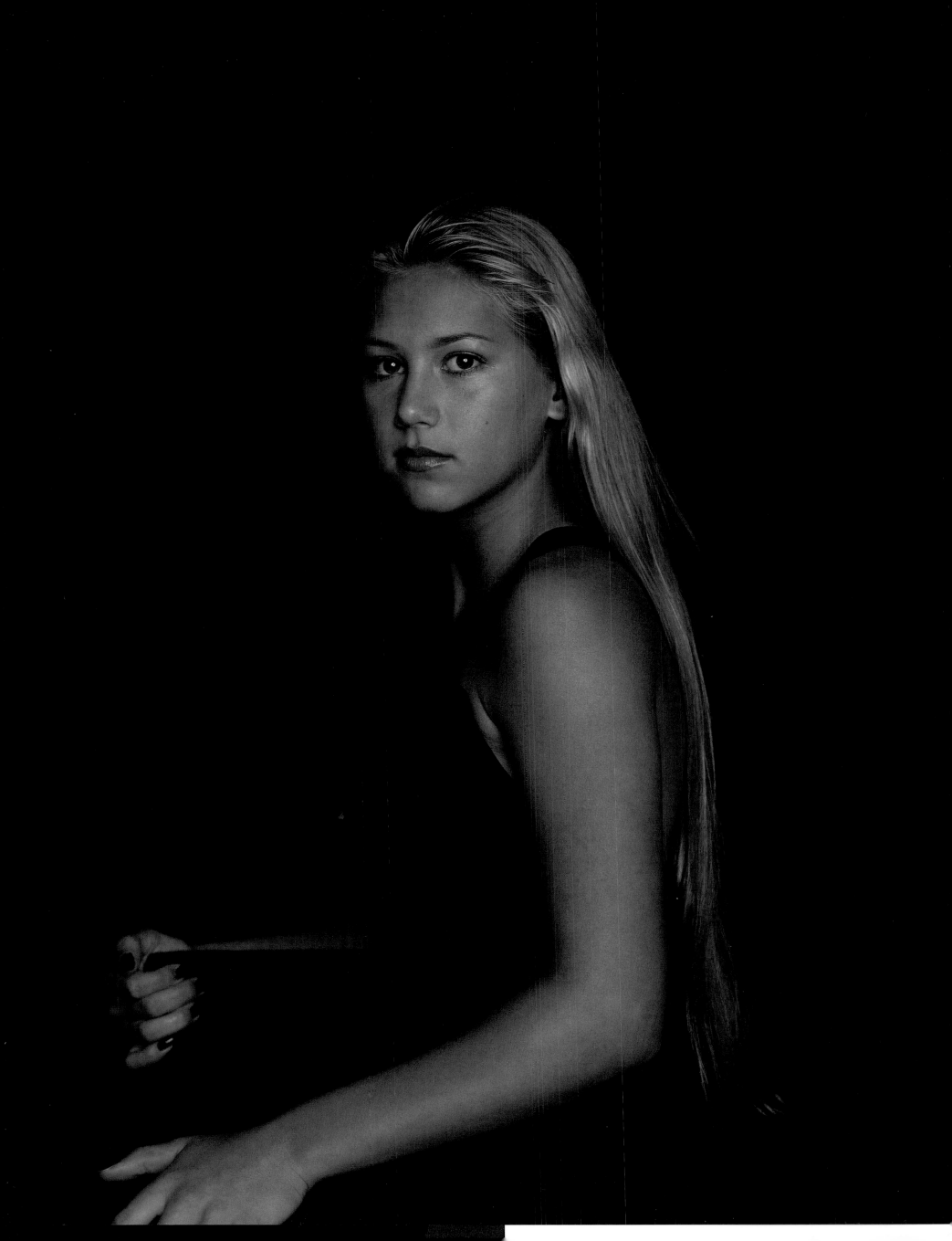

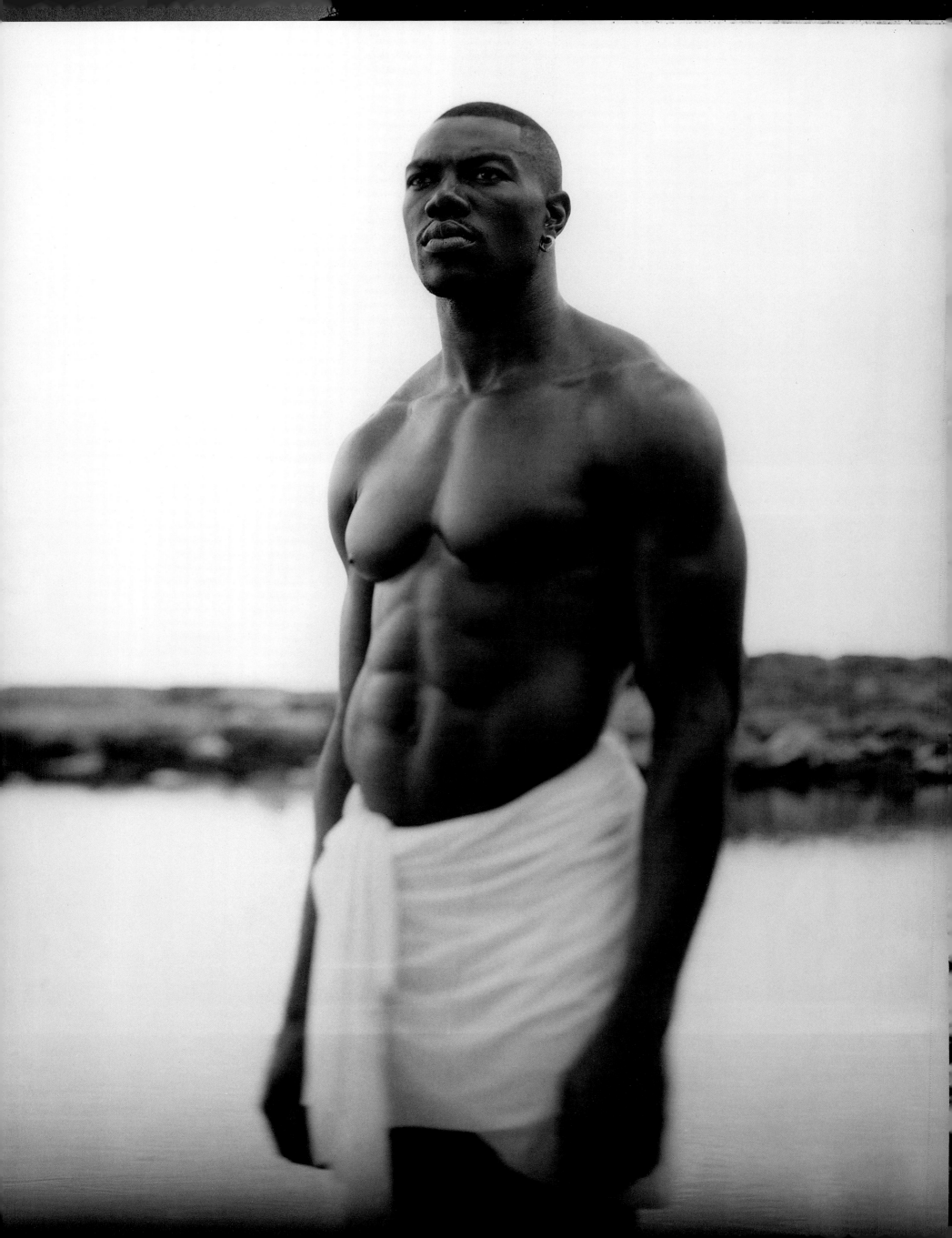

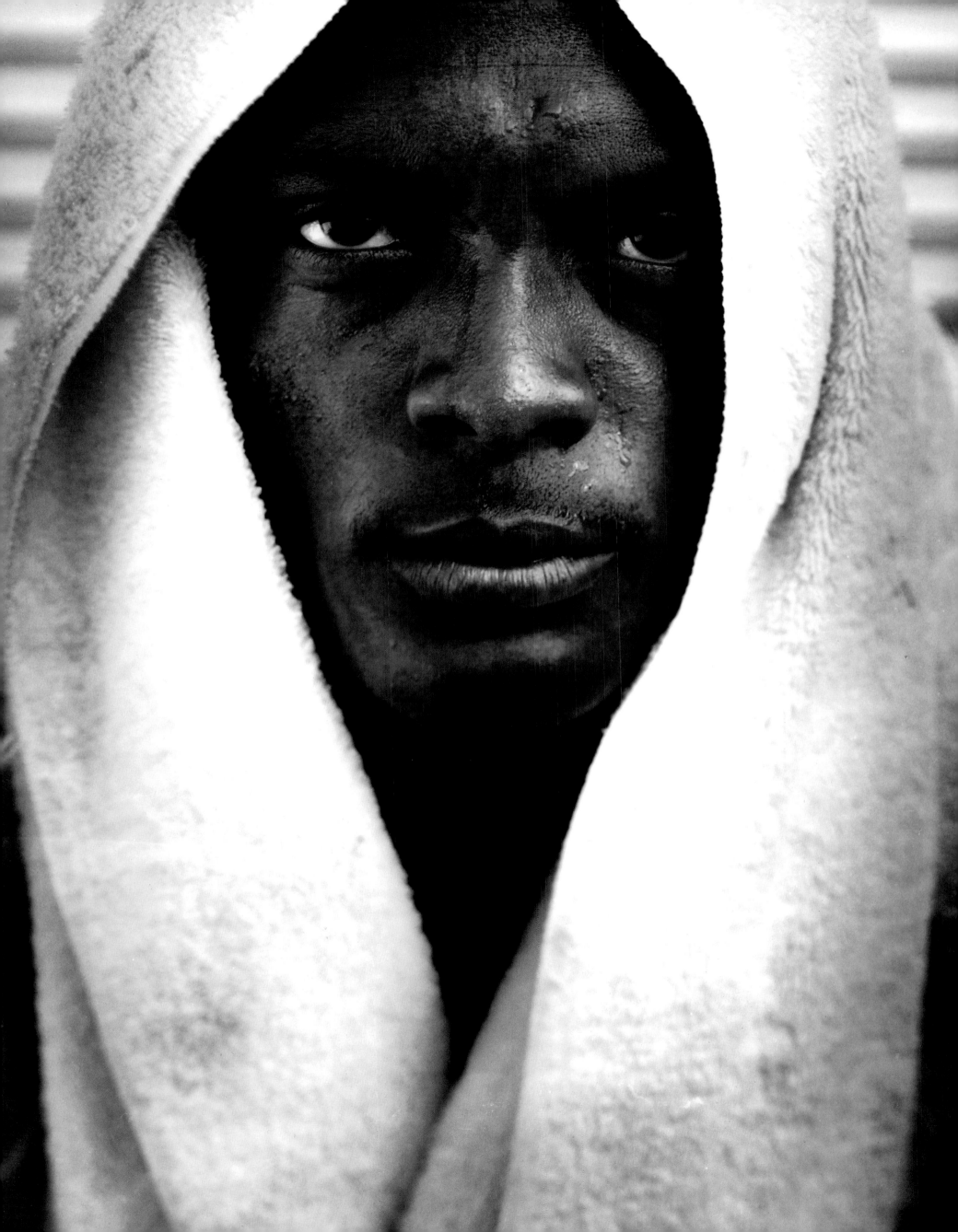

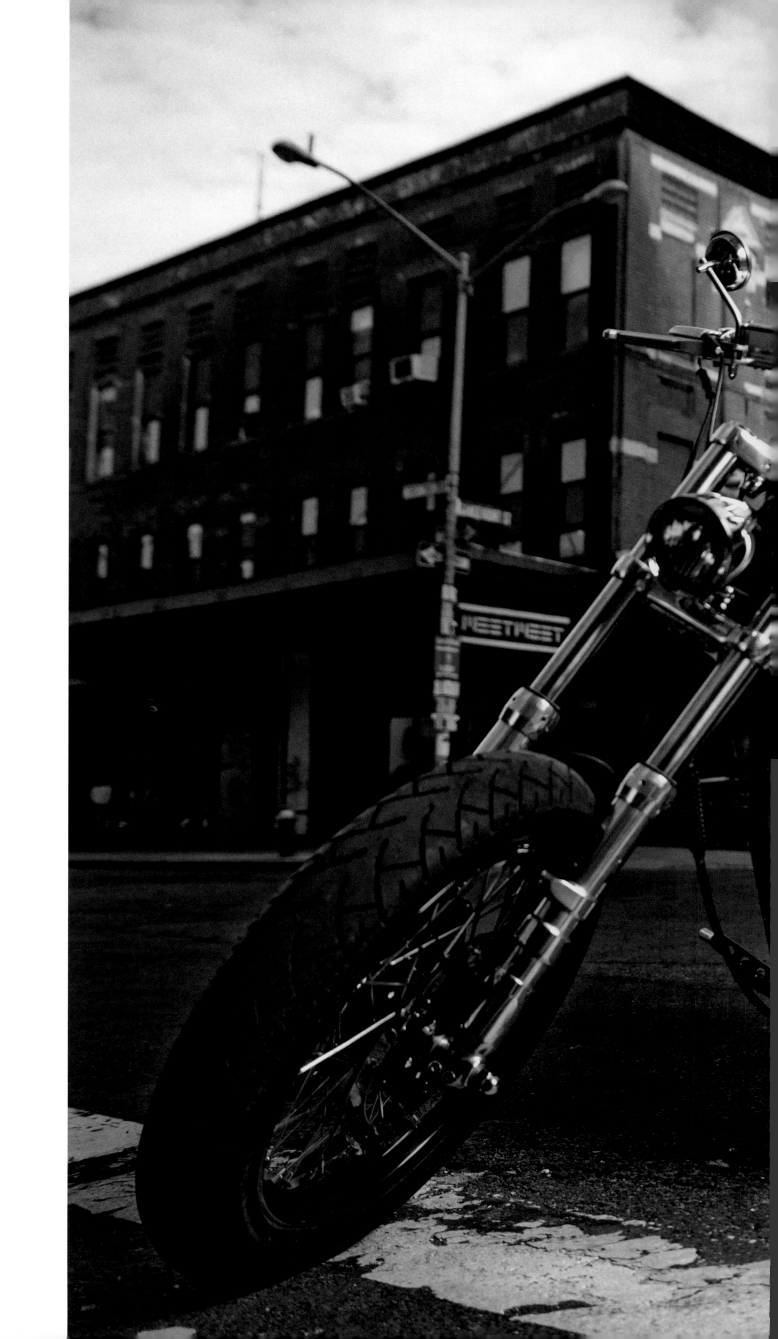

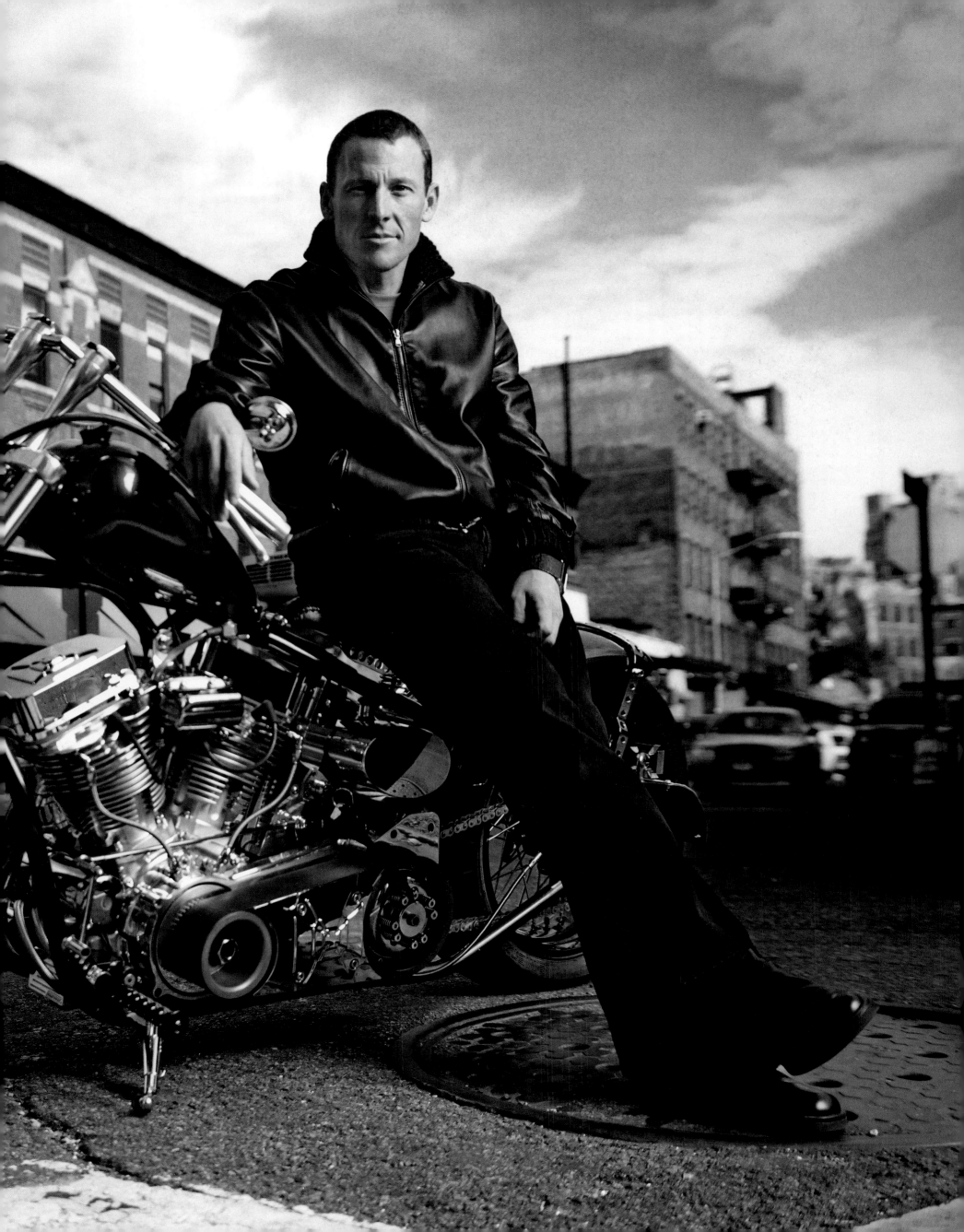

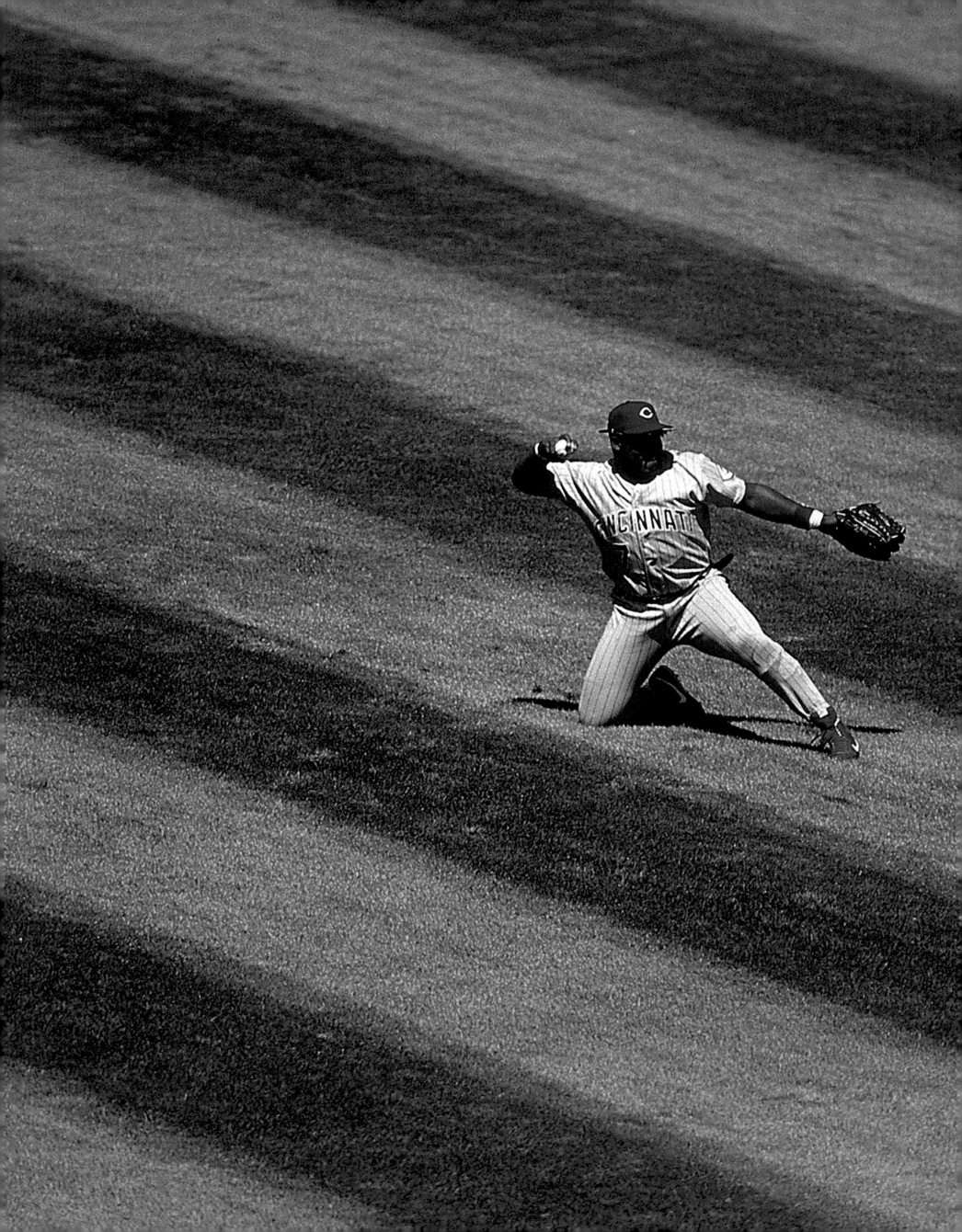

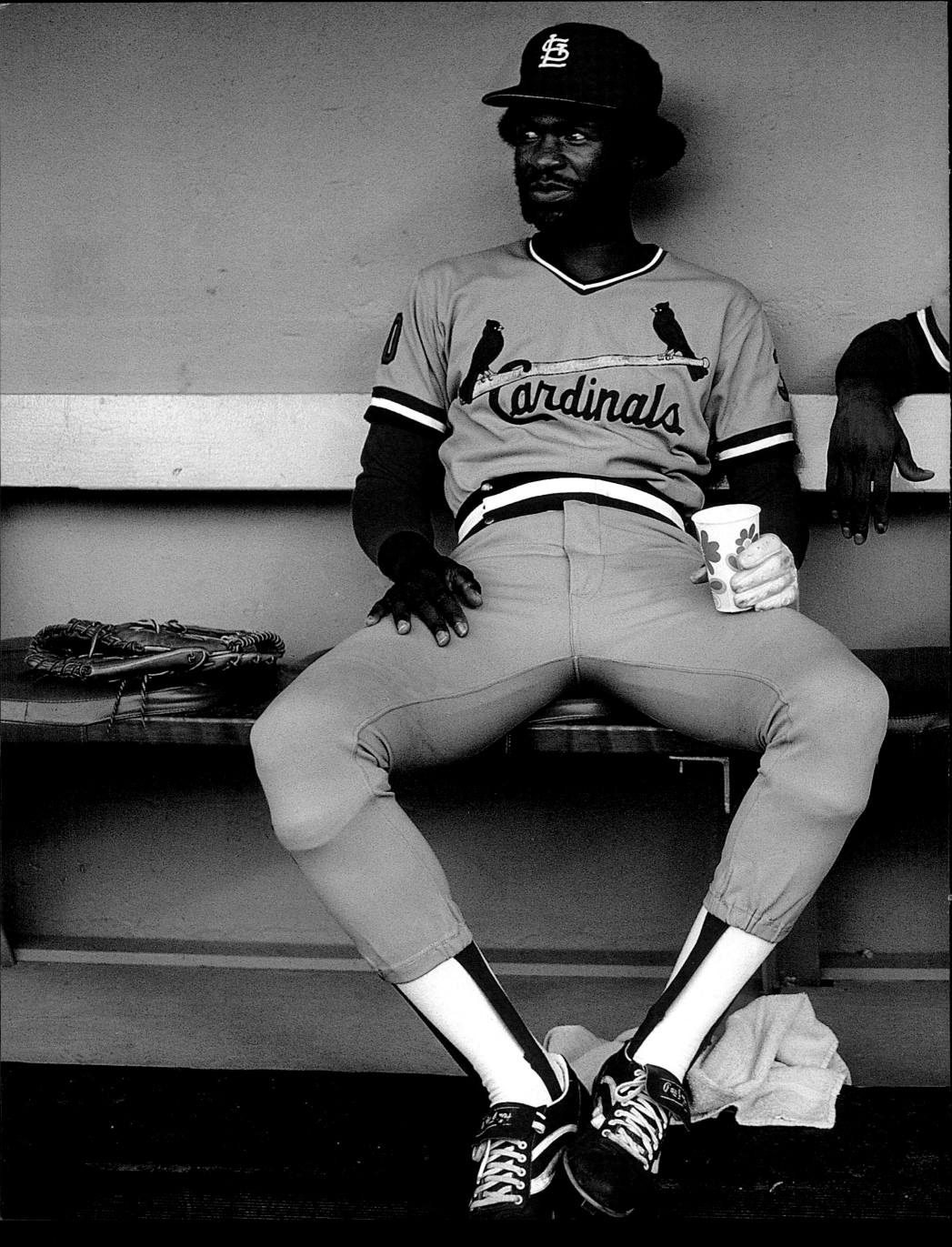

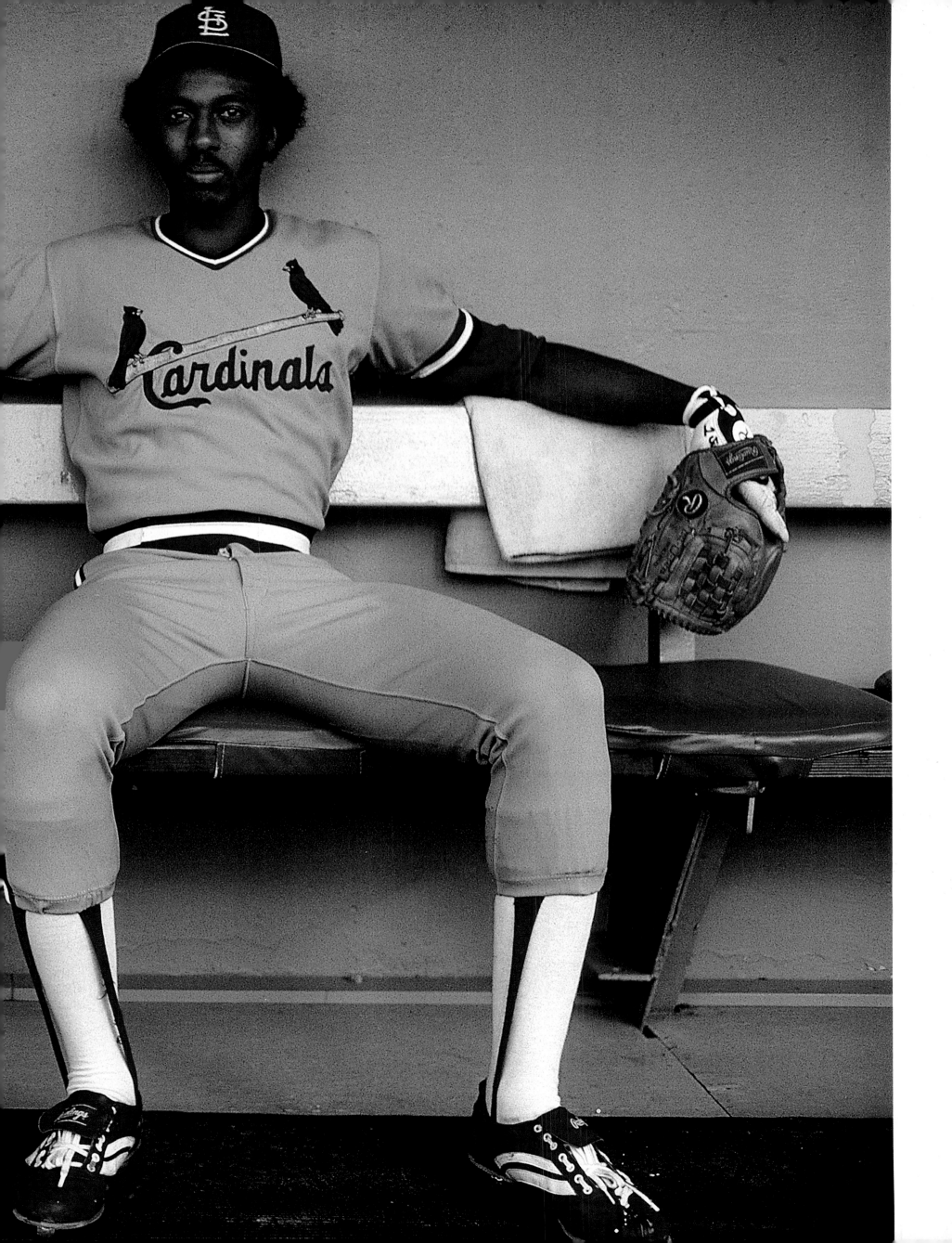

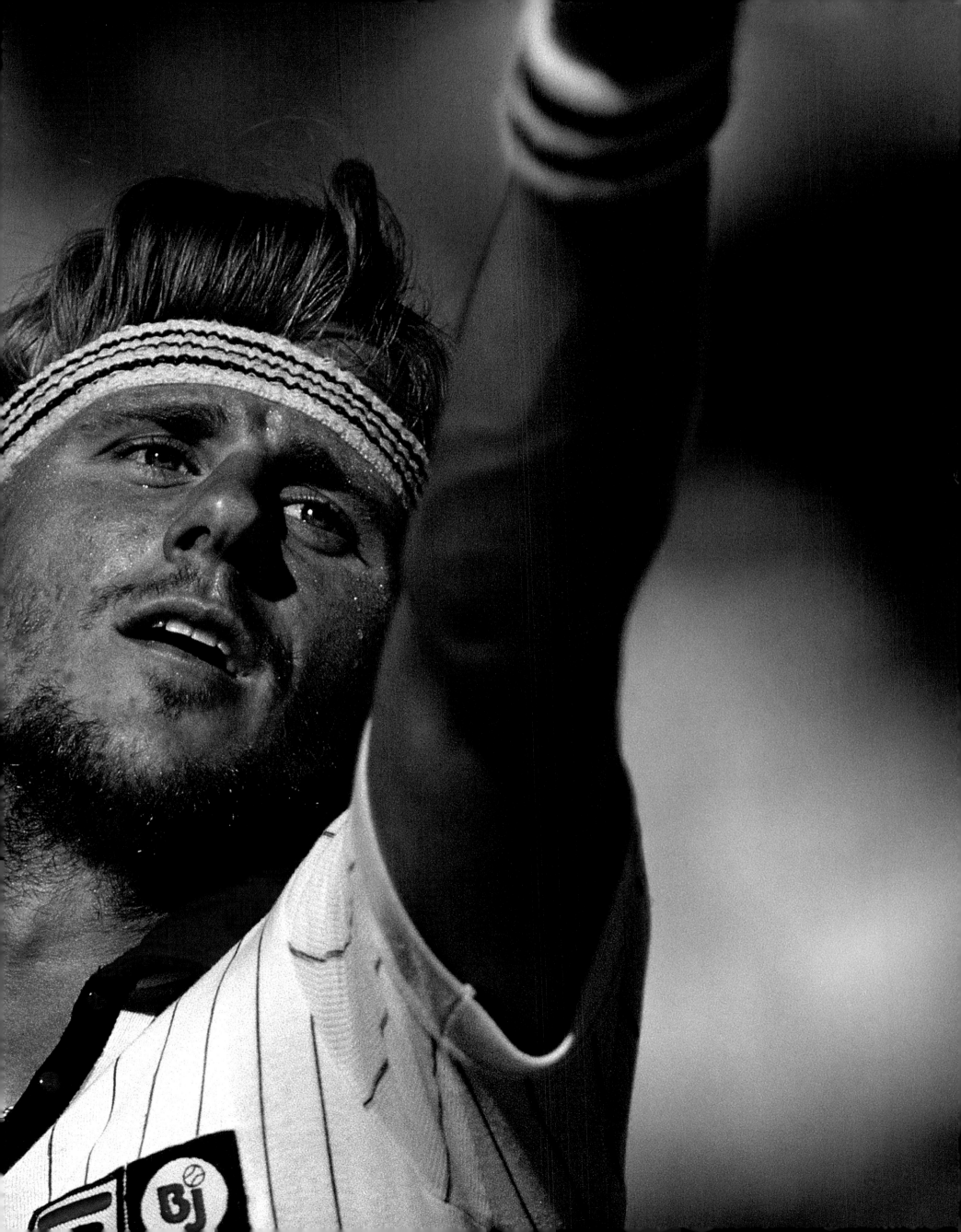

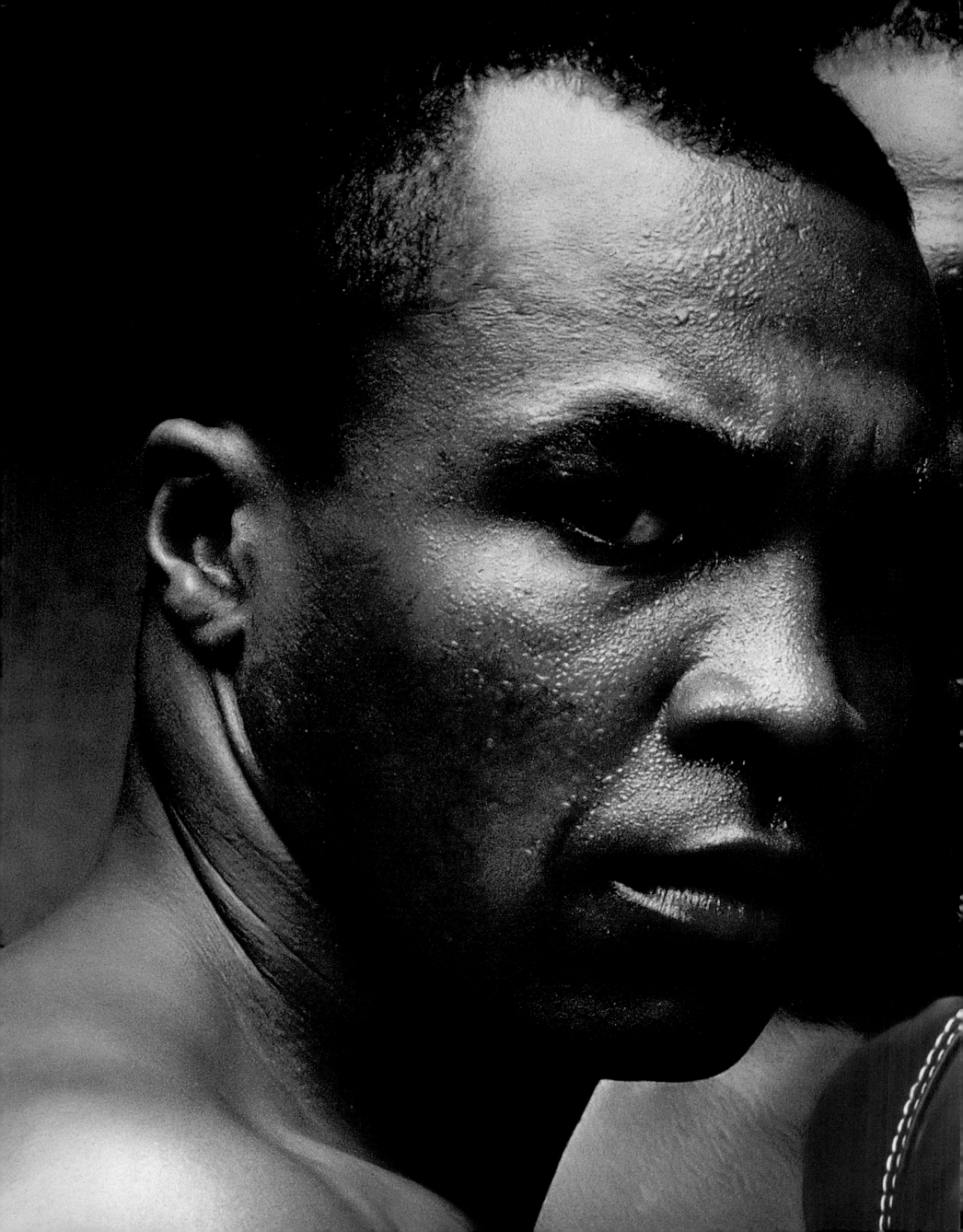

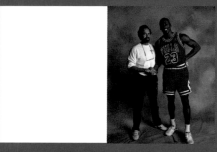
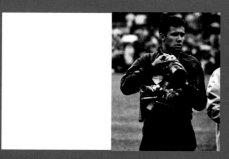
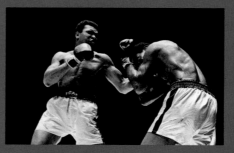
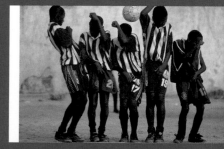

WALTER IOOSS AND MICHAEL JORDAN
CHICAGO, ILLINOIS 1991

WALTER IOOSS BY BOB PETERSON
BALTIMORE, MARYLAND 10/1964

MUHAMMAD ALI VS. ERNIE TERRELL
HOUSTON, TEXAS 1967

SALVADOR, BAHIA, BRAZIL 2001

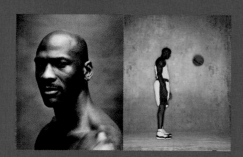
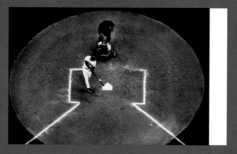
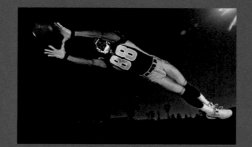
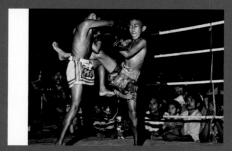

RIGHT PAGE: MICHAEL JORDAN
CHICAGO, ILLINOIS 1996

KEN GRIFFEY, JR.
SEATTLE, WASHINGTON 1996

TORRY HOLT
ST. LOUIS, MISSOURI 2001

BANGKOK, THAILAND 1995

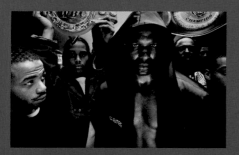
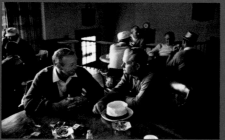
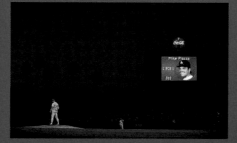
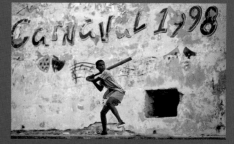

BERNARD HOPKINS
PHILADELPHIA, PENNSYLVANIA 2005

ARNOLD PALMER AND JACK NICKLAUS
LIGONIER, PENNSYLVANIA 1965

DODGER STADIUM
LOS ANGELES, CALIFORNIA 1993

HAVANA, CUBA 1999

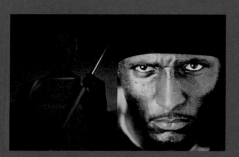
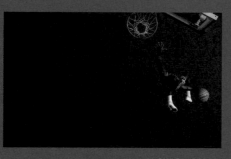
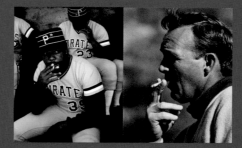
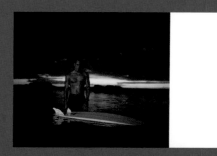

LEFT PAGE: JACKIE JOYNER-KERSEE
BEVERLY HILLS, CALIFORNINA 1991
RIGHT PAGE: RAY LEWIS
OWINGS MILLS, MARYLAND 2002

MICHAEL JORDAN
LISLE, ILLINOIS 1987

LEFT PAGE: DAVE PARKER AND GRANT JACKSON
BRADENTON, FLORIDA 1980
RIGHT PAGE: ARNOLD PALMER
PEBBLE BEACH, CALIFORNIA 1966

KELLY SLATER
HONOLULU, OAHU, HAWAII 1995

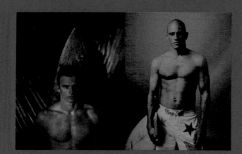
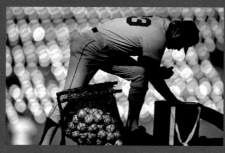
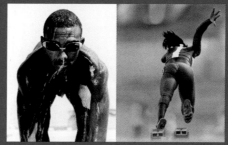
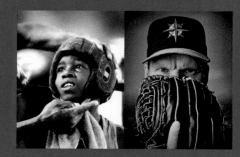

LEFT PAGE: LAIRD HAMILTON
HONOLULU, OAHU, HAWAII 1995
RIGHT PAGE: KELLY SLATER
NEW YORK, NEW YORK 2006

WALT HRINIAK
BOSTON, MASSACHUSETTS 1979

LEFT AND RIGHT PAGE: HAVANA, CUBA 1999

LEFT PAGE: HAVANA, CUBA 1999
RIGHT PAGE: RANDY JOHNSON
PEORIA, ARIZONA 1997

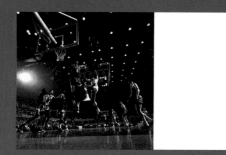
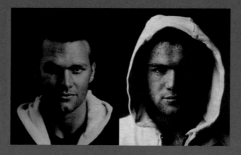
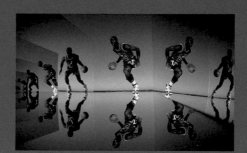
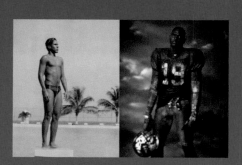

BILL RUSSELL AND ELGIN BAYLOR
LOS ANGELES, CALIFORNIA 1966

LEFT PAGE: TOM BRADY
DETROIT, MICHIGAN 2006
RIGHT PAGE: WAYNE ROONEY
MANCHESTER, ENGLAND 2006

MICHAEL JORDAN
CHICAGO, ILLINOIS 1991

LEFT PAGE: HAVANA, CUBA 1999
RIGHT PAGE: KEYSHAWN JOHNSON
HEMPSTEAD, NEW YORK 1999

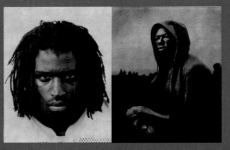

KOBE BRYANT
NEW YORK, NEW YORK 2002

JOE MONTANA
REDWOOD CITY, CALIFORNIA 1991

LEFT PAGE: RICKY WILLIAMS
DAVIE, FLORIDA 2002
RIGHT PAGE: TERRELL OWENS
SANTA CLARA, CALIFORNIA 2002

KELLY SLATER
SEBASTIAN INLET, MELBOURNE BEACH, FLORIDA 1990

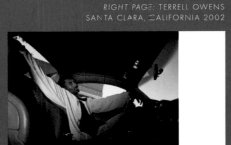
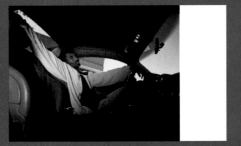
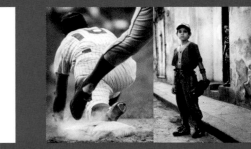

PITTSBURGH STEELERS VS. CINCINNATI BENGALS
CINCINNATI, OHIO 1976

LEFT PAGE: CHARLES BARKLEY
NEW YORK, NEW YORK 1988
RIGHT PAGE: SERENA WILLIAMS
MIAMI, FLORIDA 2005

KOBE BRYANT
LOS ANGELES, CALIFORNIA 2000

LEFT PAGE: FRANK TORRE
PHILADELPHIA, PENNSYLVANIA 1962
RIGHT PAGE: HAVANA, CUBA 1999

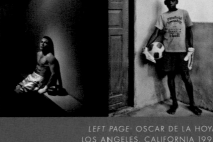

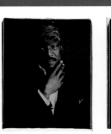

HANALEI, KAUAI, HAWAII 1976

LEFT PAGE: OSCAR DE LA HOYA
LOS ANGELES, CALIFORNIA 1995
RIGHT PAGE: SALAVADOR, BAHIA, BRAZIL 2001

JIMMY ORR AND JERRY MERTENS
BALTIMORE, MARYLAND 1962

LEFT PAGE: JIM BROWN
NEW YORK, NEW YORK 1999
RIGHT PAGE: ARNOLD PALMER
NEW YORK, NEW YORK 1999

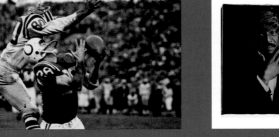
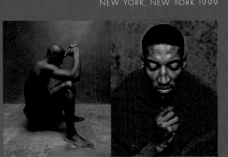

TUNNELS BEACH, HAENA, KAUAI, HAWAII 1976

LEFT PAGE: JIM BROWN
CLEVELAND, OHIO 1966
RIGHT PAGE: KYLE ROTE
BRONX, NEW YORK 1962

HAVANA, CUBA 1999

LEFT PAGE: MICHAEL JORDAN
HIGHLAND PARK, ILLINOIS 1998
RIGHT PAGE: SCOTTIE PIPPEN
DEERFIELD, ILLINOIS 1998

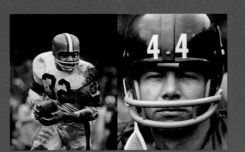

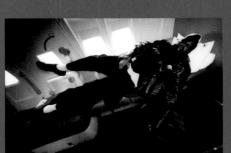

JOE NAMATH
FLUSHING, NEW YORK 1967

FANS AT THE ORANGE BOWL
MIAMI, FLORIDA 1981

SHAQUILLE O'NEAL
LOS ANGELES LAKERS TEAM CHARTER, 2002
"I GOTTA KEEP A HANDLE ON MY BIZNESS."

PHIL JACKSON AND MEL COUNTS
LOS ANGELES, CALIFORNIA 1973

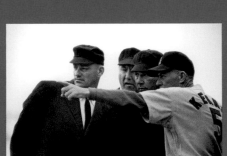
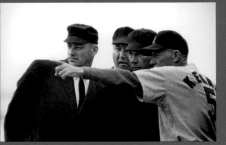

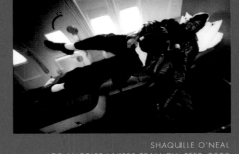
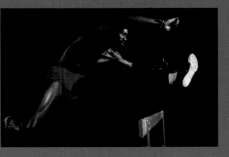
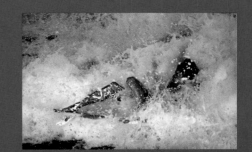

JOHNNY KEANE
ST. PETERSBURG, FLORIDA 1964

LOU BROCK
BOSTON, MASSACHUSETTS 1967

EDWIN MOSES
IRVINE, CALIFORNIA 1991

LEFT PAGE: MICHAEL PHELPS
BALTIMORE, MARYLAND 2004
RIGHT PAGE: WAYNE GRETZKY
LOS ANGELES, CALIFORNIA 1991

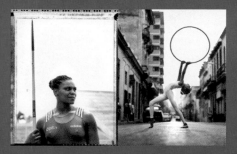

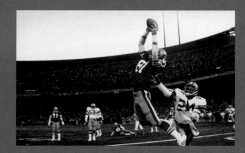

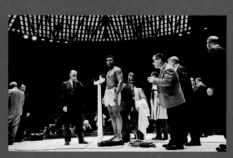

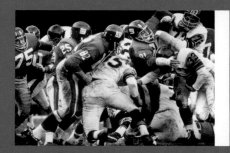

LEFT AND RIGHT PAGE: HAVANA, CUBA 1999

DWIGHT CLARK AND EVERSON WALLS
SAN FRANCISCO, CALIFORNIA 1982

MICHELLE KWAN
NEW YORK, NEW YORK 1997

PITTSBURGH STEELERS VS. NEW YORK GIANTS
BRONX, NEW YORK 1963

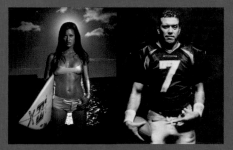

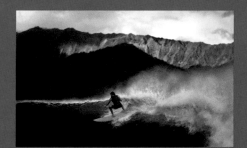

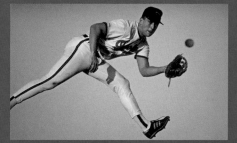

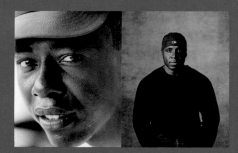
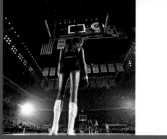

LEFT PAGE: MALIA JONES
KAHUKU, OAHU, HAWAII 1999
RIGHT PAGE: JOHN ELWAY
DENVER, COLORADO 1998

MUHAMMAD ALI
HOUSTON, TEXAS 1967

HANALEI, KAUAI, HAWAII 1976

LEFT PAGE: HANK AARON
WEST PALM BEACH, FLORIDA 1969
RIGHT PAGE: BARRY BONDS
BURLINGAME, CALIFORNIA 2004

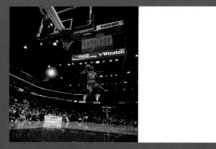

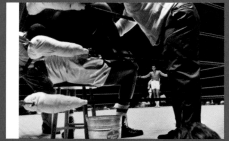

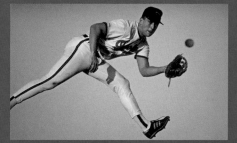

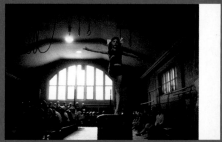

MICHAEL JORDAN
CHICAGO, ILLINOIS 1998

MUHAMMAD ALI VS. ERNIE TERRELL
HOUSTON, TEXAS 1967

CAL RIPKEN, JR.
FORT LAUDERDALE, FLORIDA 1991

WILT CHAMBERLAIN
BOSTON, MASSACHUSETTS 1967

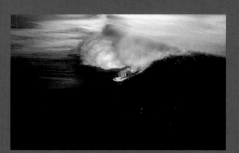

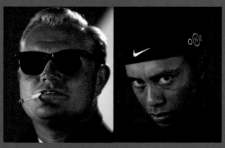

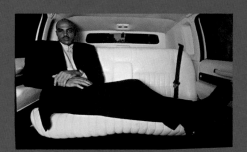

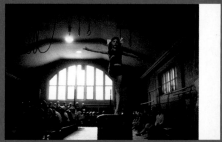

BANZAI PIPELINE, OAHU, HAWAII 1990

LEFT PAGE: JACK NICKLAUS
WEST PALM BEACH, FLORIDA 1967
RIGHT PAGE: TIGER WOODS
REUNION, FLORIDA 2007

CHARLES BARKLEY
NEW YORK, NEW YORK 1993

LEIPZIG, EAST GERMANY 1976

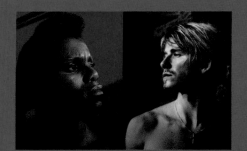

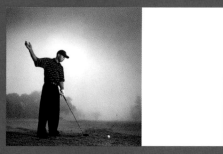

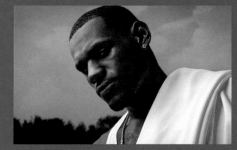

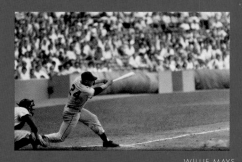

LEFT PAGE: CARL LEWIS
HOUSTON, TEXAS 1988
RIGHT PAGE: DAVID BECKHAM
LONDON, ENGLAND 1999

TIGER WOODS
ORLANDO, FLORIDA 2002

LEBRON JAMES
AKRON, OHIO 2005

WILLIE MAYS
PHILADELPHIA, PENNSYLVANIA 1962

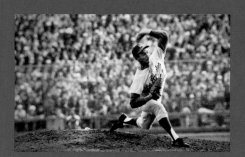

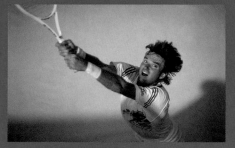

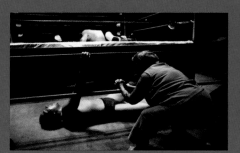

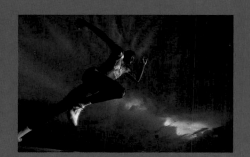

SANDY KOUFAX
MINNEAPOLIS, MINNESOTA 1965

JIMMY CONNORS
SANTA BARBARA, CALIFORNIA 1991

TAMPA, FLORIDA 1980

CARL LEWIS
HOUSTON, TEXAS 1991

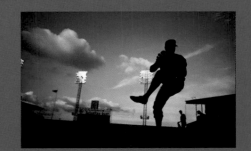
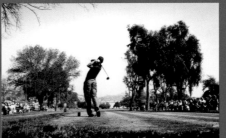
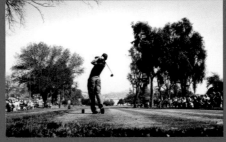
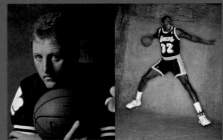

LEFT PAGE: MIKE "THE BEAR" TALIFERRO
LOS ANGELES, CALIFORNIA 1995
RIGHT PAGE: GAIL DEVERS
WESTWOOD, CALIFORNIA 1996

GREG LOUGANIS
MISSION VIEJO, CALIFORNIA 1984

TIGER WOODS
CARLSBAD, CALIFORNIA 2000

CONNIE MACK STADIUM
PHILADELPHIA, PENNSYLVANIA 1967

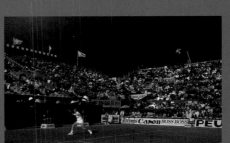
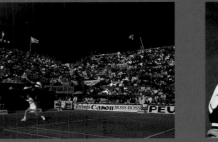
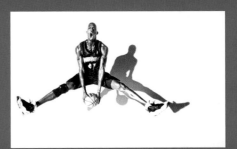

LEFT PAGE: STEFFI GRAF
CABO SAN LUCAS, MEXICO 1997
RIGHT PAGE: KEVIN GARNETT
MINNEAPOLIS, MINNESOTA 1999

WALT FRAZIER
LONG BEACH, CALIFORNIA 1973

BORIS BECKER
PARIS, FRANCE 1989

LEFT PAGE: LARRY BIRD
BOSTON, MASSACHUSETTS 1989
RIGHT PAGE: EARVIN "MAGIC" JOHNSON
INGLEWOOD, CALIFORNIA 1996

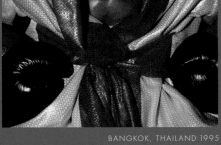

LEFT PAGE: MICKEY MANTLE AND ROGER MARIS
BRONX, NEW YORK 1962
RIGHT PAGE: JOE DIMAGGIO
BRONX, NEW YORK 1980

NEW ENGLAND PATRIOTS VS. DENVER BRONCOS
DENVER, COLORADO 1979

9/11/02 8:46 A.M.
MONTAUK POINT, NEW YORK 2002

KEVIN GARNETT
MINNEAPOLIS, MINNESOTA 1999

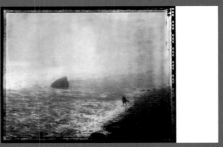
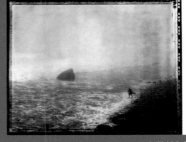
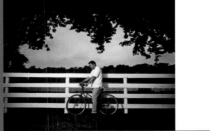
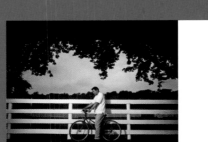
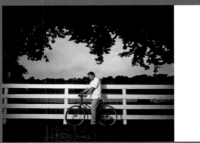

HAVANA, CUBA 1999

LEFT PAGE: CRISTIANO RONALDO
MANCHESTER, ENGLAND 2006
RIGHT PAGE: KIERAN RICHARDSON
MANCHESTER, ENGLAND 2006

MUHAMMAD ALI
BERRIEN SPRINGS, MICHIGAN 1996

LEFT PAGE: DWIGHT EISENHOWER AND ARNOLD PALMER
LIGONIER, PENNSYLVANIA 1965
RIGHT PAGE: O.J. SIMPSON
LOS ANGELES, CALIFORNIA 1968

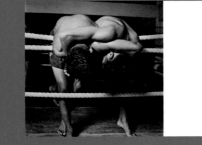
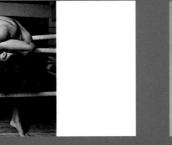
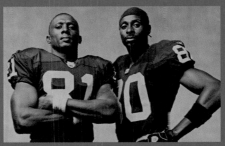
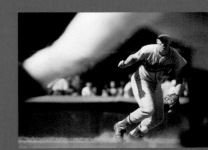

BANGKOK, THAILAND 1995

BANGKOK, THAILAND 1995

TIM BROWN AND JERRY RICE
ALAMEDA, CALIFORNIA 2002

BROOKS ROBINSON
DETROIT, MICHIGAN 1966

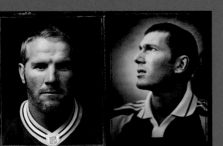
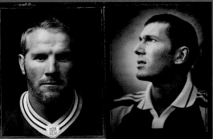

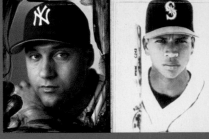

LEFT PAGE: BRETT FAVRE
GREEN BAY, WISCONSIN 2005
RIGHT PAGE: ZINEDANE ZIDANE
TURIN, ITALY 1999

WILT CHAMBERLAIN
PHILADELPHIA, PENNSYLVANIA 1967

SHAQUILLE O'NEAL
EL SEGUNDO, CALIFORNIA 2002

LEFT PAGE: DEREK JETER
TAMPA, FLORIDA 2000
RIGHT PAGE: ALEX RODRIGUEZ
MIAMI BEACH, FLORIDA 1997

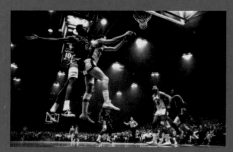
BILL RUSSELL AND JERRY LUCAS
CINCINNATI, OHIO 1966

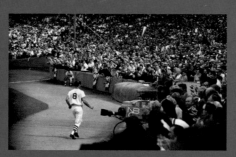
CARL YASTRZEMSKI
BOSTON, MASSACHUSETTS 1967

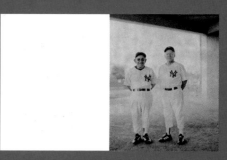
YOGI BERRA AND WHITEY FORD
TAMPA, FLORIDA 2001

MICHAEL JORDAN
COCONUT GROVE, FLORIDA 1993

JOE NAMATH
FORT LAUDERDALE, FLORIDA 1969

DAN MARINO
MIAMI, FLORIDA 1985

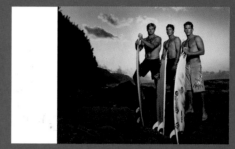
LAIRD HAMILTON, BRUCE IRONS AND ANDY IRONS
NAPALI COAST, KAUAI, HAWAII 2005

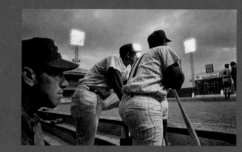
CAL MCLISH, DON DEMETER AND CLAY DALRYMPLE
PHILADELPHIA, PENNSYLVANIA 1963

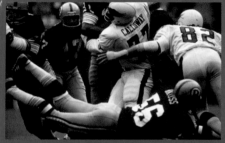
PHILADELPHIA EAGLES VS. WASHINGTON REDSKINS
WASHINGTON, D.C. 1973

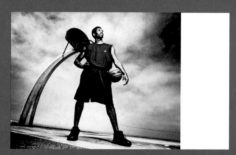
KOBE BRYANT
SAN PEDRO, CALIFORNIA 2001

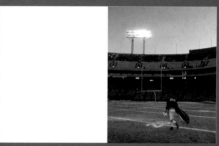
JOHNNY UNITAS
BALTIMORE, MARYLAND 1970

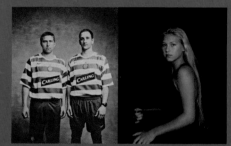
LEFT PAGE: ADAM VIRGO AND JOHN KENNEDY
GLASGOW, SCOTLAND 2006
RIGHT PAGE: ANNA KOURNIKOVA
BRADENTON, FLORIDA 1997

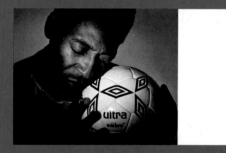
PELÉ
NEW YORK, NEW YORK 1987

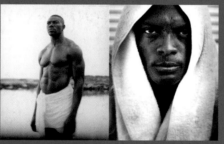
LEFT PAGE: TERRELL OWENS
HONOLULU, OAHU, HAWAII 2001
RIGHT PAGE: EDDIE GEORGE
SANTA MONICA, CALIFORNIA 1997

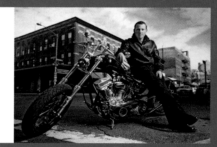
LANCE ARMSTRONG
NEW YORK, NEW YORK 2005

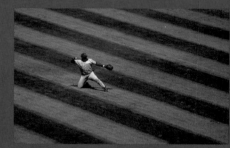
KEVIN MITCHELL
SAN FRANCISCO, CALIFORNIA 1993

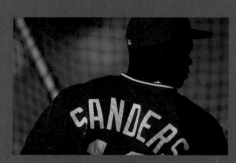
REGGIE SANDERS
LOS ANGELES, CALIFORNIA 1993

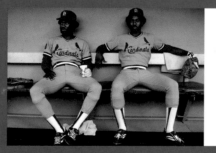
TONY SCOTT AND GARRY TEMPLETON
LOS ANGELES, CALIFORNIA 1979

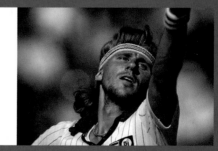
BJORN BORG
FLUSHING, NEW YORK 1978

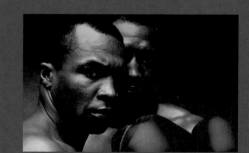
SUGAR RAY LEONARD AND THOMAS HEARNS
NEW YORK, NEW YORK 1989

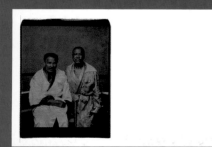
MUHAMMAD ALI AND JOE FRAZIER
PHILADELPHIA, PENNSYLVANIA 2003

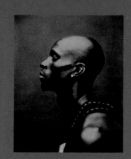
KEVIN GARNETT
MINNEAPOLIS, MINNESOTA
1999

TIME INC. HOME ENTERTAINMENT PUBLISHER *Richard Fraiman* GENERAL MANAGER *Steve Sandonato* EXECUTIVE DIRECTOR, MARKETING SERVICES *Carol Pittard* DIRECTOR, RETAIL & SPECIAL SALES *Tom Mifsud* DIRECTOR, NEW PRODUCT DEVELOPMENT *Peter Harper* ASSISTANT DIRECTOR, BRAND MARKETING *Laura Adam* ASSOCIATE COUNSEL *Helen Wan* BOOK PRODUCTION MANAGER *Jonathan Polsky* DESIGN & PREPRESS MANAGER *Anne-Michelle Gallero* BRAND MANAGER *Danielle Terwilliger*

SPORTS ILLUSTRATED EDITOR *Terry McDonell* DEPUTY EDITOR *David Bauer* DIRECTOR OF PHOTOGRAPHY *Steve Fine* SENIOR EDITOR, OPERATIONS *Stefanie Kaufman* SENIOR EDITOR, ARTICLES *Chris Hunt* COPY EDITOR *Kevin Kerr* REPORTER *David Epstein* DIRECTOR OF IMAGING *Geoffrey A. Michaud* IMAGING MANAGERS *Dan Larkin, Robert M. Thompson* ASSISTANT IMAGING MANAGER *Annmarie Modugno-Avila* IMAGING SPECIALISTS *William Y. Lew, Brian Mai, Charles Maxwell, Lorenzo Pace, Clara Renauro, Donald Schaedtler, Hai Tan, Sandra Vallejos*

NOII, INC. BOOK DESIGN *Giovanni Carrieri Russo* GRAPHIC DESIGN *Olivia Windisch*

SPECIAL THANKS Bozena Bannett, Glenn Buonocore, Suzanne Janso, Robert Marasco, Brooke Reger, Mary Sarro-Waite, Ilene Schreider, Adriana Tierno, Alex Voznesenskiy

ISBN 10: 1-60320-008-8 ISBN 13: 978-1-60320-008-0
Library of Congress Control Number: 2007907991

There have been many people who have helped to make my photographic journey as special as it has been. First and foremost are my wife, Eva, and our two sons, Christian and Bjorn. They are the core of my life, endless sources of inspiration. I couldn't live without them. I owe great debts to my mother, Barbara, who nurtured my teenage dream of being a photographer, and to my father, Walter Sr., who introduced me to photography in 1959.

Obviously SPORTS ILLUSTRATED has played an enormous role in my career and I thank the entire SI staff deeply. There are some who deserve a special mention. These include George Bloodgood, my first picture editor; Steve Fine, my longtime friend and the current picture editor; Jule Campbell, the editor who took me from the playgrounds to the white sands of the Swimsuit Issue; Diane Smith; Gil Rogin; Dan Jenkins; and Frank Deford. Among the photographers who have influenced and inspired me are John Zimmerman, Hy Peskin, Jay Maisel, Pete Turner, James Nachtwey, Peter Beard, Raphael Mazzucco, Neil Leifer, Irving Penn, Arnold Newman and Annie Leibovitz. There are many great athletes who have trusted me and given me their precious time. A short list would include Michael Jordan, Chris Evert, Ken Griffey Jr., Cal Ripken Jr., Wayne Gretzky, Joe Montana, Derek Jeter, Kelly Slater, Arnold Palmer, Jack Nicklaus and Maria Sharapova. I'd also like to thank my agents, Bill Stockland and Maureen Martel, SI Editor Terry McDonell, the SI Imaging Department—especially Geoff Michaud, Dan Larkin and Robert Thompson—and book designer Giovanni C. Russo and his No11 Inc. team, particularly Olivia Windisch who made this book beautiful.

Last but not least, thank you to the wonderful people of Montauk Point, N.Y.

Walter Iooss
New York City
October 2007

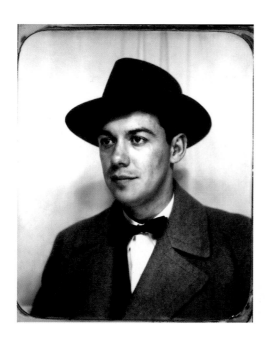
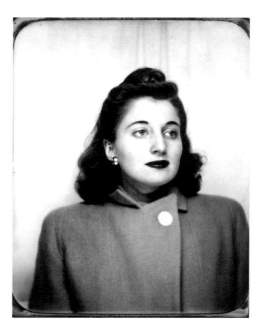

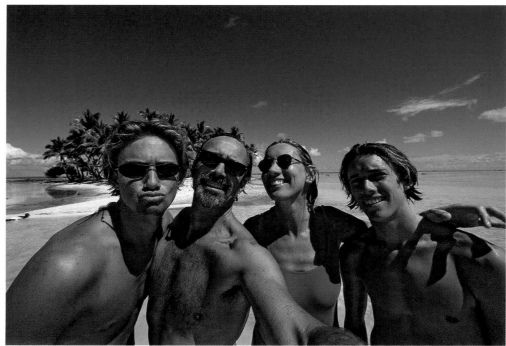